HUNGRY? CITY GUIDES

HUNGRY?
CHICAGO

THE LOWDOWN ON
WHERE THE
REAL PEOPLE
EAT!

Edited by Jennifer Worrell

Copyright (c) 2010 by Hungry City Guides
All rights reserved.

Except as permitted under the United States
Copyright Act of 1976, no part of this publication
may be reproduced or distributed in any form or by
any means, or stored in a database or
retrieval system, without the prior written
permission of the publisher.

Printed in the United States of America

First Printing: September, 2009

10 9 8 7 6 5 4 3 2 1

Library of Congress Cataloging-in-Publication Data
Hungry? Chicago:
The Lowdown on Where the Real People Eat!
by Hungry City Guides
256 pages
ISBN 13: 978-1-893329-51-5
I. Title II. Food Guides III. Travel IV Chicago

Production by Bonnie Yoon Design

Visit our Web site at www.HungryCityGuides.com

To order this Hungry? or our other
Hungry City Guides,
or for information on using them as corporate gifts,
visit us at HungryCityGuides.com

Hungry City Guides are available to the trade
through SCB Distributors:
(800) 729-6423
www.SCBDistributors.com

Hungry City Guides strives to
provide you with books that are made from at
least 40% post consumer waste recycled fiber.

THANKS A BUNCH...

...to our contributors
Ian R. Alexander, Joshua A. Arons, Susan Ball, Paul Barile, Steve and Donna Bellinger, Katelyn Bogucki, Dana Bottenfield, Annalee Bronkema, Patrick Brown, Heather Calomese, Kristen Campagna, Rachael Diane Carter, Luca Cimarusti, Laura Cococcia, Benjamin Coy, Susan "Devin" Droste, Andrea Eisenberg, Cliff Etters, Donny Farrell, Denise Goldman, Katy Graf, Whitney Greer, May C. Gruia, Julie Harber, Megan Healy, Dylan Heath, Lisa Hede, Dorothy Hernandez, Lori Hile, Gina Holechko, Charlie S. Jensen, Erika Jones, Molly Kealy, Crage Kentz, Devin Kidner, Carrie Kirsch, David Kravitz, Christine Lambino, Helen Lee, Jessica Lewis, Mark and Julia Lobo, Rhea Manalo, Debra Monkman, Nick Monteleone, Kathy Moon, Alex Moore, Norine Mulry, Kim Nawara, Craig Nemetz, Santrise Nicole, Jenna Noble, Renee Ochs, Emily Olson, Julie Owens, Denise Peñacerrada, Hillary Proctor, Nora "Noe" Quick, Lori Rotenberk, Robert Sabetto, April Schneider, Dave Shapiro, Andrew Skweres, Rachael Smith, Matthew Sove, Jim St. Marie, Jennifer Stone, Jen Tatro, Isa Traverso-Burger, Marquis Tucker, Araceli Valenciano, Lindsay Valentin, Veronica Wagner, Liz Walker, Travis Lee Wiggins, Jessica Word, Evan Wormser, and Brandon Wuske...

...and to the people who helped make it all happen
A HUGE thanks to Mari Florence (the mastermind behind the Hungry? guides), Bonnie Yoon (for her talents in design and production), Heather John, Jillian Williams, Janet Thielke, Duyen Tran, Rebecca Dorman, and Nadia Economides (for taking the book through the final stages).

CONTENTS

Key to the Book .. vi
Map O' the Town ... viii
Please Read .. x
Introduction .. xi

DOWNTOWN

Gold Coast/River North/Streeterville 2
Loop/Mag Mile/Millenium Park 18
 Top 5 Coves of Concealment 24
South Loop ... 26

NEAR NORTH SIDE

Bucktown/Wicker Park .. 31
 Small Plates in the City of Big Shoulders 38
Lincoln Park ... 44
Old Town .. 53

NEAR WEST SIDE

Little Italy ... 57
 Italian Beef: A True Chicago Food 57
Ukrainian Village/West Town 60

NEAR SOUTH SIDE

Bridgeport ... 75
Chinatown .. 75
 Chinatown Confidential ... 77
Pilsen .. 80

NORTH SIDE

Andersonville/Edgewater 85
Uptown ... 92
Lakeview/Boystown/Wrigleyville 98
Little India/Rogers Park/West Ridge 110
 Little India ... 114
North Center/Ravenswood/Roscoe Village .. 115

NORTHWEST SIDE

Albany Park/Irving Park 120
Jefferson Park/Portage Park/Norwood Park . 124
Lincoln Square .. 128
 The Drive-In
 A Look Back at a Popular American Tradition 128
 Eli's Cheesecake World .. 133

WEST SIDE

Humboldt Park .. 136
Logan Square ... 139
 Chicago's Green Party .. 143

SOUTHWEST SIDE

Ashburn/Mount Greenwood146
Garfield Ridge/Midway148

SOUTH SIDE

Beverly ..151
Chatham ...152
Hyde Park ...154
 Medici Bakery ...157
South Chicago ..161

NORTH SUBURBS

Evanston/Skokie ...163
 The Spice House ..166
Deerfield/Northbrook/Winnetka171
Highland Park/Highwood/Lake Forest174

NORTHWEST SUBURBS

Arlington Heights ..182
Glenview ..185
Niles/Lincolnwood/Morton Grove190
Palatine/Rolling Meadows/Schaumburg193

WEST SUBURBS

Cicero/Riverside ...196
Elmwood Park/Oak Park197
Naperville ...203

SOUTHWEST SUBURBS

Blue Island ...205
Bridgeview/Burbank ...205
Orland Park/Tinley Park208
 Sam's Wines: Not Just for Beverages Anymore210
Palos Heights/Palos Park213

SOUTH SUBURBS

Evergreen Park ...217
 Chicago Pizza Smackdown219

Glossary ...222
Alphabetical Index ..231
Category Index ...234
About the Contributors ..238

v

KEY TO THE BOOK

ICONS

Most Popular Menu Items

 Breakfast

 Healthy FF

 Lunch

 Cart

 Dinner

 Beer

 Vegetarian

 Cocktails

 Seafood

 Wine

 Carnivore

 Coffee

 To Go

 Tea

 BYOB

 Desserts/Bakery

Ambience

 Early Bird

 Outdoor

 Night Owl

 Live Music

 Editor's Pick

 Dance

 Solo

 People Watching

 Romantic

 Waits

 Landmark

Cost

Hungry?
Cost of the average meal:

- $ $5 and under
- $$ $5 - $10
- $$$ $10 - $15
- $$$$ $15 and over

Payment

Note that many places that take all the plastic we've listed also take Diner's Club, Carte Blanche and the like. And if it says cash only, be prepared.

- Visa
- MasterCard
- American Express
- Discover
- ATM
- Cash only

Tipping Guide

If you can't afford to tip, you can't afford to dine out. Remember, if the meals are brought to you or made for you, you should probably leave a some sort of tip. Here's a guide to help you out:

Cost of Tab	Scrooge <15%	Hungry? 20%	Hungry! 25%
$ 15	<2.25	3	3.75
$ 25	<3.75	5	6.25
$ 35	<5.25	7	8.75
$ 45	<6.75	9	11.25
$ 55	<8.25	11	13.75
$ 65	<9.75	13	16.25

MAP O' THE TOWN

① DOWNTOWN
- Magnificent Mile/Loop
- Gold Coast/River North/Streeterville
- Printer's Row

② NORTH SIDE
- Lincoln Park/Old Town
- Lakeview/Boystown/Wrigleyville
- Roscoe Village/North Center
- Uptown
- Lincoln Square
- Andersonville/Edgewater
- Rogers Park/West Ridge

③ NORTHWEST DIDE
- Wicker Park/Ukranian Village
- Logan Square/Bucktown
- Irving Park/Albany Park
- Portage Park
- North Park/Edgebrook
- Norwood Park/Edison Park
- Jefferson Park/East Village

④ WEST SIDE
- Little Italy/Greektown
- West Town/East Village
- Near West Side/Humboldt Park
- Pilsen

⑤ SOUTH SIDE
- Hyde Park/Bronzville

⑥ NORTHSHORE
- Evanston
- Wilmette

⑦ NORTHWEST
- Rosemont
- Harwood Heights/Skokie
- Niles/Park Ridge
- Des Plaines
- Morton Grove/Glenview
- Northbrook
- Wheeling

⑧ SOUTHWEST
- Oak Park/Riverside
- Naperville/Warrenville
- Lemont

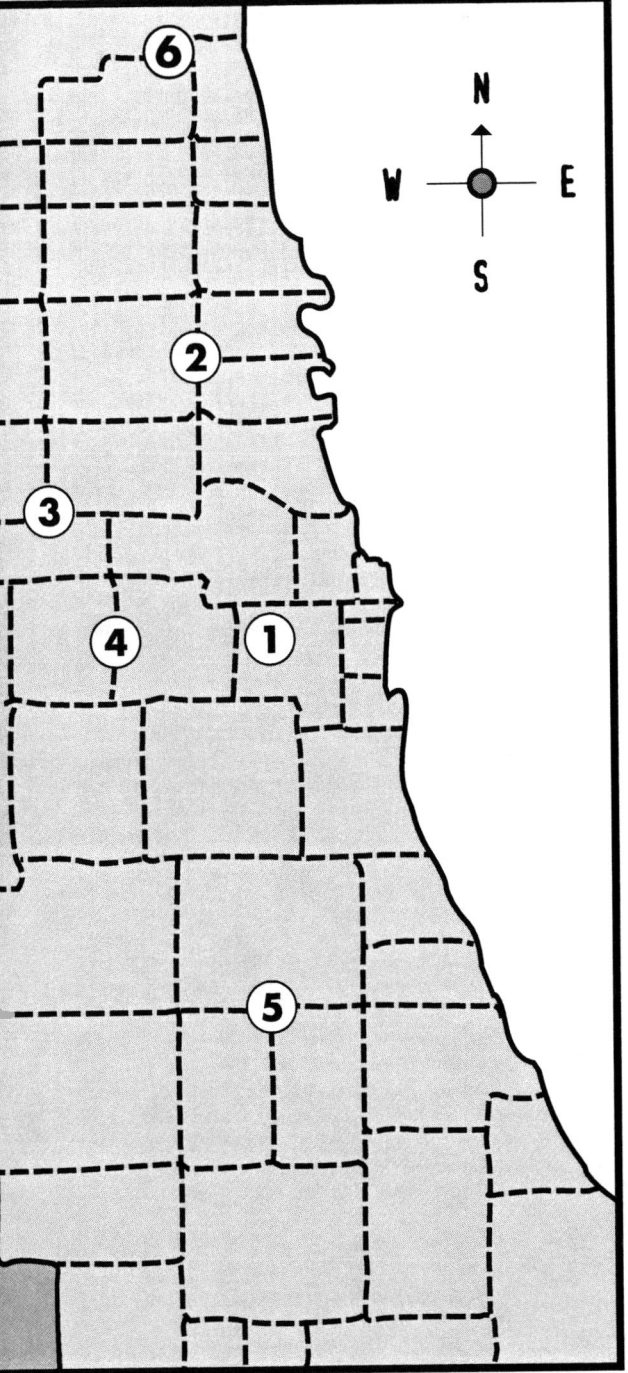

PLEASE READ

Disclaimer #1
The only sure thing in life is change. We've tried to be as up-to-date as possible, but places change owners, hours and menus as often as they open up a new location or go out of business. Call ahead so you don't end up wasting time crossing town and arrive after closing time.

Disclaimer #2
Every place in this guide is recommended, for something. We have tried to be honest about our experiences of each place, and sometimes a jab or two makes its way into the mix. If your favorite spot is slammed for something you think is unfair, it's just one person's opinion! And remember, under the Fair Use Doctrine, some statements about the establishments in this book are intended to be humorous as parodies.

And wait, there's more!
While we list hundreds of restaurants in the book, that's just the beginning of the copious eating and drinking opportunities in Chicago. Visit HungryCity-Guides.com for additional reviews, updates, and all the information you need for your next dining out adventure.

Tip, Tip, Tip.
If you can't afford to tip you can't afford to eat and drink. In the United States, most servers make minimum wage or less and depend on tips to pay the rent. Tip fairly, and not only will you get better service when you come back, but you'll start believing in karma (if you don't already).

Road Trip!
And, next time you hit the road, check the Hungry? City Guides to destinations including: New York, Boston, Washington DC and many, many more!

Don't Drink and Drive.
We shouldn't have to tell you this, but we can't say it enough. Drink responsibly. Don't drive after you've been drinking alcohol, period. If a designated driver is hard to come by, take the bus or call a cab to take you home. Split the cost with your friends to make it more affordable.

Share your secrets.
Know about a place we missed? Willing to divulge your secrets and contribute? Visit our website at www.HungryCityGuides.com and click on "Contact Us". We'll be happy to hear from you!

INTRODUCTION

Chicago is known for its ethnic diversity and culinary creativity. Among the Jewish delis in Skokie and the taquerias in Pilsen, dim sum in Chinatown and curries in Little India, you have four-star establishments known for "molecular gastronomy" and grungy little dives with the best burgers money can buy. Anything that strikes your fancy from one day to the next can be found in the Windy City, and what you can't find in restaurants and cafés you can probably find in the hundreds of grocery stores and ethnic markets. All these choices can be daunting as well as exciting. Where do you start? Just by opening this book, you've taken the first step towards a culinary adventure.

Everyone's had that moment when they're driving along and suddenly hunger strikes. What are you in the mood for? At that moment, everything. The problem is trying to satisfy your craving when you're in an unfamiliar neighborhood. With Hungry? Chicago in your glove compartment, you'll have the perfect place at your fingertips. Full of recommendations from Chicago's own, you'll never again have to wonder whether that candlelit place is too expensive or that funky hole-in-the-wall is really as scary as it looks or a diamond in the rough. There are plenty of tips about whether restaurants are better for families or dates and if there's plenty of parking or public transportation is the way to go.

Sometimes you need something a little more specific. Where can you take your best gal for a romantic dinner? With so many tapas places out there, how do you know which is worth your while? And when it comes to party planning, you're hopeless…where can you find the best places for takeout? Hungry? Chicago will save the day. Check out our sidebar index for great articles about the above topics and many more.

Eating in Chicago is not only a trip for the taste buds but an educational experience as well. Ask for the "secret" menu at TAC Quick. Discover the proper way to devour an Ethiopian meal at Ras Dashen. If you're into cheese, sign up for a tasting class at Marion Street Cheese Market. The possibilities are endless!

Having lived in Chicagoland my entire life, I've eaten my share of remarkable meals. Just look for the loving cup icon for some of my favorite haunts. You can't go wrong with a tube steak from Hot Doug's, Challah French Toast at Walker Brothers Pancake House or anything pork at Chuck's Southern Comfort Café.

Whether your tastes range from the mild to the adventurous, comforting to eclectic, or American to African, Hungry? Chicago has a recommendation for every appetite. With reviews spanning the city and suburbs, let this handbook be your guide to great eats.

—Jennifer Worrell

DOWNTOWN

DOWNTOWN

GOLD COAST/RIVER NORTH/STREETERVILLE

3rd Coast Café
An upscale neighborhood restaurant.
$$$
1260 N. Dearborn St., Chicago 60610
(at Goethe St.)
Phone (312) 649-0730
www.3rdcoastcafe.com

CATEGORY	American Restaurant
HOURS	Daily: 7 am-Midnight
GETTING THERE	Three hour valet parking is available at the Standard Parking garage next door. 3rd Coast is two blocks away from #22 Clark and #36 Broadway bus stops, and three blocks away from #70 Division bus and Red Line (Clark/Division) stops.
PAYMENT	
POPULAR DISH	It's all good! My favorite is something called a Diablo beef sandwich—thinly sliced Italian-style roast beef on grilled sourdough bread with hot peppers and au jus on the side. Make sure you order the potatoes O'Brian—tasty chunks of potatoes grilled with red and green peppers and onions. The Mrs. is fond of their salad selection and the best weekend brunch around.
UNIQUE DISH	There are two homemade soups on the menu every day. Our favorites are French onion, potato leek, chicken peanut, and roasted carrot. If they have the roasted carrot when you're there, get it! It's fabulous! And as a real surprise, they have the best pizza we have had in that area and a delicious fondue. The plates are not small, but you won't be overstuffed. The kitchen is willing to honor special dietary requests.
DRINKS	Select wine list at affordable prices by the glass or the bottle. Microbrew beers on tap.
SEATING	Third Coast is a small, cozy restaurant in two sections with a coffeehouse atmosphere.
AMBIENCE/CLIENTELE	Fantastic artwork by local artists is rotated every few months. This is an atmosphere where you can hear yourself think. There are regulars that meet for chess or just conversation.
EXTRA/NOTES	Live guitar soloists are featured occasionally. 3rd Coast also has a growing catering business.

—Steve and Donna Bellinger

Baba Palace

Cab stand with great Indian/Pakistani food.
$
334 W. Chicago Ave., Chicago 60610
(at Orleans St.)
Phone (312) 867-7777
www.babapalace.com

CATEGORY	Middle Eastern Dive
HOURS	Mon-Thurs: 11:30 am-10 pm
	Fri: 11:30 am-11 pm
	Sat: 10 am-3 pm, 5:30 pm-11 pm
	Sun: 10 am-3 pm, 5 pm-9 pm

DOWNTOWN

GETTING THERE	Limited street parking, but meters are available. Accessible by Brown and Purple lines (Chicago stop) or the #66 Chicago, #65 Grand, or #8 Halsted bus.
PAYMENT	
POPULAR DISH	Try the biryani, frontier chicken, and most definitely the naan! I recommend walking up to the counter where they display plates of food served that day so you can take a look at what you are ordering.
UNIQUE DISH	Unique dishes vary. The menu can change daily, so check the plates on the counter to see what is new or special that day. The naan is homemade brick bread. One you have it you will never want the pre-packaged grocery store stuff ever again.
DRINKS	Just water, tea, coffee (for all the cab drivers).
SEATING	There is seating, but not much. It is not always a welcoming environment, so the best bet may be carry-out. Generally, the back of the dining room is filled with cab drivers speaking any number of foreign tongues while watching Al Jazeera on satellite.
AMBIENCE/CLIENTELE	You come here for the food; it's good, cheap, well-prepared and authentic. It is open 24/7, and the clientele is generally the same round the clock. If you want to escape the neighborhood trendy spots, try Baba Palace. If you want to watch Al Jazeera TV, you can do so here.

—Julie Owens

Bijan's Bistro

Cozy bistro with a solid late night menu and brunch.
$$$
663 N. State St., Chicago 60610
(between Erie St. and Huron St.)
Phone (312) 202-1904 • Fax (312) 202-1905
www.bijansbistro.com

CATEGORY	American Bistro
HOURS	Daily: 11 am-4 am
GETTING THERE	Parking is difficult, although valet is available! Take the Red Line to Chicago or Grand. You can also take the #36 State or #66 Chicago bus.
PAYMENT	
POPULAR DISH	Sure Bijan's seems fancy, serving escargot and duck a l'orange, but the real gems in this quaint café are the sandwiches, burgers and salads. The shrimp BLT with lobster mayo is a triumph. The meatloaf is better than your mother's, paired with fries and smothered in mushroom gravy. Even in the wee hours of the morning, the house and iceberg salads are fresh, doused in Bijan's distinct and delicious dill vinaigrette.
UNIQUE DISH	The chopped cobb salad with fresh grilled chicken graduates salad to a new level. The creamy chunks of avocado and the salty, crisp bacon are balanced with bright tomato wedges and green beans, delivering a hearty lunch or a satisfying late night snack. The flash-fried calamari is surprisingly light and never greasy, no matter what time of night (or early morning)!
DRINKS	Bijan's has an extensive menu of specialty cocktails, including the seductive Black Satin martini and the Truffletini, both made with dark Godiva chocolate liqueur. Varied selections of beer and wine (by the glass or bottle) are supplemented by a lengthy list of cognac, scotch, and bourbon.

DOWNTOWN

SEATING There are tall tables in the narrow bar area, which is just mildly secluded from the main dining room. Tables are cozy but not too close, usually set for four—or even better, a candlelit dinner for two—but large groups (over ten) have difficulty claiming space. Reservations are recommended for dinner, but brunch and late night dining often yields open seats.

AMBIENCE/CLIENTELE It's a small restaurant, dimly lit, and covered in rich dark oak. The teal walls are detailed with murals in the dreamy style of Post-Impressionists. The menu is American, but the ambience is as quaint and romantic as a French bistro.

EXTRA/NOTES In warmer months, the patio is open and seats 70.

—*Jessica Word*

Bistrot Zinc

Crêpes, quiche and French toast at Chicago's most popular bistro.
$$$$
1131 N. State St., Chicago 60610
(at Cedar St.)
Phone (312) 337-1131
www.bistrotzinc.com

CATEGORY French Bistro
HOURS Daily: 11:30 am-3 pm
 5:30 pm-10pm
GETTING THERE Valet parking from 11:30 am to closing. Take Red Line to Clark/Division or the #22 Clark, #36 Broadway or #70 Division bus. There is also a paid parking lot approximately three blocks north at Goethe St.
PAYMENT
POPULAR DISH For brunch, Oeufs Épinard (poached eggs, sautéed spinach and hollandaise on English muffins). If you're in a carbs mood, the banana and nutella crêpe is a no-brainer. Other options include the granola and yogurt crêpe and brioche French toast. When it comes to dinner, I go with traditional French fare: either the Croque monsieur or the Bistrot steak. Have the mascarpone and berries dessert (les fruits frais avec mascarpone).
UNIQUE DISH There's a special dinner entree every day, often a stew or steak treat.
DRINKS The restaurant lives up to French standards with an extensive and impressive wine and champagne list.
SEATING There's plenty of table and bar seating with a mix of larger tables spaced far apart and smaller tables placed Euro-style (read: you're up close and personal with your neighbor). Reservations are accepted, and recommended for Saturday dinner or the busy weekend brunch. When you book, be sure to note your seating preference and the staff there will be glad to accommodate when and where they can.
AMBIENCE/CLIENTELE Having lived in Paris, I actually feel the French café vibe and feel transported whenever I eat there. The restaurant is filled with authentic French decor, numerous vintage prints, and a cozy zinc bar right in the center. When it's warm out, the front windows open to let in the breezy Chicago air. Bistrot Zinc doesn't give off any pretentious vibes. The clientele is always a nice mix. Every interaction I've had with the staff has been outstanding, from hostess to waitstaff to bartender.

—*Laura Cococcia*

DOWNTOWN

C-House Restaurant
World-class food, an elegant environment and sophisticated waitstaff.
$$$$
166 E. Superior St., Chicago 60611
(at St. Clair Street)
Phone (312) 523-0923
www.c-houserestaurant.com

CATEGORY	American Restaurant
HOURS	Daily: 7 am-10 pm
GETTING THERE	"Affordable" valet available. They're in the Affinia Hotel, just behind the Neiman Marcus on Michigan Ave. You can also take the Red Line to the Chicago stop or the #147 Outer Drive Express, #146 Inner Drive/Michigan Ave. Express, or #66 Chicago bus.
PAYMENT	
POPULAR DISH	The menu changes regularly, but the yellowtail fish tacos stay the same—bite-sized morsels of hamachi, avocado purée, cabbage and pickled red onion nested in a house-made corn shell—perfection. While you're at it, try any of the C-Bar (raw bar) offerings, such as the cobia with apple and preserved mushroom, or the salmon pastrami with caramelized cream cheese.
UNIQUE DISH	Try the salmon wrapped in brioche accompanied by a wild rice cake, bone marrow, parsnip purée and a hard boiled quail egg.
DRINKS	The wine/cocktail list is extensive and fairly priced. You'll find a friendly sommelier who's not trying to break your bank. The specialty cocktail list is seasonal, exceptional and refreshingly innovative. The Honey-B martini uplifts the palate with a delicate mixture of chamomile tea, St. Germaine liquor, alfalfa honey and fresh lime juice. Also, try the 29th Floor (named for the location of the rooftop bar, C-View), a racy champagne cocktail made with ginger cognac, lemongrass syrup and strawberry purée.
SEATING	Beautiful teak bar adorns the entrance, accompanied by a few cocktail tables. There's a 14-seat, highboy communal table, good for large parties. The dining room is a modern yet quaint 60 seats (so make sure to have reservations on the weekend) with an extra eight chairs around the raw bar. If you have a party of five to ten, ask for "25" (a big round table fit for a king).
AMBIENCE/CLIENTELE	Arthur Casas, famed Brazilian architect, designed the restaurant. If you're not familiar with his work, imagine Scandinavian sleekness complemented by earthy teak, leather banquettes and copper light fixtures. The space can make anyone sit up straight and say "please" and "thank you," but the staff does a remarkable job of relaxing the atmosphere. You'll find upscale, Gold Coast clientele, but also expect local foodies craving fresh fish and wearing T-shirts and jeans.

—*Matthew Sove*

Carnivale
Fiesta with a feast.
$$$
702 W. Fulton Market, Chicago 60661
(at Halsted St.)
Phone (312) 850-5005 • Fax (312) 850-3680

DOWNTOWN

www.carnivalechicago.com

CATEGORY Latin American Restaurant
HOURS Mon-Thurs: 5 pm-10 pm
Fri/Sat 5 pm-11 pm
GETTING THERE Metered parking is available, but difficult. Valet is offered for a small charge. The #8 Halsted bus is another option, and the closest El is the Green Line at Clinton.
PAYMENT
POPULAR DISH Carnivale features a range of interesting small plates including delicious mini fish tacos and beef and chicken empanadas. The smoky-sweet and mouth-watering ropa vieja is a real standout appetizer. Served on slices of fried sweet plantains, it is not to be missed. Their meat-focused entree list features all-natural pork, chicken, and beef. Fresh seafood is also featured prominently. Limited vegetarian options include quinoa with roasted vegetables and house-made linguini in Creole tomato sauce.
UNIQUE DISH Ceviche, Spanish-style marinated raw seafood, is a unique and delicious specialty. Options include shrimp, tuna, mixto (a tuna, white fish and calamari mix) and scallop. The Nantucket scallop option also features a Kumamoto oyster.
DRINKS The drink menu boasts a wide range of Latin-inspired cocktails. The raspberry mojito is a crowd-pleaser. Or treat yourself to one of the frozen margaritas or daiquiris, available in a variety of tropical fruit flavors. Carnivale features an extensive tequila menu as well as an attractive wine list emphasizing wines from South America and Spain. Carnivale has some nonalcoholic drink specialties including fruit-infused water, house-made hibiscus iced tea and mojito smoothies.
SEATING Encompassed in a mammoth two-story dining room, Carnivale features plenty of seating. The towering, loft-like space and open floor plan offers ample elbow room and can comfortably accommodate large groups.
AMBIENCE/CLIENTELE Stepping into the dining room at Carnivale, your eyes leap upward to the stained glass skylight far, far above. Bright colors and boisterous salsa music awaken your senses. Oversized lamps, abstract artwork and gigantic mirrors elicit a Buena Vista Social Club-meets-Alice in Wonderland atmosphere. This room is all about color. Warm magentas, reds, yellows, acid blues and purples abound. The setting steals the show. Most of the clientele seems to come to be a part of the scene. The music and crowd are lively but not deafening. This is a great place to come with a group to shake off a cold Chicago winter.
EXTRA/NOTES Wednesday nights feature dancing and live Latin music from 7:30 pm to 11 pm. There is always some special event happening at Carnivale.

—*Mark and Julia Lobo*

Club Lago

Your grandfather ate here. A piece of real Chicago since 1952.
$$$
331 W. Superior St., Chicago 60610
(at Orleans St.)
Phone (312) 951-2849 • Fax (312) 951-6028
www.clublago.com

DOWNTOWN

CATEGORY	Italian Restaurant
HOURS	Mon-Thurs: 11 am-10 pm
	Fri/Sat: 11 am-11 pm
GETTING THERE	Get off the Brown Line (Chicago stop) and walk a few blocks south. Or take the #66 Chicago or #65 Grand bus. Metered parking is available, but difficult.
PAYMENT	
POPULAR DISH	All the food is great, but the eggplant parmigiana puts most people's grandmother's recipes to shame. The lasagna is to die for. Daily specials roll out with the love and flavor of a home cooked meal.
UNIQUE DISH	One dish that stands out is Bracioline All' Agro, which is egg-washed veal pounded paper thin and seasoned with lemon and the perfect blend of spices.
DRINKS	Wine and bourbon. Emphasis on the bourbon.
SEATING	The tables are adorned with red and white-checkered tablecloths. A long, seasoned bar on your left and cozy booths on your right greet you as you walk in.
AMBIENCE/CLIENTELE	When you walk into Club Lago, you are greeted with open arms. The feeling is that of a nostalgic Chicago Italian joint, with low lighting and vintage jazz. People pay decorators to imitate this look.

—Craig Nemetz

D4 Irish Pub & Café
Modern day Dublin with Celtic comforts.
$$$
345 E. Ohio St., Chicago 60611
(between Fairbanks Ct. and McClurg Ct.)
Phone (312) 624-8385 • Fax (312) 624-8386
www.d4pub.com

CATEGORY	Irish Pub
HOURS	Sun: 10 am-Midnight
	Mon-Fri: 11 am-1 am
	Sat: 10 am-2 am
GETTING THERE	Street parking is difficult. D4 is located in the Streeter apartment complex and provides discounted parking in that garage. You can also take the Red Line to Grand and walk a half mile east, or take the #66 Chicago, #147 Outer Drive Express or #65 Grand bus.
PAYMENT	
POPULAR DISH	D4 boasts the bulk of traditional Irish fare with hardy plates of shepherd's pie and house braised corned beef on rye, but the noteworthy noshes on this menu are prepared with beer. The fish and chips are cuts of Atlantic cod wrapped in wondrously light batter of tempura and Harp lager. The bangers and mash is a gratifying combo of Irish sausages boiled in Smithwick's (a ruby red ale with a smooth finish) with mashed potatoes soaked in a gravy made of Bass (a toasty pale ale). Additionally, the winter menu features a stew of beef and veg, slow-simmered in the big daddy of Irish brews: rich, creamy Guinness. Served with a thick slice of real Irish soda bread, it's a St. Patty's parade in your belly.
UNIQUE DISH	The lighter selections, like sammies and salads, are the elements that elevate D4 from pubby grub to fancy fare. On a cold winter's night, try the robust spinach salad with roasted red beets or a warm tuna melt with bubbling browned cheese. On sizzling summer days,

DOWNTOWN

	there's nothing more refreshing and sweet than forkfuls of the fresh pear salad with candied pecans.
DRINKS	The beer list is primarily a collage of Euro-brews, concentrating on Ireland, complete with Beamish Stout, O'Hara's Irish Red, and even Chicago's own high-octane brew, Matilda. The wine selection is lengthy, with most glasses originating from California.
SEATING	Seating is ample with an "L" shaped bar, and a large dining room. All that, and two separate bistro-esque pockets of short round tables nuzzled up to two massive, stone fireplaces.
AMBIENCE/CLIENTELE	Just when you thought "Upscale Irish Pub" was an oxymoron, D4 proves the two concepts can co-exist. It's furnished in dark oak, gilded in emerald green, with a mix of clean tile and hardwood flooring while white bulbs of light dangle down in chandeliers. The fireplaces are crackling and quaint. Patrons are usually locals popping in for a quick lunch or retiring by the fire after a long day's work. However, when St. Patrick's Day rolls around, hold onto your green paper hat!

—*Jessica Word*

Gaylord India
Great value in the Gold Coast.
$$$
100 E. Walton St., Chicago 60611
(at Michigan Ave.)
Phone (312) 664-1700 • Fax (312) 664-1682
www.gaylordil.com

CATEGORY	Indian Restaurant
HOURS	Sat/Sun: Midnight-10 pm Mon-Fri: 11:30 am-10 pm
GETTING THERE	Parking in the area is difficult. Most buses that go down Michigan Ave. will drop off near the restaurant, but the closest options are the #147 Outer Drive Express, #151 Sheridan or #22 Clark. The nearest El stop is the Red Line at Chicago.
PAYMENT	
POPULAR DISH	The excellent lunch buffet is highly recommended. They offer eight to ten entree dishes in addition to the salad and dessert bar. Their buffet selection is large compared to their competitors. My favorite dishes are the chicken curries and chicken tikka masala. Both of these dishes are available as part of their dinner menu.
DRINKS	They have a full bar and allow BYOB with a corkage fee. Soft drinks are included with the lunch buffet.
SEATING	They have ample table and booth seating for about 200 and can accommodate parties of varying sizes. No private rooms are available.
AMBIENCE/CLIENTELE	In the evening, the ambience is date-appropriate. However, during their lunch buffet it is a family-friendly place with lots of kids.

—*Christine Lambino*

Ginza Japanese Restaurant
It's got to be good Japanese food; it's full of Japanese people.
$$$
19 E. Ohio St., Chicago 60611
(at Wabash Ave.)

DOWNTOWN

Phone (312) 222-0600
CATEGORY	Japanese Restaurant
HOURS	Mon-Fri: 11:30 am-10 pm
	Sat: 4:30 pm-9:30 pm
GETTING THERE	There are a few pay lots around, and occasionally street parking. Or take the Red Line to Grand. You can also take the #147 Outer Drive Express, #65 Grand, or #66 Chicago bus.
PAYMENT	
POPULAR DISH	At lunch, go for the special. You get to choose from teriyaki, shrimp tempura, pork cutlet, broiled fish, or Japanese-style curry. You can also pick a side of edamame, seaweed salad, sashimi salad, or a Japanese omelette. For dinner, try either the ramen or the grilled fish dinner. Both of these dishes will give you the down-home vibe that you just can't get in any other Japanese restaurant in the city. Also, make sure to peruse the menu for a variety of Japanese side dishes like Goma Ae (spinach with sesame) and Hiya Yakko (a bowl of cold tofu).
UNIQUE DISH	The grilled fish dinner will give you an idea of what a typical Japanese home-cooked meal is about. A piece of grilled mackerel, a side of miso soup, rice, and a small salad are sure to please.
DRINKS	A small variety of sake and Japanese beers available.
SEATING	Ginza is a very cozy place. The labyrinthine interior gives you a sense of privacy no matter where you're sitting. Up front, there are a couple of booths and tables as well as a sushi bar. In the back are a couple of private rooms with tatami (straw) mat floors that give the place an authentic feel. While these private rooms are a novelty and fun to sit in, make sure that you're prepared to dine while seated on the floor.
AMBIENCE/CLIENTELE	Don't let the dingy facade of Ginza throw you off. Inside the dilapidated Tokyo hotel building, you are transported to another world. Sure, the restaurant doesn't look like it's been remodeled in a few decades, but that's part of the charm of the place. As you walk into Ginza, you are greeted in Japanese with a hearty irashaimase! The interior of the restaurant looks like a typical restaurant in Tokyo furnished with the occasional Japanese knickknack to give it some character. On any visit, you are likely to run into groups of Japanese businessmen enjoying a little piece of home.

—*Alexander Moore*

Golden Bean
@ the Hotel Indigo

Laid-back and lovely locale for coffee, croissants and delicious bites.
$$$
1244 N. Dearborn St., Chicago 60622
(at Goethe St.)
Phone (312) 787-4980 • Fax (312) 787-4069
www.goldcoastchicagohotel.com

CATEGORY	American Coffee Shop
HOURS	Daily: 6 am-10 pm
GETTING THERE	A quick walk from the Red Line (Clark/Division stop). You can also take the #22 Clark bus to Goethe or #36 Broadway bus to Clark. Street parking is extremely difficult in this neighborhood.
PAYMENT	

DOWNTOWN

POPULAR DISH	For breakfast, I'm equally torn between the breakfast quesadilla and the French toast topped with blueberries and cream cheese. Sometimes I have to flip a coin to decide. For dinner, try the pizzettas. The BBQ chicken is my standby. Everything is made fresh.
UNIQUE DISH	Golden Bean lets you build your own bruschetta, letting you choose from a number of ingredients. How cool is that? I never leave anywhere without dessert and the hot fudge cake is melt-in-your mouth perfect.
DRINKS	Come for a scrumptious snack or hearty meal. Starbucks coffee and unique espresso drinks are the big attraction, especially at breakfast time. Custom smoothies and a varied assortment of teas are also big favorites.
SEATING	There is very cozy seating at the Golden Bean, and I've never had trouble finding a table. Each table is decorated with a black-and-white photo of a starfish. There is also a small counter where you can order coffee, danish, yogurt and juices if you're on the go or just want a quick snack.
AMBIENCE/CLIENTELE	Located in the lobby of Hotel Indigo, but don't expect run-of-the mill blandness. From its pink and green walls to its pineapple-shaped, striped, cushy chairs, the Golden Bean is nothing less than merry.

—Laura Cococcia

The Grill on the Alley

A great place to impress your boss or your in-laws.
$$$$
909 N. Michigan Ave. Ste. 1, Chicago 60611
(between Delaware Pl. and Walton St.)
Phone (312) 255-9009 • Fax (312) 255-9004
www.thegrill.com

CATEGORY	American Steak House
HOURS	Daily: 6:30 am-1 am
GETTING THERE	No street parking. Valet is available, but it is more expensive because it is the hotel's valet as well. Take the Red Line (Chicago stop), or the #147 Outer Drive Express, #151 Sheridan, or #146 Inner Drive/Michigan Express bus.
PAYMENT	
POPULAR DISH	Steaks, chops, and seafood are popular.
UNIQUE DISH	In addition to steaks and chops, there's upscale comfort food like meatloaf, chicken potpie and calves' liver.
DRINKS	They make an amazing fresh Ruby Red Lemon Drop martini. The bar is great, the service is fantastic and the bartenders know their stuff. It's a great place to meet friends staying in downtown hotels.
SEATING	There is plenty of seating in the large dining room, but I prefer the large dark bar. The bar is a great place to enjoy a more casual dining experience in a nostalgic atmosphere. It really is a throwback with a long sleek bar and a bartender and servers in starched white shirts and old-fashioned vests. It's the kind of bar that makes you want to order a Manhattan.
AMBIENCE/CLIENTELE	The Grill is located on the ground floor of The Westin Michigan Ave., a hotel catering to anyone from business travelers to professional athletes and tourists, so you never know who you'll meet sitting at the bar. The polished hardwood floors, leather banquettes, and white linen tablecloths are reminiscent of the old-

DOWNTOWN

school grills in New York. The bartender might roll up her shirt cuffs in the more casual bar area, but the white-jacketed waiters in the dining room will provide an impressive though unpretentious atmosphere.

OTHER ONES Check the website for locations across the US.

—*Andrea Eisenberg*

India House

Would you put Indian food and romance in the same sentence?
$$$$
59 W. Grand Ave., Chicago 60610
(between Dearborn St. and Clark St.)
Phone (312) 645-9500
www.indiahousechicago.com

CATEGORY Indian Restaurant
HOURS Sun-Thurs: 11 am-10 pm
Fri/Sat: 11 am-11 pm
GETTING THERE Valet, limited street parking, pay lots in area. Or the Red Line to Grand Ave or the #22 Clark or #65 Grand bus.
PAYMENT
POPULAR DISH Beginners will love the spinach pakora or samosas, as they offer familiar preparations and flavors. A step up would be the dahi aloo poori—a mixture of crispy wafers, potatoes, chickpeas in yogurt, and tamarind sauce all sprinkled with chat masala. Novices will also love moving on to the traditional chicken tikka masala (white meat chicken in cream sauce) or the lamb boti kabobs (lamb cubes marinated with garlic, ginger and yogurt sauce skewered, and roasted). In another direction, diners should go after the chicken lahsooni kabobs (skewered garlic chicken), crab curry (kashmiri peppers, garlic, corn, cumin, saffron, and coconut milk), or the lamb vindaloo (lamb marinated in vinegar with hot peppers and spices). After all of this heavy and spicy food, think about the kheer, an Indian version of rice pudding that will really put a nice, creamy bookend on your dining experience.
DRINKS India House boasts a full bar and an extensive wine list. There are a few phenomenal Rieslings that really complement the spices well. A knowledgeable staff will help with any questions. The bar also offers the traditional lassi, a blended drink made with fresh yogurt and many different flavors.
SEATING Large, welcoming booths line one wall of the main dining room, and management makes sure not to cram tables on top of each other to properly give diners their space. A few steps in the back lead up to a separate dining area that is capable of being rented out as a private party room. Take a table by the Grand Ave. windows and watch passersby envy your sumptuous dinner.
AMBIENCE/CLIENTELE A dimly lit, burgundy-walled, white-tablecloth dining room with gold accents and candlelight really sets this restaurant apart. Servers wear jackets and ties, the wine is cared for like a child, and the music does not intrude on conversation. Patrons include business-people, travelers, families, and couples.
OTHER ONES • 1521 W. Schaumburg Rd., Schaumburg, 60194
• 228-230 McHenry Rd., Buffalo Grove, 60089
• 2809 Butterfield Rd., Ste. #100, Oak Brook, 60523

—*Evan Wormser*

DOWNTOWN

NoMI
@ the Park Hyatt Chicago

Fabulous fine dining blended with fashionable flair.
$$$$
800 N. Michigan Ave., Seventh Fl., Chicago 60611
Phone (312) 239-4030 • Fax (312) 239-4029
www.nomirestaurant.com

CATEGORY	French Restaurant
HOURS	Sun: 11 am-9 pm
	Mon-Fri: 6:30 am-10 pm
	Sat: 7 am-9 pm
GETTING THERE	NoMI has valet parking (four hours with validation), but the Red Line (Chicago stop) is just steps away. Or take the #66 Chicago, #145 Wilson/Michigan Express, or #146 Marine/Michigan Express.
PAYMENT	ATM, Discover, American Express, MasterCard, Visa
POPULAR DISH	Markedly distinct French cuisine with a creative edge of Asian flair, NoMI brings variety to all of its dishes. I'm a huge fan of the seafood dishes, most notably the sea bass and scallops (prepared with pine nuts!). The asparagus makes a brilliant starter, as does the rich beet salad. While NoMI also serves a decent brunch, I must admit there are better in Chicago.
UNIQUE DISH	While I've mentioned NoMI's general tendency toward French/Asian twists, there are a number of "off message" choices to highlight. The signature NoMI sushi roll (sushi is offered in plentiful amounts in the lounge), gnocchi and burgers (!) round out the restaurant's accessibility to all palates.
DRINKS	An after-work hotspot to see and to be seen, NoMI is one of my favorite lounges in the city for cocktails. In fact, they have a number of signature cocktails. The wine selection is exhaustive—some might argue a bit overpriced—but I'm a sucker for a good glass of red.
SEATING	Never fear, NoMI is not short-seated. It has the bar, the lounge, the dining room (holds 120), and three private dining rooms (one holds 16, one holds ten and the chef's table seats four). The Art Gallery room is also available for receptions.
AMBIENCE/CLIENTELE	Given its atmosphere of modern sophistication, the Chicago chic along with businessmen and-women usually comprise the majority of the clientele. The view from the main dining room is of the historic Michigan Ave. and is nothing less than brilliant. If you opt for formal dining, be prepared to spend a good two hours or so here to do the experience justice. The less formal lounge, with its dim lighting and sultry music, invites intimate conversation. In the summer, the patio lends itself to pleasure.

—*Laura Cococcia*

Perry's Deli

For big sandwiches and a bigger personality.
$$
174 N. Franklin St., Chicago 60606
(between Randolph St. and Lake St.)
Phone (312) 372-7557
www.perrysdeli.com

CATEGORY	American Deli
HOURS	Mon-Fri: 7:30 am-2 pm

DOWNTOWN

GETTING THERE No parking. Take the Blue Line to Clark/Lake, then walk two blocks west, or take the #56 Milwaukee, #125 Water Tower Express or #157 Streeterville bus.
PAYMENT
POPULAR DISH My favorite sandwich is the K-O—turkey piled excessively high with bacon! You get the option of wheat or rye breads, Russian dressing or mayo. I get it on rye with Russian dressing and cheese. All sandwiches come with awesome pickle spears. Lots of people come to Perry's for the corned beef. It is piled high to the sky and the flavor does not disappoint.
UNIQUE DISH The sandwiches at Perry's are about the size of Montana (seriously, they are massive). Most times they should feed two people, but I have seen lots of younger guys down whole sandwiches in one sitting.
DRINKS Soft drinks, water.
SEATING The room is large, but Perry's draws a large crowd.
AMBIENCE/CLIENTELE The walls are covered with very random stuff, like pictures of the owner, Boris, with patrons, reviews, and other stuff that I can't quite figure out. It is very common for the line to reach down the street, but the food is worth the wait.
EXTRA/NOTES Perry's takes their telephone off the hook at 11 am everyday. If you want to phone in an order, you must do so before then. Delivery is also available.

—*Julie Owens*

Roy's Hawaiian Fusion

Where Hawaiian isn't just fused in the cooking, it's in the attitude.
$$$$
720 N. State St., Chicago 60610
(at Superior St.)
Phone (312) 787-7599
www.roysrestaurant.com

CATEGORY Hawaiian Restaurant
HOURS Sun: 5 pm-9 pm
Mon-Sat: 5 pm-10 pm
GETTING THERE Street parking is difficult, however, valet parking is available. The #36 Broadway bus or the Red Line to the Chicago stop are more convenient options.
PAYMENT
POPULAR DISH While the accompanying ingredients and preparation may vary from month to month, Roy's Butterfish tends to be their most popular entree, and their sashimi and sushi rolls are always great for an appetizer. Remember to save room for the chocolate molten cake, a flourless cake filled with a warm, gooey chocolate sauce and served with a scoop of vanilla ice cream. But keep in mind it takes 15-20 minutes to prepare so it's best to order it with your entrees.
UNIQUE DISH Delectable items such as pan-seared scallops and sugarcane-skewered halibut are just an inkling of the savory dishes that grace the menu of Roy's. The coconut-crusted tiger shrimp in Hawaiian pineapple chili sauce had me wishing that I could lick the plate. Also, take note of their seasonal prix fixe menu, which includes a choice of appetizer, entree and dessert.
DRINKS Roy's offers a distinctive wine selection along with an array of signature cocktails. Try the Original Hawaiian martini (fresh Maui pineapple infused with Skyy Vodka and mixed with Stoli Vanilla and

DOWNTOWN

Malibu coconut rum). Or if you're feeling exotic, the sparkling hibiscus is another delightful concoction. It's a refreshing mix of Domaine Chandon Sparkling Rose, hibiscus nectar and Belvedere vodka.

SEATING Seating is plentiful with enough space so you're not overwhelmed by the conversation at the next table.

AMBIENCE/CLIENTELE The Hawaiian cuisine comes with the Hawaiian attitude of a relaxed and amiable environment coupled with the joys of impeccable service.

OTHER ONES Various locations are located around the US.

—*Rachael Carter*

Soupbox
Warm soup is a necessity during the winter.
$$
50 E. Chicago Ave., Chicago 60611
(at Wabash Ave.)
Phone (312) 951-5900
www.thesoupbox.com

CATEGORY American Restaurant

HOURS Daily: 11 am-10 pm

GETTING THERE Close to the Chicago Red Line stop and the #66 Chicago bus stop. Street parking is almost impossible.

PAYMENT

POPULAR DISH Soupbox has twelve different soups available every day, chosen out of a vast collection of recipes. However, their two classics are tomato basil and cream of chicken and wild rice. The tomato basil tastes very fresh, and the basil complements the light bisque and does not overpower the palate. For something more filling, get this soup in a bread bowl. The creamy chicken and wild rice is their number one seller. The cream base is full of fluffy wild rice and chunks of chicken.

UNIQUE DISH Mixing the soups is something Soupbox encourages. Every day there is a themed combination, the most humorous being the Old Greg, a combination of clam chowder and lobster bisque. One of the best soups to combine with others is the spinach artichoke, which they do not frequently offer.

DRINKS The soup and salad combo comes with a free fountain drink.

SEATING Scattered around the soup bar are a few two- and four-person tables. Seating is difficult to come by during the lunch hour.

AMBIENCE/CLIENTELE One of the great things about this restaurant is the staff. If you have a difficult time selecting your soup, they are more than happy to offer you a taste. You could sample all their varieties sans judgment! During the winter, the staff gets very busy. Occasionally there are lines out the door. Even though the small restaurant can get crowded, the staff remains kind and helpful which maintains Soupbox's relaxed vibe.

EXTRA/NOTES Their website lists the day's soups at all of their locations so you can make sure they have your favorite before you stop by.

OTHER ONES • 2943 N. Broadway, Chicago, 60657
• Ogilvie Transportation Center food court 500 W. Madison, Chicago 60661

—*Katelyn Bogucki*

DOWNTOWN

Spiaggia and Café Spiaggia

Is it possible to top this scrumptious fare? Perhaps only in Tuscany.
$$$$
980 N. Michigan Ave., Chicago 60611
(at Oak St.)
Phone (312) 280-2750
www.spiaggiarestaurant.com

CATEGORY	Italian Restaurant
HOURS	Sun: 6 pm-9 pm Mon-Thurs: 6 pm-9:30 pm Fri/Sat: 5:30 pm-10:30 pm
GETTING THERE	Street parking is difficult. Discounted parking available in the One Magnificent Mile building (entrance is on the northwest corner of Walton St. and Michigan). A two-block walk from the Red Line Chicago stop and the #3 King, #145 Wilson or #146 Marine/Michigan buses.
PAYMENT	ATM
POPULAR DISH	At Spiaggia, I recommend the tasting menu, which includes a number of unbelievably unique dishes and an optional pairing of eight wines. The ravioli and wood-roasted sea bass are savory. For carnivorous folks, I'd recommend the steak.
UNIQUE DISH	The potato gnocchi is not only my beloved, but a renowned favorite of visitors to Cafe Spiaggia. The gelato trio is a close runner-up (my obsession is the Nutella, Hazelnut and Red Raspberry Swirl).
DRINKS	The whole experience calls for a glass of wine; there are more than 700 bottles to choose from. Try it with a sampling of gourmet cheeses (Spiaggia has over 100); ask their fromager to help guide you. Bottled beer is also available.
SEATING	Spiaggia has private party and banquet rooms that can hold up to 350. In the main dining room, there is seating for 125 and 26 at the bar.
AMBIENCE/CLIENTELE	Spiaggia is both elegant and charming, emanating a true fine dining feel. That being said, I've mentioned above that Café Spiaggia is a bit more casual, yet still offers Spiaggia's graceful atmosphere, mixed with a sprinkle of coziness. Spiaggia Café is a great place for lunch or dinner out with friends when you don't need a lot of intimacy.
EXTRA/NOTES	In the spirit of full disclosure, Spiaggia is an extremely expensive eatery, definitely in the top ten priciest restaurants in Chicago. This should in no way discourage you from visiting—the experience is unique and in my opinion, Spiaggia has helped both shape and represent Chicago's finest. NOTE: For Spiaggia, a jacket is required for dinner, tie optional, and jeans are not permitted. Reservations are highly recommended as Spiaggia is often booked weeks in advance.

—*Laura Cococcia*

SushiSamba Rio

Chic, sleek...sushi!
$$$$
504 N. Wells St., Chicago 60610
(at Illinois St.)
Phone (312) 595-2300 • Fax (312) 595-0532
www.sushisamba.com

CATEGORY	Fusion Lounge

DOWNTOWN

HOURS	Sun/Mon: 11:45 am-11 pm Tues: 11:45 am-Midnight Weds-Fri: 11:45 am-1 am Sat: 11:45 am-2 am
GETTING THERE	Valet parking for relatively cheap or take your chance with the difficult-to-find street parking or pay lots. Take the Brown Line to the Chicago or Merchandise Mart stop, or the #37 Wells or #156 LaSalle bus.
PAYMENT	
POPULAR DISH	The sushi is obviously the main focus here, but it would be extremely foolish to not try some of the carnivorous fare. The seared otoro Kobe beef is beyond amazing, and the churrasco with your choice of three or five meats is enough to send you into a meat coma…a delicious coma at that. As far as the sushi goes, you can either order by the piece or get one of the signature rolls. The latter is the way to go, especially since there is normally a special "signature roll" that is sure to be appealing.
UNIQUE DISH	The blend of Japanese, Brazilian and Peruvian food seems really off-the-wall but somehow manages to work. The miso-marinated Chilean sea bass is a prime example of fine fusion cuisine. The tapas-style appetizers will leave you wanting more.
DRINKS	Full bar with signature cocktails. It is Chicago's only Brazilian specialty caipirinha bar.
SEATING	Seating varies between the outskirts of the room, the perfect-for-drinks rooftop lounge, and the circular sushi bar that is front and center.
AMBIENCE/CLIENTELE	SushiSamba really captures the meaning of chic. The restaurant seems more like a club when you first walk in, but once you sit down, you can't help but look around and enjoy the sleek decor and feel like you have your fingers on the pulse of Chicago.
OTHER ONES	Various locations throughout the US.

—*Andrew Skweres*

Taza

Great, authentic Mediterranean food at unbelievable prices!
$$
176 N. Franklin St., Chicago 60606
(at Lake St.)
Phone (312) 201-9885 • Fax (312) 201-9886

CATEGORY	Middle Eastern Diner
HOURS	Mon-Fri: 10 am-4 pm
GETTING THERE	It is best to walk or take the Blue Line to Clark/Lake. You can also take the #56 Milwaukee or #14 Jeffrey Express bus, which lets you off just a few blocks south.
PAYMENT	
POPULAR DISH	Falafel! Falafel! And more falafel! Moroccan chicken is not available every day, but if you have the chance, try it—it is outstanding. Chicken shwarma, dill rice, kabobs, hummus, and turkey are all excellent choices.
UNIQUE DISH	The best part about Taza is the signature falafel. They always have some samples for those passing through the line.
DRINKS	Soft drinks, iced tea, water.
SEATING	Limited seating, not fancy. Just a clean place to eat your lunch and move on.
AMBIENCE/CLIENTELE	Taza is a little restaurant that may not be as pretty as some other lunch spots, but the walls are painted and the floors and counters are always clean. The food is

DOWNTOWN

a great value for the price. "Taza" translates to "fresh." I do not doubt this in the least. Eating at Taza makes you feel healthy.

EXTRA/NOTES The line can sometimes be out the door, especially in nicer weather at lunchtime. Do not be dismayed; the line moves really quickly.

—Julie Owens

Tempo Café

Never miss a beat...
$$$
6 E. Chestnut St., Chicago 60611
(at State St.)
Phone (312) 943-4373 • Fax (312) 943-4425
www.tempocafechicago.com

CATEGORY American Diner
HOURS 24/7
GETTING THERE Metered parking can be found. The Red Line stops just south at Chicago. The #36 Broadway bus stops at the corner of State and Chestnut, or you can take the #147 Outer Drive Express or #66 Chicago bus. The majority of patrons are on foot.
PAYMENT $ ATM
POPULAR DISH With such a vast menu and a wide spectrum of options, you could point to a fresh Greek salad or the mountainous tuna melt or even a turkey dinner. But when you mention Tempo breakfast comes to mind, specifically the omelettes. Bright, fluffy eggs are stuffed with vegetables and served atop crisp breakfast potatoes. These creations will fill you up for days, and the innumerable combinations means you'll never get tired of coming up with something new.
UNIQUE DISH Even Tempo's menu has some shocking points. You may point to the stir-fries as the odd lot but the chicken liver sauté sticks out a bit more. Laced with a variety of mushrooms and caramelized onions, the livers meld very well with their accompaniments and the dish comes together nicely.
DRINKS Among your typical teas, coffees, and cappuccinos you'll find luscious milkshakes and freshly squeezed juices. Try their orange and grapefruit juice blend to really boost your vitamin C count.
SEATING Tempo crams in about 85 guests with four first-come-first-served counter seats. Summer patio seating adds another 50 seats or so. A row of double-sided booths splits the dining room in two and an army of two-tops line the rest of the floor to complete a rather simple seating arrangement.
AMBIENCE/CLIENTELE There is a very comforting feel about the layout of the restaurant with natural tones on the walls accented by red booths on the outer edges of the seating area. Festive decorations accompany the changing seasons and the continual rotation of plants and flowers keep the decor pleasant and light. These deuces are frequently combined to accommodate the families and larger groups that are always welcomed at Tempo. It is also a local celebrity hot spot filled with younger and older couples alike looking for a relaxing breakfast or a place to read the paper.

—Evan Wormser

DOWNTOWN

LOOP/MAGNIFICENT MILE/MILLENIUM PARK

Avec

Come together now: a quaint, rustic, and satisfying dining experience.
$$$
615 W. Randolph St., Chicago 60606
(at Jefferson St.)
Phone (312) 377-2002
www.avecrestaurant.com

CATEGORY	French Bistro
HOURS	Sun: 3:30 pm-11 pm
	Mon-Thurs: 3:30 pm-Midnight
	Fri/Sat: 3:30 pm-1 am
GETTING THERE	Valet parking is available for a relatively low charge. Metered and street parking are also an option, but often scarce. A short walk from the Pink or Green Line stations at Clinton, or take the #56 Milwaukee bus.
PAYMENT	
POPULAR DISH	Delectable bacon-wrapped medjool dates stuffed with imported fresh chorizo and served with a piquillo pepper-tomato sauce have become Avec's must-have signature dish. The spicy sauce compliments the smoky-sweet flavor combinations of the dates without being too overpowering. This dish is served with fresh crusty bread, so sop up each little bit! The menu is succinct and each item is strong with a great balance of rich flavors, including classics such as focaccia with taleggio cheese, truffle oil and fresh herbs.
UNIQUE DISH	With an inviting menu that reflects the minimalist cedar-dominated decor, Chef Grieveson is successful in her execution of simple, no-frills fare made with fresh, seasonal ingredients and innovative flavor combinations. The food is served family-style with small plate options. Large plates are made with more hearty ingredients and portions.
DRINKS	A smart, moderately priced wine list focuses on wines from France, Spain, Italy and Portugal, and many are available by the glass. The cuisine is wine-inspired, so be sure to ask your server or sommelier for suggested wine pairings to go with your food selections. Avec has one of the most expansive digestif menus in the city. The beer selections are diverse and can be somewhat intimidating, but the staff offers insightful recommendations by request and never disappoints. Avec offers a full bar and coffee and espresso drinks.
SEATING	Seating is communal. Tables and a long banquette stretch the entire length of the restaurant, facing a long bar with additional seating. Space is tight but cozy, creating camaraderie in the midst of the bustle of fellow diners and servers alike. Avec does not take reservations, but their staff is smart at maximizing their available space. You are a VIP from the moment you enter the restaurant, not just when you are seated at the table.
AMBIENCE/CLIENTELE	Communal seating, open kitchen and close quarters allow each diner to witness the action that is the heartbeat of Avec's day-to-day operations. The decor, a rustic "spa-chic" with a character all its own, offers a sort of culinary foreshadowing of the minimalist, yet simultaneously rich, complex ingredients and flavor combinations of each menu item. The clientele is

DOWNTOWN

diverse, from the suburbanites who left the kids with a babysitter, to the River North professionals, to the out-of-town culinary disciples willing to stray off the downtown grid to discover true city classics.

—Denise Peñacerrada

Blackbird
This Blackbird sings a lovely tune.

$$$$
619 W. Randolph St., Chicago 60606
(at Jefferson St.)
Phone (312) 715-0708
www.blackbirdrestaurant.com

CATEGORY American Restaurant
HOURS Mon-Fri: 11:30 am-10:30 pm
Sat: 5:30 pm-10:30 pm
GETTING THERE Park in the local garage consider taking a cab or hopping the Blue Line to Grand.
PAYMENT
POPULAR DISH The veal sweetbreads make a delightful start to what will undoubtedly be a fantastic meal. The crispy Swan Creek Farm duck breast is amazingly flavorful given the relatively lean (for duck) cut of meat. However, it is imperative you save room for dessert, for their milk chocolate cremeaux melts in your mouth when combined with the curry ice cream. You'll no doubt leave Blackbird with a vow to return, but don't get too attached to just one dish because their menu is seasonal. Don't fret, though, as you will surely find another dish that will satisfy even the most experienced palate.
DRINKS They serve a nice selection of wines and will gladly recommend a glass/bottle for those not experienced in wine tasting.
SEATING Seating is very minimal with only about 60 seats that are placed moderately close together. On busy nights, the second floor may be used for additional seating, offering guests a little more space between one another. Otherwise, the second floor acts as their private dining area, which can be used for work functions and private parties.
AMBIENCE/CLIENTELE This restaurant typically feeds more of the "hipster" types; it's a place to see and be seen. Jeans would not be appropriate attire, but don't dig up your Sunday best either. The decor is modern-minimalist, but with very comfortable seating. The staff does not try to rush you out, and with the spacing of the dishes you will likely enjoy a meal over the span of approximately two hours.

—Jenna Noble

Heaven on Seven
Heaven on Seven: gumbo as good as your mama makes!

$$$
111 N. Wabash Ave. Seventh Floor, Chicago 60602
(at Washington St.)
Phone (312) 263-6443 • Fax (312) 263-3777
www.heavenonseven.com

CATEGORY Cajun Restaurant

19

DOWNTOWN

HOURS	Mon-Fri: 9 am-4 pm Sat: 10 am-3 pm
GETTING THERE	Street parking is difficult, so go for a parking lot. Or take the #56 Milwaukee, #147 Outer Drive Express, or #157 Streeterville bus, the Brown, Purple, Pink, Orange or Green Line to Randolph/Wabash or the Blue Line to Washington/Dearborn.
PAYMENT	$
POPULAR DISH	If the lines stretching out the door for the past 27 years don't tell you that chef/proprietor Jimmy Banos is doing something right, one taste of the gumbo and you will discover that he is. This is the real thing. A substantial roux supports a Southern Louisiana stew of flavors that your Mama would love. Also, try the étouffée of the Day.
UNIQUE DISH	Jimmy serves a wide variety of Louisianan classics and Louisiana-inspired dishes like gumbo, jambalaya, étouffée, and red beans. The Louisiana Soul Deluxe (LSD) is a nice sampler plate of some of his favorites. His pasta dishes, while not traditional, are very good as well.
DRINKS	Beer, wine and Hurricanes.
SEATING	The dining room and counter service has enough seating for 120.
AMBIENCE/CLIENTELE	A mix of loop office workers and tourists come to dine at the hand of local celebrity chef Jimmy Banos in a former Greek coffee shop adorned with all manner of Mardi Gras regalia.
EXTRA/NOTES	Once a month, usually on the third Friday, Jimmy serves dinner. Call for more details.
OTHER ONES	•600 N. Michigan Ave., Second Fl, Chicago 60611, (312) 280-777 • 224 S. Main St., Naperville 60540, (630) 717-0777

—*Ian Alexander*

La Scarola

What's good for the Chicago elite is good for you too!
$$$
721 W. Grand Ave., Chestnut Street 60610
(at Milwaukee Ave.)
Phone (312) 243-1740 • Fax (312) 243-1742
www.lascarola.com

CATEGORY	Italian Restaurant
HOURS	Sun-Thurs: 11 am-10 pm Fri/Sat: 11 am-Noon
GETTING THERE	You can search for street parking, or pay $5 for valet. Or take the Blue Line to Grand. You can also take the #56 Milwaukee, #65 Grand, or #8 Halsted bus.
PAYMENT	DISCOVER AMERICAN EXPRESS MASTERCARD VISA
POPULAR DISH	If the local celeb sightings don't knock you off your feet, the broccoli and goat cheese is sure to do the trick. Tossed in a light olive oil over rigatoni pasta, this medley will do wonders for your stomach. For an equally delicious option, the macaroni arrabiata will prove to be a spicy counter to the broccoli and goat cheese. They are generous on the cheese and perfect on the zest, giving you a spicy pasta dish that will bring you to your knees.
DRINKS	La Scarola is certainly not known for their wine/beer list, but they offer patrons a similar array of alcoholic offerings that can be found in most restaurants around Chicago, along with soda, tea, and coffee.

DOWNTOWN

SEATING	Seating is very crowded, so be prepared to use your "indoor voices." La Scarola is all about family, so get to know your close-by neighbors; you never know when you'll be seated next to local celebs such as Lou Canellis or Walter Jacobson.
AMBIENCE/CLIENTELE	La Scarola holds a very warm and inviting decor with beautiful murals and pictures of past patrons covering the walls. Though many of Chicago's "upper crust" frequent this establishment, patrons are usually friendly and smiling, prices are reasonable, and portions are satisfying. All in all, it's a cozy spot to enjoy a traditional Italian dish without the exorbitant prices.

—Jenna Noble

Monk's Pub
Holy half-pound burger! Pub and grub to satiate the soul.
$$
205 W. Lake St., Chicago 60606
(between Post Pl. and Wells St.)
Phone (312) 357-6665
www.mmonks.com

CATEGORY	American Pub
HOURS	Mon-Fri: 9 am-Midnight
GETTING THERE	Parking is difficult! Taxi cabs are plentiful, or take the #156 LaSalle bus, Red Line to State/Lake or Brown/Blue/Green/Purple/Orange lines to Clark/Lake.
PAYMENT	
POPULAR DISH	Monk's menu is built upon their considerable catalog of half-pound, flame-broiled burgers. Particularly, The Smoke burger—brushed with a tangy BBQ sauce, topped with American cheese, bacon, three crunchy onion rings and smeared with chipotle mayonnaise—is smoky, tangy and spicy. Burgers and sandwiches come with a heap of fries (substitute the curly Cajun fries—you won't be sorry!). Not into beef? Turkey and vegetarian burgers are also more than a mouthful.
UNIQUE DISH	Burgers can be topped with fancy cheeses—like Roquefort and feta—and smattered with olives. Don't let the peanut shells on the floor fool you—the roster of burgers at a fair value is serious business.
DRINKS	Imports like Warsteiner Pilsner and Guinness Stout top a decent list of bottles (import and domestic). The local Goose Island Honker's Ale is a reliable deal. Wine and martinis are more than respectable.
SEATING	Around 5 pm, seating can be hard to come by, especially later in the week. Settle into a booth, grab a high-boy stool, or plop right down at the bar if you can. Large groups fresh from the office often push tables together and lay claim to the back room.
AMBIENCE/CLIENTELE	If a library and a Medieval tavern meshed, the result is Monk's Pub. The Loop crowd comes to kick back and fill up during lunch or after work, but even those who don't work downtown will find this hideaway well worth a visit. Tucked beneath the El tracks, the dark wood walls, exposed brick, and details in the decor like the antique Schlitz lanterns give Monk's Pub an authentic, snug feel. With peanut shells crunching beneath your boots, a beer in hand, and a big ol' burger on your plate, hunker down and hope for a snowstorm.

—Jessica Word

DOWNTOWN

Petterino's

Eat among the stars before curtain call!
$$$$
150 N. Dearborn St., Chicago 60601
(at Randolph St.)
Phone (312) 422-0150
www.petterinos.com

CATEGORY	American Restaurant
HOURS	Sun: 11 am-7:30 pm
	Mon: 11 am-10 pm
	Tues-Thurs: 11 am-10:30 pm
	Fri/Sat: 11 am-11 pm
GETTING THERE	Complimentary valet for patrons dining after 7 pm. Street parking is non-existent. Via bus, use the #22 Clark or #36 Broadway. Petterino's is one block from the Blue Line (Washington/Dearborn stop) and 2 blocks from the Red Line (State/Lake).
PAYMENT	
POPULAR DISH	My favorite two dishes are the chicken picatta and chicken parmesan. Both come with a large breast of chicken and the sauces on both entrees are some of the best I've ever eaten. The chopped salad is one that I wouldn't pass up either. The dressing is a unique house blend and there is always enough to share!
UNIQUE DISH	Petterino's is very well known for its pre-theater prix fixe menu. You get an appetizer, entree and dessert for a decent price served in time for you to make your curtain call. They offer the 7 After 7—your choice among seven appetizers, entrees and desserts after 7 pm.
DRINKS	A full bar is available so you can wet your palate.
SEATING	Petterino's is small with intimate seating. Reservations are required if you are going to the theater, but I would still recommend a reservation for after 8 pm.
AMBIENCE/CLIENTELE	Petterino's is known for its comical caricatures of famous celebrities that adorn most of the walls in the main room. The clientele is always theater-ready in elegant dress and the staff makes you feel like you're a VIP. The ambience is classy and sophisticated.
EXTRA/NOTES	A private room is available for parties of 20–200. Carry-out is also available. Petterino's Monday Night Live has been a hit with singers, guests and critics alike since opening in 2007. This open mic evening of talent has showcased some of Chicago's most prominent cabaret and musical theater artists and continues to provide surprises at each performance. Singers should provide sheet music in their key. Sign-up begins each evening at 7 pm.

—*Debra Monkman*

Province

Spanish and Latin-American flair that suits all appetites.
$$$$
161 N. Jefferson St., Chicago 60661
(between Randolph St. and Lake St.)
Phone (312) 669-9900
www.provincerestaurant.com

CATEGORY	Latin American Restaurant
HOURS	Mon-Thurs: 11:30 am-10:30 pm
	Fri/Sat: 11:30 am-11:30 pm

DOWNTOWN

GETTING THERE Valet parking. In close proximity to the Green Line (Clinton stop) and Ogilvie Transportation Center. You can also take the #56 Milwaukee or #8 Halsted bus.
PAYMENT
POPULAR DISH Tortilla soup with avocado and roasted chicken is spicy with bold flavors. The blood orange salad has plenty of tangy goat cheese to compliment the citrus. The rabbit confit is a hearty, comforting, and tender entree. But save room for the Chocolate 3 Ways. Who doesn't love chocolate, chocolate, chocolate?
UNIQUE DISH The menu is divided into several sections: bites, raw, soups/salads, small, big, and bigger. The size of each dish depends on the section. The Green Acres Farms taquitos fit perfectly in the bites section, and the beef cheeks can be found in the big section. Other dishes such as the ten hour braised lamb can be ordered in a smaller, lunch-size portion or the larger, dinner size.
DRINKS Full bar, wine list, cocktails, and Three Floyds draft beers.
SEATING There is a private dining room for parties and events. Tabletops are made from cork, and a large petrified tree divides the dining room. Depending on the side of the room, guests could be seated close together at banquettes or at larger tables.
AMBIENCE/CLIENTELE Clean lines and modern touches create a relaxed atmosphere. Couples and larger parties dine at Province while some solo diners sit at the bar. This is a great place to go after work or on a Saturday night date.

—*Emily Olson*

Russian Tea Time

For gabbing over tea, gathering of friends, or a romantic night out.
$$$$
77 E. Adams St., Chicago 60603
(between Michigan Ave. and Wabash Ave.)
Phone (312) 360-0000 • Fax (312) 360-0575
www.russianteatime.com

CATEGORY Russian Restaurant
HOURS Sun-Thurs: 11 am-9 pm
Fri/Sat: 11 am-Midnight
GETTING THERE There is metered street parking all around and an array of parking garages. Also near the Adams/Wabash stop of the Green and Brown lines. You can also take the #56 Milwaukee, #62 Archer or #36 Broadway bus.
PAYMENT
POPULAR DISH The pumpkin or asparagus Varenikys are a great way to start the meal. They are stuffed dumplings filled with perfectly paired vegetables and cheese. If you are a meat eater, try the beef Stroganoff—lean sirloin cooked with mushrooms, onions, and dill served over noodles. If you are not into meat, try the stuffed green bell peppers. This dish comes with two green peppers overstuffed with an array of sautéed vegetables garnished with cilantro and served over rice. Both of these menu items come with beets and a carrot salad that helps cleanse your palate while tingling your taste buds. The chocolate lava cake is known to be sinful. This cake is the cure for any chocolate craving, and it's served with vanilla ice cream on the side.

DOWNTOWN

UNIQUE DISH — Russian Tea Time carries on the tradition of afternoon tea. They have a full tea service that is served every day from 2:30 pm–4:30 pm. Their classic Russian Caravan tea has a sweet and bold taste that can't be beat, but there are many other choices of tea. All tea is served with lemon and a choice of white or raw sugar cubes. Cranberry and raisin scones topped with homemade whipped cream arrive first. Next come the savories, which include salmon and cream cheese tea bites, mini ruebens, and spring crêpes. Several sweet treats are included to top off the tea service: traditional tea time cookies, mini rugala, and petite Napoleon torte.

DRINKS — There is a fully stocked bar with fine wines and liquors, and beer drinkers will also be pleased with the available selection. However, there is a slogan that Russian Tea Time promotes, "A shot of vodka the proper russian way." They are so serious about their vodka to the extent of listing rules of how to drink it as the Russians do. The most popular items on their vodka menu are the Vodka Flights—basically taste tests of three different types of vodka.

SEATING — If intimate and romantic is what you are going for, you are in the right spot. It is also perfect for dinner with several friends. There is even a room near the back available for private parties.

AMBIENCE/CLIENTELE — The restaurant makes you feel as if you are in a friend's home because of their great hospitality and courteous staff. The dimmed lighting creates a cozy, intimate atmosphere. The decor is very appropriate for the restaurant, with classic vintage teapots placed throughout the dining rooms. In the background you will hear soft Russian music playing .

—*Megan Healy*

TOP 5 COVES OF CONCEALMENT

Ever feel like going out, but NOT quite up to fighting the masses? Or perhaps you need to hold a serious conversation, but are not interested in sharing it with the table next to you? Nor are you particularly interested in joining theirs! For that night when being seen on the scene is not the goal, check out these five restaurants that offer not only privacy, but great food and drink:

Skip the Café Bernard entrance to **Red Rooster** on Halsted and round the corner onto Dickens Ave. There is no sign, only a red rooster painted on the door! This is a great French restaurant with a wonderful wine selection. It is very small with only a handful of tables, so you may want to make a reservation.

2100 N. Halsted St., Chicago 60614, (773) 871-2100, cafebernard.com

Russian Tea Time is an authentic Russian restaurant serving hearty meals with some central Asian flavor (and an impressive vegetarian menu). For the goal-oriented romantics out there, this venue boasts a 100 percent engagement proposal-acceptance rate!

77 E. Adams St., Chicago 60603, (312) 360-0000, russianteatime.com

DOWNTOWN

Geja's Café easily has the best fondue restaurant in the city! This is one of the few fondue restaurants that successfully avoid cooking the natural flavor out of your food with over-flavored oil bases, a fate that seems to befall most other fondue restaurants in the area.

340 W. Armitage Ave., Chicago 60614, (773) 281-9101, gejascafe.com

Italian Village can be hard to find as there are three restaurants at this location. Once you enter the front revolving door, ascend the stairs to the far right. This is a darkly lit Italian restaurant with private coves upon request (mention this when making your reservation).

71 W. Monroe St., Chicago 60603, (312) 332-7005, italianvillage-chicago.com

Violet Hour has no sign; you must look for the unmarked door after you pass Penny's Noodles. This is the place you go for very creative, very original alcoholic drinks. The bartender may take a while with your beverage, but this is due to the painstaking effort to make each libation the very best it can be. A romantic notion indeed! Need something to wash down with your specialty drink? Violet Hour provides a small, but varied noshing menu for those desiring a snack to compliment your libations. Try the duck confit "sammie" (mini-sandwich) or coconut fried shrimp in vanilla sauce.

1520 N. Damen Ave., Chicago 60622, (773) 252-1500, thevioletHour.com

—*Liz Walker*

UFood Grill
Food for U that tastes good, too!
$$
200 W. Jackson Blvd., Chicago 60606
(at Wells St.)
Phone (312) 922-1200
www.ufoodgrill.com

CATEGORY	Organic Fast food
HOURS	Mon-Fri: 8 am-8 pm Sat: 11 am-6 pm
GETTING THERE	There is metered parking and expensive garage parking is also available. Accessible via Blue Line (Jackson/Dearborn exit). You can also take the #14 Jeffrey Express, #56 Milwaukee or #1 Indiana/Hyde Park bus.
PAYMENT	
POPULAR DISH	The tomato chicken bruschetta sandwich is zesty and delicious. The fries complete the sandwich, which are cooked in a trans fat-free oil.
DRINKS	You won't find an alcoholic beverage in sight here, but you will find some delicious "Smuuthies" and high-protein "Prolattas," which can serve as a healthy meal replacement.
SEATING	There are a few tables inside for those who choose to dine-in, but many people opt for take-out during lunch hours since the restaurant is located in a prime downtown space close to many Loop corporations. The seating itself is comparable to most fast-food

DOWNTOWN

	places—lots of metal and cushionless seating, but it does the job during lunch hour.
AMBIENCE/CLIENTELE	Don't expect to meet your new best friend here, as most people are in a hurry to either finish eating or grab their take-out and go. Staff are friendly, but tend to rush you, even if you've never been there before. It's fairly bright inside, so it feels like a corporate cafeteria, but the food is great and worth the few shortcomings of ambience.
OTHER ONES	• 823 S. State St., Chicago 60605 • 2218 N. Lincoln Ave., Chicago 60614

—*Jenna Noble*

SOUTH LOOP

Bongo Room
Great people-watching at this sunny breakfast joint.
$$$
1152 S. Wabash Ave., Chicago 60605
(at Roosevelt Rd.)
Phone (312) 291-0100

CATEGORY	American Diner
HOURS	Sat/Sun: 9 am-2 pm Mon-Fri: 8 am-2 pm
GETTING THERE	Plenty of metered parking and pay lots. The Red, Orange and Green lines to Roosevelt will get you within walking distance. You can also take the #4 Cottage Grove, #29 State or #12 Roosevelt bus.
PAYMENT	Discover, American Express, MasterCard, Visa
POPULAR DISH	The chocolate tower French toast, BLT benedict, and Intelligentsia coffee are fantastic.
UNIQUE DISH	A lot of people go with the pancakes here (ask for a half order), but I think the sweet potato black bean breakfast burrito is where it's at, and I haven't seen anything like it on any other menu in Chicago.
DRINKS	BYOB. They are happy to bring mimosa setups if you bring the champagne.
SEATING	It's pretty small in there, but they make creative use of all the available space. And yes, that means that your neighbors will be very close.
AMBIENCE/CLIENTELE	Young parents with little kids, hung-over hipsters, older couples reading the paper, folks on their way to church and yuppies on their way to the museum all mix at this sunny breakfast spot with great service. Unless you get here early you'll have to wait. Grab a paper or a cup of coffee because the wait is worth it.
OTHER ONES	1470 N. Milwaukee Ave., Chicago 60622, (773) 489-0690

—*Andrea Eisenberg*

DOWNTOWN

Eleven City Diner
EXTRA EXTRA The Deli is Resurrected!
$$
1112 S. Wabash St., Chicago 60605
(at 11th St.)
Phone (312) 212-1112
www.elevencitydiner.com

CATEGORY	Jewish Deli
HOURS	Sun: 9 am-9 pm
	Mon-Thurs: 8 am-9 pm
	Fri/Sat: 8 am-11 pm
GETTING THERE	Plenty of street parking and valet parking is available on the weekend during brunch. Or take the Red, Green, or Orange lines to the Roosevelt stop, or the #29 State, #4 Cottage Grove, or #146 Inner Drive/Michigan Express bus.
PAYMENT	
POPULAR DISH	Owner Brad Rubin's labor of love is a hand-restored homage to the Jewish deli of days gone by. Hand sliced, house cured and smoked classics like corned beef, pastrami and brisket literally melt in your mouth. Eleven City's patty melt is the best rendition in the city. Other classics like the Reuben and a sublime chopped beef liver will tickle your (Kosher) pickle. Hand-dipped shakes and a full soda fountain round out the fun. This is the real deal!
UNIQUE DISH	Eleven City is all about the classics. Brad Rubin has painstakingly recreated the classic deli and wrapped it in a hip, cool environment. There is very little on the menu that does not hark back to the golden age of deli-dom. The soup has vastly improved since Eleven City opened, filling a hole in what was an otherwise faithful recreation of the real thing.
DRINKS	Sure Eleven City has a full liquor bar, but the drinks worth noting are the hand-dipped shakes made with Homer's ice cream and the soda fountain creations, where all manner of phosphates and egg creams can be made to order.
SEATING	In a big open space, there are plenty of tables and a full deli counter. There is also an upstairs party room available with seating for 40 people.
AMBIENCE/CLIENTELE	Rubin hand-restored the space, paying attention to all of the details including the wood-grained Formica counters and salvaged '50s-style booths. Mix these with an open, airy loft space, exposed cement, subway tiles, and a '40s and '50s jazz soundtrack and you have a blueprint for a deli revival.
EXTRA/NOTES	Brunch is wild at Eleven City. Be prepared for long waits on the weekends and in the summer when the al fresco area is open on the sidewalk. This place is also kid friendly.

—*Ian Alexander*

DOWNTOWN

Manny's Cafeteria & Delicatessen
The best Jewish deli this side of New York!
$$
1141 S. Jefferson St., Chicago 60607
(at Roosevelt Rd.)
Phone (312) 939-2855 • Fax (312) 939-2856
www.mannysdeli.com

CATEGORY	American Restaurant
HOURS	Mon-Sat: 5 am-8 pm
GETTING THERE	Free valet! Otherwise, limited street parking in the area. You can also take the #8 Halsted, #12 Roosevelt, or #18 bus.
PAYMENT	
POPULAR DISH	Potato pancakes, turkey pastrami, corned beef, matzo ball soup—all the Jewish comfort foods.
UNIQUE DISH	The sandwiches here are huge! Plus, how do you not order a side of soup and a potato pancake (latke)? Specials change daily. There are hot plates, cold plates and multiple varieties of soup every day. Not many restaurants have liver and onions on the menu, but yes, you can get it at Manny's.
SEATING	Plenty of seating. Manny's dining room consists of simple tables and chairs, but it does the trick. It's a big, open, cafeteria-style eatery.
AMBIENCE/CLIENTELE	You can wear your track suit or a $4,000 business suit to lunch at Manny's. The patrons consist of all walks of life, grabbing trays and making their way through the cafeteria-style setup to order massive portions of food. You can't over- or under-dress here, and you never know who will be elbowing you in line. The owners and family of Manny's are usually on-hand, making sure things are working as they should, sometimes cracking a joke or pointing out an article with Manny's mentioned. The place has changed very little since it opened so many years ago. That is because it hasn't needed to.
EXTRA/NOTES	One of the latest celebrities to cause a stir during lunch at Manny's was our own President Barack Obama! Coach Mike Ditka, Chicago politicians, judges, attorneys, bad guys and great gals have all eaten at Manny's. They also cater, and do a great job.

—*Julie Owens*

White Palace Grill
Whenever you're hungry, they'll be waiting for you...
$$
1159 S. Canal St., Chicago 60607
(at Roosevelt Rd.)
Phone (312) 939-7167
www.whitepalacegrill.com

CATEGORY	American Diner
HOURS	24/7
GETTING THERE	There is some street parking, but watch the signs for restrictions. There are some pay lots nearby. It's close to the Blue Line (Clinton stop), or you can take the #12 Central/Harrison, #18 16th/Cicero, #62 Archer/Harlem or #38 Canal/Taylor buses.
PAYMENT	

28

DOWNTOWN

POPULAR DISH Most people come for breakfast. There is a wide variety of omelettes and egg choices and pancakes and the like. The entire menu is available 24 hours a day, which means that you can get your grits and eggs for dinner if that's what you're into. There is a wide selection of sandwiches piled high and thick steak fries. The sandwiches come with a cup of soup.

UNIQUE DISH They don't serve a particularly unique dish, but their BLT might be the best in the entire city. They begin with white bread that is ever-so-lightly toasted. The tomato slice is thick and juicy. The lettuce is perfectly separated and layered. The bacon is thickly cut and plentiful. There is a thin layer of mayo on the bread to enhance the flavors, not overpower them.

DRINKS They pour one of the best cups of coffee in Chicago. Other than that they serve standard diner fare: juices, milk, iced tea, soft drinks.

SEATING There is a snack bar that wraps around the kitchen service window. There are a few booths in the front section of the restaurant. The tables are standard Formica like your grandma had in her kitchen when you were growing up.

AMBIENCE/CLIENTELE This is a no-frills diner with an old-timey sensibility—think Arnold's on Happy Days. There are a lot of cool rock-and-roll concert promo posters and memorabilia on the walls. The neighborhood is changing and so is the clientele. With the big box stores and the health clubs sprouting up and Chinatown continuing to expand, there is an interesting cross-section of people.

EXTRA/NOTES The movie "Backdraft", starring Robert DeNiro and Kurt Russell, filmed its diner scenes in White Palace. The hand-painted mural on the east wall shows famous Chicagoans including The Blues Brothers, Walter Payton, and Michael Jordan. On Sundays, weather permitting, there is the Canal Street Market, an enormous outdoor market.

—Paul Barile

NEAR NORTH SIDE

NEAR NORTH SIDE

BUCKTOWN/WICKER PARK

Caffe De Luca
Time slows down for breakfast, lunch and dinner at this European-style café.
$$$
1721 N. Damen Ave., Chicago 60647
(between Wabansia Ave. and St Paul Ave.)
Phone (773) 342-6000 • Fax (773) 342-5998
www.caffedeluca.com

CATEGORY	Italian Restaurant
HOURS	Sun/Weds/Thurs: 7 am-9 pm
	Mon/Tues: 7 am-5 pm
	Fri/Sat: 7 am-10 pm
GETTING THERE	A few free parking spots available in the rear, and street parking is ample, but often crowded along Damen. The #50 Damen bus and the Damen Blue Line stops are nearby.
PAYMENT	
POPULAR DISH	Turkey paninis are made with fresh ingredients and are enjoyable on a sunny day on the back patio.
UNIQUE DISH	With various homemade selections including tomato and basil, cheese, potato, spinach, and goat cheese, De Luca's frittatas are a satisfying shift from traditional bacon and eggs.
DRINKS	Assorted coffee drinks, hot cocoa, fruit smoothies, cocktails, beer, and wine by the glass or bottle are available. Try the De Luca Bomber (coffee with Bailey's, Kahlúa and Grand Marnier).
SEATING	Additional seating is available on the back patio, which is a nice reprieve from bustling Damen Ave.
AMBIENCE/CLIENTELE	Taking a break from a day of shopping, locals stop in for a quick bite to eat or cup of coffee. High ceilings, warm colors and an open coffee bar are inviting for friends looking to catch up over pizza and a glass of wine. Once you step inside, you'll never want to leave.
OTHER ONES	7427 West Madison St., Chicago 60130 (708) 366-9200

—*Jennifer Stone*

Chaise Lounge
Head here to conclude a date on an all-time high.
$$$
1840 W. North Ave., Chicago 60622
(between Honore St. and Wolcott Ave.)
Phone (773) 342-1840 • Fax (773) 324-1865
www.chaiseloungechicago.com

CATEGORY	American Lounge
HOURS	Sun: 2 pm-11 pm
	Tues-Thurs: 4 pm-11 pm
	Fri: 4 pm-Noon
	Sat: 2 pm-Noon
GETTING THERE	Valet and metered parking are available. You can also take the #56 Milwaukee or #72 North bus or the Blue Line to Damen.
PAYMENT	
POPULAR DISH	With robust and flavorful appetizers such as truffle potatoes and Gouda macaroni and cheese for under

NEAR NORTH SIDE

$10, Chaise provides a savory dining experience at a fraction of traditional fine dining gourmet costs. Vegetarians can select from a great variety of artisan cheese salads. Meat lovers can indulge in favorites such as braised beef accompanied by potatoes and asparagus that is so palate-pleasing it is delivered by the chef herself!

UNIQUE DISH The gourmet crab cakes are different from the dining usual and will exceed expectations. Gourmet desserts are limited to four, but they too are delish.

DRINKS A full drink menu includes weekly specials and swanky offerings like Mojito carafes. The wine list is impressive and pairs perfectly with the menu offerings.

SEATING The dining area is impressive with white decor and an abundance of indoor and outdoor seating. Summer is a sexy occasion with guests lounged on the inside, outside, and rooftop deck area.

AMBIENCE/CLIENTELE Chaise Lounge is a unique experience. It provides a happy ending on every account: great gourmet food, wines and drinks, ambience, decor, service, and impressions. Chaise has the aesthetic of a place where you want to look your best. Dinner at Chaise is the perfect complement to an evening alone, with a friend, or with that special someone.

EXTRA/NOTES When the weather is nice, call ahead to RSVP! Parking and reservations become flooded.

—Santrise Nicole

Coast Sushi

Bring on the chopsticks and wine key, it's time for sushi.
$$$
2045 N. Damen Ave., Chicago 60647
(at Dickens Ave.)
Phone (773) 235-5775
www.coastsushibar.com

CATEGORY Japanese/Sushi Restaurant

HOURS Sun: 4 pm-10 pm
Mon-Sat: 4 pm-Midnight

GETTING THERE Parking can be tough on the weekends. Street parking is free and available if you don't mind walking a couple of blocks. The #50 Damen bus lets off on the corner of Dickens.

PAYMENT

POPULAR DISH While Coast offers a broad spectrum of dining fare, the sushi and sashimi are definitely the way to go. Order four or five sushi and sashimi rolls for the table and enjoy the combinations. The Maki rolls are well stuffed and the fish is deliciously fresh. The spicy salmon roll is probably one of the favorites for its low price, freshness, and spicy mayo, however, it's worth budgeting for the pricier signature maki rolls like the White Dragon. This roll is filled to the brim with shrimp tempura, wasabi tobiko (wasabi-flavored caviar), cream cheese, avocado, spicy scallion sauce, eel sauce, and spicy wasabi dressing.

UNIQUE DISH The Sunrise Roll certainly stands out as an interesting and fantastic combination of flavors. Ginger-seared tuna is wrapped with mango and mint, creating a fantastically fresh and crisp roll.

DRINKS There seems to be a limitless amount of confusion around the BYOB policy at Coast. Currently there

NEAR NORTH SIDE

	is a two-bottle limit per person. The servers cannot uncork the bottle for you at the table. This eliminates any corkage fee.
SEATING	Seating is surprisingly plentiful, though tables are pretty jam-packed together. Generally, if you're okay with your neighbors being an elbow's distance away, you won't mind the seating at Coast. They also have a sushi bar and comfortable benches in the waiting area. Considering the neighborhood and size of the facility, they have managed to work a large amount of seating into a fairly small space.
AMBIENCE/CLIENTELE	Coast definitely employs a minimalist mentality to its decorating. The front of the restaurant is open, with a large host desk and benches for waiting. The restaurant itself has simplistic wooden tables and chairs with bamboo tones throughout. Very dim lighting makes for a potential good date spot despite the close proximity to fellow diners. This is a hopping spot for larger parties and more intimate pairs alike.

—Norine Mulry

Enoteca Roma
An Old-World meal without the new money attitude.
$$$
2144 W. Division St., Chicago 60622
(at Leavitt St.)
Phone (773) 342-1011 • Fax (773) 342-4355
www.enotecaroma.com

CATEGORY	Italian Restaurant
HOURS	Sun: 10:30 am-11 pm Mon-Thurs: 5 pm-11 pm Fri: 5 pm-Noon
GETTING THERE	Take the Blue Line (Division stop), and trek 10–15 minutes by foot or hop the #70 Division bus. Meters on Division are readily available during the week, but tougher on the weekends. Best Bet? Bike it.
PAYMENT	
POPULAR DISH	Try the Piemonte bruschette (brie, green apples, and honey). The seasoned Enoteca visitor will tell you to add the Emilia (tomatoes, garlic, basil, and prosciutto), Enzo (fresh strawberries and mascarpone cheese with balsamic reduction) and Calabria (goat cheese and roasted red peppers) to that plate. Next, move on to the Pera (pear ravioli in a walnut-cream sauce with Gorgonzola cheese). The sweet pear is delightfully paired with the creamy, somewhat salty Gorgonzola while the walnuts add a crunchy texture.
UNIQUE DISH	One of the more noteworthy offerings is the tableside polenta. They start with a marble slab and spread the warm polenta across the surface. Your filling of choice is then added to the polenta and left to cool and thicken to a more substantial, easy-to-slice texture.
DRINKS	A refined, well-rounded wine list and a knowledgeable staff. They offer at least three different flight options and include sparkling wine and dessert wine. Enoteca also has an extensive menu of beers, domestic and imported, that includes Delirium Tremens.
SEATING	There is not a lot of seating available in the winter months without the benefit of the backyard beer garden. They do, however, open up Letizia's Bakery, which doubles the available seating. During the week,

NEAR NORTH SIDE

seating is not a problem, although reservation are recommended. During peak dinner hours on a Friday or Saturday, a reservation is a must.

AMBIENCE/CLIENTELE The owners pride themselves on the lack of pretension: "No Velvet, No Couches, No Attitude" is professed on their website. The atmosphere is warm, with a decor of reds and browns that make you feel at home. In the summer, request a seat in the beer garden that sits unsuspectingly behind the restaurant. Out back you can sit on real couches. You can also sit out front in their sidewalk café area if you're not opposed to Division Street traffic. They conveniently offer heat lamps and blankets for both outdoor seating areas.

—Liz Walker

The Handlebar Bar & Grill
An edgy veggie hangout!
$$$
2311 W. North Ave., Chicago 60647
(between Oakley Ave. and Claremont Ave.)
Phone (773) 384-9546 • Fax (773) 384-3320
www.handlebarchicago.com

CATEGORY Vegetarian Restaurant
HOURS Sun: 10 am-11 pm
Mon-Thurs: 10 am-Midnight
Fri/Sat: 10 am-2 am
GETTING THERE There is some metered street parking that is relatively easy to find. If you are a CTA lover, the #72 North bus would be your best bet. Handlebar would much rather you either walk or ride your bike.
PAYMENT
POPULAR DISH One of the most popular dishes is the buffalo "chicken" wrap. This wrap is filled with buffalo-flavored seitan, romaine lettuce, onions, tomatoes and vegan ranch dressing. The French fries are homemade, and the freshness makes all the difference. The cheddar grits are also a must-have. These grits are creamy, a bit salty, and delicious.
UNIQUE DISH Vegetarian biscuits and gravy with two buttery, melt-in-your-mouth biscuits covered with seitan gravy. Other breakfast options include French toast, egg sandwiches, and Huevos Diablos. The "Devil's Eggs" are two corn tostadas piled high with beans, rice, cheese and fried eggs.
DRINKS The menu boasts 26 different options, but always make sure to check for specials and new arrivals. The Handlebar is great about trying products from local breweries and taking suggestions from its patrons. There are also a variety of wines sold both by the bottle or glass. Handlebar also sports a full bar.
SEATING There isn't an abundance of seating, but then again there has never been a line. I would suggest coming with a small party as most of the tables are two- or four-tops with not too much space to move them. Think intimate conversation in a comfortable, not at all stuffy, environment. Also, there is outdoor seating in the spring and summer, perfect for a weekend brunch or happy hour with friends.
AMBIENCE/CLIENTELE The feel of this place is very artistic. Many of the patrons are artists in their own right, from painters to musicians to actors. As you would often expect with

NEAR NORTH SIDE

vegetarian establishments, the clientele is very liberal. The decor is also rather simple. There are some posters advertising local musicians and performances as you walk in, and the bar is decorated with different pieces of local art.

EXTRA/NOTES The Handlebar is a strong advocate of biking and all the local organizations that support creating a cleaner Chicago. The first Wednesday of every month plays host to the Chicago Biking Federation for happy hour, and free fries are given to bike messengers (with ID) on Mondays.

—Molly Kealy

Harold's Chicken Shack #36
Perhaps the least healthy and most delicious of Chicago institutions.
$$
1361 N. Milwaukee Ave., Chicago 60642
(between Wood St. and Paulina St.)
Phone (773) 252-2424
haroldschicken.com

CATEGORY American Fast food
HOURS Daily: 11 am-10 pm
GETTING THERE Metered street parking is difficult to find, especially on weekends. You can get off the Blue Line at Damen and walk a few blocks southeast on Milwaukee. Alternately, take the #56 Milwaukee bus.
PAYMENT
POPULAR DISH The fried chicken, of course, is the main attraction here. The chicken is fried in half vegetable oil and half beef tallow, which gives it a flavor more like traditional southern fried chicken. Not only this, but the chicken is cooked to order, which means you'll have to wait 10-15 minutes for your order, but it will be crispy on the outside, juicy and tender on the inside. Get a bucket and spring a little extra for mild, hot, or barbecue sauce. Individual meals are a quarter or half chicken served on a piece of white bread with fries.
UNIQUE DISH Catfish and perch (available in buckets or in individual meals), livers, gizzards, and fried okra are all on the menu.
DRINKS Soft drinks and bottled water.
SEATING There's a bench and a few stools to relax on while you wait for your order.
AMBIENCE/CLIENTELE This is a sparse but clean place. Just regular folks hanging out, waiting for their chicken.
OTHER ONES Check the website for more locations!

—Dave Shapiro

Honey 1 BBQ
The quickest way to get to Arkansas in Chicago.
$$$$
2241 N. Western Ave., Chicago 60647
(at Lyndale Ave.)
Phone (773) 227-5230
www.honey1bbq.com

CATEGORY Barbecue Restaurant
HOURS Sun: 1 pm-9 pm
Tues-Thurs: 11 am-11 pm
Fri/Sat: 11 am-Midnight

35

NEAR NORTH SIDE

GETTING THERE	There is plenty of metered parking available. Honey 1 BBQ is also accessible via the #49 Western bus.
PAYMENT	
POPULAR DISH	You come here for the meat. Honey 1 has the meatiest, smokiest ribs available in the city, with a house-made sauce that's the perfect accompaniment. It's not too spicy, not overly sweet, just a fantastic complement to their very, very decadent smoked meats. If you desire a more seafaring meal, their fried perch is also quite pleasant. It has a crisp cornmeal crust and is a great target for a squeeze of lemon juice.
UNIQUE DISH	What makes Honey 1 unique is their glassed-in wood smoker, one of the few that exist in Chicago. The meats smoke for upwards of twelve hours, creating true BBQ, not a boiled, fall-off-the-bone imitation. Honey 1 uses only hickory to achieve their signature style.
DRINKS	A variety of soft drinks are available.
SEATING	Plenty of seating is available for you and your friends.
AMBIENCE/CLIENTELE	The ambience is sterile, to say the least. The dining area is all white walls with linoleum on the floors and tabletops. The ambience is not the draw to this particular restaurant.
EXTRA/NOTES	This is an establishment I really recommend for take-out. The experience of the food is only heightened by a cold beer or a nice red wine.

—*Joshua Arons*

Hot Chocolate

Dinner plus chocolate in all forms. Why bother with dinner?
$$$
1747 N. Damen Ave., Chicago 60647
(at Willow St.)
Phone (773) 489-1747 • Fax (773) 489-1777
www.hotchocolatechicago.com

CATEGORY	American Lounge
HOURS	Sun: 10 am-2 pm, 5:30 pm-10 pm
	Tues: 5:30 pm-10 pm
	Weds: 11:30 am-2 pm, 5:30 pm-10 pm
	Thurs: 11:30 am-2 pm, 5:30 pm-11 pm
	Fri: 11:30 am-2 pm, 5:30 pm-Midnight
	Sat: 10 am-2 pm, 5:30 pm-Midnight
GETTING THERE	Driving is best if you plan on using valet. Street parking is available, but it can be difficult. You can take the blue line to Damen, then walk north four blocks or take the #50 Damen bus.
PAYMENT	
POPULAR DISH	The trio desserts—small samplings of three desserts in a certain category—are fabulous. The bananas sampling is one of my favorites, and includes banana brioche bread pudding with a milk chocolate hot fudge center, Moloko Milk Stout foam, a banana "royale" split with fleur de sel short crust, coffee ganache banana sherbet, and banana coffee cake. The chocolate #1 is always to die for—warm Colombian chocolate ganache and Muscovado sugar meringue tart, stuffed chocolate soufflé, salted caramel ice cream, and homemade pretzels.
UNIQUE DISH	The hot chocolate of course! You can have any version you like: white, dark, and milk chocolate with different types of cocoa are all available. All flavors include homemade marshmallows.

NEAR NORTH SIDE

DRINKS	Chocolate, chocolate, chocolate, however you want to have it—warm, cold, on ice, mixed, blended—it's all yours! Why not have a cup of hot cocoa and a milkshake?
SEATING	Hot Chocolate is a very cozy, small place. I wouldn't come with a crowd since seating is always first come first served, though bar seating is available. The place is hopping even at 10 pm!
AMBIENCE/CLIENTELE	Very trendy, upscale, but very warm and inviting with chocolate brown...well, everything, including the modern furniture. The smell of chocolate is always in the air.
EXTRA/NOTES	Dessert specialties are always for sale at the front counter. Private parties can be scheduled.

—*Debra Monkman*

House of Sushi & Noodles

Magnificent maki memories!
$$$$
1610 W. Belmont Ave., Chicago 60657
(at Lincoln Ave.)
Phone (773) 935-9110
www.houseofsushiandnoodles.com

CATEGORY	Japanese/Sushi Restaurant
HOURS	Sun: 4 pm-10 pm Mon/Tues: Noon-10:30 pm Thurs/Fri: Noon-11 pm Sat: Noon-10 pm
GETTING THERE	You can find metered street parking on Ashland or Lincoln. It's close to the Brown Line (Southport stop) and lots of buses (#77 Belmont, #9 Ashland, and #11 Lincoln).
PAYMENT	DISCOVER, MasterCard, VISA
POPULAR DISH	You go to The House of Sushi & Noodles for one thing: The Roll Sushi Buffet. There are over 40 maki rolls on the menu. I suggest going with a lot of friends: you can order up to two Maki rolls per person at a time. By the time you're done you'll be quite full and have tried lots of unique maki rolls. The buffet comes with miso soup and some vegetable tempura.
UNIQUE DISH	My favorite is the Godzilla maki. I'm a big sucker for cream cheese and spicy sauce.
DRINKS	Sake, Sapporo, and wine to enjoy with your meal.
SEATING	Make sure you enter on the Belmont side. The restaurant actually wraps around to the Lincoln side of the building as well, but that entrance is usually locked with a sign to go to the Belmont side. Although there is lots of seating, it fills up very fast. This place is very popular. Try going for lunch to miss the crowd or call for reservations.
AMBIENCE/CLIENTELE	You'll find all types of people of all ages enjoying their sushi and maki. I don't know when it started, but the walls are covered with pictures of customers. You'll have fun while you're eating or waiting for your next maki looking at the random funny pictures of people posing for the camera. I've been there before when the chef was walking around taking pictures but he didn't take mine. Maybe next time!

—*Travis Lee Wiggins*

NEAR NORTH SIDE

SMALL PLATES IN THE CITY OF BIG SHOULDERS

Tapas Chicago-style means good food, good drinks and good times, all to be shared in the form of small plates. Every tapas lover knows that for typical Spanish tapas in Chicago, there are always the popular standbys. River North's Café Iberico and Lincoln Park's Café Ba Ba Reeba and Emilio's are all as dependable as your best friend. There's also a plethora of tapas hot spots popping up all the time in the Windy City so it can be tough to navigate the crowded scene. What makes Chicago's tapas scene unique are the spots off the beaten path or hidden gems.

For example, **Sapori Trattoria** a restaurant known for Italian cuisine, offers Tapas Tuesday—tapas with Italian flair. Diners are treated to the chef's Italian culinary delights by sampling a wide array of dishes.

2701 N. Halsted Ave., Chicago 60614, (773) 832-9999, saporitrattoria.net

Other venues include bars and lounges such as **People Lounge**. This Wicker Park hot spot offers a $3 select tapas menu (very traditional dishes such as goat cheese and tortillas can be found here) Sunday through Thursday.

1560 N. Milwaukee Ave., Chicago 60622, (773) 227-9339, www.peoplechicago.com

If you're looking for the atypical Chicago tapas experience, a pitcher of red sangria, queso de cabra, patatas bravas and some good bread and olive oil for dipping, **Café Iberico** on a Saturday night is the real deal.

739 N. LaSalle Dr., Chicago 60610, (312) 573-1510, www.cafeiberico.com

For a change of pace, check out globally inspired small plates in spots such as **Exposure Supper Club** in South Loop, where you'll find Asian-influenced tapas such as wok-charred edamame, crisp Asian calamari salad and sesame-seared tuna tataki. Going along with the global theme, there's also Moroccan lamb lollipops and goat cheese terrine. Or head over to Wicker Park's **Between Boutique Café and Lounge**, home to "Top Chef" contestant Radhika Desai. She may not have won the title, but her creative dishes meant for sharing—such as spicy mantou burgers and pan-roasted mussels—might have swayed the judges' table.

Exposure Supper Club—1315 S. Wabash Ave., Chicago 60605, (312) 662-1082

Between Boutique Café and Lounge —1324 N. Milwaukee Ave., Chicago 60622, (773) 292-0585, www.betweenchicago.com

Venturing away from trendy establishments to the far-flung neighborhoods, you'll find **Café Marbella** in North Park. This charming BYOB is for times that you want to get together with good friends but don't want the hassle or pretension of some haute spot. Their creative dishes will rival any of the big boys—check out the figs wrapped in bacon atop a brandy cream sauce.

3446 W. Peterson Ave., Chicago 60659, (773) 588-9922, www.cafemarbella.com

— *Dorothy Hernandez*

NEAR NORTH SIDE

Irazú
All the benefits of a taqueria with none of the regret.
$$$
1865 N. Milwaukee Ave., Chicago 60647
(at Oakley Ave.)
Phone (773) 252-5687
www.irazuchicago.com

CATEGORY	Latin American Restaurant
HOURS	Mon-Sat: 11:30 am-9:30 pm
GETTING THERE	There is a small parking lot and readily accessible street parking. You can also access via the #56 Milwaukee or #49 Western bus or the Blue Line to Western.
PAYMENT	$ ATM
POPULAR DISH	The potato tacos are a vegetarian dish that doesn't make you long for meat. These tacos are more accurately taquitos stuffed with mashed potatoes served with rich mole sauce and fresh guacamole. On a platter with rice and beans, this dish is satisfying to even the most committed carnivore.
UNIQUE DISH	The items that set Irazú apart all link to its heritage in authentic Costa Rican dining. Their main condiment is the Lizano sauce, which is a non-spicy, citrusy, complex sauce that is used to marinate their food.
DRINKS	Irazu is BYOB. Their drink menu sets itself apart with a number of unique non-alcoholic options, including house made horchata, oatmeal milkshakes, and fresh carrot juice.
SEATING	Seating is cozy and fills up quickly during peak dining periods. Irazu encourages larger parties to arrive before 5:30 pm or after 8 pm.
AMBIENCE/CLIENTELE	Utterly unpretentious, the restaurant is decorated in bright murals. The clientele is friendly and mixed, with Wicker park professionals mingling with Logan Square hipsters and families.
EXTRA/NOTES	Lizano sauce is available for sale at the restaurant or on their website.

—*Joshua Arons*

Letizia's Natural Bakery
Delicious, hot, grilled, ground, brewed, and steamed.
$$
2144 W. Division St., Chicago 60622
(at Leavitt St.)
Phone (773) 342-1011
www.superyummy.com

CATEGORY	American Bakery
HOURS	Sun-Weds: 6 am-11 pm Thurs-Sat: 6 am-5 pm
GETTING THERE	There is metered parking along Division and some free street parking on Leavitt and Hoyne Ave. Parking is typically easy to find, and the neighborhood has wide bike lanes. Nearby buses are the #49 Western and #70 Division.
PAYMENT	AMEX MasterCard VISA
POPULAR DISH	"The Grazer" (fresh spinach, mushrooms, red onions, tomato, balsamic vinaigrette, and mozzarella on foccacia) is everything panini should be: crispy, warm, flavorful, and fresh. Great meat options are the "Gobble Gobble" (smoked turkey, tomatoes, spinach,

NEAR NORTH SIDE

red onion, mayo, and Grey Poupon on seven-grain bread) or the ham version of the same, aptly named the "Oink Oink." Classic grilled panini such as grilled mozzarella and tomato or hot Capicolla and mozzarella are made on homemade olive oil focaccia and grilled with mozzarella, fresh sliced tomatoes, and red onion. Paninis can also be custom-made.

UNIQUE DISH Right past the extensive panini menu is a massive pastry case filled with goodies that range from simple pleasures such as cookies, pies, and cheesecakes to intricately designed sweet delights such as the torta Lamponi (triple layers of Italian chocolate sponge cake, chocolate ganache, and raspberries with a rich chocolate ganache frosting) or the hazelnut truffle (layers of chocolate Italian sponge cake and layers of flourless chocolate ganache with ground hazelnuts).

DRINKS Letizia's offers Fantasia fresh juices, Naked Juice and smoothies, FUZE drinks, fresh squeezed lemonades, bottled waters (both sparkling and still), fresh-squeezed orange juice, and classic sodas. They are use only the best beans for roasting from Caffe Umbria.

SEATING With a few tables by the front window and a long banquette along the wall that faces the bar, seating can be tight during busier hours, especially when other guests decide to camp out to use Letizia's free Wi-Fi. Warmer weather allows for patio seating.

AMBIENCE/CLIENTELE The look is a typical rustic neighborhood coffee shop, made complete with delicious food anchored by delectable fresh-baked goods. The ambience is very laid-back and conducive to study and work. Walls of exposed brick and old dark wooden tables and chairs create an atmosphere with the kind of warmth only established city coffee shops are able to possess.

—*Denise Peñacerrada*

Milk and Honey Café

A cozy café with the best pancakes and granola.
$$

1920 W. Division St., Chicago 60622
(between Winchester Ave. and Wolcott Ave.)
Phone (773) 395-9434 • Fax (773) 395-8909
www.milkandhoneycafe.com

CATEGORY American Cafe
HOURS Sun: 8 am-4 pm
Mon-Fri: 7 am-4 pm
Sat: 8 am-5 pm
GETTING THERE Street parking is generally easy to find and free on nearby side streets. The #70 Division bus lets off on the corner of Damen Ave., and the Blue Line Division stop is approximately five blocks away. There is also a loading zone for people picking up to-go items.
PAYMENT
POPULAR DISH Strawberry banana pancakes include fresh pieces of banana and as always, house-made granola in the batter. Fresh strawberries top three thick, fluffy pancakes served with whipped butter and maple syrup. The side of chicken sausage is a fantastic savory counterpart to the pancakes. If you're coming for brunch, the sandwich offerings are also quite diverse. The house-made herb-crusted roast beef sandwich on toasted ciabatta is mouth-wateringly moist and flavorful.

NEAR NORTH SIDE

UNIQUE DISH The huevos rancheros, a casserole scramble of eggs, black beans, tortillas, and monterey jack and cheddar cheeses, certainly stands out. This is only offered on Saturday and Sunday (They offer a similar item, served burrito-style, during the week.) The menu is quite eclectic in general, but this is the only Mexican fare that makes an appearance.

DRINKS The café boasts a fairly extensive selection of beer and wine, but every time I dine I can't pass up the mimosa. The café team also makes superb espresso beverages for your morning caffeine kick.

SEATING Seating is fairly limited, especially during the colder months when patio seating is unavailable. The interior only fits about 50 people, and the line that forms leaves little room for movement. If at all possible, check out the café during the week. The weekend crowds can be atrocious and there is nowhere to wait except along the counter and the bar.

AMBIENCE/CLIENTELE The menu and drinks are written on large blackboards on the wall and behind the counter. The café has a bustling, homey feel. Small tables of two- and four-tops are spread thoughout the café, a pastry case in front displays delectable cupcakes and croissants, and there's always a great neighborhood crowd.

—Norine Mulry

Silver Cloud Bar and Grill

Frito pie and baked Chevre, available in one convenient, tidy, restaurant package!

$$

1700 N. Damen Ave., Chicago 60647
(at Wabansia Ave.)
Phone (773) 489-6212 • Fax (773) 489-2834
www.silvercloudchicago.com

CATEGORY American Bar & Grill
HOURS Sun: 10 am-Midnight
Mon-Fri: 11:30 am-2 am
Sat: 10 am-3 am
GETTING THERE Metered parking is available but can be difficult to find, especially on weekends. Silver Cloud is easily accessible via the #56 Milwaukee, #72 North, or #50 Damen bus, or take the Blue Line to Damen.
PAYMENT
POPULAR DISH Silver Cloud has two service sessions throughout the day, with slight variations between their lunch and dinner menus. This being the case, your two best bets are going to be the grilled cheese and tomato soup during lunch service, and Grandma's meatloaf during dinner. The grilled cheese is everything you want it to be: two perfectly browned pieces of bread stuck together with gooey, melted cheese. The soup is Campbell's tomato, and there is nothing better in the world to dip grilled cheese into. Grandma's meatloaf is realistically much better than my own grandmother's version. The mashed potatoes are smooth, the gravy rich, and the meatloaf moist and warming.
UNIQUE DISH There is a decided commitment to presenting all the heartwarming comfort food you know well from your youth. chicken pot pie, pot roast, Sloppy Joes, and Frito pie all hold places of reverence on the menu,

NEAR NORTH SIDE

	and what's more, are all executed flawlessly at this unpretentious and relaxed bar locale.
DRINKS	Full bar. Try the excellent Bloody Mary or revolving list of seasonal martinis.
SEATING	Plenty of seating is available inside, with lots of booths, tables, and bar seating. During warmer months, the outdoor patio is a wonderful place to take in the beautiful Wicker Park neighborhood and its dog walking, tanned residents.
AMBIENCE/CLIENTELE	The ambience of Silver Cloud is warm and worn. It's a bar that's changed very little in the past 50 years, with the exception of a TV here and there. The clientele is varied, ranging from young mothers to old punks, depending on the time of day.

—*Joshua Arons*

Silver Palm
Throw momma from the train!
$$$
768 N. Milwaukee Ave., Chicago 60622
(at Ogden Ave.)
Phone (312) 666-9322
www.thesilverpalmrestaurant.com

CATEGORY	American Bar & Grill
HOURS	Sun: 5 pm-Midnight Tues-Sat: 6 pm-2 am
GETTING THERE	Scarce street parking is available. No lot parking; don't dare park in the CVS lot or you will be towed! You can also take the Blue Line to Chicago or the #56 Milwaukee, #66 Chicago, or #65 Grand bus.
PAYMENT	
POPULAR DISH	There are tons of exotic appetizers, like delicious goat cheese, duck wings, and calamari. Even the soups and salads are, in a word, decadent. The baked apple pie is a small piece of heaven.
UNIQUE DISH	Duck Club Sandwich. Enough said.
DRINKS	The bar is the size of my deck. The drinks are by far the best priced for quality and quantity in town, and the wine list is pretty damn extensive with most bottles at the $50 point. Try the rocking martinis, margaritas, and stiff "problem solving" drinks. Who wants some homemade apple pie and a white chocolate martini?
SEATING	There are approximately 15 tables. It's very cozy, but not a good place for the kiddies.
AMBIENCE/CLIENTELE	What a unique place to dine! Silver Palm is set in a boxcar. The atmosphere can turn loud due to an overly boisterous (read: hammered) crowd. No judgment here. Let a cocktail be your umbrella!

—*Marquis Tucker*

Sultan's Market
They claim to have the best falafel sandwich in Chicago.
$$
2057 W. North Ave., Chicago 60647
(at Hoyne Ave.)
Phone (773) 235-3072
www.chicagofalafel.com

CATEGORY	Middle Eastern Fast food

NEAR NORTH SIDE

HOURS	Sun: 10 am-9 pm
	Mon-Sat: 10 am-10 pm
GETTING THERE	Sultan's is easy to find as it is located in Wicker Park, one of the most accessible spots in the city. The #72 North, #50 Damen, and #56 Milwaukee buses all run late, and the Blue Line (Damen stop) is available 24 hours a day.
PAYMENT	$ ATM
POPULAR DISH	Their falafel sandwich deserves the hype. Fresh pita pockets stuffed with homemade hummus, two falafel and cool Jerusalem salad, these sandwiches are perfectly crafted. The falafel is always warm and crispy and the hot sauce they offer is just hot enough to avoid discomfort. (Always order your falafel spicy!)
UNIQUE DISH	The Zatter Fattia is truly the gem of Sultan's menu. They take a piece of their zatter bread—a soft flatbread covered with an intense paste made from oregano, thyme, and sumac—cut it in half and make a delicious little sandwich out of it. Always order it with baba ganooj. They make the best I've ever had.
DRINKS	A wide variety of juices and soft drinks.
SEATING	There are only twelve tables in Sultan's of various sizes. Don't worry, they open up really quickly. During the spring and summer they have a nice patio area, too.
AMBIENCE/CLIENTELE	Everyone likes Sultan's, so don't expect a specific type of customer. This place is fast-paced. Make sure you have your order ready once you get to the counter. Be warned, the dudes preparing your food aren't going to kiss your butt.
EXTRA/NOTES	You should always consider getting two sandwiches at Sultan's. Chances are if you only get one, you'll want another about an hour later.
OTHER ONES	2521 N. Clark St., Chicago 60614

—Luca Cimarusti

Zen Noodles
Worship the wok!
$$$
1852 W. North Ave., Chicago 60622
(at Wolcott Ave.)
Phone (773) 276-8300 • Fax (773) 276-8381

CATEGORY	Pan-Asian Restaurant
HOURS	Sun-Thurs: 11 am-10 pm
	Fri/Sat: 11 am-11 pm
GETTING THERE	Metered street parking is available, but it's almost never easy to find a parking space. The Wolcott stop on the #72 North bus route is almost directly in front of the restaurant, or take the Blue Line to Damen.
PAYMENT	DISCOVER AMERICAN EXPRESS MASTERCARD VISA
POPULAR DISH	From Yaki Soba to Pad Thai to Bamee garlic chicken, noodles are where Zen excels. In addition to this, the stir-fry options are great, especially the garlic stir-fry. And I can't seem to go more than a couple of weeks without a big steaming bowl of roasted duck noodle soup. There's something about tender duck meat in cinnamon broth with cilantro, garlic oil, and green onion.
DRINKS	Zen is BYOB and has a full bar. There's a few signature cocktails and a small selection of domestic and imported beers. Zen also has the standard soft drinks, as well as a nice array of bubble teas and Asian smoothies. (Though aside from flavors like lychee, I'm not sure

NEAR NORTH SIDE

SEATING what exactly makes them Asian.) Hot tea, Thai iced coffee and delicious Thai iced tea are also available.

SEATING This is a comfy restaurant, with walls painted in red and yellow, warm track lighting, and enough space between tables to give breathing room. Sitting at the tables near the front gives an excellent opportunity for people-watching. The bar outside the partially open kitchen, however, gives you the best spot to hear one of the greatest sounds known to mankind: the sizzle of food being stir-fried in a red hot wok.

AMBIENCE/CLIENTELE The obvious effort put into the decor doesn't seem quite matched when it comes to the music. As opposed to keeping with the relaxed, comfortable visual style, the stereo pumps out pop hits, power ballads and the like. On a busy night it's hardly noticeable, but if you're trying to enjoy a quiet lunch, it can sometimes be a little distracting. The place is generally full of mostly twenty-somethings all looking for the same thing: a relaxed atmosphere in which to enjoy some great food.

EXTRA/NOTES Zen does both carry-out and delivery. There's a small delivery charge per order. The delivery is always incredibly fast (15-20 minutes), even during peak hours.

—Dave Shapiro

LINCOLN PARK

The Bourgeois Pig
It's like eating in your grandpa's house, but better.
$$
738 W. Fullerton Pkwy., Chicago 60614
(at Lincoln Ave.)
Phone (773) 883-5282 • Fax (773) 929-6570
www.bpigcafe.com

CATEGORY American Sandwich Shop
HOURS Sun: 8 am-10 pm
Mon-Sat: 7 am-10 pm
GETTING THERE One block from the Fullerton stop of the Brown, Red, and Purple lines on theI El. There is street parking available and a parking garage on Lincoln. You can also take the #74 Fullerton or #11 Lincoln bus.
PAYMENT
POPULAR DISH The funny part about "The Pig" is that all of the sandwiches are named for famous books. One of my favorites is The Great Gatsby, which takes the club sandwich to a new level with avocado and focaccia. Another great sandwich is The Sun Also Rises, a turkey sandwich with hummus and alfalfa sprouts.
UNIQUE DISH The great thing about the place is that everything is unique; you will have a tough time finding anything here that you could get anywhere else.
DRINKS It was started as a coffeehouse, so you can get your morning joe here. If the regular stuff doesn't do it for you, they have the Depth Charge, which is coffee reinforced with up to four shots of espresso. They have one of the largest loose-leaf tea collections in the

NEAR NORTH SIDE

country. If you want something more, there is a cornucopia of lattes, hot chocolates, and other beverages served hot or cold. They also have a fine selection of smoothies for those hot Chicago summers.

SEATING "The Pig" is designed to be a place for community and conversation like the coffeehouses of old Europe. They have small tables, but the larger tables are the interesting places to sit. One of the rules is that if there is an empty seat, it is available for anyone and so, especially on the second floor, you might find yourself seated with three people you have never met before. It is also a great place to read a book or work. There is a room on the second floor with couches and easy chairs that are perfect for a discussion or a cozy place to read.

AMBIENCE/CLIENTELE Cozy is how I would describe The Bourgeois Pig. Depending on the time of day it can be quiet and peaceful or wild and busy. Since it is close to DePaul University, many of the students and professors will meet friends or classmates for a study session or even oral Spanish exams. There is a philosophy professor who will hold discussions on the second floor. It is truly a hidden gem.

—*Patrick Brown*

Bricks Chicago
Thin slice pizza love in the deep-dish center of the world?
$$

1909 N. Lincoln Ave., Chestnut Street 60610
(at Wisconsin St.)
Phone (312) 255-0851
www.brickschicago.com

CATEGORY Italian/Pizzeria Restaurant
HOURS Daily: 5 pm-10 pm
GETTING THERE Street parking is extremely difficult. There is a paid lot right by Bricks. You can take the #11 Lincoln, #22 Clark, or #36 Broadway bus. Taxis are always plentiful upon leaving.
PAYMENT
POPULAR DISH The Ditka pizza is my favorite—just heaps of meat and cheese. Veggie lovers, do not fear—the vegetarian pizza is also a must. You can also create your own pie, choosing from over 20 different ingredients.
UNIQUE DISH Bricks is not just known for its pizza. It boasts a nice collection of salads, Italian-style grinders, pasta and appetizers, including unbelievable garlic bread with cheese.
DRINKS They have a fantastic microbrew selection that goes well with pizza. If you're a wine fan, their selection is more than decent.
SEATING Bricks has 45 tables in the dining room, 20 at the bar and a few cocktail tables. Reservations are accepted for parties of six or more.
AMBIENCE/CLIENTELE Bricks isn't in the most obvious location. When you see the sign on the sidewalk, you need to walk down a short flight of stairs that brings you to its entrance. Its cozy, subdued atmosphere sends you a bit back in time and adds to the character of the overall experience. It's also a perfect place for a quiet night on one's own—many a time, I've gone on my own to eat and drink at the bar and watch what's on the TV. The bar staff is as friendly and competent as the waitstaff.

NEAR NORTH SIDE

EXTRA/NOTES	It must be noted that Bricks does deliver, a lifesaver for cold Chicago nights when you want to remain holed up at home.

—*Laura Cococcia*

Café Bernard
Ooh la la! A hidden gem in Lincoln Park.
$$$$
2100 N. Halsted St., Chicago 60614
(at Dickens Ave.)
Phone (773) 871-2100 • Fax (773) 929-7671
www.cafebernard.com

CATEGORY	French Restaurant
HOURS	Sun: 5 pm-10 pm
	Mon-Thurs: 5 pm-10:30 pm
	Fri/Sat: 5 pm-11:30 pm
GETTING THERE	Metered parking is available and valet on Thursdays, Fridays, and Saturdays. Parking can be difficult in the area on weekends. Take the #73 Armitage or #74 Fullerton bus or the Brown Line to Armitage.
PAYMENT	
POPULAR DISH	The Fillet du Boeuf is excellent and always cooked perfectly. It comes with a delicious brown sauce. The potatoes are the right texture and not too buttery.
UNIQUE DISH	Baked Brie en Croute will make your head spin. It's brie wrapped in pastry, accompanied with cranberry sauce and small servings of fruit. They also have a great selection of specials that I highly recommend considering.
DRINKS	They have a full bar and offer wines by the bottle and glass. They are also BYOB with a small corkage fee.
SEATING	The café seats around 75 people. They serve big groups, but the place is more appropriate for small groups or couples.
AMBIENCE/CLIENTELE	The ambience is quiet and romantic. The restaurant is decorated with French artwork and they occasionally have French music playing. The lighting is dim to help with the romantic vibe. The clientele is not your typical Lincoln Park crowd; instead, it's mostly people in their 30s and above.
OTHER ONES	• Red Rooster, 2100 N Halsted St, Chicago 60614, (773) 929-7660

—*Christine Lambino*

The Grove Restaurant
Family-style dining in a comfortable, casual environment.
$$$
501 W. Diversey Pkwy., Chicago 60614
(at Pine Grove Ave.)
Phone (773) 248-0398

CATEGORY	American Restaurant
HOURS	Daily: 7 am-8 pm
GETTING THERE	Parking can be a challenge. The #76 Diversey bus stops at the corner, and the #22 Clark and #151 Sheridan bus stops are about three blocks away.
PAYMENT	ATM
POPULAR DISH	I am not usually a fan of omelettes because at most places an omelette is just a hard cooked scrambled egg folded over some cheese and stuff. At the Grove, the

omelettes are fluffy and huge; I have never finished one! There is a nice variety of comfort food and the portions are large. We almost always take home a doggie bag. They make a huge, wonderful taco salad that is served in a deep fried tortilla bowl with warm ground beef or chicken and fresh veggies. Meals are served the old-fashioned way—soup or salad, entree and dessert. The kitchen is willing to make substitutions.

DRINKS There is a bar and a nice wine list, along with sodas, tea and coffee.

SEATING The Grove is a cozy, medium-sized neighborhood restaurant with many tables, booths and some counter seats. Sometimes there is a short wait.

AMBIENCE/CLIENTELE In a word, The Grove is homey. The staff is very friendly. If you are a regular customer, you become a friend. They call you by name and engage you in conversation. They'll remember what you like and know what to recommend. These are folks who enjoy what they do. Although far from a sports bar, you can always watch the current game.

—*Steve and Donna Bellinger*

Lito's Empanadas

Lito's Empanada's: one thing done right!

$

2566 N. Clark St., Chicago 60614
(at Wrightwood Ave.)
Phone (773) 857-1337

CATEGORY Colombian Restaurant

HOURS Sun: Noon-7 pm
Mon-Weds: 10 am-8 pm
Thurs: 10 am-10 pm
Fri/Sat: 10 am-Midnight

GETTING THERE Parking is very hard to find on Clark. The #22 Clark bus is the way to travel.

PAYMENT

POPULAR DISH With a limited menu, every empanada is popular in its own right. The standard chicken and beef empanadas are fabulous. The beef incorporates raisins into the mix, adding a little sweetness. The BBQ pork empanada has extremely moist, flavorful, slow-cooked pork in a tangy BBQ sauce. There are two vegetarian empanadas for you herbivores out there: the spinach empanada is good, though the mozzarella oozes out after the first bite. The vegetarian empanada is far more filling and flavorful with green pepper, cilantro, onion, potato and chipotle peppers. You can easily fill up on two for around $5.

UNIQUE DISH The Hawaiian empanada seems the most out of place on this menu. Think Hawaiian pizza—ham, mozzarella and pineapple. I wouldn't add any of the homemade salsa to this one; it is great as it is. Make sure to order the banana and chocolate empanada. Let it cool before the hot chocolate leaks out all over your face. This is certainly a messy experience, but absolutely tasty. Ask for extra napkins!

DRINKS Soda and Vitamin Water are sold here.

SEATING There are only five window seats available. Lito's is more of a take-out place unless you are solo and just want a quick bite to eat. The seats face Clark, which is always good for people-watching.

NEAR NORTH SIDE

AMBIENCE/CLIENTELE The ambience is rather cold. It really is more of an in-and-out kind of place. Lito's does draw many repeat customers because the food is so tasty and the prices are right.

—*Molly Kealy*

Molly's Cupcakes
With a percentage of proceeds donated to local schools, this is Chicago's destination for guilt-free dessert.

$

2536 N. Clark St., Chicago 60614
(at Deming Pl.)
Phone (773) 883-7220
www.mollyscupcakes.com

CATEGORY American Bakery

HOURS Sun: 8 am-10 pm
Mon: Noon-10 pm
Tues-Thurs: 8 am-10 pm
Fri/Sat: 8 am-Midnight

GETTING THERE Parking is difficult in the surrounding area. Take the #22 Clark or #36 Broadway buses. The closest El stop is the Brown Line at Diversey, but it's a walk.

PAYMENT

POPULAR DISH Molly's offers classic flavors like chocolate, vanilla, carrot and red velvet, as well as toppings like fresh baked brownie bites, marshmallow fluff or a side of their homemade ice cream. If you're going to Molly's, go all out and try one of their center-filled cupcakes. These come in a variety of flavors like pumpkin, Chocolate Decadence and Cookies-N-Cream.

UNIQUE DISH The Ron Bennington: I Have My Own Cupcake. This cupcake was created in honor of Ron Bennington, comedian and co-host of the XM Radio show "Ron and Fez." This decadent creation is a chocolate cupcake filled with butterscotch and peanut butter, topped with chocolate ganache and butterscotch bits.

DRINKS Molly's serves Chicago's finest coffee: Intelligentsia. Wolfy, the owner's brother, waits behind the coffee bar to whip up delicious lattes, cappuccinos and his self-proclaimed "best hot chocolate."

SEATING There are a few tables for parties of two to six and a couple cozy window seats that are perfect for dates. However, the best seats are the four toggled swings located in front of the coffee bar. Sitting on a swing and eating a cupcake is a great way to get in touch with your inner child, something Molly's encourages.

AMBIENCE/CLIENTELE John Nicolaides opened Molly's to honor his favorite elementary school teacher, Miss Molly, who baked cupcakes to celebrate her students' birthdays. The theme of childhood is carried out with the collection of vintage lunch boxes behind the dessert display case, a sprinkle station, brightly colored tables, and art from local children. Thus, many families visit Molly's after school and during the day on weekends. On Friday and Saturday nights, the restaurant becomes a haven for dates and the bar crowd.

EXTRA/NOTES John donates part of the proceeds to help local schools. He also donates cupcakes for fundraisers.

—*Katelyn Bogucki*

NEAR NORTH SIDE

Pasta Palazzo
Good people, good pasta, good prices in this Italian eatery.
$$
1966 N. Halsted St., Chicago 60614
(at Armitage Ave.)
Phone (773) 248-1400 • Fax (773) 687-6104
www.pastapalzzo.com

CATEGORY	Italian Restaurant
HOURS	Sun: 11:30 am-8:30 pm
	Mon-Thurs: 11:30 am-9:30 pm
	Fri/Sat: 11:30 am-10:30 pm
GETTING THERE	Street parking is difficult, but there's metered parking along Armitage. Take the #8 Halsted or #73 Armitage bus or the Brown Line train to Armitage.
PAYMENT	
POPULAR DISH	Get started with their lick-the-plate-clean creamy baked goat cheese dressed in tomato-basil sauce and served with delicious garlic bread. Or sink your teeth into the mouthwatering grilled portabella sandwich on tomato focaccia, spread with pesto mayo and topped with fontinella cheese.
UNIQUE DISH	If anything, one should experience their handmade pastas, including the jalapeño gnocchi. This spicy take on the potato dumpling is stuffed with jalapeños and served in roasted red pepper purée.
DRINKS	Pasta Palazzo's drink list is fairly limited but what they lack in spirits they make up with delicious food and a laid-back atmosphere.
SEATING	The restaurant seats about 40 people in a cluster of high-top tables, including the twelve-seat counter that gives an up close and personal view of the open kitchen.
AMBIENCE/CLIENTELE	Be prepared to speak up with your dining companions as Pasta Palazzo's open kitchen and close-knit seating can get a bit noisy. Otherwise, expect the friendliest of service.

—*Rachael Carter*

Pequod's Pizza
It's not burned, it's caramelized!
$$
2207 N. Clybourn Ave., Chicago 60614
(at Webster Ave.)
Phone (773) 327-1512 • Fax (773) 327-4294
www.pequodspizza.com

CATEGORY	Italian/Pizzeria Restaurant
HOURS	Daily: 11 am-2 am
GETTING THERE	Easy to find metered parking, or the paid parking lot across the street by the Webster Place Theater. Or you can take the #9 Ashland or #74 Fullerton bus.
PAYMENT	
POPULAR DISH	Pequod's is quite unique and best known for their deep-dish pizza. Their toppings are generous and the cheese is ooey-gooey. Extra cheese is melted onto the crust, giving each deep-dish pizza the locally famous caramelized edges. Their sauce is a little tangy, but they also serve a "chunky-style" on request that gives a sweeter flavor. Be prepared to wait about 40 minutes for your pizza if you are just walking in, but they do have a "phone ahead" policy so that you can call ahead of time to minimize your wait if you're in a hurry.

NEAR NORTH SIDE

DRINKS	Pequod's offers standard beverages, including pop, standard beers, and wine. As an added bonus, though, they do offer IBC Root Beer.
SEATING	Pequod's has two floors of seating with plenty of room between you and your neighbors; there is also a bar on both floors with available seating. The wait time to be seated on even the busiest night is rarely over 15 minutes. Private rooms are also available at an extra cost.
AMBIENCE/CLIENTELE	The brick interior and smell of delicious pizza makes Pequod's a warm and inviting space for dining in. There are televisions located throughout the restaurant for those looking to watch some sports and the patrons are generally very laid-back and ready to have a good time. The staff is very friendly and are always happy to engage in conversation with guests. No matter what time you go to Pequod's, you will surely have an enjoyable meal and experience.
OTHER ONES	8520 Fernald Ave., Morton Grove 60053

—*Jenna Noble*

Salt and Pepper Diner

This greasy spoon takes you back to the 50s and cures your hangover.
$$

2575 N. Lincoln Ave., Chicago 60614
(at Wrightwood Ave.)
Phone (773) 525-8788

CATEGORY	American Diner
HOURS	Daily: 7 am-4 pm
GETTING THERE	Street parking is difficult. Take the Brown Line (Diversey stop) or the #11 Lincoln/Sedgwick bus.
PAYMENT	$ ATM
POPULAR DISH	For a hearty breakfast, try one of their omelettes. The most popular omelettes are the Clark Street (diced ham, mushrooms, tomato and Swiss cheese) and the Veggie (tomato, green peppers and mushrooms). For lunch, you cannot go wrong with their grilled cheese, served on white or wheat toast with pickles on the side. Their bread is always buttered and toasted to perfection. For something a little healthier, their turkey wrap (sliced turkey breast, Swiss cheese, tomato, pickle, onion and mayo) is quite popular. Adding avocado to this dish is recommended. For vegetarians, their black bean veggie burger is delicious and comes with all the trimmings.
UNIQUE DISH	"Griddle Favorites" inclueds buttermilk, pecan and cinnamon apple pancakes as well as French toast and waffles. Their banana nut French toast is made with three slices of banana nut bread and served with fresh bananas, pecans and powdered sugar. For $2, strawberries or bananas and whipped cream can be added to any dish.
DRINKS	Like a good diner, they offer milkshakes and malts. They use Hershey's syrup, which makes their chocolate milk and milkshakes taste like something mom used to make. Their strawberry shakes are refreshingly sweet. For those who want to enjoy an alcoholic beverage with their meal, you can visit their Wrigleyville location or bring your own vodka to the Lincoln Park location. For $2, they will supply you with everything you need to turn your own vodka into a Bloody Mary.

NEAR NORTH SIDE

SEATING	This is a small, intimate diner with a long wait on the weekends. There are booths for four and two booths for six to eight and barstools for single diners or those who want to watch the cooks whip up the entrees.
AMBIENCE/CLIENTELE	This diner has been featured in a few movies and has a truly authentic feel. The waitstaff is personable and more than willing to have a conversation, especially during the week, when they are slow. If you come a few times, they might even remember your name or your order. On the weekends, parents bring their kids, making it a little more packed than usual.
OTHER ONES	3537 N. Clark St., Chicago 60657

—*Katelyn Bogucki*

Stanley's Kitchen and Tap

Come for the chicken, stay for the cheers!
$$
1970 N. Lincoln Ave., Chicago 60614
(between Armitage Ave. and Sedgwick St.)
Phone (312) 642-0007 • Fax (312) 642-0008
www.stanleyskitchenandtap.com

CATEGORY	Southern Restaurant
HOURS	Sun: 10 am-2 am Mon-Fri: 11 am-2 am Sat: 11 am-3 am
GETTING THERE	Limited street parking available. Free parking on Lincoln, but side streets are permit only. Cabs are plentiful and there are bicycle racks. Your best options are the #73 Armitage, #11 Lincoln or #22 Clark bus.
PAYMENT	ATM, American Express, Discover, MasterCard, Visa
POPULAR DISH	Hands down, they have the best macaroni and cheese in the city. Made with American, cheddar and Swiss cheese and baked to perfection. Another crowd favorite is the Southern fried chicken. The meal comes with your choice of a side, and you would be crazy not to indulge in the mashed potatoes and gravy. Don't forget a slice of sweet potato pie for dessert.
UNIQUE DISH	On Saturdays and Sundays, Stanley's brunch buffet is the way to go. Served from 10 am–4 pm, the buffet offers everything from homemade waffles to fried chicken and mashed potatoes. Someone at the omelette bar will scramble up your favorite combination and the homemade cookies and cinnamon rolls are sure to satisfy your sweet tooth.
DRINKS	With more than 60 different varieties, the bar certainly does live up to its claim of having the most American whiskeys in Chicago. You are always welcome to a free shot of smooth-as-silk Kessler. The bar is also fully stocked with a wide assortment of beers and spirits. During Saturday and Sunday brunch, make sure you take advantage of the Bloody Mary bar.
SEATING	The bar area has one long banquette and about eight high-tops. The dining area has plenty of seating and is very kid-friendly. There is a private party space downstairs.
AMBIENCE/CLIENTELE	Stanley's can't figure out what kind of ambience they are going for. The dining area looks like it is straight out of the '50s with red and white stripes on the walls, tables embellished with old-school Coca-Cola symbols, and a replica of a London phone booth. The bar area is completely different; you can find anything

NEAR NORTH SIDE

	from Cubs paraphernalia to a fish caught by one of the owners years ago. The jukebox is filled with a wide array of music, and the six televisions are always tuned to a ball game. Barrels filled with peanuts are available as bar snacks and if you have a marker handy, be sure to graffiti the walls.
EXTRA/NOTES	A fan of the Blackhawks and Cubs, Michael Jordan has been spotted watching his favorite teams. Sunday nights at Stanley's are famous: live-band karaoke draws in patrons by the hundreds. Expect a line if you aren't there before 9 pm (6:30 pm if Monday is a holiday). With a coloring contest every month, you are encouraged to bring the whole family for dinner.
OTHER ONES	324 S. Racine Ave., Chicago 60607, (312) 433-0007

—Molly Kealy

Tarascas International

Dignified Mexican fare with down and dirty margaritas.
$$$
2585 N. Clark St., Chicago 60614
(between Deming Pl. and Wrightwood Ave.)
Phone (773) 549-2595
www.cocinatarascas.com

CATEGORY	Fusion Restaurant
HOURS	Sun: 9 am-11 pm Mon-Thurs: 4 pm-11 pm Fri: 4 pm-Midnight Sat: 9 am-Midnight
GETTING THERE	Parking is difficult! Take the #22 Clark or #36 Broadway bus instead.
PAYMENT	
POPULAR DISH	What makes this place feast-worthy is the integrative Mexi-Caribbean fusion, like the plantain-crusted Mahi-Mahi and the cilantro salmon wrapped in a banana leaf. Other popular choices include the Pechuga Poblana (grilled chicken breast smothered in decadent Chihuahua cheese and poblano sauce) and the Churrasco (sirloin filet doused in a rustic chimichurri served with sweet plantains) proves Tarascas provides way more than your traditional Mexican meal—it's a culinary cruise through the Caribbean.
UNIQUE DISH	The Burrito Tarasco is a hot item, and you can taste why. With juicy steak, bacon, refried beans, and Chihuahua cheese wrapped in a sun-dried tomato tortilla, smothered in chipotle sauce and pico de gallo, it's a not just a burrito, it's a beast!
DRINKS	Tarascas serves the most potent, most powerful, most monstrous margaritas in all of Chicagoland. At a whopping 45 ounces, the award-winning Jumbo Margarita is just the right blend of salt, sweet, and sauce, but heed caution! They mean it when they say, "One—and you're done!"
SEATING	There is plenty of seating during lunch service on the weekends; reservations strongly recommended on Friday and Saturday nights. Sidewalk seating is the place to be on summer Saturday afternoons.
AMBIENCE/CLIENTELE	On the weekends, it's relaxing. At night the restaurant sparkles with tiny twinkle lights lining the ceiling and buzzes with laughter and easy conversation.

—Jessica Word

NEAR NORTH SIDE

Toast
Breakfast, baby…breakfast!
$$
746 W. Webster Ave., Chicago 60614
(at Burling St.)
Phone (773) 935-5600

CATEGORY	American Brunch
HOURS	Mon-Fri: 7 am-2:30 pm
	Sat: 8 am-2:30 pm
GETTING THERE	Street parking is scarce, but not impossible. Don't dare park in the lot next to Toast or you will be towed! You can also take the Red Line to Fullerton or the #8 Halsted, #22 Clark or #152 Addison bus.
PAYMENT	
POPULAR DISH	Toast's most popular dish: breakfast. A big breakfast is often hard to find time for. There is always something seemingly more important to attend to. Well, Toast is here to save the day! This is a kind of place where lots of regulars go for stuffed French toast, mimosas, and eggs Benedict.
UNIQUE DISH	Try the huevos with chorizo and cheddar (scrambled eggs with chorizo, cheddar, jalapeños, and potatoes).
DRINKS	The best hot chocolate ever—no lie! Strawberry mimosas run a close second. The tea selection is impressive too.
SEATING	There are approximately 20 seats. It's very kid-and family-friendly. You will have to check your patience, though; the wait can be upwards of one hour. Ouch! But here's the catch: it's bloody worth it. Sit at the breakfast bar, have a few laughs with the waitstaff, or grab a Starbucks up the street. Leave your name on the list—you'll thank me later.
AMBIENCE/CLIENTELE	Atmosphere is homey (read: nostalgic), with hardwood floors and wood tables with white tablecloths. It's a souped-up cattle call, but who cares? Lincoln Park is one of the wealthiest neighborhoods in Chicago, so expect to see fashion from Gap to Gucci.
OTHER ONES	Toast Two, 2046 N. Damen Ave., Chicago 60647

—*Marquis Tucker*

OLD TOWN

Dinotto Ristorante
Bring your appetite and don't worry if you can't try the whole menu.
$$$
215 W. North Ave., Chestnut Street 60610
(at Wells St.)
Phone (312) 202-0302
www.dinotto.com

CATEGORY	Italian Restaurant
HOURS	SUMMER: Sun: 5 pm-10 pm
	Mon-Thurs: Noon-11 pm
	Fri/Sat: Noon-Midnight
	WINTER: Sun: 5 pm-10 pm
	Mon-Thurs: Noon-10 pm
	Fri/Sat: Noon-11 pm

NEAR NORTH SIDE

GETTING THERE	Paid lot on the corner of North and Wells, ample street parking and a valet service. Or take the #72 North or #73 Armitage bus or the Brown Line to Sedgwick.
PAYMENT	
POPULAR DISH	The spaghetti bolognese and veal milanese are my tried and true favorites; the caprese salad and calamari are no-brainers for appetizers. You can't leave without having dessert, so it would have to be the Apple Tart.
UNIQUE DISH	Dinotto cooks up guaranteed specials every night, made fresh that day. You can rarely go wrong choosing one of the special courses to add some variety.
DRINKS	The wine list is extremely extensive and Dino (the owner) and his staff are extremely well versed in recommending something that will suit your palate. The bar area is one of the coziest in the city and they'll welcome any visitor interested in a small bite and sip of wine.
SEATING	Dinotto has seating for 100, bar seating for six, and a gorgeous outdoor patio. They will host private parties in their back room with reservations. They also cater for any special occasion; just give advance notice.
AMBIENCE/CLIENTELE	Dinotto brings a bit of Italy to Chicago. The decor and intimate feel distinguishes it from other Italian spots in the city. You feel as if you could easily be eating at your dining room at home. The patio, decorated with vines and flowers, is hands down one of the best outdoor seating venues in the city.

—*Laura Cococcia*

Old Jerusalem

Authentically delicious and easy on your pocket.

$

1411 N. Wells St., Chicago 60610
(between Burton St. and Schiller St.)
Phone (312) 944-0459 • Fax (312) 943-9978
www.oldjerusalemrestaurant.com

CATEGORY	Middle Eastern Restaurant
HOURS	Daily 11 am-11 pm
GETTING THERE	There is metered parking, but it's not too easy during busy hours. You can also take the #72 North or #156 LaSalle bus. Also, the Brown and Red lines are within walking distance.
PAYMENT	
POPULAR DISH	Keeping in mind that I'm a vegetarian and haven't ordered any meat products, I'd truly kill for their falafel sandwiches, their tebouleh, hummus and baba ganouj. The liquid yogurt is fresh and substantial. The lentil soup is out of this world.
UNIQUE DISH	They can prepare any specialty you like.
DRINKS	The usual sodas and water plus Arabic coffee, liquid yogurt, and lemonade. They offer a very low corkage fee so you can BYOB.
SEATING	This comfortable, relaxed restaurant has capacity for maybe 40 people.
AMBIENCE/CLIENTELE	The ambience is clean and quiet. It's more for friends than for a romantic dinner, but it's good if you want to treat someone to a delicious authentic Middle Eastern treat at a fair price. The staff is amicable and attentive with no attitude. If you have small kids, they help you with the stroller. The owners are almost always on-site

NEAR NORTH SIDE

and are courteous and unpretentious. Service is fast yet fresh, so if you're in a hurry, it's an ideal place to go for a quick bite.

EXTRA/NOTES They have carry-out and delivery for a nominal fee.

—Isa Traverso-Burger

Uncle Julio's Hacienda

¡Mi hacienda es su hacienda!
$$$
855 W. North Ave., Chicago 60622
(at Clybourn Ave.)
Phone (312) 266-4222
www.unclejulios.com

CATEGORY Mexican Restaurant
HOURS Mon-Thurs: 11 am-10:30 pm
Fri: 11 am-11:30 pm
GETTING THERE Valet parking is available for a small charge. Street parking is available on Clybourn, south of Halsted St. Located near the North/Clybourn stop on the Red Line as well as the #72 North bus.

PAYMENT
POPULAR DISH Choose from a number of delicious fajita options. The chicken and beef fajitas come to your table sizzling and overflowing with fixins. The Vegetable Fajitas Especiale is equally delicious. A grilled portobello stands out among the bountiful array of veggies. All fajitas come with hot, tasty, freshly made tortillas.
UNIQUE DISH Quail a la Parilla is sweet and smoky grilled quail basted with chipotle barbeque sauce. For the more adventurous, marinated and mesquite-grilled frog legs are also offered.
DRINKS A good selection of Mexican beers and a large tequila menu are featured prominently. Their signature Swirl margarita is frozen layers of homemade sangria and margarita. Choose from other frozen margaritas, margaritas on the rocks, or if that isn't enough, a custom margarita can be made just for you.
SEATING Big groups are easily accommodated as well as more intimate groupings.
AMBIENCE/CLIENTELE You feel as if you are stepping into a dusty yet elegant border town ranch. You'll feel right at home, like you are a member of Uncle Julio's extended family. This is a place for families, so bring the kids over and show them the tortilla machine churning out the delicious discs. And like all family gatherings, the room can get pretty lively with conversation, especially when the margaritas are flowing. In summertime, the outdoor patio is the place to enjoy a frosty drink with your amigos.
OTHER ONES 2360 Fountain Square Dr., Lombard, 60148
(630) 705-9260

—Mark Lobo

NEAR WEST SIDE

NEAR WEST SIDE

LITTLE ITALY

Al's Italian Beef
A mean beef!
$$
1079 W. Taylor St., Chicago 60607
(at Carpenter St.)
Phone (312) 226-4017 • Fax (312) 738-1556
www.alsbeef.com

CATEGORY	Italian Fast food
HOURS	Mon-Fri: 9 am Midnight
	Sat: 10 am-Midnight
GETTING THERE	Parking is difficult. Thankfully Al's has a large, free parking lot. If using public transportation, the best bet would be the #38 Ogden/Taylor bus, but the #60 Blue Island/26th, #12 Roosevelt and #8 Halsted run nearby as well.
PAYMENT	$ ATM
POPULAR DISH	The Italian Beef is this joint's most famous meal. They offer it in three sizes: little (four inches), regular (six inches), and big (eight inches).
UNIQUE DISH	For those who aren't feeling too beefy, they offer a pepper sandwich. This is simply sweet bell peppers on an Italian roll, dipped in au jus from the beef—a great substitute for lighter appetites.
DRINKS	A soda fountain, iced tea, ICEEs, shakes, and malts.
SEATING	There are absolutely no seats inside, but there is plenty of standing room and countertop space for those eating on the go. In warmer weather, there are a couple of picnic tables outside.
AMBIENCE/CLIENTELE	All walks of life eat here. This location is primarily for those who want to run in, grab good food, and leave. If you happen to come at a busy hour and have to wait in line to place your order, there is plenty of memorabilia and autographed celebrity photos to admire while waiting.
OTHER ONES	Check the website for more locations!
EXTRA/NOTES	They offer delivery.

—*Jessica Lewis*

ITALIAN BEEF: A TRUE CHICAGO FOOD

Definition of Italian Beef sandwich (for those who do not know)—Italian-style beef is thin-sliced beef served on delicious Italian or French bread seasoned with various Italian herbs and spices, usually oregano and garlic. The sandwich can be dipped or dry. Dipped means just that—the sandwich is dipped in au jus gravy so you have soggy bread. Condiments can include mozzarella cheese, provolone cheese, and hot or mild giardiniera.

Italian Beef sandwiches are to Chicago what Philly Cheesesteaks are to Philadelphia and Po' Boys are to New Orleans. No one agrees on who has the best, but we have our favorites.

NEAR WEST SIDE

THE BEST BEEF PLACES IN CHICAGO:

Portillos—started as small hot dog trailer. Now there are locations all over Chicagoland and the lines consistently wrap around the building at dinnertime.

Mr. Beef on Orleans—Jay Leno eats here while in Chicago. The drippy beefy goodness is hard to pass by.

Wrigley Field—Find a concession that has the Beef sandwiches. They are fantastic, a great value for the money, and fill you up better than a hot dog.

Buona Beef—Buona is great for catering beef for parties.

Al's Beef—rumored to be the original Chicago Italian Beef restaurant.

You can venture into almost any hot dog stand in Chicago and find Italian Beef on the menu. The most common sandwich size is six inches, but many restaurants offer big beefs, or larger sizes. The average price for a regular beef sandwich is under $6. Unless you are a professional, do not attempt to eat an Italian Beef sandwich in the car. They can be messy. Best to eat that hot Italian Beef sandwich quickly at a counter in its paper wrapper.

— Julie Owens

Pompei
Fast, delicious, Italian food for those who don't have the time to wait.
$$
1531 W. Taylor St., Chicago 60607
(at Ashland Ave.)
Phone (312) 421-5179 • Fax (312) 421-8060
www.pompeipizza.com

CATEGORY	Italian Cafeteria
HOURS	Sun: 11 am-9 pm Mon-Sat: 10 am-10 pm
GETTING THERE	Street parking is available with pay boxes along Taylor Street. Pompei is busiest for lunch during the week, so street parking during this time can be a hassle. The Pink Line (Polk stop) is closest; the Blue Line (Racine stop) is a few more blocks away. You can also take the #9 Ashland or #7 Harrison bus.
PAYMENT	Discover, American Express, MasterCard, Visa
POPULAR DISH	Pizza, sold by the square slice, with toppings that are pretty traditional like sausage, pepperoni, spinach, chicken, and olives. Pompei also serves Pizzicotto, its version of a calzone. The pizzicottos are delicious and filling, with a number of untraditional fillings such as steak fajita and BBQ chicken. The cream-based pasta sauces are velvety and rich, sometimes with a heavy hand on the cheese.
UNIQUE DISH	The homemade desserts are popular and delicious, especially the cannoli. Pompei serves a number of traditional Italian treats, including tiramisu, lemon

NEAR WEST SIDE

	cookies, and biscotti. The lemon cookies with white sugar frosting are light, airy, and addictive!
DRINKS	Pompei serves wine and domestic beer, in addition to self-service fountain drinks. You can also get a caffeine jolt from tea and a selection of coffee drinks including cappuccinos, lattes and mochas.
SEATING	Pompei offers plenty of seating to accommodate the large lunch rush during the week. The indoor dining area has about 35 tables and are quickly turned over during the lunch rush—just wait a minute and a table will open up. During the summer, the restaurant opens a fairly large covered outdoor seating area.
AMBIENCE/CLIENTELE	Don't expect formal fine dining at Pompei, just good Italian food served fast. The customers are primarily local businesspeople, students, and hospital workers. The exterior of the building is designed to look like a large Tuscan villa, with a Mediterranean-styled rooftop that definitely stands out on a busy Chicago street. Pompei's interior decor is patterned after an Italian piazza, with columns and rustic painted walls.
OTHER ONES	Check the website for more locations!
EXTRA/NOTES	They offer delivery.

—*Jen Tatro*

Thai Bowl
Get Thai-ed up!
$$
1049 W. Taylor St., Chicago 60607
(at Carpenter St.)
Phone (312) 226-9129 • Fax (312) 226-6314

CATEGORY	Thai Restaurant
HOURS	Daily: 11 am-10 pm
GETTING THERE	Parking is difficult in this neighborhood. Your best bet would be to take the #60 Blue Island/26th or #8 Halsted bus. The Racine Blue Line stop is just a little over half a mile away.
PAYMENT	
POPULAR DISH	Thai Bowl's Pad Thai is some of the best (if not the best) in the city. It is my personal gold standard of comparison when trying out new Thai restaurants. Besides tasting great, the portions are monstrous!
DRINKS	They do not serve alcoholic beverages. Smoothies and teas are extremely delicious. They are made with fresh fruit and come in a wide variety of flavors, with the option to add tapioca.
SEATING	In the cold seasons, the seating here is minimal and pretty compact, but when it is warm they have extra seating on the patio.
AMBIENCE/CLIENTELE	Thai Bowl definitely serves a lot of UIC students, either dining alone or in huge groups. Due to the fact that college students tend to be hungry—A LOT—this place gets pretty crowded and can therefore be slightly uncomfortable. They do have flat screen televisions hanging from random points to distract your attention regarding space. Oh yeah, and great food does the trick, too.
OTHER ONES	2410 N. Lincoln Ave. Chicago 60614, (773) 929-9996

—*Jessica Lewis*

NEAR WEST SIDE

UKRANIAN VILLAGE/WEST TOWN

A Tavola
Hidden in plain sight, A Tavola proves that when your food is this good, the people will find you.
$$$
2148 W. Chicago Ave., Chicago 60622
(between Hoyne Ave. and Leavitt St.)
Phone (773) 276-7567
www.atavolachicago.com

CATEGORY	Italian Restaurant
HOURS	Mon-Thurs: 5:30 pm-10 pm Fri/Sat: 5:30 pm-10:30 pm
GETTING THERE	There is no valet parking, but at least street parking is pretty easy on this stretch of Chicago.
PAYMENT	
POPULAR DISH	If they have it, try beef short ribs served over mushroom risotto. The ribs are fork-tender and the risotto is creamy and rich. Every mouthful is heaven. Another outstanding entree is lamb shank served over wilted baby spinach.
DRINKS	A Tavola has a full bar and a nice wine list. If you're going to have a cocktail here, it's best to order something pretty standard. There is a nice selection of budget-friendly Italian wines by the glass, and a reasonable selection of Italian wines by the bottle. In fact, they have some awesome reds: Amarone and Brunello.
SEATING	A Tavola is small, with room in the main dining room for about 80 people. There is no bar to sit and have a drink if you are waiting for your table. Given the lay of the land, reservations are highly recommended, especially on the weekends. In the summer there is an outdoor patio tucked away in the back of the house. It is very quiet and private, so much so that you could forget all about the big city just outside the front door. There is a room upstairs reserved for large parties and private functions.
AMBIENCE/CLIENTELE	A Tavola is in an old, converted brick house with a high-pitched roof. The house is probably 80 years old or more. While the inside has been converted into a restaurant, outside there is no evidence of a commercial establishment to be found. So inconspicuous is A Tavola that you will probably pass right by it on your first visit. The only sign is the name of the restaurant in frosted glass on one of the front windows. The main dining room is a romantic, dimly lit date place. The tables are a comfortable distance apart so that you don't feel crowded while dining. Because of the low light in the room, you will probably tend to speak in a lower voice. If there is music playing, you won't really notice it.
EXTRA/NOTES	A Tavola's chef/owner Daniel Bocik offers cooking classes on "select" Mondays starting at 6:30 pm. In the class you will prepare a four-course meal and eat it afterward. The classes cost $50 and reservations are required.

—Jim St. Marie

NEAR WEST SIDE

Butterfly Sushi Bar and Thai Cuisine
A good sushi bar, but don't forget about the Thai food!
$$$
1421 W. Chicago Ave., Chicago 60642
(at Noble St.)
Phone (312) 492-9955 • Fax (312) 243-7596
www.butterflysushibar.com

CATEGORY	Thai Restaurant
HOURS	Sun: Noon-11 pm Mon-Thurs: 11 am-10 pm Fri/Sat: 11 am-11 pm
GETTING THERE	There's no valet, and street parking can get tricky, especially on the weekends. During the week you can sometimes find parking on Chicago Ave. You can also take the #66 Chicago or #9 Ashland bus to Chicago Ave., then walk east a few blocks.
PAYMENT	
POPULAR DISH	All of the nigiri sushi is fresh and tasty. There is a large selection of maki rolls and special maki rolls. The Red Dragon is a good roll with spicy shrimp and cucumber wrapped with tuna and avocado. The miso soup never disappoints and is a great starter along with edamame. Another good starter is the deep-fried soft-shell crab with tempura sauce.
UNIQUE DISH	For a non-sushi entree, do yourself a big favor and get the banana duck curry. It is a roasted duck breast, cut into pieces and served with sliced bananas and pineapple, tomatoes, bell pepper and fresh basil leaves. It is simmered in a mild red curry sauce and served with a side of white rice.
DRINKS	Butterfly is BYOB, so not much doin' on the drink menu, but they do offer soft drinks and green tea. The best thing is the Thai iced coffee. If you've never had it, try it! It's espresso mixed with sweetened condensed milk served over ice. It's like a milkshake and is a good dessert substitute. They also offer smoothies in mango, lychee, pineapple, and peach.
SEATING	Butterfly is small and seats fewer than 50 people. There are 14 two-top tables and six seats at the bar. There is a continuous banquette against the left and right walls. Such a small place fills up quickly. On the weekend during prime time you can expect an hour-plus wait and there's really no place to wait.
AMBIENCE/CLIENTELE	The service staff and sushi chefs are all very friendly and courteous. On busy nights they are all in a hurry, but they remember you if you come in more than once. The atmosphere is relaxed and comfortable with a touch of simple elegance. There's no television anywhere and they don't pound you to bits with piped-in music. A younger crowd frequents here. The dress is very casual (jeans and tees) but you won't feel out of place if you show up dressed more formally.
EXTRA/NOTES	Butterfly does a lot of carry-out business. They also deliver, and you can order online from their website. In addition to this, they cater! The Grand Ave. location has some sidewalk seating in the summer.
OTHER ONES	1156 W. Grand Ave., Chicago 60642, (312) 563-5555
EXTRA/NOTES	They offer delivery.

—Jim St. Marie

NEAR WEST SIDE

Chickpea
Mom's homemade cooking, Middle Eastern style.
$
2018 W. Chicago Ave., Chicago 60622
(at Damen Ave.)
Phone (773) 384-9930
www.chickpeaonthego.com

CATEGORY	Middle Eastern Restaurant
HOURS	Daily: 11 am-10 pm
GETTING THERE	Street parking is available, but is limited. Best to call in the order and carry-out. You can also take the #50 Damen, #66 Chicago, or #49 Western bus.
PAYMENT	$
POPULAR DISH	The mussakhkhan (sumac-spiced chicken with pine nuts and onions on olive oil-glazed flatbread) and fasoolya (braised lamb with green beans and tomatoes with rice) are delicious. Plates give smaller portions, but the prices are great so you can afford to order a few dishes.
DRINKS	They offer bottled water, soda, and juice.
SEATING	The restaurant is geared toward being a take-out/delivery establishment, so seating is cozy.
AMBIENCE/CLIENTELE	The dining room is decorated with American movie posters with Arabic writing and warm wall colors that make you feel right at home.

—*Rachael Smith*

Coalfire Pizza
Neapolitan-style pie in Chi-town.
$$$
1321 W. Grand Ave., Chicago 60605
(between Elizabeth St. and Ada St.)
Phone (312) 266-2625 • Fax (312) 226-0354
www.coalfirechicago.com

CATEGORY	Italian/Pizzeria Restaurant
HOURS	Daily: 5 pm-10 pm
GETTING THERE	Street parking is available or you can take the #56 Grand bus. The Blue Line Grand stop is less than half a mile away.
PAYMENT	Discover, American Express, MasterCard, Visa
POPULAR DISH	This is coal-fired pizza in all its glory. These thin crust beauties have conquered the land of the deep dish pie. Coalfire and its 800-degree coal-fired oven turn out the best thin crust pizzas in Chicago and maybe the best east of New Haven.
UNIQUE DISH	The intense heat of the oven creates a coal char that is the signature characteristic of a Coalfire pizza. The pizzas are extremely thin, so much so that they discourage the use of too many toppings on one pie as it disturbs the integrity of the pie. Pizza with hot or sweet sausage, hot Calabrese salami and exquisite cheeses are your best choices. Salads and calzones are also available.
DRINKS	Soft Drinks.
SEATING	Not much, no reservations are accepted, and it's first come first served.

NEAR WEST SIDE

AMBIENCE/CLIENTELE	This is an East Coast joint. The owners hail from New England and the oven is the centerpiece of the show. Coalfire gets so busy during primetime that they can't always handle to-go orders. Come early and don't mind the wait. It is worth it.

—Ian Alexander

De Pasada

Simple, inexpensive Mexican food. A great place for carry-out.

$

1108 N. Ashland Ave., Chicago 60622
(at Thomas St.)
Phone (773) 278-4886

CATEGORY	Mexican Hole-in-the-wall
HOURS	Daily: 9 am-10 pm
GETTING THERE	Street parking on Ashland and neighborhood side streets. If coming by bus, take the #9 Ashland. You can get there via the Blue Line to the Division stop. From Division, it's a couple of blocks south.
PAYMENT	
POPULAR DISH	The Super burrito and Super tacos are the popular dishes here. The burrito is made from a large flour tortilla filed with carne asada (skirt steak), chicken, or barbacoa (shredded spiced beef) wrapped in foil with green salsa to pour over it. The taco is soft-shell served with a choice of carne asada, chicken, barbacoa, lengua (beef tongue), or pastor (pork), topped with lettuce, tomato, cheese, sour cream and guacamole. It too is served wrapped in foil with green salsa.
UNIQUE DISH	A good choice is to try the tacos with a couple different meats. Tongue anyone? For dessert they have flan and tres leches cake.
DRINKS	De Pasada is BYOB. They offer canned sodas, horchata (half-cooked rice pureed in water with cinnamon and honey), bottled water, lemonade, Jarritos (low carbonated fruit-flavored soft drinks), Jumex nectar drinks, and coffee.
SEATING	Located in a small storefront, De Pasada is tiny. With 20 people in it, the place would be packed. There are five tables: two four-tops, two three-tops and one two-top. There are also three fixed stools at the counter.
AMBIENCE/CLIENTELE	This is a very simple, basic place. It is one square room with one window and door. The furniture is old, but sturdy. There is one television mounted in the corner that is always on. They do a lot of take-out so people are in and out quickly. If you are eating in, your food will be prepared quickly and served in a plastic basket or on a plastic plate. De Pasada translates to "along the way." It's a good place to stop in for a quick meal while you're on your way.
EXTRA/NOTES	The Taylor St. location delivers.
OTHER ONES	1519 W. Taylor St., Chicago 60607, (312) 243-6441

—Jim St. Marie

NEAR WEST SIDE

El Barco Mariscos
Authentic Mexican seafood and atmosphere.
$$
1035 N. Ashland Ave., Chicago 60622
(at Cortez St.)
Phone (773) 486-6850
www.elbarcorestaurant.com

CATEGORY	Mexican Restaurant
HOURS	Daily: 10 am-11 pm
GETTING THERE	There is a small free lot just across Cortez. You can usually find a spot close by on Ashland. The neighborhood side streets are not very good options, especially on the weekends. You can also take the #9 Ashland bus or take the Blue Line to Division.
PAYMENT	
POPULAR DISH	The fried whole red snapper. The presentation is unique: it's served upright on a cast iron plate surrounded by rice and vegetables. El Barco also has an extensive offering of appetizers: oysters, shrimp cocktails, grilled octopus, and calamari, four types of ceviche and quesadillas. The shrimp quesadillas are a stand-out.
DRINKS	El Barco serves up a great frozen mango margarita. It comes in a big, wide bowl glass. You can also get a giant Corona beer served on ice in its own little bucket. They have all the typical Mexican beers that you would expect and sangria.
SEATING	El Barco is a nice-sized restaurant that is configured for maximum seating. Most of the tables are four-tops. The chairs look like they came from a border town furniture store. They are antique-looking, sturdy lacquered wood with fabric cushions and straight backs. In the summer there is a nice sidewalk patio that runs the entire length of the building. El Barco has a bar, but there aren't any stools. It really doesn't cater to bar business, so don't expect to go in and park yourself there for drinks and chips.
AMBIENCE/CLIENTELE	This is a fun place. It's colorful, very lively, and festive. The restaurant is in a small stand-alone building that is long and narrow. There are four or five small TVs mounted up high. They all run popular Mexican music videos; think Mexican MTV. It's a popular place so it's usually very busy, even during the day. Most of the patrons and employees are Spanish-speakers.

—*Jim St. Marie*

Flo
Bringing the Southern bowl to the Windy City.
$$
1434 W. Chicago Ave., Chicago 60622
(at Bishop St.)
Phone (312) 243-0477
www.eatatflo.com

CATEGORY	Mexican Restaurant
HOURS	Sun: 9 am-2:30 pm
	Mon-Sat: 8:30 am-10:30 pm
GETTING THERE	No valet, only street parking. Finding a space on Chicago Ave. can be difficult. You can usually find parking not far away on the residential streets to the

NEAR WEST SIDE

south. You can also take the #66 Chicago bus or the #9 Ashland bus to Chicago Ave. If you're coming by train, take the Blue Line to Division.

PAYMENT

POPULAR DISH For breakfast, try Huevos Verdes, a stacked enchilada layered with cheddar cheese and chorizo, ladled with green chile, topped with two fried eggs, and served with home fries and pico de gallo. The shrimp enchiladas with green chile sauce topped with grated jack cheese and served with rice and black beans is delicious, nicely spiced, and a nice portion for lunch. Try the grilled calamari with lemon, garlic, and grilled salsa fresca. The San Juan posole, a hearty stew of hominy with lean pork, red chiles and garlic, accented with a cabbage salad can be an entree or shared appetizer. The grilled salmon is cooked perfectly and the mango salsa complement it well.

UNIQUE DISH It's the bowl dishes that are interesting and worth trying. They have four: San Juan posole, chicken chile verde (chicken breast grilled with spiced yellow squash, red pepper and onion, served with rice in roasted green chile, and jalapeño sauce), Flo bowl (grilled chicken, shrimp, andouille sausage, zucchini, red pepper, and onion with roasted garlic sauce and rice), and carne adovada (a rich and spicy traditional New Mexican stew of lean pork, and red chiles with rice, served with cucumber salad).

DRINKS Flo has a full bar and they can make pretty much whatever you like to drink. They've got all kinds of fun specialty cocktails. For Sunday brunch, the Bloody Marys really hit the spot and are very spicy!

SEATING Flo is not a big place. When you walk in there is a small bar that might seat six people. You can eat at the bar if you like. The front dining room will seat 50–60 people. Most of the tables are two-tops. The back room has seven tables and will seat 20 people. There is no outdoor seating.

AMBIENCE/CLIENTELE Flo is in a building that is probably 100 years old. The space is narrow with exposed brick walls, hardwood floors and high ceilings. The walls also have a lot of folk art on them. You get a sense that the people who own the restaurant designed it and decorated it. Flo is a labor of love. The clientele are neighborhood folks who go there because the food is so good. It's very casual: comfy jeans and tees are fine.

EXTRA/NOTES This place is very popular for Sunday brunch. They offer free delivery on work-site lunch orders of $50 or more and catering for parties and other events.

—Jim St. Marie

Habana Libre
Until they lift the embargo, this is the best thing going for Cuban food.
$$
1440 W. Chicago Ave., Chicago 60642
(at Bishop St.)
Phone (312) 243-3303 • Fax (312) 243-3353

CATEGORY Cuban Restaurant
HOURS Sun: Noon-10 pm
Mon-Thurs: 11 am-10 pm
Fri/Sat: 11 am-11 pm

NEAR WEST SIDE

GETTING THERE Finding parking on Chicago Ave. is never easy. Residential side streets are your best bet. By bus, take the #66 Chicago or the #9 Ashland to Chicago Ave.

PAYMENT

POPULAR DISH For an appetizer, try the empanadas stuffed with chicken, shrimp, and vegetables. But before you go with the safe bet, try one, just one empanada, with Guayaba con Queso (guava and cheese). Also highly recommended is the Ceviche de Camarones.

UNIQUE DISH For the main course, you have to go with the Picada Habana Libre. This is a Cuban sampler dish with marinated chicken breast, shredded beef and pork, white rice, black beans, Puerto Rican rice (brown, seasoned rice with peas), fried plantains, and a green plantain chip. For dessert, try the Flan de Coco. For the more adventurous, go with the Cascos de Guayaba con Queso—slices of poached guava with a firm white cheese.

DRINKS BYOB. You can get authentic Latino soft drinks like Jarrito Mandarina (a Mandarin orange-flavored drink), Materva (a super caffeinated soft drink), and Jupina (pineapple soda). Of course there is Café Cubano (espresso with lots of sugar added). There is also a nice selection of batidos (Cuban-style milkshakes with milk, sweetened condensed milk, sugar, ice, and tropical fruits like mango and papaya

SEATING Habana Libre is a small place that seats maybe 60 or 70 people. There are three booths in the back, but they almost seem like they are not part of the rest of the restaurant.

AMBIENCE/CLIENTELE It is narrow and deep with one door and one window looking out on to Chicago Ave. There are star ornaments hanging from the ceiling. The walls are decorated with Cuban folk art dolls, travel posters for Cuba and a map of Cuba. The staff is very friendly and are happy to describe the menu items in detail. The clientele is diverse: young, old, college students, professionals, Latinos and non. It's very casual and relaxed. This small casual place is packed on the weekend with lines out the door. It's best to call ahead and get a read on the wait.

—Jim St. Marie

La Lucé
Lost in the sauce!
$$
1393 W. Lake St., Chicago 60607
(at Ogden Ave.)
Phone (312) 850-1900 • Fax (312) 421-3819
www.lalucewestloop.com

CATEGORY Italian Restaurant

HOURS Sun: 4 pm-9 pm
Mon-Thurs: 11 am-10 pm
Fri: 5 pm-11 pm

GETTING THERE Large, free parking lot directly across the street and valet on weekends only (free during lunch; $5 during dinner). You can also take the Green Line to Ashland or the #9 Ashland bus.

PAYMENT

POPULAR DISH The lasagna is the best Chicago has to offer, boasting grand taste with grandma nostalgia. What makes

NEAR WEST SIDE

this dish so special? The sauce! The sauce is so full-bodied that it can be a meal in itself. The portions are large enough for two, but are even better served as leftovers. Meals are served with choice of soup, salad, and warm French bread. Bruschetta, calamari, and salads are voluminous and perfect for sharing.

UNIQUE DISH Try the Banana Lucé with caramelized bananas in brown sugar and amaretto served with vanilla ice cream.

DRINKS The bar is comprehensive, featuring svelte California and Italian wines. Bottles are affordable within the $30 price point.

SEATING The dining rooms (upstairs and downstairs) each seat 100 and the bar seats eight. The tables are small but can be combined to suit larger groups. La Lucé is not kid friendly; it's best for couples or large parties.

AMBIENCE/CLIENTELE La Lucé is a quaint, Old-World Italian restaurant tucked away in Chicago's near west side. The restaurant is decked out in rich dark wood and white tablecloths with a very intimate feel. Pre-gamers serve as frequent diners, while others rely on La Lucé for the romance and trustworthy menu selections.

EXTRA/NOTES La Lucé is located within five blocks of the United Center. There are private party and banquet facilities. The second floor may be reserved for private parties as well.

—*Marquis Tucker*

La Pasadita
The best taco dive in Chicago!
$
1140 N. Ashland Ave., Chicago 60622
(at Division St.)
Phone (773) 278-2130
www.pasadita.com

CATEGORY Mexican Dive

HOURS Daily: 9 am-3 am

GETTING THERE It is best to walk or take the Blue Line (Division stop). You can also take the #56 Milwaukee, #9 Ashland or #70 Division bus. There is extremely limited lot space and parking is at your own risk. Metered street parking is available, but getting a spot is tough and this street is popular with the meter police.

PAYMENT

POPULAR DISH Steak tacos and burritos! The tacos and burritos are hot and fresh all the time. The tortillas are always fresh. La Pasadita does not mess around with pitiful iceberg lettuce and bean fillers here. The tacos and burritos are served with some of the best meat, topped with onions and cilantro. This is truly a carnivore's delight. The green salsa is so tasty that it puts all other restaurant salsas to shame.

UNIQUE DISH The most unique items are brain and tongue tacos and burritos.

DRINKS You just can't come here and skip the horchata! It is so flavorful. This horchata (rice water) is the best in the city, served from a trough. They also have soda, Jarritos (Mexican soda), and Mexican beers such as Modelo or Tecate.

SEATING This is not a fancy dining room. You go in, wait in line, order your food, scarf down said food and leave.

NEAR WEST SIDE

Or, order food, go to car, scarf down food and go. There are booths inside, but they are not designed for hanging out. LaPa is about eating.

AMBIENCE/CLIENTELE This is not the place to come of you are seeking ambience. Stepping inside La Pasadita feels like you have entered a taqueria in Mexico. Usually the counterperson speaks English, and she may be the only one. During the day, you encounter lots of city and construction workers getting grub. At night, the clientele runs the gamut from after-dance high-schoolers, drunks and just plain hungry people. The floors have cracked tiles, the counter is beat up and the bathroom is functional but scary. Just don't think about it and you will enjoy your food.

EXTRA/NOTES A crowd tends to appear between 2 am-3 am on weekends, right about when the bars close, making for longer lines. However, they always serve everyone who is in line before their posted 3 am close time. In fact, we have been there well after 3 am and have still gotten food.

OTHER ONES
- 1132 N. Ashland Ave., Chicago 60622, (773) 384-6537
- 1141 N. Ashland Ave., Chicago 60622, (773) 278-0384

—Julie Owens

Mariscos El Veneno
Great Mexican seafood and crazy hot salsa!
$$

1024 N. Ashland Ave., Chicago 60622
(at Cortez St.)
Phone (773) 252-7200

CATEGORY Mexican Restaurant
HOURS Daily: 10 am-10 pm
GETTING THERE No lot and no valet. Street parking can be a little tricky. Take care on the side streets because the residential area parking is permit only. You can also take the Blue Line to Division and take a short walk north on Ashland, or the #56 Milwaukee, #70 Division, or #9 Ashland bus.

PAYMENT
POPULAR DISH The Mojarra a la Diabla. This is a fairly good-sized fish cooked whole—head, fins, it's all there. It's served with fries and salad. I prefer to order several small plates to share, like the Marlin ceviche, Ostiones (oysters), and Cocktel de Pulpo (octopus). But my absolute favorite is the fish tacos. You can spend some bucks on some of the entrees, but my wife and I have had a nice sampling of well-prepared items and gotten out for under $40 while taking some food home with us!

UNIQUE DISH You will be served a corn tortilla topped with Marlin ceviche. Put just a tiny bit of the habañera on it and you start thinking, "if this is the starter, this place is going to be great."

DRINKS This place is BYOB, so show up with a case of your favorite beer and the server will bring you a bucket full of ice to keep it chilled and some plastic mugs.

NEAR WEST SIDE

SEATING	They don't have any glasses for drinking wine, and no one really does. This is more of a beer-drinking place. This cozy little spot has maybe ten tables and will seat about 50 people. There's no bar or waiting area; when it's full, people wait outside.
AMBIENCE/CLIENTELE	Nothing fancy or elegant, and nothing pretentious either. The walls are painted blue. There is a service bar/work area where the servers get soft drinks and rice water that is made to look like a cabana with a thatched roof. Most of the clientele are Spanish-speakers out for a great Mexican seafood dinner. A jukebox plays a mix of Mexican pop and more traditional dance tunes with a polka beat.
OTHER ONES	6651 S. Pulaski Rd., Chicago 60629, (773) 582-5576

—*Jim St. Marie*

May Street Market

A neighborhood spot with a world-class feel, market-fresh fare, and great atmosphere.

$$$

1132 W. Grand Ave., Chicago 60622
(at May St.)
Phone (312) 421-5547 • Fax (312) 421-6316
www.maystreetmarket.com

CATEGORY	American Bistro
HOURS	Mon-Sat: 5 pm-10 pm
GETTING THERE	Valet is offered at dinner. Street parking is usually available, especially on Hubbard St., one block south of Grand. It's also easily accessible via the Blue Line at Grand/Milwaukee or the #65 Grand bus.
PAYMENT	
POPULAR DISH	I highly recommend the Maytag blue cheesecake. It is prepared with a Medjool date and shallot compote and features arugula, spiced pecans, and mandarin sorbet for an unbelievably reasonable price.
UNIQUE DISH	roasted venison leg with pistachio crust, chive spaetzle, spiced carrot puree, and juniper sauce.
DRINKS	They have a full bar with an excellent cocktail list (try the nectar martini) and a superb wine list that is updated often to reflect the seasons.
SEATING	The restaurant has two rooms, The Market room and The Bistro room. The Market room offers white linen service while The Bistro room offers a more cozy and intimate atmosphere.
AMBIENCE/CLIENTELE	This unique restaurant in the quickly-becoming-vibrant neighborhood of West Town is a vacation away from home and looks like it just stepped out of a European postcard. The food is wonderful, the prices are extremely reasonable, the ambience is cozy and inviting, and the patrons are delightful. The manager treats every customer like a guest in his home. Chef Alex is a world-class culinarian who often steps from the kitchen to personally greet his guests. Come here prepared to dine in a truly unique environment and leave with an indelible mark that will make you return time and time again.

—*Nick Monteleone*

NEAR WEST SIDE

Natalino's

There's always room for one more great Italian restaurant.
$$$
1523 W. Chicago Ave., Chicago 60642
(at Armour St.)
Phone (312) 997-3700 • Fax (312) 997-3705
www.natalinoschicago.com

CATEGORY	Italian Restaurant
HOURS	Sun: 4 pm-9 pm
	Tues-Sat: 5 pm-2 am
GETTING THERE	Complimentary valet! There's usually parking close by on the residential side streets. You can also take the #66 Chicago or the #9 Ashland bus (get off at Chicago and walk one block east).
PAYMENT	
POPULAR DISH	The sauteed calamari with cherry peppers and diced tomatoes in oregano, garlic and white wine sauce is one of my favorite dishes. I also like the arugula salad tossed with gorgonzola cheese, pancetta, caramelized pecans, cherry tomatoes and shaved fennel topped with balsamic vinaigrette. The lamb special is perfectly prepared.
UNIQUE DISH	Escarole and beans—white beans and escarole served in chicken broth.
DRINKS	Natalino's has a nice selection of red and white wines by the glass and they are not stingy with their pours. They have the usual line up of beers with Peroni and Stella on tap. They also have the obligatory specialty martinis. The bar has a good stock of scotches, vodkas, cognacs, and liqueurs. One thing I like when I'm in an Italian restaurant is dark Sambucca, and Nat's has it covered.
SEATING	The dining room is what you would expect in a nice restaurant; acceptably comfortable chairs, white tablecloths and napkins. The room is a good size and you don't feel crowded. Servers don't have to bump into your chair every time they pass. This has got to be one of the best bars in town. It's a deep bar with plenty of room if you want to eat there.
AMBIENCE/CLIENTELE	There is a good mix of people here from all ages and walks of life. There are a few windows with shades so you are never aware of anything going on outside, and you kind of have the feeling that you're in a private room. If I wanted to take a date out for a memorable evening, this place would definitely make my short list.

—*Jim St. Marie*

Old Oak Tap

Old Oak Tap—a really nice place that should do well.
$$
2109 W. Chicago Ave., Chicago 60622
(at Hoyne Ave.)
Phone (773) 772-0406 • Fax (773) 772-0407
www.theoldoaktap.com

CATEGORY	American Restaurant
HOURS	Sun: 11 am-3 am
	Tues-Fri: 11 am-2 am
	Mon: 5pm-2 am

NEAR WEST SIDE

GETTING THERE Metered street parking on Chicago Ave. and free parking on the side streets. If you want to bus it, take the #66 Chicago, #50 Damen or #70 Division. There's no train or subway close by.

PAYMENT

POPULAR DISH This place is perfect for sharing a selection of small plates. The Chinese five-spice pork belly sandwich was good, but what I really liked were the mashed potatoes that I got for my side dish.

UNIQUE DISH Try the Baja-style, lightly seasoned beer batter on firm white fish. They serve them in corn tortillas with cabbage, pico de gallo, and spicy aioli. Aioli is traditionally a sauce made from garlic and olive oil that looks and acts like mayonnaise. They serve you three of them so if you're sharing you'll want to take that third one for yourself. Another great dish is the roasted beet salad with goat cheese, walnuts and spinach topped with truffle vinaigrette.

DRINKS This is a beer place. They have plenty of excellent microbrews in the bottle and on tap and the right glass to serve them in. Delerium Tremens Belgian Golden Ale is one worth trying. I also like the Maudite Red Ale from Canada. They've got the bases covered with four white and four red wines by the glass, a respectable bottle offering, and six bottle offerings. Of course, there is the ubiquitous martini menu.

SEATING It's got very high ceilings that give it a spacious feeling. The tables in the dining area are all two-tops. It doesn't matter how many people you have in your party, they will just put as many of those two-tops together as they have to. The bar area seems a little small because this place gets busy and you feel cramped when it starts jumping.

AMBIENCE/CLIENTELE This is a well-financed, tastefully designed, hip, comfy room. It is divided by elevation and low partitions. They play the typical piped-in bar music of the day, but it's not so loud that you can't hear your date going on at length about how good the fish tacos are.

—Jim St. Marie

Shokolad Pastry & Cafe

Ukraine with love! A charming café and bakery preparing wonderful homemade pastries and baked goods.

$

2524 W. Chicago Ave., Chicago 60622
(at Maplewood Ave.)
Phone (773) 276-6402 • Fax (773) 276-6410

CATEGORY World/International Bakery

HOURS Sun: 10 am-7 pm
Tues-Thurs: 8 am-7 pm
Fri/Sat: 9 am-7 pm

GETTING THERE Street parking is available on Chicago Ave. or side streets. You can also take the #49 Western, #52 Kedzie/California or CX49 Western Express bus.

PAYMENT

POPULAR DISH For breakfast, go with the Ukrainian sweet cheese crepes—perfectly made crepes with sweetened farmer's cheese filling and berry sauce. Borscht, a beautiful crimson-colored beet soup served with a dollop of sour cream and homemade rolls with garlic sauce, is

NEAR WEST SIDE

	always available. There is also a very nice mixed green salad with pears, apples, dried cherries, and caramelized pecans topped with crumbled bleu cheese.
UNIQUE DISH	For an entree, you have to try the varenyky, Ukrainian pirogues. They offer them stuffed with potato and cheese or meat. If you have a sweet tooth, try the cherry or blueberry. Another interesting entree is the Ukrainian-style pork chop—a boneless slice of pork pounded flat, breaded, and fried, served with a generous helping of slaw and mashed potatoes.
DRINKS	A reach-in refrigerator has a selection of juices and bottled water. They serve very nice coffee, espresso, and cappuccino served in a large, deep cup.
SEATING	Shokolad has plenty of room with a dozen or so two-tops and four stools at the coffee bar. Thirty people would fill every seat but it wouldn't feel cramped.
AMBIENCE/CLIENTELE	Ukrainian is spoken here. You'll hear a lot of it as people sit and chat over coffee and pastries, read, or just marvel over the delicious, picture-perfect baked goodies. Service is friendly and enthusiastic. They're happy to make recommendations and explain what is what.
EXTRA/NOTES	There is a very reasonably priced catering menu featuring several sandwiches along with meat, seafood, and vegetarian selections. And of course, there are the homemade pastries.

—*Jim St. Marie*

Tecalitlan

Hard to say, easy to swallow.
$
1814 W. Chicago Ave., Chicago 60622
(at Wood St.)
Phone (773) 384-4285 • Fax (773) 384-5347
www.tecalitlanrestaurant.net

CATEGORY	Mexican Restaurant
HOURS	Mon-Thurs: 10 am-Midnight Fri-Sun: 10 am-2 am
GETTING THERE	Tecalitlan has a free adjacent parking lot. It's just a few blocks from the Division stop of the Blue Line. You can also take the #66 Chicago or #9 Ashland bus.
PAYMENT	ATM
POPULAR DISH	The enchiladas suizas dinner plate: four enchiladas with your choice of filling (cheese, chicken, ground beef or steak), covered in melted cheese, accompanied by refried beans (also covered in cheese) and yellow rice. Another tasty entree is the taco salad. This is basically a taco in salad form—lettuce, tomatoes, onions, beans, cheese, guacamole, sour cream, and your choice of meat served in an edible bowl made from a flour tortilla.
UNIQUE DISH	Try the lengua ranchero (beef tongue in ranchero sauce) or lengua en salsa verde (beef tongue in green sauce).
DRINKS	This place is known for its wonderful margaritas. They offer frozen or shaken margaritas in lime, strawberry, mango, and more. Best of all, there are drink specials.
SEATING	Seating here is plentiful, and if by any chance they run out of available seats, there usually is not more than

NEAR WEST SIDE

a ten-minute wait, as their service is highly efficient. Though any seat is fine, the back of the restaurant is reminiscent of some cozy patio in Mexico, equipped with tons of plants and a magnificent overhead mural of a cloudy sky.

AMBIENCE/CLIENTELE Weekdays aren't extremely busy, but on weeknights there will be lots of professionals mingling and gathering for drinks. During the day on weekends, expect to see families, and once night hits, the drinking crowd and couples pour in. Occasionally the jukebox will blast music, either randomly or by request. Overall, it is a very comfortable, welcoming atmosphere.

OTHER ONES Hacienda Tecalitlan, 820 N. Ashland Ave., Chicago 60622, (312) 243-1166

—*Jessica Lewis*

Village Pizza

Big Chicago-style pizza. Gigantic Chicago-style attitude.

$$

2356 W. Chicago Ave., Chicago 60622
(at Western Ave.)
Phone (773) 235-2900

CATEGORY Italian/Pizzeria Restaurant
HOURS Daily: 11 am-5 pm
GETTING THERE There is metered street parking. Make sure you don't park in the Burger King parking lot; they will tow. You can also take the #66 Chicago or #49 Western bus.
PAYMENT
POPULAR DISH Try the Jumbo Slice—a massive, flavorful, fresh slice of pizza—and a drink. This is probably the best "by the slice" place in Chicago. It is regular old pizza with little to no flair, but what sets it apart is that everything is extremely fresh and flavorful, and each pizza receives a heavy dose of extra-zesty marinara sauce.
DRINKS A soda fountain includes eight different beverage options.
SEATING Six tiny tables. Depending on how drunk you are, don't be surprised if you end up sharing one with a stranger. During the summer months, there are a couple of outdoor tables.
AMBIENCE/CLIENTELE I could write an entire book about what happens at this place. The owner, a man named John, has even said that he cares about his pizza as much as he does his own children. With such a kind-hearted take on the pizza business, you'd expect someone along the lines of Willy Wonka. You'd be wrong. Prepare to be judged, scowled at, and probably even yelled at while ordering your Jumbo Slice.
EXTRA/NOTES The gentleman who owns Village goes by the name John Bacci because he used to be the head chef at Bacci Pizzeria (which is located across the street). Word on the street says that the Bacci family wanted to change the famous recipe and John wasn't having any of that, so he bailed, opened up shop across the street, and started selling a better pizza for less.

—*Luca Cimarusti*

73

NEAR SOUTH SIDE

NEAR SOUTH SIDE

BRIDGEPORT

Ed's Potsticker House
Potsticker paradise.
$$
3139 S. Halsted St., Chicago 60608
(at 31st St.)
Phone (312) 326-6898

CATEGORY	Chinese Restaurant
HOURS	Daily: 11 am-10 pm
GETTING THERE	Take the #8 Halsted bus all the way or hop on the Orange Line towards Midway, exit at Halsted, and take the Halsted bus the remaining four blocks.
PAYMENT	
POPULAR DISH	People come for the house special potstickers, which aren't the normal crescent shaped dumplings, but long and slender like a cigar.
UNIQUE DISH	The Shanghai style pork dumplings, or soup dumplings, as they're known. Place the dumpling in a spoon, bite the top off and drizzle in some vinegar. Slurp out the soup/vinegar mixture, then plop the remaining pork-filled dumpling in your mouth and enjoy. While many restaurants offer this specialty, most serve a dried-up version. The amount of broth contained within the dumpling is the measure of quality.
DRINKS	Bring your favorite beer or wine. Every table receives hot tea.
SEATING	The booths along the wall are cute and inviting, however, they're a bit cramped. Take a table instead.
AMBIENCE/CLIENTELE	The neighborhood is a bit neglected and the interior of the restaurant isn't much of an improvement, but with this said, people don't come for the atmosphere, they come for the dumplings.

—*Matthew Sove*

CHINATOWN

Lao Szechuan
Triple tasty—authentic Chinese in a town of sweet and sour chicken.
$$
2172 S. Archer Ave., Chicago 60616
(at Cermak Rd.)
Phone (312) 326-5040 • Fax (312) 326-5018

CATEGORY	Chinese Restaurant
HOURS	Daily: 11:30 am-Midnight
GETTING THERE	Metered parking is available. The Red Line stops at Chinatown. You can also take the #62 Archer, #21 Cermak, or #29 State Street bus.
PAYMENT	
POPULAR DISH	If you crave heat, try the boiled beef in spicy Szechuan sauce, house special spicy sole fish filet, or, for a nicely balanced spicy/sweet blend, Tony's chicken. If you prefer milder eats, you'll find a wide selection

NEAR SOUTH SIDE

of traditional Szechuan dishes that use little or no hot spices. A fun option for two or more diners is the Szechuan hotpot, a metal pot of simmering stock (your choice of flavor and spiciness) on a burner in the middle of the table. Ingredients are then placed into the pot and cooked at the table. Typical hotpot offerings include seafood, meat, vegetables, and mushrooms. This option is particularly popular during winter months.

UNIQUE DISH Chef Tony Hu's primary concern is the authenticity of ingredients. He goes so far as to import spices and seasonings directly from China. This attention to detail and quality has established Lao Szechuan's reputation for authentic, awe-inspiring flavors.

DRINKS Limited beer and wine. Be cautious of the "Chinese wines," which are served in shot glasses, high in alcohol (40%+) and intensely flavored (in a bad way). The flavor will stick with you all night, no exaggeration.

SEATING The table space is fairly limited, especially for such a popular restaurant. Expect to wait at least ten minutes. If you need sustenance ASAP, try one of Tony's other restaurants: Lao Beijing (2138 S. Archer Ave.) or Lao Shanghai (2163 S. China Pl.), but only if you really can't wait.

AMBIENCE/CLIENTELE The waiters are efficient and rude, as should be expected in any good Chinese restaurant. They'll only approach you if you ask for attention, so don't shy away from raising your hand. The dining room looks well-worn and slightly dirty, which is the standard in Chinatown. Seating is tight and the volume loud, but all is forgotten after the first bite. The clientele is more diverse than in any other restaurant in Chinatown.

OTHER ONES 1331 W. Ogden Ave. Downers Grove 60515, (630) 663-0303

—*Matthew Sove*

The Noodle

Pho sho'—a delicious way to get souped up.
$$

2236 S. Wentworth Ave., Chicago 60689
(at 22nd Place)
Phone (312) 674-1168

CATEGORY Vietnamese Diner
HOURS Daily: 10 am-11 pm
GETTING THERE Street parking is tough, but available. It's a short walk from the Cermak/Chinatown stop on the Red Line. You can also take the #21 Cermak or #62 Archer bus.
PAYMENT
POPULAR DISH Complex, but familiar with a thin broth and a variety of fresh ingredients, delicately spiced pho is enough to bring a discerning diner back for repeat visits. There are a variety of ways that one can order pho, including vegetarian, seafood, and mixed meats (with tripe). The beef broth brims with rice noodles. Bean sprouts and fresh mint leaves are added to taste at the table. For the less daring, there is brisket, lean flank and beef.
UNIQUE DISH There are a few other items on the menu such as spring rolls (delicious) and a few rice dishes, but people generally congregate here for the pho.

NEAR SOUTH SIDE

DRINKS The bubble tea is a nice icy touch to go with the soup. The thick, cold, sweet drink with tapioca pearls on the bottom is a favorite especially when it is made with fresh fruit. Tea at The Noodle is also very good. Jasmine tea seems to cleanse the palate more, which accentuates the cinnamon in the pho broth.

SEATING There is plenty of room for families or for groups as well as smaller tables for singles or doubles. The Noodle feels like a diner where you can just sit back, relax, and enjoy conversation and hot tea with a great picture window looking out onto Wentworth. There is a wall-to-wall bench facing tables that hold the necessary accoutrements for eating pho, including decorative ceramic spoons.

AMBIENCE/CLIENTELE The Noodle is a place that locals go to eat. The price makes it right for younger diners to come in for lunch. The atmosphere is relaxed and homey like a '50s diner minus the poodle clock. The huge picture window that faces out onto Wentworth fills the room with light and affords an impeccable view of the city as it rolls past like a silent picture. Young and old, students from the University of Illinois, and the occasional Chicago police officer can be found enjoying their steaming soup and drinking bubble tea. It is down to earth and very clean.

—*Paul Barile*

CHINATOWN CONFIDENTIAL

The main reason to visit Chinatown is the food: barbecue pork, pot stickers, sweet and sour chicken, or whatever your heart desires. Avoid the lure of the shops and restaurants on the outskirts of Chinatown. Go straight to Chinatown Square, a two-level retail center that features a varied selection of colorful shops and dining. If you're visiting during dinner hours, shop before you eat since the stores close early and the meal should take a long time, especially if you go with a group of friends or family (which allows you to taste more food). Remember, even though you're in Chicago, the culture is Chinese. Don't expect the server to wait on you. If you need something, ask. When ready to order, raise your hand and call someone over.

If you've only got one meal in Chinatown you mut go to **Lao Sze Chuan** located at the far west end of the Square. Chef/Owner Tony Hu cooks up gourmet cuisine with authentic, imported ingredients. Expect a wait, but the food is well worth it. As the name suggests, they serve primarily Szechuan province cuisine, which is known for its spiciness. Try Tony's chicken (fried morsels of chicken in a sweet and spicy batter), sole fish filet in chili bean sauce, or the Hot Pot. If you can't stand the heat, order one of the plentiful non-spicy options.

2172 S. Archer Ave., Chicago 60616, (312) 326-5040, laoszechuan.com

Chef Hu owns two other restaurants, **Lao Shanghai** and **Lao Beijing**, also located in the Square, which are great alternatives if

NEAR SOUTH SIDE

Lao Sze Chuan is too busy.

Lao Shanghai—2163 S China Pl., Chicago 60616

Lao Beijing—2138 S. Archer Ave., Chicago 60616, (312) 881-0168, tonygourmetgroup.com

After you've eaten way too much, visit the plaza at the center of the square to walk off the extra calories. Here you'll find the twelve animals of the zodiac cast in bronze. If you don't know your animal, have no fear: each statue lists the associated years. Maybe now you'll find the answer to why a person born in 1960 never smiles and always has something negative to say.

If you're planning to come to town near the end of January or the beginning of February, save your visit for Chinese New Year (the date varies so check the Chinatown website for details: www.chinatownchicago.org). Expect fireworks, parades, dragon boat races and "lucky money" in red envelopes.

—*Matthew Sove*

Phoenix Restaurant

Phoenix dim sum...prepare yourself for a blissful food coma.

$$

2131 S. Archer Ave., Chicago 60616
(at Wentworth Ave.)
Phone (312) 328-0848 • Fax (312) 328-0850
www.chinatownphoenix.com

- **CATEGORY** Chinese Restaurant
- **HOURS** Sun: 8 am-3 pm, 5 pm-9:30 pm
 Mon-Thurs: 9 am-3 pm, 5 pm-9:30 pm
 Fri: 9 am-3 pm, 5 pm-10:30 pm
 Sat: 8 am-3 pm, 5 pm-9:30 pm
- **GETTING THERE** Two lots are located on Wentworth and parking can be validated for a discount. There is a small metered lot directly across the street. Metered street parking can be found along Archer, but it's difficult to find a spot. The Red Line Cermak/Chinatown stop is a short walk away. You can also take the #62 Archer bus.
- **PAYMENT**
- **POPULAR DISH** Phoenix's bao (small buns served either steamed or pan-fried) are legendary. With both savory and sweet options, these buns are stuffed with almost anything imaginable—barbeque pork, chicken, sweet custard and taro root are just a few. Traditional Chinese congee (thick rice porridge with generous chunks of meat and green onion) is fantastically done. A sure pleaser is the chicken and rice wrapped in either a lotus leaf or bamboo leaf. Save room for dessert treats such as the tiny custard tarts and airy, deep-fried sesame balls stuffed with sweet red bean paste. Most intriguing is the giant wooden barrel of dau fu fa, silken tofu served in a sweet ginger-flavored syrup.
- **UNIQUE DISH** Dim sum is served the traditional Chinese way, with sweet Chinese ladies pushing around carts of steamer baskets. Dishes are less saucy, more savory, and of better quality than most Chinese restaurants around. Service is friendly and very attentive. Food can be prepared mild, medium or hot at customer request.

NEAR SOUTH SIDE

DRINKS Phoenix offers a full bar and a selection of Chinese beers and wine. A quick tip: get the chrysanthemum tea. It has a great delicate flavor and better health benefits than the jasmine tea that is automatically served to each table.

SEATING Phoenix is split into three large rooms that can be blocked off for private events. Most are large round tables with ample seating for large groups. Seating is plentiful, but dim sum is very popular on weekends. It's best to arrive before 11 am to ensure you get a table right away.

AMBIENCE/CLIENTELE Phoenix has a very different feel during their dim sum hours than their dinner hours. Dim sum is often crowded and buzzing with activity and becomes a maze of tables, food carts, tiny Chinese children underfoot and the occasional wide-eyed tourist group. Dinners are more quiet and refined.

—Denise Peñacerrada

Seven Treasures Cantonese Cuisine
Authentic flavorful fare on a budget.
$$
2312 S. Wentworth Ave., Chicago 60616
(between 23rd St. and 23rd Pl.)
Phone (312) 225-2668
www.seventreasures.com

CATEGORY Chinese Hole-in-the-wall
HOURS Sun-Thurs: 11 am-2 am
Fri/Sat: 11 am-2:30 am
GETTING THERE There's metered parking on Wentworth and on the side streets. There's a public parking garage by the bank across the street and a pay lot northeast. Easily accessible by the Red Line (which runs into the wee hours of the night and frequently) to the Cermak/Chinatown stop. You can also take the #62 Archer, #44 Wallace/Racine or #29 State bus.

PAYMENT
POPULAR DISH Order the braised noodles (broiled egg noodles with oyster sauce) and steamed rice plates. These run the gamut from the familiar (BBQ pork) to the more exotic (roasted duck with beef tripe). Try them with shrimp dumplings—Seven Treasures has some of the tastiest, heartiest dumplings around for an incredible budget-friendly price. Or try the rice plate with BBQ pork and fried eggs over rice (aka the 554). For a couple bucks more, add Chinese broccoli and you've got a complete, satisfying meal. Their wonton soup is a specialty.

UNIQUE DISH Barbecue offerings range from traditional meats such as duck, pork and chicken to more adventurous offerings such as tongue, intestine, duck feet and pig ear. There's also a healthy selection of vegetarian dishes such as stir-fried lettuce with garlic sauce and spinach with bean cheese (bean curd, like a saltier tofu, not actually cheese). Even the side dishes take a walk on the wild side—jellyfish anyone?

DRINKS Seven Treasures offer a wide range of bubble drinks (with tapioca pearls) and smoothies (just milk and fruit). They also offers many hot teas (a fresh pot of

NEAR SOUTH SIDE

hot tea comes with every meal) and cold drinks (there are many authentic drinks to choose from, including Hong Kong-style milk tea and ice with red beans and milk).

SEATING There's hardly ever a wait at Seven Treasures, where the dining room is a no-frills, nondescript large space with plenty of light. The busiest time will probably be late at night when hungry diners flock after a night of drinking or maybe fueling up before heading out to a 4 am bar.

AMBIENCE/CLIENTELE It is a hole-in-the-wall, but any knowledgeable food lover knows that hole-in-the-wall equals authentic, affordable food. Customers range from large groups of friends to solo diners to couples to families. The ambience is on the extremely casual side, but you can't beat the experience of eating authentic Chinese food in an unassuming joint for such a low price.

—*Dorothy Hernandez*

PILSEN

Carnitas Urupan
Looking for the best carnitas in Chicago? Look no further!
$$
1725 W. 18th St., Chicago 60608
(at Paulina St.)
Phone (312) 226-2654

CATEGORY Mexican Restaurant
HOURS Daily: 7 am-8:30 pm
GETTING THERE Hoo boy, good luck. Metered street parking is the only option available for drivers. Since the neighborhood (18th Street specifically) is very busy, parking isn't always as available as one would hope. The good news is that Carnitas Urupan is mere steps west of the 18th Street stop of the Pink Line. You can also take the #9 Ashland, #50 Damen or #18 bus.

PAYMENT $
POPULAR DISH It's rumored that Carnitas Urupan is the oldest carnitas joint in Chicago. And it's quite possible that rumor is true. Either way, Carnitas Urupan serves the best slow-roasted pork in the city. It's pretty much a traditional taqueria and very traditional in its service (which is amazingly efficient). The owners are friendly (offering a sample of the fare if you're waiting) and the place is clean and quirky with pig-centric art on the walls. The carnitas are served with salsa, warm corn tortillas, and escabeche (pickled jalapenos, onions, and carrots, yum!).

UNIQUE DISH Carnitas Urupan also serves menudo (tripe) and cesos (cow brain) empanadas.
DRINKS There is no alcohol served, but the selection of Jarritos is comprehensive!
SEATING Taqueria-style. The seating varies between two-top and four-top booths.

AMBIENCE/CLIENTELE	Carnitas Urupan is what I imagine walking into a Mexico City carnitas joint would feel like. The walls are tiled and decorated with paintings and pictures of the source of their carnitas, and the place always feels busy even if you're the only person there. The staff is always cleaning, cooking or prepping more carnitas. As you eat, giant bowls of hot carnitas are brought from the kitchen all the way through the restaurant to the front where they're chopped and packed for take-out. It's a great advertisement!
EXTRA/NOTES	Take-out is an option; there is always a line of folks at the front of the restaurant waiting to take home some delicious pork. You can also order by the pound, and one pound is enough for two people to share.

—*Clifford Etters*

La Cebollita

La Cebollita: not your typical McMexican joint!

$$

1807 S. Ashland Ave., Chicago 60608
(at 18th St.)
Phone (312) 492-8443

CATEGORY	Mexican Restaurant
HOURS	Daily: 8 am-10 pm
GETTING THERE	Like much of Chicago, parking in Pilsen is mostly metered. Unlike other parts of the city, however, it is not as hellish. Alternatively, the best way to get there is via the Pink Line to the 18th Street stop or the #9 Ashland, #60 Blue Island/26th or #21 Cermak bus.
PAYMENT	
POPULAR DISH	La Cebollita serves up fantastic Mexican-style breakfasts that include Huevos Salseros—eggs smothered in three of their delicious salsas: rancheros, green, and chipotle.
DRINKS	La Cebollita is a BYOB joint, but before you bring in a case of Corona, try the restaurant's amazing drinks. La Cebollita does a mean champurrado, a chocolate-based cornmeal drink that is thick and served hot. It goes great with the tamales! They also have an extensive selection of Jarritos (Mexican pop), in flavors including tamarind and lime, which are my drinks of choice. If you are in the mood for a punch of Vitamin C, order the freshly squeezed orange juice.
SEATING	This restaurant has plenty of seating for any size party and is great even if you are grabbing a bite by yourself. If you love people-watching, then grab a window table that will afford you a great view of the two busiest streets in Pilsen.
AMBIENCE/CLIENTELE	La Cebollita has many followers (both locals and non-Pilsenites alike) that crowd into this place for some amazing, and amazingly cheap, food. If you visit enough, the servers will know your name and what you regularly order. The locals engrossed in their tamales will pick their heads up from their plates and grunt a hello in your direction. Overall, this is a place that comes as close to a "Cheers" atmosphere as you will find on this side of Chicago.

—*Devin Kidner*

NEAR SOUTH SIDE

Nuevo León
Authentic Mexican food, vibrant atmosphere, and BYOB!
$$
1515 W. 18th St., Chicago 60608
(at Ashland Ave.)
Phone (312) 421-1517 • Fax (312) 563-0828
www.nuevoleonrestaurant.com

CATEGORY	Mexican Restaurant
HOURS	Daily: 7 am-Midnight
GETTING THERE	Street parking is readily available and free on the side streets. Also, the #9 Ashland bus lets off on the corner of 18th St., and the Pink Line (18th St. stop) is only a few blocks west.
PAYMENT	$ ATM
POPULAR DISH	The spectrum of popular dishes at Nuevo León includes everything from carne asada (a favorite among local diners) to the Filete Nuevo León (the signature steak dish of the restaurant). Try the Fajitas de Camaron al Mojo de Ajo—shrimp fajitas grilled with garlic, onions, green pepper and tomatoes—served with rice and guacamole. The visual display alone is colorful and exuberant. The Bistec a la Mexicana is, if less visually stimulating, still quite delicious. Skirt steak simmered in the house-recipe salsa and served with refried beans and rice makes for a very brown dish, but the steak is tender and the salsa has just the right degree of heat.
DRINKS	Nuevo León does not serve alcohol, but they are, however, BYOB and they have quite a selection of both American and Mexican sodas.
SEATING	The restaurant is a fairly small facility and seating is comfortable (you're not packed like sardines in a can.) The seating area is very open with mostly tables and a few booths. If you are looking for a romantic date spot, there's not much privacy. Since the restaurant is a popular spot in the area, there is likely to be a wait, especially on weekends.
AMBIENCE/CLIENTELE	The atmosphere at Nuevo León is, in a word, vibrant. Orange, red, and gold hues permeate throughout. Strategies of fountains, flowers, and "windows" overlooking what I assume is Nuevo León, Mexico, decorate the walls. A jukebox continually and loudly pulses out popular Spanish music and the evident popularity of the place among community members (parents with their kids, a few younger couples) lend a very happy, homey, feel.

—Norine Mulry

Skylark
Chicago's gourmet dive bar.
$$
2149 S. Halsted St., Chicago 60608
(at Cermak Rd.)
Phone (312) 948-5275

CATEGORY	American Restaurant
HOURS	Sun-Thurs: 4 pm-2 am Fri/Sat: 4 pm-3 am
GETTING THERE	Street parking on Halsted St. is generally available. There is a bike rack right out in front. If coming by

NEAR SOUTH SIDE

public transportation, the #21 Cermak and #8 Halsted buses are convenient and can be accessed from both the Blue Line (Halsted stop) and the Red Line (Cermak stop).

PAYMENT	$ ATM
POPULAR DISH	I highly recommend the pulled pork sandwich and the macaroni and cheese as a side dish.
UNIQUE DISH	Skylark's claim to fame is the infamous Tots and Sauce appetizer—a huge basket of tater tots served with three homemade sauces. How can you go wrong?
DRINKS	Skylark has a wonderful beer selection and they charge a low price for their microbrews that hail from local breweries. They make pretty mean cocktails that are also rather inexpensive.
SEATING	During the weekend hours, seating can be scarce. It is a pretty cozy room with adequate table space, but it draws lots of people on weekends after about 9 pm.
AMBIENCE/CLIENTELE	Skylark is a cozy bar for neighborhood regulars and early dinner patrons, but it gets packed on weekends with Wicker Park hipsters who found out the owners also own Rainbo.
EXTRA/NOTES	One thing about Skylark is that the music is always great! On Monday nights, there is a free live music series and on other days, the bartenders and owners flood the bar with their music choices played on vinyl.

—*Renee Ochs*

NORTH SIDE

NORTH SIDE

ANDERSONVILLE/EDGEWATER

Ann Sather
You won't have enough room for breakfast!
$$
5207 N. Clark St., Chicago 60640
(at Foster Ave.)
Phone (773) 271-6677 • Fax (773) 271-1149
www.annsather.com

CATEGORY	Swedish Restaurant
HOURS	Mon-Fri: 7 am-2 pm
	Sat/Sun: 7 am-4 pm
GETTING THERE	There is metered street parking on Clark and Foster. The surrounding neighborhood is permit free, so it's usually not too hard to find parking. You can also take the #92 Foster, #22 Clark, or #50 Damen bus.
PAYMENT	
POPULAR DISH	Ann Sather is the perfect place to get that breakfast, brunch, or lunch. Swedish pancakes with lingonberries, Swedish meatballs, and three egg omelettes all are good. I find myself always getting the crab cake or smoked salmon benedict. They are well known for cinnamon rolls, which is a side dish, but could be a meal in itself. You'll get two side dishes with any egg entree, but make sure you split those cinnamon rolls.
UNIQUE DISH	Try the Swedish sampler (roasted duck with lingonberry glaze, Swedish meatball, Swedish potato sausage, buttered noodles, sauerkraut and Swedish brown beans) or the Swedish Breakfast Sampler (one Swedish pancake, one Swedish meatball, Swedish potato sausage and one egg).
DRINKS	Orange and apple juices, superior coffee.
SEATING	There is a lot of seating downstairs and on the weekends the upstairs is open, which seats 85. I've rarely had to wait to be seated. There are so many tables that even if there is a line, you won't have to wait long, and there is usually cake or coffee available if you do.
AMBIENCE/CLIENTELE	You'll find the place bustling in the morning on the weekend, with lots of neighborhood people, families, and locals trying to cure that hangover or just getting a great meal to start the weekend. Everybody loves the food, so you get a pretty good cross-section of people from the surrounding neighborhoods.

—*Travis Lee Wiggins*

Ethiopian Diamond
If you're looking for something different, try Ethiopian Diamond.
$$
6120 N. Broadway St., Chicago 60660
(between Hood Ave. and Glenlake Ave.)
Phone (773) 338-6100
www.ethiopiandiamondcuisine.com

CATEGORY	Ethiopian Restaurant
HOURS	Sun-Thurs: Noon-10:30 pm
	Fri/Sat: Noon-11 pm
GETTING THERE	There are a lot of metered spots. Parking during the week is easy, but Friday and Saturday nights are a

NORTH SIDE

tough. The #36 Broadway bus runs in front. The Red Line Granville stop is only about a block northeast.

PAYMENT

POPULAR DISH A mix of injera, watt, and tibs. Injera is the traditional Ethiopian sour bread on which most of the food is served. Watt is an Ethiopian method of slow-stewing or braising meat (typically beef, chicken or lamb) and vegetables, and can vary from mild to mouth-scorching hot. Tibs is cubed meat seasoned and marinated in garlic, then sautéed with onions and vegetables. There are several salad/vegetable dishes that aren't to be missed, like the lentil salad (yemisir azifa) and the collard greens (gomen).

UNIQUE DISH Order the whole tilapia (assa tibs). It comes to the table piping hot and scored along the flank, making it easy to pluck right off the bone. Perfectly seasoned, it practically melts in your mouth.

DRINKS Beer and wine with a very nice selection of premium ales like Xingu (Brazil), Hakim (Ethiopia), Castle (South Africa) and Tusker (Kenya). I recommend trying the Tej, which is an Ethiopian honey wine. Also, Ethiopian Diamond serves Buna, which is fresh-ground Ethiopian-grown coffee served in a clay pot.

SEATING The seating at Ethiopian Diamond is made up of mostly small tables that can be pushed together for larger groups. As it is pretty popular, you may find yourself sitting closer to another dinner party.

AMBIENCE/CLIENTELE Nothing too special, but it doesn't take away from the experience either. I've always had very cheerful, helpful service each time I've been here.

EXTRA/NOTES Occasionally there is live jazz playing, and the place can get very crowded. To avoid looking too gauche, when eating with you fingers/hands, don't use your left hand as it is a breach of etiquette.

—*Clifford Etters*

Flourish

Your surrogate mother on the north side.
$
1138 W. Bryn Mawr Ave., Alden 60001
(between Broadway St. and Winthrop Ave.)
Phone (773) 271-2253 • Fax (773) 271-2949
www.flourishbakerycafe.com

CATEGORY American Bakery

HOURS Mon-Sat 7:30 am-9 pm
Sun 8 am-6 pm

GETTING THERE Take the Red Line to the Bryn Mawr stop. You can also take the #36 Broadway, #151 Sheridan, #92 Foster or #146 Inner Drive/Michigan Express bus. Biking is always an option, and driving isn't a huge hassle.

PAYMENT

POPULAR DISH The featured popover changes daily and gets you off to an oh-so-good start. Piping hot and filled with cheese and meat, it's a tasty treat that can't be beat! My favorite is sausage. Top it off with a slice of red velvet or carrot cake—both are the smoothest and creamiest in the city. Yum!

UNIQUE DISH Flourish bakes a limited supply of big, flaky pot pies—complete with crust on the bottom—every day. Each day features a different recipe, so check first. They go on sale at noon, and once they're gone, you're

NORTH SIDE

	out of luck. You can eat it there or take it home and scarf it down.
DRINKS	Coffee, tea, and bottled juices are available. The coffee is good, but beverages are not the draw here.
SEATING	There is plenty of cozy seating along the side and in the back. A few tables are up front, too. Grab a seat at the bar along the window for a front row view of foot traffic on Bryn Mawr, where something interesting always happens.
AMBIENCE/CLIENTELE	Flourish has a decidedly reserved kitsch to it that doesn't go overboard. The ceilings are enormously tall, which gives Flourish an open feel similar to a high school cafeteria (but much nicer).

—*Robert Sabetto*

Icosium Kafe

Icosium Kafe: where crêpes are the new brunch.
$$
5200 N. Clark, Chicago 60640
(at Foster Ave.)
Phone (773) 271-5233
www.icosiumkafe.com

CATEGORY	French Brunch
HOURS	Sun: 9 am-10 pm Mon-Thurs: 9 am-10 pm Fri/Sat: 9 am-11 pm
GETTING THERE	Street parking can be a tad difficult, but the neighborhood is bike friendly and it's easy to access by taking the #92 Foster or #22 Clark bus.
PAYMENT	
POPULAR DISH	Crêpe Yussuf (white and brown sugar mixed with butter, cinnamon and raisins paired with pistachio ice cream) is a standout on the menu. But any sweet crêpe will do.
UNIQUE DISH	Surprisingly, it is Icosium's fruit bowl that has me licking the plate. A fresh blend of strawberries, bananas, pineapple, kiwi and mango sprinkled with cinnamon is the favorite among my group.
DRINKS	Icosium is a BYOB crêpe spot with coffee, teas, and other assorted café drinks.
SEATING	Seating is plentiful. There has never been a problem with a wait, and there's plenty of elbow room so you don't hear other diners' conversations.
AMBIENCE/CLIENTELE	It's a completely relaxed and friendly environment. This is always a great stop for a midday bite or to escape the typical brunch crowd.
OTHER ONES	2433 N. Clark St., Chicago 60614, (773) 404-1300

—*Rachael Carter*

Indie Café

Best Japanese food in town!
$$$
5951 N. Broadway Ave., Chicago 60660
(at Thorndale Ave.)
Phone (773) 561-5577

CATEGORY	Japanese/Sushi Cafe
HOURS	Sun: Noon-10 pm Mon-Thurs: 11:30 am-10 pm Fri/Sat: 11:30 am-10:30 pm

NORTH SIDE

GETTING THERE	You can find metered parking on Broadway or Thorndale. Indie Café is about a half block from the Thorndale Red Line stop. You can also take the #36 Broadway, #147 Outer Drive Express, or #22 Clark bus.
PAYMENT	
POPULAR DISH	I recommend the sushi deluxe—you can experience one piece of nine different kinds of sushi and a California roll. If you are trying sushi for the first time, you should go to Indie, because it's really the best sushi that you're going to get anywhere.
UNIQUE DISH	They have custom dishes like the Indie signature curry (classic mussamun curry with cashews and potatoes, featuring aromatic spices and fresh herbs) or the Indie salad (seaweed salad mixed with spicy mayo, crab stick, and masago).
DRINKS	Indie Café is BYOB, so make sure to pick up that wine before coming. There is a Dominick's with an extended wine selection almost right next door.
SEATING	Indie started out as a pretty cozy restaurant. Indie gets packed at night, especially on weekends because of their great food, so come early if you can. If you can't, the waitstaff will take your phone number so you can head across the street for a drink while you wait.
AMBIENCE/CLIENTELE	From the well-designed menus to the lighting fixtures, this place is put together. Indie continues to improve itself. Usually you'll have a candle at your table and all tables have a nice cozy feel. It's relaxed, even if there are a lot of people eating, and it's not too loud for a romantic night out. Indie Café has great style, from the fancy chopsticks to the well-decorated platters to the sushi bar that looks like a work of art. You almost want to bring your camera and take a picture of your food before you eat!

—Travis Lee Wiggins

La Unica

Savory Latin food while you do your grocery shopping.
$
1515 W. Devon Ave., Chicago 60660
(between Greenview Ave. and Bosworth Ave.)
Phone (773) 274-7788 • Fax (773) 274-7785

CATEGORY	Latin American Cafeteria
HOURS	Sun: 8 am-5 pm Mon-Sat: 8 am-9 pm
GETTING THERE	There is a free small parking lot, metered parking, and free street parking. The #155 Devon, #36 Broadway or #22 Clark bus will also get you here.
PAYMENT	
POPULAR DISH	This place is ideal for meat consumption. I suggest ropa vieja, Pan con Lechón, Tostones or any other common Cuban savory dish. I'd die for their yucca frita (white rice and plantains). The quantities are large, and the menu is extensive. Keep in mind that Cuban food is very similar to Colombian and Venezuelan food. You can go grocery shopping too, since the dining area is in the back of a supermarket.
UNIQUE DISH	They sell hard-to-find items like white cheese in the grocery store, as well as chorizo Español and other delicatessen items at great prices. Other products like plantains, hard-to-find vegetables, and imported chocolates and cookies, are also available.

NORTH SIDE

DRINKS	The Cuban coffee and Frescolita are things you can never go wrong with. They offer a variety of drinks you cannot find easily in Chicago, so experiment!
SEATING	It's very open, informal, comfortable, and delicious, and the service is good. Imagine a smaller version of a school cafeteria.
AMBIENCE/CLIENTELE	Multi-generational families and people from diverse backgrounds and social statuses come here. This is a secret haven to many and a favorite place for regulars, and you'll find the usual Latin camaraderie.
EXTRA/NOTES	I first discovered this place looking for Malta, white cheese, chorizo, and other Venezuelan specialties since we miss our food very much. To my surprise, in the back of this small supermarket, I found a full menu of things I used to see everyday.

—Isa Traverso-Burger

M. Henry
Their mantra is pretty simple, "Eat well. Live long."
$$
5707 N. Clark St., Chicago 60660
(at Edgewater Ave.)
Phone (773) 561-1600 • Fax (773) 561-1635
www.mhenry.net

CATEGORY	American Restaurant
HOURS	Sat/Sun: 8 am-3 pm Tues-Fri: 7 am-2:30 pm
GETTING THERE	Street parking can be difficult, so it's best to take the bus. Take the #22 Clark bus and get off at Edgewater or ride the #84 Peterson bus to Clark and walk south a couple of blocks.
PAYMENT	
POPULAR DISH	Try Jorges' black bean cakes and eggs—two deliciously spicy black bean cakes topped with chipotle sour cream, two eggs and savory house potatoes.
UNIQUE DISH	If you have a sweet tooth, try the decadent blackberry bliss cakes—hotcakes layered with blackberries and mascarpone cream, finished off with a brown sugar and oat crust.
DRINKS	This eatery is BYOB but has its own organic house blend coffee, an assortment of café drinks and teas as well as freshly squeezed juices.
SEATING	The restaurant seats up to 85 guests while offering catering services for private parties as well.
AMBIENCE/CLIENTELE	Like any brunch place, M. Henry has that bustling atmosphere but without the distraction. There should be no problem carrying on a conversation with your dining companions. However, if you're caught having to wait it can get a bit crowded.

—Rachael Carter

Moody's Pub
One of the north side's best kept secrets...
$$$
5910 N. Broadway St., Chicago 60660
(at Thorndale Ave.)
Phone (773) 275-2696
www.moodyspub.com

NORTH SIDE

CATEGORY	American Pub
HOURS	Mon-Fri 11:30 am- 1 am
	Sat: 11:30 am-2 am
	Sun: Noon-1 am
GETTING THERE	A fairly large parking lot right next door shared with the Broadway Bank. Metered parking in front. Take the #36 Broadway bus to Thorndale, or the Red Line to the Thorndale stop.
PAYMENT	$ ATM
POPULAR DISH	The Moodyburger: a half-pound burger cooked to order, served with an ample helping of their delicious fries, a pickle spear, lettuce, tomato, and onion slice. You can customize your Moodyburger with cheese, bacon, sautéed mushrooms, and pimiento-stuffed olives.
DRINKS	Moody's has a full bar with a full list of libations known as Fireside Fantasies (which are all served hot and are more winter-centric) and Pub Potions (which are all sweeter, fruity, and enjoyed by plenty of guests during the summer on the patio).
SEATING	Moody's is pretty open. Inside, the tables are nicely sized, but sometimes a bit close together. Outside on the patio, the seating consists of a mix of four-tops and picnic tables.
AMBIENCE/CLIENTELE	The ambience is dark, dark, dark! There are several fireplaces and it's usually pretty easy to get a table next to one of them unless it's the depth of winter, and then these tables are prime real estate. During summer and early fall, Moody's opens up their patio/beer garden. The customers of Moody's are an eclectic mix. You'll see young families, immigrants, hipsters, hippies, and retirees here.

—*Clifford Etters*

Pasticceria Natalina

When a trip to Sicily just isn't in the cards.
$
5406 N. Clark St., Chicago 60640
(between Balmoral Ave. and Rascher Ave.)
Phone (773) 989-0662 • Fax (773) 989-1078
www.p-natalina.com

CATEGORY	Italian Bakery
HOURS	Sun: Noon-9 pm
	Weds-Sat: Noon-10 pm
GETTING THERE	There are meters and a few small pay lots nearby. Weekends can be tricky. The #22 Clark bus runs right by.
PAYMENT	DISCOVER, AMERICAN EXPRESS, MASTERCARD, VISA
POPULAR DISH	Everything here is amazing, but anything with cream (custard, cannoli, éclairs) will particularly get your heart racing. The flavors are balanced and subtle.
UNIQUE DISH	Offerings change daily. Sicilian cheesecake is light and creamy with the subtlest zing of lemon. I also loved the candied tangerine and lemon, which is the perfect balance of sweet and tart.
DRINKS	Tea and coffee are your choices.
SEATING	A bar with a few seats is available, but this is not a place where you'll want to sit and sip coffee. It is quite small and gets crowded, especially on Saturday. Your best bet is to take your purchases with you. If you're dining at a nearby restaurant, this is the best spot for dessert.

AMBIENCE/CLIENTELE	Everything about this place is elegant, modern and sophisticated. As soon as you open the door, sweet, subtle scents of baking waft over, and you're hooked. The space is downright minimalist, bright, and airy to showcase the gorgeous array of pastries. Portions are individually sized, which is perfect for sharing or mixing. Even the take-out boxes—a cool sort of paper lotus blossom—are refined. Pasticceria Natalina actually looks more like an art studio than a bakery. There are no walls between the front counter and the kitchen, so you can see everything being made right in front of you.
EXTRA/NOTES	Natalie and Nick, the owners/operators, are friendly and knowledgeable.

—*Robert Sabetto*

Ras Dashen

Why go to Ethiopia when Ethiopia can come to you?

$$

5846 N. Broadway Ave., Chicago 60660
(at Ardmore Ave.)
Phone (773) 506-9601 • Fax (773) 506-9685
www.rasdashenchicago.com

CATEGORY	Ethiopian Restaurant
HOURS	Daily: Noon-11 pm
GETTING THERE	Metered street parking is easy to find. It's a short walk from the Thorndale Red Line stop. You can also take the #36 Broadway or #147 Outer Drive Express bus.
PAYMENT	
POPULAR DISH	The best deal is the Omnivore Dinner for Two, which also has a vegetarian counterpart. With either, you get to choose three entrees and three sides, each slightly smaller than full-size portions. I suggest trying the Kitfo Tere. This is an Ethiopian-style steak tartar seasoned with kibe (spiced butter) and mitmita (red pepper blend). Also try the Ib, soft cheese made fresh daily with cultured buttermilk. Another one of my favorites is the Tikil Gomen Alicha—mildly spiced cabbage, potato, and carrot stew—tasty!
DRINKS	Ras Dashen has a full service espresso bar and lots of spirits and cocktails. If you'd like a beer, try the Hakim from Ethiopia—it's a stout beer with chocolate and roasted malt flavors. Wine? Try a glass of the Enat Tej, a specialty Ethiopian-style wine made from honey and Ethiopian hops (gesho) that compliment and balances the spice in the food.
SEATING	Ras Dashen is a decently-sized restaurant and you will find a lot of people eating there on any given night. I have never had to wait for a seat, even though the place is packed as it gets later into the evening.
AMBIENCE/CLIENTELE	You'll find people from all over the globe enjoying this experience. Edgewater's diversity really shines here.
EXTRA/NOTES	On Friday nights from 8:30 pm to 10:30 pm, there is live music—a band called Magic Carpet. They're a good blend of jazz and world music and play just loud enough to give that extra ambience, but you'll still be able to hold a conversation. Quadrangle plays on Wednesdays and the first Saturday of every month.

—*Travis Lee Wiggins*

NORTH SIDE

A Taste of Heaven

Cookies and brownies and cakes, oh my!

$

5401 N. Clark St., Chicago 60640
(at Balmoral Ave.)
Phone (773) 989-0151

CATEGORY	American Bakery
HOURS	Sun: 8 am-10 pm
	Mon-Thurs: 7 am-10 pm
	Fri/Sat: 7 am-11 pm
GETTING THERE	Metered parking is available, but the best route is the #22 Clark bus to Balmoral.
PAYMENT	
POPULAR DISH	While usually seasonal, the vegetarian chili has always been a staple. Served in a café mug, the chili is a perfect starter to any entree. But it's the desserts that make this place what it is: a taste of heaven. Anyone hankering for something sweet should order a slice of Jeannine's Cake, a triple layer yellow cake with fresh blueberries, strawberries and raspberries smothered in a creamy vanilla frosting.
UNIQUE DISH	The nostalgia of Thanksgiving always has me coming back to The Brown Derby, a flour tortilla wrapped around turkey, stuffing, cranberry sauce and sweet potatoes.
DRINKS	No alcoholic beverages are served but that's never stopped anyone sitting down for a cup of coffee of loose-leaf tea.
SEATING	Seating is limited and folks like to camp, so get there before or after the lunch rush. Patio seating is available, weather permitting.
AMBIENCE/CLIENTELE	Every walk of life seems to pass through here, which only adds to the popularity of the place. As one friend described, "It's like sitting in Grandma's kitchen."

—*Rachael Carter*

UPTOWN

Alice & Friends' Vegetarian Café

Vegan bliss…who would've thought?

$$

5812 N. Broadway Ave., Chicago 60660
(at Ardmore Ave.)
Phone (773) 275-8797
www.aliceandfriends.com

CATEGORY	Vegetarian Cafe
HOURS	Mon-Fri: 4 pm-10 pm
	Sat: Noon-9 pm
GETTING THERE	There's metered parking up and down Broadway. The café is just west of the Bryn Mawr and Thorndale stops on the Red Line. You can also take the #36 Broadway, #84 Peterson, or #147 Outer Drive Express bus.
PAYMENT	

NORTH SIDE

POPULAR DISH	The Almond unChicken is to die for. It is extremely flavorful and satisfying. On certain days the special is a dish called "'Nuff Said," which is Alice and Friends' take on a pork stir-fry. It is so good, it will bring tears to your eyes. Just get the vegan chocolate mousse pie. Seriously.
UNIQUE DISH	With the exception of some teas that include honey, everything at Alice and Friends is vegan. The fake meat, whether it's the unBeef, the unChicken, or the unPork, is shockingly convincing. You could probably come here with friends who think that vegetarianism is for wimps and still be praised for the restaurant suggestion.
DRINKS	Water and tea. No alcohol is served and BYOB is prohibited.
SEATING	This place is very small and quaint with only eleven tables.
AMBIENCE/CLIENTELE	Shhhhhhh. Alice and Friends is very, very quiet. The restaurant has a lot of books, posters, and videos on display made by "The Supreme Master." They inform customers about the joy one will reach by being kind to our animal friends.

—*Luca Cimarusti*

Ba Le Sandwiches & Deli

Good sandwiches, great prices, AMAZING bread!
$$
5018 N. Broadway Ave., Chicago 60640
(at Winnemac Ave.)
Phone (773) 561-4424
www.balechicago.com

CATEGORY	Vietnamese Sandwich Shop
HOURS	Daily: 7:30 am-8 pm
GETTING THERE	There is metered parking on the street, but the easiest way to get there is by taking the Red Line to Argyle. The restaurant is about a block north.
PAYMENT	$
POPULAR DISH	The most popular dishes are definitely the Vietnamese sandwiches. The bread is amazing, with a nice thick crust (but not so hard that you are afraid of breaking a tooth) with a light but flavorful middle, it is enough of a reason to come to Ba Le. (The bread is available packaged and ready to go.) They offer a wide variety of fillings for the sandwiches, from pork, chicken, and shrimp to tofu and meatballs. All the sandwiches are garnished with shredded carrots, jalapeño, cilantro, and shredded radish. All are delicious, though my personal favorite is the Chinese Pork.
UNIQUE DISH	In addition to the sandwiches, Ba Le has many other food items such as salads, sweets, rice dishes, egg rolls, and sausages. I think the most unique items are the rolls. The rolls are filled with either pork, shrimp, or Chinese sausage and all are served with peanut sauce.
DRINKS	Smoothies are on the menu, complete with tapioca balls. Thai iced tea and coffee are also offered.
SEATING	Ba Le is mainly a carry-out restaurant. There are two tables for dining in, however, they are small and off in a corner. Dining in is okay if you are just getting a quick bite to eat, but don't expect to come with a large group of people. There just isn't enough space.

NORTH SIDE

|AMBIENCE/CLIENTELE|The ambience of the bakery is casual, warm, and inviting. The walls are white, which highlights all the food items offered. Locals, young adults, businessmen and women, retirees, and college students are all drawn to the good food and great prices.|

—*Katy Graf*

Ben's Noodles and Rice

Get a lot more than noodles & rice at Ben's Noodles and Rice!
$$

1139 W. Bryn Mawr Ave., Chicago 60660
(at Broadway St.)
Phone (773) 907-8936 • Fax (773) 907-8947
www.bensnoodlesandrice.com

CATEGORY	Thai Restaurant
HOURS	Sun: Noon-9 pm Mon/Tues: 11 am-9 pm Thurs: 11 am-9 pm Fri/Sat: 11 am-10 pm
GETTING THERE	Metered street parking is available on Bryn Mawr and Broadway. If you go west on Bryn Mawr into the Andersonville neighborhood there is plenty of free street parking (no permit needed)! Ben's is conveniently located half a block northwest from the Bryn Mawr stop on the Red Line. You can also take the #92 Foster, #84 Peterson, or #147 Outer Drive Express bus.
PAYMENT	Discover, MasterCard, VISA
POPULAR DISH	Ben's Noodles and Rice is a Thai restaurant, and you'll find all the classic and popular Thai dishes. The thing that makes Ben's special is excellently prepared dishes at a great price. You'll see people ordering ahead and picking up Ben's on their way home from work as they get off the Red Line. I prefer the Thai standard, Pad See-Eiw with chicken. They also make their own crab rangoon, which is an excellent appetizer.
UNIQUE DISH	Most dishes can also be prepared for vegetarians or with tofu.
DRINKS	Ben's is BYOB, so if you'd like a drink with dinner, go ahead and bring it. Like many Asian restaurants, there isn't fountain soda—they'll bring you a can with a glass of ice—but I do suggest trying the Thai iced tea or Thai iced coffee. It's sure to wake you up and bring a smile to your face.
SEATING	Ben's is very small with eleven or so tables, but you shouldn't have a problem getting a seat (I've never waited in my three years going there.) A lot of Ben's clientele seems to be people picking up orders, so feel free to just stop in.
AMBIENCE/CLIENTELE	It is very cozy with two attentive owners making sure you have everything you need. The waitstaff isn't pushy at all, no matter how busy they are, and you can spend as much time as you like before or after dinner. The front of the restaurant has very large glass windows that face Bryn Mawr that make it a great place to people-watch.
EXTRA NOTES	They offer delivery.

—*Travis Lee Wiggins*

NORTH SIDE

Pho 777
Cures the common cold and the occasional hangover!
$$
1065 W. Argyle St., Chicago 60640
(between Kenmore Ave. and Winthrop Ave.)
Phone (773) 561-9909

CATEGORY	Vietnamese Restaurant
HOURS	Mon: 9:30 am-10 pm
	Weds-Fri: 9:30 am-10 pm
	Sat/Sun: 9 am-10 pm
GETTING THERE	Street parking and a few pay lots, but the best way to get there is the Red Line. Pho 777 is right off of the Argyle stop. Then you don't have to worry about getting home in your beef soup coma. You can also take the #36 Broadway or #151 Sheridan bus.
PAYMENT	
POPULAR DISH	For those who don't know about Pho, it is clear beef stock with noodles. It comes with a side of assorted greens, hot peppers and a lime that you mix in to taste. You can also get raw slices of beef on the side that are thin enough to cook in the hot soup.
DRINKS	The drink menu is limited, but it does have very good lemonade, which is made with limes. There is also Vietnamese coffee and pearl tea.
SEATING	The seating area is large with a variety of tables. Some are family-sized round tables for big groups and others can only fit two to four people.
AMBIENCE/CLIENTELE	The ambience is a lot like the rest of the places on Argyle. There are a few of those lucky cats that wave and a soundtrack of old pop music covered by Asian singers. The area has a large Vietnamese population, and the clientele consists mostly of locals.

—*Dylan Heath*

Sun Wah BBQ
Welcome to Chicago. Everybody duck!
$$
5041 N. Broadway St., Chicago, IL 60640
(at Broadway St.)
Phone (773) 769-1254

CATEGORY	Chinese Restaurant
HOURS	Sun-Weds: 9 am-9 pm
	Fri/Sat: 9 am-9:30 pm
GETTING THERE	Take the Red Line to Argyle or the #36 Broadway, #81 Lawrence, or #92 Foster bus. There is also ample metered street parking.
PAYMENT	
POPULAR DISH	The Beijing duck is part of a five-course meal at a reasonable price. Either Chef Laura Cheng or Chef Kelly Cheng begins the deliberate process of slicing the succulent meat off of the bone. Then diners receive a small plate with soft and steamy Taiwanese hot dogs buns, the perfect pocket for the slices of duck. With a dollop of homemade hoisin sauce, this is a sandwich like no other. While we eat sandwiches and the legs and wings, the rest of the duck is taken to the back and used to make soup and fried rice.
UNIQUE DISH	While there are perennial favorites such as the garlic fried ribs, people tend to go to Sun Wah for the duck.

NORTH SIDE

DRINKS Domestic beers like Old Style, Budweiser, Michelob, and Miller Lite, imported beer such as Tsing Tao, Taiwan, Kirin, and Heineken; also soy milk and canned pop are available.

SEATING There is a smallish, casual dining area. Larger tables come with a lazy susan for sharing food. It isn't fancy, but it's clean and functional. In a city that values function over form, the dining area is perfect. You just have to be steady enough to walk past the gleaming take-out counter with the formerly living ducks and other poultry glistening under the light. There is a narrow pass-through to get into the dining room, but the warm welcome is worth it. It is an unassuming little room that offers an olfactory treat while you wait for your dinner.

AMBIENCE/CLIENTELE This might be one of the most diverse collections of diners in the city. Hardcore foodies mingle with locals who are aware of the quality for the price. College kids on a budget sit across from people who have come up from Chinatown on the south side of the city. The atmosphere is casual and relaxed. The staff is very knowledgeable about the various offerings. Blue jeans are as welcome here as a suit and tie or dress.

EXTRA/NOTES When ordering the duck it isn't a bad idea to call a day before. The demand is so high these days that it isn't a necessity anymore, but it doesn't hurt. When ordering the garlic fried ribs, you still need to call a day in advance.

—Paul Barile

Tank Noodle (Pho Xe Tang)

Best Pho in Chicago. Slurping is encouraged!
$$
4953–55 N. Broadway St., Chicago 60640
(at Argyle St.)
Phone (773) 878-2253
www.tanknoodle.com

CATEGORY Vietnamese Noodle House
HOURS Sun: 8:30 am-9 pm
Mon/Tues: 8:30 am-11 pm
Thurs-Sat: 8:30 am-11 pm
GETTING THERE There is metered street parking, but the easiest way to get there is via the Red Line to the Argyle stop. The restaurant is less than a block southwest from there.
PAYMENT
POPULAR DISH Although they do have a wide selection of other dishes, you go for the Pho. Choose from beef, chicken, pork, or a combination. All come in a rich and flavorful broth (that's actually the best part!) with long noodles, onions, and a side plate of condiments including bean sprouts, lime, basil, and cilantro.
DRINKS A wide variety of drinks are on the menu—fruit juices, coffees, soda, tea, and smoothies. Tank is also BYOB.
SEATING There are plenty of seats available. Tank is always busy, but there is usually a table or two open.
AMBIENCE/CLIENTELE Tank is very laid-back and casual. The decor is scarce, tables are plain, and there is little mood, but you come for the food, not the ambience. The restaurant is located on a corner, so two whole walls are just floor

NORTH SIDE

to ceiling windows, which opens up the room but fits in with the casual atmosphere. Pop music, rap, and modern hits add to the relaxed dining experience. A wide range of people come to Tank, from families with small children to groups of young people, men and women in business suits, college students, and locals.

—Katy Graf

Thai on Clark

Keep it simple—and delicious. If you cook it they will come.

$$

4641 N. Clark St., Chicago 60640
(at Leland Ave.)
Phone (773) 275-2620

CATEGORY	Thai Restaurant
HOURS	Mon-Thurs: 11 am-9:30 pm Fri/Sat: 11 am-10 pm
GETTING THERE	Metered street parking is available. You can also take the #22 Clark, #78 Montrose, or #81 Lawrence bus.
PAYMENT	
POPULAR DISH	One popular dish is the edamame. Steamed in ocean salt, the little beans are popped out of the pod still warm. I have never been there when someone didn't order edamame.
UNIQUE DISH	The teriyaki salmon is something that I have never had anywhere else, and likely wouldn't want to try anywhere else. The salmon is cooked slightly more thoroughly than usual, but this is tender and moist salmon that falls off the fork. The word "succulent" can only be used to describe this perfectly seasoned seafood when it hits your taste buds. It is served on a bed of steamed broccoli, and the rice is always perfect. There is always enough food to make you feel good and full. This dinner is followed by the most sublime coconut ice cream with a couple of peanuts on top.
DRINKS	Thai on Clark is BYOB, and there are liquor stores within walking distance. They do have Thai teas and coffees that are delicious.
SEATING	There are about seven or eight mismatched tables and chairs. There are two larger tables for groups and a variety of smaller tables for couples. The dining area almost seems to be an afterthought—something they tacked on to keep them busy between the high volume of take-out orders. There is plenty of room to move around between the tables.
AMBIENCE/CLIENTELE	This is a homey, family-friendly environment. There is nothing fancy about Thai on Clark's atmosphere. They blend kitschy Thai relics with the odd flair of Americana. The tables don't match, but the bamboo placemats do. The dining room is wide open, making it easy to relax and eat without rushing or getting bumped and hassled by other diners. The clientele alternates between hipsters and working folks. The service is cordial. It is clearly a family business and they take great pride in it. It is unassuming and plain with the focus on the food and the service more than anything else.

—Paul Barile

NORTH SIDE

That Little Mexican Café
"Where you peso little and get so much!"
$$

1055 W. Bryn Mawr Ave., Chicago 60660
(at Winthrop Ave.)
Phone (773) 769-1004

CATEGORY	Mexican Restaurant
HOURS	Sun-Thurs: 11 am-9:30 pm Fri/Sat: 11 am-11:30 pm
GETTING THERE	There is a small lot behind the restaurant that fills up quickly. Metered street parking out front. Conveniently located a half block east from the Bryn Mawr Red Line stop. You can also take the #147 Outer Drive Express or #92 Foster bus.
PAYMENT	
POPULAR DISH	I suggest trying a Mexican standard—the steak burrito. The steak is succulent and would be good just eating it on its own—but here it's in your burrito!
UNIQUE DISH	If you order guacamole they bring over a "guacamole station" and make it fresh right in front of you.
DRINKS	That Little Mexican Café has a full service bar and it's great for margaritas. It's one of the only places you can get a drink on the Bryn Mawr strip, but while they have most things that you could want, this place functions mostly as a restaurant with a small bar in it and not the other way around. There is an extensive liquor selection and some wine.
SEATING	That Little Mexican Café is only three blocks from the ever-popular Hollywood Beach and there is seating outside the restaurant on the sidewalk. There is plenty of seating inside, and I've never had to wait even on a Friday or Saturday night. There are some tables in the bar, and the restaurant has a good mix of tables that are always packed, but never packed enough so that you have to wait.
AMBIENCE/CLIENTELE	There's a great interior design with high ceilings, medium lighting, and a warm color scheme. You'll feel comfortable and see the cooks working in the kitchen, permeating the whole place with Mexican freshness.
OTHER ONES	1010 Church Ave., Evanston 60201, (847) 905-1550

—*Travis Lee Wiggins*

LAKEVIEW/BOYSTOWN/WRIGLEYVILLE

Byron's Hot Dogs
Ignore your arteries and reward your taste buds.
$

1017 W. Irving Park Rd., Chicago 60613
(at Sheridan Rd.)
Phone (773) 281-7474
www.byronshotdogs.com

CATEGORY	American Restaurant
HOURS	Sun: 10 am-11 pm Mon-Thurs: 10am-10 pm Fri/Sat: 10 am-11 pm

NORTH SIDE

GETTING THERE	There is ample parking in the back of the restaurant and on Irving Park. Byron's is a block north and a block west of the Red Line (Sheridan station). You can also take the #80 Irving Park or #151 Sheridan bus.
PAYMENT	ATM
POPULAR DISH	Though hamburgers and hot dogs are phenomenal here, the condiments really set Byron's apart. Each sandwich is topped with heaps of lettuce, tomatoes, onions, green peppers, chile peppers and celery salt. The finished product is a towering sight to behold, and you may have to unhinge your jaw to eat it.
UNIQUE DISH	Aside from the classic American fare, Byron's has great ethnic foods like gyros, Polish sausage, and tamales.
DRINKS	Pepsi products.
SEATING	Byron's is primarily a take-out joint, but there are two small wooden benches in the parking lot.
AMBIENCE/CLIENTELE	From businesspeople in suits to laborers in torn jeans, Byron's has the diverse clientele that you would expect at a popular hot dog stand. The stand itself is very small and cramped; lines go out the door on busy nights. Watching the cooks yell and banter as they frantically churn out orders is a memorable experience in itself.
EXTRA/NOTES	Call ahead or order online to avoid the long lines.
OTHER ONES	• 1701 W. Lawrence Ave., Chicago 60640 • 7237 W. Madison Ave., Forest Park 60130

—*Brandon Wuske*

Chen's

This ain't yo momma's dim sum!
$$
3506 N. Clark St., Chicago 60657
(at Cornelia Ave.)
Phone (773) 549-9100 • Fax (773) 248-8721
www.chenschicago.com

CATEGORY	Chinese Restaurant
HOURS	Sun-Thurs: 4 pm-11 pm Fri/Sat: 4 pm-Midnight
GETTING THERE	Metered street parking is hit-or-miss. There is a pay lot across the street. Or take the Red Line to Addison or the #8 Halsted, #22 Clark, or #152 Addison bus.
PAYMENT	
POPULAR DISH	The "hot plates" are large enough for two. The Mongolian Beef, a familiar Chinese dish, is exquisite, featuring slightly sweetened beef cooked to tender perfection. Kung Bao, a Szechwan (spicy) dish, is a crowd-pleaser, offering plenty of kick for the daring. Chen's made-to-order maki rolls including spicy tuna and California rolls, but the salmon skin roll is king.
UNIQUE DISH	Peking duck has to be pre-ordered.
DRINKS	Chen's has a comprehensive martini list. The house recipe, Chen's Martini, is a plum and vodka fusion that is deeply original, intense, and a treat for the senses. More luxe martinis include the Fruitini, a twist on the elusive French martini.
SEATING	The main dining room has about 30 tables and a completely separate section at the bar. Tables are small and generally made for two. Chen's is a kid-friendly restaurant with plenty of high chairs and toddler seats.
AMBIENCE/CLIENTELE	The atmosphere is Asian-contempo-chic, ideal for date night or a chance to catch up with a group of

NORTH SIDE

friends or co-workers. The main dining room is intimate enough for a romantic dinner with a loved one but unobtrusive enough for groups. Frequent diners include locals from Wrigleyville, Lincoln Park, and Lakeview, as well as suburban transplants after a Cubs game, and the after-work hipsters toting distressed leather briefcases and designer specs.

EXTRA/NOTES Chen's has a private dining area seating up to 120 guests and up to 200 for a cocktail reception.

—*Marquis Tucker*

Chicago Diner
Their "meat" entrees will please both vegetarians and carnivores.
$$$
3411 N. Halsted St., Chicago 60657
(at Roscoe St.)
Phone (773) 935-6696 • Fax (773) 935-8349
www.veggiediner.com

CATEGORY Vegetarian Diner
HOURS Sun: 10 am-10 pm
Mon-Thurs: 11 am-10 pm
Fri/Sat: 11 am-10:30 pm
GETTING THERE Free street parking after 6 pm during the week and Saturday and Sunday from 10 am–11 pm. Or take the #36 Broadway #22 Clark bus or the Belmont Red Line.
PAYMENT
POPULAR DISH The Radical Reuben is always a favorite: two slices of marble rye filled with sliced seitan, onions, peppers, sauerkraut, vegan Thousand Island dressing and vegan cheese. Their daily brunch menu packs plenty of favorites like their buttermilk biscuits and "sausage" gravy.
UNIQUE DISH The vegan shakes are so delicious and definitely an upgrade from traditional diner milkshakes. The cookie dough shake has bits of vegan cookie dough swirled in creamy vegan ice cream, a decadent dairy-free treat. Their cocoa mousse cake, espresso torte and banana poppyseed cake (chocolate layer cake with banana custard filling, ganache, and frosting swirls), are some of their most popular.
DRINKS A limited alcohol selection, although their offerings are quite nice. Some highlights are local Goose Island Nut Brown Ale, Organic Sam Smith Ale, and Stella Artois. There are five organic vegan wines available by the glass or bottle, including a delicious Nuevo Mundo Cabernet-Malbec. They also serve organic Rain vodka and Cuervo margaritas. Non-alcoholic beverages include organic fair trade coffee, assorted teas, cider, Izze sodas and Reeds Ginger Brew.
SEATING The seating is limited to only a few booths and tables. Reservations are not accepted, so plan on waiting if you are going during peak hours like weekend brunch.
AMBIENCE/CLIENTELE Like many city diners, this establishment has a friendly vibe. You can visit Chicago Diner for some coffee or a nutritious meal. The staff is very laid-back and are happy to help explain anything on the menu. There are booths overlooking the bar and drink station so you can watch them whip up lattes and vegan shakes.

—*Katelyn Bogucki*

NORTH SIDE

Coobah
A fun restaurant and bar with creatively prepared food and drinks.
$$$
3423 N. Southport Ave., Chicago 60657
(at Newport Ave.)
Phone (773) 528-2220
www.coobah.com

CATEGORY	Latin American Restaurant
HOURS	Mon-Fri: 5 pm-1 am Sat: 10 am-2 am
GETTING THERE	Free lot in the back. You can also take the #152 Addison, #77 Belmont, or #11 Lincoln bus or the Brown Line to Southport.
PAYMENT	
POPULAR DISH	The grilled beef skewers are sliced flank steak marinated in a lychee-soy mix with a miso-chile sauce served over jasmine rice. The hanger steak is served with chipotle mashed potatoes and pickled red onion with a soy-cider gastrique. The Mahi Mahi is served with coconut mashed potatoes, grilled radicchio, roasted tomato, and a chive oil-black vinegar reduction. There's also a good brunch menu that is worth trying. They offer traditional dishes like French toast, pancakes (Coobah Cakes) and Huevos y Bistek (eggs and steak), all prepared with the Latin American inspiration that you find on the rest of the menu.
UNIQUE DISH	Try the stylized sugarcane Caesar salad, a mix of romaine lettuce and flash-grilled radicchio served with sugarcane, Manchego cheese, and Caesar dressing. Pan seared diver scallops served with sherry-spiked cabrales cream sauce and roasted beet and bacon salad is one of the best appetizers you'll find anywhere! The pork tenderloin bicol is pork tenderloin stuffed with shrimp, bacon, coconut and pineapple and served with jasmine rice and vegetables. For dessert, without question, it's the Piña Colada bread pudding.
DRINKS	Mojitos as good as you'll find anywhere in the city, and great Brazilian Caipirinhas. They offer other interesting tropical/Latin-inspired concoctions like Uva Caribe, Margaritas, Coobah Libres and Sangria served by the pitcher. There's also a very nice selection of beers from Central and South America, including the hard-to-find Xingu from Brazil. Coobah also has a decent selection of wines by the glass and bottle.
SEATING	The main dining room seats around 80 people with ten seats at the bar. Most of the tables are two-tops and they are placed close together. In the summer they have outdoor seating with a front row view of all the action happening on busy Southport.
AMBIENCE/CLIENTELE	Coobah has a very rustic, almost bohemian vibe. Everything has a distressed look and most of the materials in the restaurant are dark. The lighting is low and diffused by hammered copper shades. It is a well-conceived design that comes together with salvaged furniture and found objects. The service is very friendly. On weekends and nights when there's live music it can get pretty lively and loud.
EXTRA/NOTES	There's live entertainment Wednesday/Thursday nights.

—Jim St. Marie

NORTH SIDE

The Counter
Tired of the usual? How about a COUNTER-measure?
$$
3666 W. Diversey Pkwy., Chicago 60614
(between Broadway St. and Clark St.)
Phone (773) 935-1995 • Fax (773) 935-1997
www.thecounterburger.com

CATEGORY	American Fast food
HOURS	Sun-Thurs: 11 am-10 pm Fri/Sat: 11 am-Midnight
GETTING THERE	There is metered parking for the brave who do not mind a challenge and a parking garage for those who don't mind paying a little more for an easy spot. The CTA #76 bus stops just down the street, or you can take the Purple Line/Brown Line and exit at Diversey.
PAYMENT	
POPULAR DISH	There are more than 300,000 possible combinations for your burger, with choices varying from the type of bun to the vast assortment of toppings. For those who find it difficult to choose, The Counter offers a "Burger of the Month."
UNIQUE DISH	They serve some pretty amazing fried dill pickles.
DRINKS	The Counter serves the usual array of beverages, which includes pop, shakes/malts, and a typical assortment of beer and wine.
SEATING	The restaurant is small, so seating is elbow-to-elbow. However, the crowd is typically laid-back so don't be afraid to say hello to your neighbors! For more private time, there is counter seating with ample room or there are several tables off to the side that will give you a little extra breathing room.
AMBIENCE/CLIENTELE	One could describe The Counter as a hamburger joint for the metropolitan twenty somethings and families combined. It's cozy and hip without being pretentious. The Counter is located just around the corner from Landmark Century Theater, so it's perfect when looking for dinner and a movie. On the weekends you can expect a wait, but the line tends to move fairly quickly compared to other local restaurants.

—*Jenna Noble*

Cozy Noodles & Rice
The outlandish décor draws you in, the great food and friendly service keeps you coming back.
$$
3456 N. Sheffield St., Chicago 60657
(at Clark St.)
Phone (773) 327-0100 • Fax (773) 327-0109
www.cozychicago.com

CATEGORY	Pan-Asian Restaurant
HOURS	Sun-Thurs: 11 am-10 pm Fri/Sat: 11 am-10:30 pm
GETTING THERE	Free parking lot, but spaces are limited. Expect to use street parking; however, keep in mind that Wrigley Field and the bars on Clark are just around the corner. Your best bet is to take the Red Line to Addison, head west and take a left on Sheffield. You can also take the #22 Clark, #152 Addison, or #77 Belmont bus.
PAYMENT	

NORTH SIDE

POPULAR DISH	Order the baby egg rolls and the crab rangoon, but save room for the main course. The Thai curries are monstrous and delicious. The Golden Noodles are the perfect mixture of savory and sweet.
UNIQUE DISH	You'll find the typical Thai/noodle shop offerings with a slight twist like delicious Panang curry poured over crispy, wide rice noodles.
DRINKS	They offer Thai iced tea and an assortment of bubble teas, but why bother since it's BYOB? This type of cuisine calls for a refreshing lager or a crisp white wine. Make sure to buy the alcohol before coming to the neighborhood; the liquor store selections in the area are minimal and overpriced.
SEATING	The name is Cozy for a reason: twelve two-tops are packed into a 20-by-20-foot room. If it's warm outside, opt for the patio seating, but keep in mind that BYOB laws in Chicago do not permit alcohol on patios. Also, be careful of the tables; they're made of old, manually-operated sewing machine bases, movable foot pedals still intact.
AMBIENCE/CLIENTELE	Kitsch even covers the bathroom walls: the men's has a superhero/Andy Warhol theme and the women's features a wall of Pez dispensers and a My Size Barbie. The over-decoration doesn't create a chaotic environment, as one might think. It's easy to forget the outlandishness with a bowl of steaming curry in front of you and your favorite wine chilling by your side. Expect to find young and old, rich and poor, who travel from all over the city for a cozy environment, extensive menu, and delicious food.

—Matthew Sove

Duck Walk

Saunter over to Duck Walk for hearty portions of Thai done right.
$$
919 W. Belmont Ave., Chicago 60657
(at Wilton Ave.)
Phone (773) 665-0455
www.duckwalkchicago.com

CATEGORY	Thai Restaurant
HOURS	Sun-Thurs: 11 am-10 pm Fri/Sat: 11 am-11 pm
GETTING THERE	Street parking can be difficult, so it's best to take the #77 Belmont or #22 Clark bus. Many find it is even better to board the Red or Brown Line trains and hop off at the Belmont stop for easy access.
PAYMENT	
POPULAR DISH	A popular dish here would be the Pad Thai noodles—thin rice noodles mixed with tasty stir-fried chicken, egg, bean sprouts, peanuts and green onion. Another favorite are the potstickers—deep-fried dumplings filled with chicken and veggies and served with a sweet-and-sour soy sauce.
UNIQUE DISH	This spot serves some of the best curry dishes in town. My personal favorite is the panang curry, a sweet blend of red and green peppers, coconut milk, citrus leaves, and Asian spices. If you can't stand the heat, add some jasmine rice to ease the zing.
DRINKS	Duck Walk offers bubble tea lattes, fountain drinks, coffee, tea, and is also a popular BYOB.

NORTH SIDE

SEATING	Duck Walk can be described as comfortably cozy. While limited seating is available (the restaurant can hold up to 24 guests), I've never had a problem getting in for a quick bite. Due to its popularity, parties of four or more should make reservations.
AMBIENCE/CLIENTELE	Whether you come in with a good book or to people-watch with a friend, Duck Walk has the coziness of a neighborhood café without the exclusivity.

—Rachael Carter

Duke of Perth

If Cheers was Scottish, based in Chicago, and had fish and chips flowing free, this would be it.
$$$
2913 N. Clark St., Chicago 60657
(at Oakdale Ave.)
Phone (773) 477-1741
www.dukeofperth.com

CATEGORY	World/International Pub
HOURS	Mon: 5 pm-12 am Tues-Sun: Noon-2 am
GETTING THERE	Metered parking is available along both Clark and Broadway Street to the west. Parking is easier during lunch hours. Many side streets are permit-only. You can also take the #22 Clark bus.
PAYMENT	
POPULAR DISH	Duke of Perth's fish and chips is the stuff deep-fried dreams are made of! Beer-battered fish and chips are fried to order and served with peas. A touch of malt vinegar takes this dish right over the top. Wednesdays and Fridays offer all-you-can-eat fish and chips, and refills can be made per request—like fish-only or no peas (for you purists out there).
UNIQUE DISH	Burgers trigger feelings of Scotland pride and nostalgia with names such as The Hearth Fire crusted burger (char-burger topped with crispy fried onions and melted bleu cheese with hot jus) and the Sean Connery burger, (Broiled, not 'sh-tirred,' this giant of a burger is topped with sautéed onions, mushrooms, tomatoes and your choice of melted cheese.).
DRINKS	The Duke has an impressive whiskey cellar selection separated into geographical regions. The waitstaff and bartenders are happy to help navigate. A fine selection of Scottish, English, and stateside beers are also available on tap, as is an assortment of bottles.
SEATING	There's counter seating at the bar as well as two rooms of low wooden pub tables and rickety chairs. The Duke's fish and chips special draws in so many people that even with the abundant seating, the place gets crowded on Wednesday and Friday evenings. In warmer weather, The Duke opens a picturesque, floral-accented large patio in the back of the restaurant.
AMBIENCE/CLIENTELE	A focus on dark woods, authentic Scottish décor, and an inviting fireplace provides a warm atmosphere and comfortable dining. The clientele seems to be dominated by neighborhood regulars, many of whom are on a first-name basis with longstanding waitstaff. Newcomers are warmly invited into this family.

—Denise Peñacerrada

NORTH SIDE

El Burrito Mexicano

The perfect place to refuel after a long night on Clark Street.
$$

936 W. Addison Ave., Chicago 60613
(at Wilton Ave.)
Phone (773) 327-6991

CATEGORY	Mexican Hole-in-the-wall
HOURS	Sun-Thurs: 10 am-2:30 am
	Fri/Sat: 10 am-4:30 am
GETTING THERE	There is scarce street parking. There are plenty of lots since it's next to Wrigley Field. Or take the Red Line to Addison. The restaurant is the first building to the left of the station. You can also take the #152 Addison or #22 Clark bus.
PAYMENT	$ ATM
POPULAR DISH	The burritos are enormous and packed with a variety of meats. The standard burrito fillings are all here (chicken, steak, ground beef), but more adventurous diners may want to chow down on chorizo (Mexican sausage) or lengua (beef tongue).
UNIQUE DISH	Though most people come for the tacos and burritos, the restaurant also serves delicious steak dinners that come with rice, beans, and salad. The Bistek a la Mexicana, diced sirloin with onions, tomatoes, and hot peppers, is especially good.
DRINKS	Canned sodas, fresh lemonade, and horchata.
SEATING	The restaurant is small and very cramped with only five booths.
AMBIENCE/CLIENTELE	The restaurant itself is small and sparsely decorated. The place is very popular and is often packed with locals and Wrigleyville revelers, especially on weekend nights. Given the amount of hungry bar-hoppers in the area, it can get pretty noisy at night.

—Brandon Wuske

North Coast Cafe

Be sure to bring your appetite to this Lakeview diner.
$$

3613 N. Broadway St., Chicago 60613
(at Addison)
Phone (773) 549-7606 • Fax (773) 549-7640

CATEGORY	American Diner
HOURS	Daily: 7 am-9 pm
GETTING THERE	There's street parking or take the Red Line to Addison and walk three blocks east. You can also take the #36 Broadway, #152 Addison, or #80 Irving Park bus.
PAYMENT	MasterCard VISA
POPULAR DISH	Breakfast is the way to go here. North Coast features pancakes, waffles, and a creative array of omelettes. Try the Prince Charles omelette with chicken, broccoli, almonds, onions, Jack cheese, and hollandaise sauce.
UNIQUE DISH	Try the potato casserole. Each casserole is named for an American city. The Kansas City, for example, has sirloin cubes and mushrooms.
DRINKS	BYOB. Coffee and Pepsi products are also offered.
SEATING	The North Coast Café is generously large. With dozens of tables scattered over two areas, seating is ample.
AMBIENCE/CLIENTELE	North Coast attracts casually dressed couples and locals from the surrounding Boystown neighborhood.

NORTH SIDE

The patrons tend to be older. The restaurant itself is spacious, casual, and brightly lit. There are two TVs in the dining area to keep you entertained.

EXTRA/NOTES Though the restaurant closes at 5 pm in the winter, it stays open until 9 pm in the summer and offers a large dinner menu with Greek, Italian, and American favorites.

—*Brandon Wuske*

Orange

Looking for bacon and eggs? Look elsewhere. Orange's fresh take on classic dishes is for adventurous eaters only.

$

3231 N. Clark St., Chicago 60657
(at Belmont Ave.)
Phone (773) 549-4400

CATEGORY American Restaurant

HOURS Mon-Fri: 9 am-3 pm
Sat/Sun: 8 am-2:30 pm

GETTING THERE Street parking is difficult but it is possible to find a metered space, especially during the week. To get here by bus, take the #22 Clark or #77 Belmont. Or take the Red, Purple or Brown lines to Belmont.

PAYMENT

POPULAR DISH Besides entrees like the French toast kabobs, jelly doughnut pancakes and the delicious Omelette #6 (filled with asparagus, wild oregano, and aged ack cheese topped with a balsamic reduction), Orange also offers weekly specials. One special is usually a savory egg dish and the other is a themed pancake flight made up of three silver dollar pancakes served four different ways.

UNIQUE DISH When dining at Orange, ordering Fruishi is mandatory. It's their signature appetizer and the flavors change weekly. Every order comes with one "roll" and one "sashimi," which are made out of infused rice and seasonal fruit served over fruit purée.

DRINKS A small bucket containing golf pencils and a checklist of fruits sits on every table. To order a cup of fresh squeezed juice, you simply check off which fruits you would like and give the list to your server. They also serve coffee, both plain and orange-infused. For those who enjoy citrus, the orange-infused coffee is highly recommended.

SEATING Unlike many brunch spots, Orange offers plenty of tables for more than two guests. There are booths scattered throughout the restaurant decorated with colorful throw pillows that make dining very comfortable. The best seat in the house is the booth in the front window.

AMBIENCE/CLIENTELE The bright, orange interior and laid-back staff give this restaurant a warm vibe. Due to the nature of their dishes, they attract an adventurous crowd of young and hip individuals and occasionally families. All of the orange-inspired art on the walls is fun to look at and there is always a variety of fruit displayed behind the juice counter.

OTHER ONES 2011 W. Roscoe St., Chicago 60618 (773) 248-0999

—*Anonymous Review*

NORTH SIDE

Pick Me Up Café
A laid-back vibe, a jukebox and vegan cheese fries.
$$
3408 N. Clark St., Chicago 60657
(at Roscoe St.)
Phone (773) 248-6613

CATEGORY	American Diner
HOURS	Sun: 11 am-5 am
	Mon-Thurs: 11 am-3 am
	Fri/Sat: 24 Hours
GETTING THERE	Neighborhood street parking is iffy but possible, as long as the Cubs aren't in town.
PAYMENT	
POPULAR DISH	For garlic lovers, The Bumpen Grinder—veggies and cheese on a baguette with a garlicky spread—is perfect. The gnocchi, served in a tomato cream sauce, is also delicious. The veggie chili is amazing. Sandwiches, eggs benedict, chili, pancakes, stir fry, sundaes: all your favorite food groups are represented.
UNIQUE DISH	The vegan cheese fries are pretty amazing. The vegan shakes taste pretty much like the real thing!
DRINKS	In addition to the aforementioned shakes, they have a full coffee bar and a small selection of beers.
SEATING	This isn't a huge place, but even when packed it never feels too cramped. There are lots of two- and four-seat tables and a few larger ones for the inevitable crowd that wanders in from time to time.
AMBIENCE/CLIENTELE	The Pick Me Up has a reputation of being a hipster magnet, but the truth is it attracts anyone that likes a comfortable, unique restaurant that's open into the wee hours. The décor is somehow both colorful and subdued. You might find yourself at the Monopoly table, or maybe the Wonder Woman table. Or maybe you'll find yourself tucked away in a corner with a nice vantage point for people-watching. The jukebox is a hipster's dream, with everything from Radiohead to Lou Reed and beyond. The laid-back atmosphere and diverse menu make this a nice place to grab a bite when your party is famished late at night but can't decide what kind of food to get.

—Dave Shapiro

Pizza Rustica
Enjoy the vibrant flavors of the Mediterranean just blocks away from Lake Michigan.
$$
3913 N. Sheridan Rd., Chicago 60613
(at Dakin St.)
Phone (773) 404-8955
www.pizzarusticachicago.com

CATEGORY	Italian/Pizzeria Cafe
HOURS	Sun/Mon: Noon-10 pm
	Weds/Thurs: Noon-10 pm
	Fri/Sat: Noon-11 pm
GETTING THERE	There's limited street parking, but fortunately the restaurant is just across the street from the Red Line (Sheridan station). You can also take the #80 Irving Park, #151 Sheridan, or CX80 Irving Park Express bus.
PAYMENT	

NORTH SIDE

POPULAR DISH	As you may have guessed, the pizza takes center stage here. It has a firm, sugary crust and a sweet sauce that is sure to start an addiction. The toppings are fresh and eclectic. The Patate Rosmarino pizza, for example, is topped with rosemary and thinly sliced potatoes.
UNIQUE DISH	Aside from pizza, the menu offers the gamut of Italian classics from tortellini to lasagna to panini.
DRINKS	BYOB, or sit back and enjoy an espresso, cappuccino, or lemon iced tea.
SEATING	There are several two- and four-person tables, which is sufficient since the place is rarely packed. Outdoor seating is available when the weather allows.
AMBIENCE/CLIENTELE	With its solid peach walls, red curtains, and white tablecloths, the restaurant has the casual feel of a neighborhood café. Italian-themed artwork, painted by local artists, lines the walls and adds to the cozy ambiance. If you like a piece, buy it—all of the artwork is for sale.
EXTRA/NOTES	Though the restaurant is small and usually quiet, it is great for parties. Pizza Rustica offers two four-course, prix fixe menus for special occasions. Also, you can go to the restaurant's website and print off their coupons to save a few bucks on your next meal.

—*Brandon Wuske*

TAC Quick Thai Kitchen
Authentic Thai food in chic surroundings.
$$
3930 N. Sheridan Rd., Chicago 60613
(at Dakin St.)
Phone (773) 327-5253

CATEGORY	Thai Bistro
HOURS	Sun: 11 am-11 pm Mon-Thurs: 11 am-10 pm Fri/Sat: 11 am-11 pm
GETTING THERE	Street parking in the surrounding neighborhood, but you can skip the hassle by taking the Red Line to Sheridan. The restaurant is half a block south of the station.
PAYMENT	
POPULAR DISH	The Pad Thai is fresh and delicious and served in heaping portions. TAC Quick serves hearty noodle soups with lettuce, green onion, bean sprouts, cilantro, and your choice of beef, chicken, or dumplings—the perfect tonic for a frigid Chicago night.
UNIQUE DISH	Try the peanut curry. The savory peanut flavor blends wonderfully with the rich curry. For dessert, don't miss the Thai custard, a warm bean curd cake topped with cashews and peanut shavings.
DRINKS	BYOB. If you're in the mood for something exotic, try the coconut juice served in an actual coconut shell.
SEATING	The dining room is large and has ample seating.
AMBIENCE/CLIENTELE	The sharp angles, dim lighting, candlelit tables, and dark red walls covered with abstract art create a chic but relaxed atmosphere. Although the restaurant has a trendy feel, the staff is not snooty or pretentious. You'll typically find young professionals enjoying good food and quiet conversation. It's a great place to take a date.
EXTRA/NOTES	TAC Quick delivers all items on its menu.

—*Brandon Wuske*

NORTH SIDE

Uncommon Ground
Ideal for having a casual lunch or coffee as well as a nice date.
$$$$
1214 W. Grace St., Chicago 60613
(at Clark St.)
Phone (773) 929-3680 • Fax (773) 929-0805
www.uncommonground.com

CATEGORY	American Restaurant
HOURS	Sun-Thurs: 9 am-11 pm Fri/Sat: 9 am-Midnight
GETTING THERE	It's Wrigleyville, so good luck finding a "legal" parking space. Weekdays may offer a little hope, but weekends are nearly impossible. Buses and cabs are plentiful.
PAYMENT	
POPULAR DISH	The food at Uncommon Ground is from local farmers' markets and their very own rooftop garden so the only steady year-round offerings are their burgers and appetizers. Try one of their daily or seasonal specials. In the winter, they feature pumpkin ravioli topped with a creamy sage brown butter sauce, toasted hazelnuts and Gorgonzola. In addition to seasonal pasta dishes, they also serve Italian-style pizzas with a cracker crust and a variety of cheeses and sauces.
UNIQUE DISH	Perhaps their most delicious and innovative dishes are their seafood entrees. Some of their offerings include pecan-crusted tilapia served over an orange reduction with side of couscous and skate wing with parsnip puree, crispy fennel and Marcona almond brown butter. Another popular and unique entree is their lean buffalo skirt steak served with caramelized onions and thick-cut potatoes. Though their main courses are hearty, it is a good idea to save room for dessert. Most are accompanied by their house-made gelato with flavors like whiskey, caramel goat cheese and salty peanut. Their chocolate chip banana bread pudding and whiskey gelato is highly recommended.
DRINKS	Their cocktails feature house-infused liquor like organic ginger vodka, vanilla bean bourbon and chai sweet vermouth. Year-round, they feature their tree-tini which is made with the organic ginger vodka, liquor 43, tart apple syrup and apple cider, and every time someone orders it, they plant a tree.
SEATING	There is always a crowd here but their large dining areas can accommodate several guests. There are plenty of seats available at both the bar and coffee bar for drinks only. There are also several couches scattered throughout the restaurant, perfect for lounging.
AMBIENCE/CLIENTELE	Buzzwords like "organic," "Intelligentsia coffee," and "live music" may portray Uncommon Ground as a hipster haven. However, it is a very warm and welcoming restaurant. The staff is very friendly and accommodating; it is obvious they enjoy their job and take pride in the dishes they serve. They support local artists by hanging up different pieces on their walls and contribute to the music scene by booking local musicians.
EXTRA/NOTES	On almost every night of the week, there is someone performing at Uncommon Ground.
OTHER ONES	1401 W. Devon Ave., Chicago 60660, (773) 465-9801

—*Katelyn Bogucki*

NORTH SIDE

Wakamono
Fresh sushi and an elegant atmosphere—Zen in the heart of Lakeview.
$$$
3317 N. Broadway St., Chicago 60657
(at Aldine Ave.)
Phone (773) 296-6800
www.wakamonosushi.com

CATEGORY	Japanese/Sushi Restaurant
HOURS	Daily: 4 pm-11 pm
GETTING THERE	There is some metered parking. Take the Red Line to Belmont, then hop on the #77 Belmont bus headed west until you reach Broadway.
PAYMENT	
POPULAR DISH	The fish is so fresh (it literally melts in the mouth) that one needn't move past the sashimi offerings. But if you have a hankering for maki, try the Oedipus roll (filled with fresh salmon, avocado, spicy sauce, and cucumber, topped with salmon roe & wasabi mayo), the Yo La Mango roll (mango wrapped spicy salmon, grilled asparagus, tamago, cucumber, tempura crumbs, shichimi pepper flakes) or one of the nightly specials.
UNIQUE DISH	Start the meal with miso. Wakamono adds a needed twist to this Japanese standard: fresh dashi broth, delicious nuggets of tofu, kelp, fried shallots, and the kicker: thinly sliced jalapeño.
DRINKS	Wakamono has a full bar with specialty cocktails (try the Litchi Martini), but it's also BYOB-friendly. When they say friendly, they mean it: for a nominal corkage fee, they open your bottle(s), offer an ice bucket if necessary, and provide proper stemware.
SEATING	It's a quaint dining space with 15 to 20 tables packed tightly together and a small patio, weather permitting.
AMBIENCE/CLIENTELE	The lines are clean, decorations sparse, colors neutral, and textures rich. The feeling is wholly Zen, but don't expect New Age Zen cheesiness; the owners really pull this off. You'll be transported out off the hustle and bustle of city life to a peaceful center. The bar, separated by a shoji door, takes on a more celebratory and oddly Chinese feel; a dragon pillar is the main eye attraction and WWII-era Chinese pinups adorn the walls. The clientele is mainly young/middle-aged neighborhood folks (expect them to come flooding in by 7:30 pm), but expect a diverse crowd from around the city.
EXTRA/NOTES	They offer delivery.

—*Matthew Sove*

LITTLE INDIA/ROGER'S PARK

Sher-A-Punjab
Tandoori is fab at Sher-a-Punjab!
$$
2510 W. Devon Ave., Chicago 60659
(between Campbell Ave. and Maplewood Ave.)
Phone (773) 973-4000

CATEGORY	Indian Restaurant
HOURS	Daily: 11:30 am-10 pm

NORTH SIDE

GETTING THERE	There's a free lot at St. Timothy's Church at 6326 N. Washtenaw Ave., Mon–Fri from 5–10 pm and Sat–Sun from Noon–10 pm. Or take the #155 Devon or #49B Western bus.
PAYMENT	MasterCard VISA
POPULAR DISH	Sher-A-Punjab hosts a buffet for lunch and dinner. The buffet is small with a good cross-section of foods, and you should automatically order it. Naan will be delivered to your table, but you can order tandoori dishes as well. Make as many trips to the buffet as you like, and you're sure to leave here satisfied.
UNIQUE DISH	The chicken tandoori is plentiful and feeds 4 people easily. Served plainly with lemons and onions, this is a must-have with the buffet, or as an à la carte dish.
DRINKS	Pop, water, tea, coffee, beer or wine complement the food well.
SEATING	A smallish dining room seats up to 50 people, and on weekends at dinner time it can get crowded. Small families will find seating easily, though large groups may want to choose off-peak times.
AMBIENCE/CLIENTELE	Sher-A-Punjab has a great atmosphere with lively Indian music. It is affordable with good food at a great price, and the staff is friendly, treating you like family they actually like.
EXTRA/NOTES	There are dozens of other restaurants with a similar name, one even right across the street, but none are as good. Make sure you have the correct location for the true experience. A word of caution for vegetarians: the buffet requires a working knowledge of the differences between Indian and Pakistani dishes. Labeled with names but not ingredients, vegetarians must be on guard against hidden beef. Omnivores and carnivores alike be warned: the beef typically has bones in it.

—*Susan "Devin" Droste*

Udupi Palace

A crunchyspicysoursweet vegetarian heaven.
$$

2543 W. Devon Ave., Chicago 60618
(at Maple Ave.)
Phone (773) 338-2152 • Fax (773) 338-2155
www.udupipalace.com

CATEGORY	Indian Restaurant
HOURS	Daily: 11:30 am-9:30 pm
GETTING THERE	Metered street parking is available on Devon and on some adjacent side streets, but it can be difficult to find a spot at peak times. Many side streets require a parking permit to park legally, so be careful. By bus: take the #49B Western to Devon and walk west a block and a half, or take the #155 Devon.
PAYMENT	Discover American Express MasterCard VISA
POPULAR DISH	For an all-in-one introduction to south Indian vegetarian cuisine, order a thali. You'll receive a round metal tray filled with small bowls, each holding a small portion of a different dish, typically bread, rice, soup, vegetable curries, a bean dish, yogurt relish, a spicy pickle and something sweet for dessert.
UNIQUE DISH	Dosai (huge, thin, rice crepes filled with vegetables) and uthappam (thick rice-and-lentil pancakes topped with veggies and served with sambar, a tart soup)

NORTH SIDE

	aren't strictly unique—they are south Indian but they will be an excellent novelty for diners only familiar with more typical northern menus.
DRINKS	The restaurant doesn't serve alcohol, but you're welcome to bring your own. There is no corkage fee.
SEATING	Reservations are accepted, especially for dinner and large parties.
AMBIENCE/CLIENTELE	The decor isn't the draw here: there's nothing to distinguish Udupi Palace from dozens of other Indian restaurants across the city and beyond. Come for the food and the people-watching—the tables always seem to be filled with multi-generational Indian families out for a treat, students homesick for Mom's idli, and mother/daughter pairs resting their feet after a morning's sari shopping.
EXTRA/NOTES	Indian cuisine typically uses lots of dairy products, so vegans may have to tread carefully when ordering, especially since the waiters can be vague about exactly what goes into each dish.
OTHER ONES	730 Schaumburg Rd., Schaumburg 60194, (847) 884-9570

—*Veronica Wagner*

Uru-Swati
Get your vegetarian groove on.
$$

2629 W. Devon Ave., Chicago 60659
(at Talman Ave.)
Phone (773) 262-5280 • Fax (773) 262-5281

CATEGORY	Indian Restaurant
HOURS	Sun/Mon: 11 am-9 pm Weds/Thurs: 11 am-9 pm Fri/Sat: 11 am-10 pm
GETTING THERE	Metered street parking is easy to find on weekdays, but tricky on weekends. Take the #155 Devon bus.
PAYMENT	
POPULAR DISH	Pani Puri, a dish consisting of hollow puris (rice puffs). The way to eat this is really fun. You poke a hole in the puri and put in some diced boiled potatoes, lentils and a scoop of spicy water. The result is a crunchy explosion of spicy, exotic Indian flavors that are surely pleasing to the palate. The Chana Bhatura is not too shabby either—a combination of chick peas, onions and savory exotic Indian spices gives off just the right amount of spicy flavor. The vegetarian Kesari Biryani is also very good. The potatoes, cashews, peas, onions, and exotic spices are enough to make this dish an all-time favorite.
UNIQUE DISH	They sell traditional Indian and Pakistani snacks and sweets such as Gulab Jamun—dough made of milk solids, flour and cream swimming in sugar syrup and flavored with cardamom seeds and rose water or saffron—along with other sweets such as Barfi (condensed milk with sugar), and Laddoo (balls of chickpea flour dipped in sugar syrup).
DRINKS	You will find the usual sodas, tea, coffee, and shakes. Uniquely Indian is the Lassi, which can either be sweet or traditional, with a combination of yogurt, salt, pepper, spices and ice. The Mango Lassi is absolutely one of my favorites. Falooda, a popular summer

NORTH SIDE

drink in India, Bangladesh, Pakistan and the Middle East, is a combination of rose syrup, vermicelli and tapioca seeds mixed with milk and water.

SEATING The place can seat up to 65 people at tables or booths.

AMBIENCE/CLIENTELE Uru-Swati is a laid-back, cozy place and is an ideal place for quiet lunches and dinners. One of the walls displays the Chicago skyline in 3-D and you can easily recognize the Willis Tower. The ceiling is painted like the day sky with matching fluffy clouds. The clients, as expected, are health enthusiasts. However, there are also a handful of customers giving their tummies a break from heavy meat dishes.

EXTRA/NOTES Uru-Swati offers catering for all occasions and meals can be ordered for take-out. Interestingly enough, they can ship some orders anywhere in the United States. An English-translated menu is also available.

—*Rhea Manalo*

Viceroy of India

The Viceroy of Little India commands your enjoyment.

$$$

2520 W. Devon Ave., Chicago 60659
(between Campbell Ave. and Maplewood Ave.)
Phone (773) 743-4100 • Fax (773) 743-8673
www.viceroyofindia.com

CATEGORY Indian Restaurant

HOURS Daily 11:30 am–3:30 pm, 5 pm–10 pm

GETTING THERE There is a free lot at St. Timothy's Church at 6326 N. Washtenaw Ave., Mon–Fri from 5 pm–10 pm and Sat/Sun from Noon–10 pm. Or take the #155 Devon or #49B Western bus.

PAYMENT

POPULAR DISH Try the chicken Tikka as an accompaniment to the sumptuous and varied buffet. As with many Indian restaurants, you get naan at the table. Try a little of everything. The samosas are great, as is the Mutter Paneer, rice, and the dessert choices. Note that lunch-time is buffet and dinner is à la carte.

UNIQUE DISH The chicken will complement any selection from the buffet at lunch, while during the à la carte dinner, your best bet is the Tandoori mix grill, a combo plate of meats in this traditional style with naan and rice. There is a good selection and variety of foods showing a cross-section of India's many culinary choices. A true buffet, any appetite will be satisfied at lunch, while the dinner invites family-style dining. Lovers of all levels of spice will find what suits them, and the buffet allows you to explore and try new things.

DRINKS Standard beverages served here.

SEATING There is very ample seating with a cozy, community feel. Dozens of tables can accommodate romantic couples to large groups, or even the on-the-go solo lunch diner.

AMBIENCE/CLIENTELE The decorating is upscale but cozy, bright, and perfect for groups. The lunch crowd is relaxed, the dinner crowd is predominantly families and couples.

EXTRA/NOTES The hours work strangely here, so note that from 11:30 am–3:30 pm daily there is a buffet with à la carte dishes available, while from 5 pm–10 pm it's pure à la carte. There is free live music on Friday and

NORTH SIDE

Saturday nights, making conversation difficult, but you will have fun and enjoy a true Indian experience. This is a true Indian buffet, so it's highly vegetarian-friendly.

OTHER ONES 233 E. Roosevelt Rd., Lombard 60148

—Susan "Devin" Droste

LITTLE INDIA

Your map may say "Devon," but on this stretch of the avenue, you're definitely on "Mahatma Gandhi Marg," as the city's honorary street signs advise.

Chicago's Little India runs along Devon between Western (2400 west) and roughly California (2800 west). The street is lined with sari shops and stores selling ornate gold jewelry (or armfuls of plastic bangles), bookstores with titles in Hindi and Urdu, DVD outlets offering the latest Bollywood epics, and Indian restaurants and groceries.

Hungry strollers have many choices. For casual snacks and sweets, there's **Sukhadia's** at 2559 W. Devon or **Annapurna** at 2608 W. Devon. Vegetarians are spoiled for choice at **Mysore Woodlands** (2548) or **Udupi Palace** (2543). **Gandhi India** (2601) is a popular family-style restaurant with a great lunch buffet. **Tiffin** (2536) is rather upscale, perfect for a special night out. Walk east to **Kamdar Plaza** (2646) for ready-to-eat samosas (pastries filled with spicy potatoes and peas), dhokla (steamed chickpea batter topped with peppers and cilantro), burfi (nut-based "fudge"), and a wide variety of crunchy, spicy snack mixes all available by the pound. If you can't wait to dig in, you can place an order and take a seat in the shop's miniature diner.

Rather cook it yourself? **Fresh Farms International Market** (2626) offers a huge selection of fresh fruits and vegetables (some familiar, others like bitter melon and opo squash less so), as well as large bakery and dairy sections. The takeaway counter in front sells juices squeezed to order and fruit salads. Just a few doors east at 2610, **Patel Brothers** is the place for spices (you'll never buy those tiny, expensive jars from the supermarket again!), rice, oils and ghee (clarified butter), nuts, pickles, and chutneys.

To extend your East Asian adventure, just keep walking east on Devon. When the street crosses Western Ave., its shops and restaurants change to Pakistani and Bangladeshi—but that's another tale.

—Veronica Wagner

NORTH SIDE

NORTH CENTER/RAVENSWOOD/ROSCOE VILLAGE

El Llano
The best Colombian food in Chicago is in this neighborhood gem.
$$$
3941 N. Lincoln Ave., Chicago 60613
(at Irving Park Rd.)
Phone (773) 327-1659

CATEGORY	Colombian Restaurant
HOURS	Daily: 11 am-10 pm
GETTING THERE	Metered street parking is usually available on Lincoln, Irving Park, or Damen Ave. The Irving Park Brown Line stop is about four blocks east of El Llano, and the #50 Damen and #80 Irving Park buses have stops less than half a block away. The #11 Lincoln bus stops only yards from the front door.
PAYMENT	
POPULAR DISH	Almost everything is served with a side of cassava (fried yucca root, delicious!), tostones (pressed and fried plantain), a boiled potato, and sweet plantains. I'm partial to the rib eye (ask for extra chimichurri, it's the best in the city) and the veal. I recommend the combination platter for first time visitors—it's the rib eye and a serving of their roasted chicken that should not be missed. Everything is flavored perfectly, then grilled and roasted so that the smoke and sear impart an extra level of delightfulness to the dish.
UNIQUE DISH	Try the pork skin appetizers, little delicious fatty fried nuggets of heaven, served piping hot with lime slices. Squeeze the lime, add a dash of salt and enjoy!
DRINKS	El Llano serves soft drinks in the can, fresh juices (like mango and passion fruit), and Malta. It's also BYOB with no corkage fee, so make sure you take a bottle or two of wine and enjoy!
SEATING	El Llano is pretty spacious, but there are times that are more crowded than others. Sunday lunch and dinner tend to see lots of families, so you may want to plan accordingly.
AMBIENCE/CLIENTELE	El Llano is a no-frills sort of place. There's a lot of Colombian pride demonstrated by the knickknacks on the walls and the serapes on the ceiling. The staff of El Llano is very welcoming and gracious. You'll feel like part of the family in no time!

—Clifford Etters

Hot Doug's
"There are no two finer words in the English language than 'encased meats,' my friend."
$$
3324 N. California Ave., Chicago 60618
(at Roscoe St.)
Phone (773) 279-9550 • Fax (773) 279-9553
www.hotdougs.com

CATEGORY	American Restaurant
HOURS	Mon-Sat: 10:30 am-4 pm
GETTING THERE	There may be street parking available on California. The #52 California bus also has a stop directly across the street.

NORTH SIDE

PAYMENT	$
POPULAR DISH	That's up to you! Doug's selection of encased meats from around the world is comprehensive, and his combinations of sausages and toppings elevate the humble sausage to gourmet status.
UNIQUE DISH	There are daily specials and exotic choices like the game sausage of the week. All sound delicious and are updated on their website. Doug offers duck fat fries that are amazingly delicious. If you've never treated yourself to duck fat fries, do yourself a favor and go to Hot Doug's on a Friday or Saturday, the only days these are offered.
DRINKS	Soda fountain
SEATING	Seating can be plentiful or scarce depending on how long the line is. Diner turnover is pretty quick though, and the staff is really good about keeping the tables clean and ready for new diners.
AMBIENCE/CLIENTELE	Hot Doug's atmosphere is fun and quirky with lots of hot dog memorabilia and faux-facts, and the clientele is a very eclectic mix. Locals, tourists, cube dwellers and roughnecks all brush shoulders and stand in line here!
EXTRA/NOTES	Hot Doug's is extremely popular. Unless you get there when they open at 10:30 am, expect to stand in line for at least ten minutes and if the weather's good, the wait can be as much 45 minutes. .

—Clifford Etters

Late Night Thai

If you're craving spicy food at 4 am...
$$
1650 W. Belmont Ave., Chicago 60657
(at Paulina St.)
Phone (773) 327-9945
www.latenightthai.com

CATEGORY	Thai Restaurant
HOURS	Daily: 9 pm-5 am
GETTING THERE	Metered street parking is readily available on Belmont. Otherwise, it's a short walk from the #11 Lincoln bus or the Paulina Brown Line stop.
PAYMENT	$ ATM
POPULAR DISH	The pineapple chicken (or tofu) curry is liquid gold. The coconut milk with a kick of flavorful curry smothering bell peppers and bits of pineapples. Served with a sizable side of Jasmine rice to soak up the sauce (and/or the alcohol sloshing through your body), it could easily be mistaken for soup. Other popular dishes include: Pad Thai, Khee Mao, basil chicken, Thai spicy chicken, sausage fried rice, pineapple fried rice, and Massaman curry. As with most Asian joints, tofu can be substituted for chicken or beef.
UNIQUE DISH	You won't find the Crazy Lard Nar—a combination of the Khee Mao veggies and spices with Lard Nar's noodles and gravy—anywhere else. That's because Alan concocted this wildly popular combination himself. The variety of fried rice—from sausage to shrimp to BBQ—and plethora of pineapple dishes blows other Thai places out of the water.
DRINKS	Soft drinks, tea, Thai iced tea, and water. The place is BYOB but most customers don't, given that they have

NORTH SIDE

|SEATING|already consumed a lot of "B" before arriving and are instead looking for some steaming rice to soak it up. With only five or six tables and a short wooden counter facing the front window, the seating area is cozy. You can also carry out, and lots of people do, although you sacrifice the late-night camaraderie that the small space, open room, and late hour induce.|
|AMBIENCE/CLIENTELE|Elegant dining this is not. You'll find plasticware, cafeteria-style trays, and Chinet rather than china on the wood-veneer tables, even for "here" orders. The crowd of mostly young people in various stages of inebriation, united by the common purpose of grabbing spicy late night grub, inspires feelings of almost conspiratorial friendliness. The bright, orange walls contribute to the vibrant mood, suggesting that 4 am was created for nothing so mundane as sleeping!|

—Lori Hile

Over Easy
Eggs-actly the right place for breakfast or brunch.
$$
4943 N. Damen Ave., Chicago 60625
(between Argyle St. and Ainslie St.)
Phone (773) 506-2605

CATEGORY	American Diner
HOURS	Sun: 8 am-3 pm
	Tues-Sat: 7 am-3 pm
GETTING THERE	Free street parking can be a problem, especially on weekends. The #50 Damen bus takes you virtually to the door, or take the Brown Line to Damen and walk north.
PAYMENT	
POPULAR DISH	The name's the tipoff, and the breakfast menu makes it clearer with headings like cracked eggs, eggs & flour (pancakes), and eggs & cream (French toast). Try frazzled eggs with grilled bologna and spicy maple mustard, or Emily's dream pancakes, layered with blackberries and served with orange butter and raspberry coulis. Breakfast is served all day. For lunch (11 am–3 pm), the grilled brie sandwich with Granny Smith apple and watercress is outstanding.
UNIQUE DISH	The breadth of choice makes over easy special. Sure, you can always order a coupla fried eggs with bacon and red potato hash, but check the always-changing weekend brunch specials for alternatives like Dátiles con Tocino benedict (poached eggs on an English muffin with date jam, ham, and bacon, topped with roasted red pepper hollandaise) or James Joyce's favorite breakfast sandwich (eggs scrambled with corned beef and chives, topped with Irish cheddar and piled into a toasted roll).
DRINKS	Julius Meinl coffee and loose-leaf teas.
SEATING	This is a small place, with seating for 36 (including five counter seats). Tables seat two or four and, though the ever-friendly staff will happily combine tables for larger groups, this isn't the best choice for a big gathering.
AMBIENCE/CLIENTELE	There's a retro feel to this small, cozy room, which is usually filled to capacity, especially on weekends. (Free coffee makes the wait for a table more bearable.)

NORTH SIDE

You'll see young families from the neighborhood, friends catching up over glasses of "freckled" OJ (blended with strawberries), couples and seniors, all elbow-to-elbow and having a great time.

—Veronica Wagner

Spacca Napoli
One-of-a-kind Neapolitan-style pizza in a friendly atmosphere.
$$$
1769 W. Sunnyside Ave., Chicago 60640
(between Ravenswood Ave. and Hermitage Ave.)
Phone (773) 878-2420
www.spaccanapolipizzeria.com

CATEGORY	Italian/Pizzeria Restaurant
HOURS	Sun: Noon-9 pm
	Tues: 5 pm-9 pm
	Weds-Fri: 11:30 am-3 pm, 5 pm-9 pm
	Sat: 11:30 am-10 pm
GETTING THERE	Take the Brown Line to Montrose. Street parking is also available, or you can take the #78 Montrose or #50 Damen bus.
PAYMENT	
POPULAR DISH	Bianca pizza with mozzarella di bufala, arugula, and olive oil: you don't miss the red sauce with this alternative pizza. The funghi pizza with tomatoes, mushrooms, mozzarella, and basil is a traditional mushroom pizza with creamy mozzarella. Big enough for two, insalta mista (house salad) has green and black olives and a light olive oil balsamic dressing. Also, try the tiramisu; a simply delicious way to end dinner.
UNIQUE DISH	Try the specialty pizzas, such as the Diabolo with crushed red peppers and spicy salami.
DRINKS	Italian beers and wines, limoncello, and espresso.
SEATING	The wait on a busy night can be lengthy, and there is not a lot of room to sit while waiting. During the warm weather, take advantage of the outdoor seating.
AMBIENCE/CLIENTELE	A casual and friendly ambience makes customers return to this neighborhood pizzeria. Large groups are welcome, but groups of two to four seem to take up most of the dining room.
EXTRA/NOTES	The custom-made oven was created by third- and fourth-generation Italian artisans.

—Emily Olson

NORTHWEST SIDE

NORTHWEST SIDE

ALBANY PARK/IRVING PARK

Chiyo
Asian tastiness rolled up with eclectic charm.
$$$$
3800 W. Lawrence Ave., Chicago 60625
(at Hamlin Ave.)
Phone (773) 267-1555 • Fax (773) 267-1744
www.chiyorestaurant.com

CATEGORY	Japanese Restaurant
HOURS	Sun: 4 pm-10 pm Tues-Sat: 4 pm-11 pm
GETTING THERE	There is street parking, but it's a difficult to find a spot. The #81 Lawrence bus is the closest. The Brown Line at Kimball is half a mile east.
PAYMENT	
POPULAR DISH	The most popular dishes are the sushi selections. Here you can find all the standard sashimi and maki staples, from sweet shrimp to sea urchin to yellow fin tuna. They also have some sushi combo choices as well as various non-sushi selections, such as Kobe beef and chicken teriyaki.
UNIQUE DISH	I'd never heard of either clam miso soup or a Pink Panther sushi roll (tomato, cucumber and masago) before.
DRINKS	Drinks include a broad selection of American and Japanese beer, sake, and shochu (Japanese vodka). Also, the restaurant had a Saki-tini in melon and cherry flavors.
SEATING	The restaurant has a 50-person capacity and features a roomy, single-level space. Typical of just about any Japanese restaurant, there's a counter area where you can watch your sushi being crafted.
AMBIENCE/CLIENTELE	Chiyo is just plain cute, from the smiling ceramic cat occupying a little space near the sushi counter to one of the waitresses that you almost want desperately to be your grandmother. The restaurant mixes the elegance that's standard for most Japanese restaurants (cream-colored, thin string curtains, dark wood furniture, and hanging rice paper lamps) with the quaintness of a neighborhood place (rainbow-colored Christmas tree lights draped in the front window, dolls, and mix 'n' match serving dishes).

—*Whitney Greer*

La Villa
This could be one of Tony Soprano's favorite Italian joints—only no one gets whacked here.
$$$$
363 N. Pulaski Rd., Chicago 60641
(at Patterson Ave.)
Phone (773) 283-7980 • Fax (773) 283-9539
www.lavillabanquets.com

CATEGORY	Italian Restaurant
HOURS	Mon-Thurs: 2 pm-Midnight Fri: 2 pm-1 am Sat: 11 am-1 am Sun: 11 am-11 pm

NORTHWEST SIDE

GETTING THERE	There is street parking and two large, free, off-street parking lots. You can take the #53 Pulaski or #56 Milwaukee bus, or the Metra UnionPacific Northwest line to Irving Park.
PAYMENT	
POPULAR DISH	They have thin pizza, which in the city of deep dish is somewhat of a fan favorite. Their stuffed pizza is, to an Italian-American, passive/aggressive deep dish. They also have their version of deep dish. A flavorful sauce like the recipe used at La Villa creates a pizza that garners loyal fans. Delivery starts at 10 am every day for a reason. Their salad bar, which comes free with certain meals, has everything from calamari salad to tapioca pudding.
UNIQUE DISH	The otherworldly focaccia is right out of the oven.
DRINKS	La Villa houses a complete bar away from the main dining room. The bar contains a small dining area TVs, mostly playing local sports, and the ubiquitous accordion player slaughtering sing-a-longs ranging from Jimmy Buffet to Frank Sinatra. The bar is not very complex—you have your standard popular bottled beer and a variety of mixed drinks—but it is a place to kick back with a pre-meal cocktail.
SEATING	There are small tables and private booths as well as larger tables for groups who come in to eat some of that wildly popular thin crust pizza. The tables in the main dining room can get kind of tight, but there are tables and bigger Godfather-style booths in the bar. There is an overflow dining area just beyond the bar.
AMBIENCE/CLIENTELE	The rooms are all decorated in dark red velvet and leather and lots of highly polished black wrought iron. The red plaid tablecloths and the olive oil and breadsticks on every table let you know you are in for an authentic treat. The music moves between Sinatra and Caruso. The clientele ranges from the local businessmen to families who have been coming in for generations and consider certain waitresses like one of their own. There always seems to be a local kids' sports team celebrating, or bemoaning, their last contest.
EXTRA/NOTES	On Sundays they alternate between a balloon sculptor and a magician for the kids. Every autumn (Sept-Nov), they host their Italian Fiesta, which includes a variety of amazing meals for a reasonable price. They also offer delivery.

—*Paul Barile*

McNamara's
Not the average pub, but more a surprising Irish find.
$$

4328 W. Irving Park Rd., Chicago 60641
(at Lowell Ave.)
Phone (773) 725-1800 • Fax (773) 736-1690

CATEGORY	Irish Restaurant
HOURS	Sun-Fri: 11 am-2 am
	Sat: 11 am-3 am
GETTING THERE	Located a few blocks west of the Blue Line (Irving Park station). The #80 Irving Park bus stops just one quick block away. Beware of the #80 Express! There's no stopping between destinations no matter how hard you pull the cord. Street parking along Irving Park is hit or miss throughout the week and sparse on

NORTHWEST SIDE

the weekend. However, side streets such as Lowell, Kildare Ave., and Kostner Ave. are close and free.

PAYMENT

POPULAR DISH Try the shepherd's pie, the classic McNamara burger and a slew of signature sandwiches which are delightfully colorful both to the eye and the mouth.

UNIQUE DISH Daily specials are presented with dishes like the large-portion meatloaf and chicken parmesan.

DRINKS Whether you've got a taste for a half-priced bottle of wine, a traditional cocktail, or just a stunningly dark Guinness, McNamara's eclectic and inviting bar staff is more than willing to delight with these and almost every Irish beer on tap.

SEATING Like most Irish pubs, tables in the bar are tight, yet give off a "come on in and grab a pint" atmosphere. Past the bar is the quaint, almost bistro feel, of the rather spacious dining room. Several tables and booths are placed just close enough to make you feel as though you are not the only one in the room.

AMBIENCE/CLIENTELE The large plasmas in the bar seem to blend the new world technology with the old time Irish charm. Irish paraphernalia lingering on every wall catches your eye, including the portraits adorning each table in the dining room. All year round, McNamara's brings in a very diverse crowd. During a simple lunch, you're bound to run into the local businessman on his break going over papers in a suit and tie, the mom or dad out on the lavish patio with some friends and their kids, and even the rough and scraggily lad from around the corner just in for a quick pint.

—Annalee Bronkema

Semiramis

Excellent food and friendly service equals one of the best choices for Middle Eastern food in the city.

$$

4639-41 N. Kedzie Ave., Chicago 60625
(between Eastwood Ave. and Leland Ave.)
Phone (773) 279-8900
www.semiramisrestaurant.com

CATEGORY Lebanese Restaurant

HOURS Sun-Thurs: 11 am-10 pm
Fri/Sat: 11 am-11 pm

GETTING THERE Free or metered street parking on Kedzie is usually not a problem. If you're taking the El, ride the Brown Line to Kedzie, then walk a quarter of a block south. Or from the Blue Line, transfer to an eastbound #81 Lawrence bus and exit at Kedzie.

PAYMENT

POPULAR DISH The Fattoush salad (a mélange of finely-diced cucumber, tomato, green pepper, radish, lettuce and toasted pita bread tossed with mint, lemon juice and sumac) can't be beat, especially when accompanied by the chicken chawarma special sandwich (grilled shredded chicken, eggplant, red cabbage, cucumber pickles, tomato, hummus, tahini and spicy harissa sauce). Try the lentil soup and the mixed grill (beef and lamb kabobs, served with lamb and beef "meatballs," rice and grilled vegetables). Top it off with something sweet, like a date-filled mammoul cookie.

NORTHWEST SIDE

UNIQUE DISH Sure, you've eaten French fries, but here the Lebanese version, dusted with sumac (a tart spice popular in the Middle East) and served with garlic mousse, is unique and addictive.

DRINKS Semiramis is BYOB with a low corkage fee, and there's a handy liquor store right across the street. End your meal with the Arabic coffee flavored with cardamom.

SEATING The restaurant can seat about 50 diners, at paper-topped two- and four-person tables (which can be combined for larger parties). The dining room is bright and airy and hung with colorful ethnic textiles. On most weekdays, you'll be seated promptly.

AMBIENCE/CLIENTELE You'll share the dining room with a mixture of neighborhood people who share the owners' Middle-Eastern background, vegetarians who come for the excellent baba ghannouj, tabbouleh and falafel (all available on the often-ordered vegetarian plate), and assorted chowhounds from all over the city.

EXTRA/NOTES You can book a private party here, order for delivery (with a low delivery charge and minimum), or drop in to pick up take-away orders.

—*Veronica Wagner*

Smoque
The wonderful world of BBQ at your fingertips, napkins included.
$$$
3800 N. Pulaski Rd., Chicago 60641
(at Grace St.)
Phone (773) 545-7427
www.smoquebbq.com

CATEGORY Barbecue Cafeteria

HOURS Sun: 11 am-9 pm
Tues-Thurs: 11 am-9 pm
Fri/Sat: 11 am-10 pm

GETTING THERE There is a small off-street lot, some street parking on Pulaski, and it's a short walk from the Blue Line (Irving Park stop). You can also take the #53 Pulaski or #80 Irving Park bus.

PAYMENT

POPULAR DISH People come from all over for the mouthwatering brisket. The brisket goes through an intensive cooking procedure that guarantees smoky, rich quality and complex flavor. Rather than bury their finely selected and seasoned meats in BBQ sauce, the good people at Smoque rely more heavily on the rubs. In the case of the brisket, they employ a two-layer spice rub before applying a thin coat of sauce.

UNIQUE DISH Baked macaroni and cheese is an art form and should not be trifled or experimented with. It is a casserole-type dish brimming with thick noodles, bathed in velvety cheese and covered by a crusty top, making the entire dish like a small pie rather than the standard mac & cheese.

DRINKS There is a soda dispenser and canned pop, but that is pretty much it.

SEATING The hard wooden everything and red-and-white plaid tablecloths lends an authentic feel. There is a high school cafeteria aesthetic that keeps the diner focused on the meal. Smoque is one of those places where someone will look at your plate, ask you about your dinner and before you know it, you have a new friend.

NORTHWEST SIDE

AMBIENCE/CLIENTELE There is a harried sense about the place. The dining room is stripped down, but without the feeling that you are missing anything. The clientele are primarily locals who are smart enough to grab it and go. One good sign is there are always owners on hand to check to make sure you are enjoying your meal. The layout is very casual. This is a place where lawyers in their Top-Siders and sweaters rub elbows with mechanics in their greasy overalls and everyone is equal—and equally satisfied by their meal.

—Paul Barile

JEFFERSON PARK/PORTAGE PARK/NORWOOD PARK

Gale Street Inn

If you want to go to New York but can't, try this dim, cozy favorite!
$$$
4914 N. Milwaukee Ave., Chicago 60630
(at Gale St.)
Phone (773) 725-1300 • Fax (773) 725-0859
www.galestreet.com

CATEGORY American Restaurant
HOURS Sun: 10:30 pm-9 pm
Mon: 4 pm-10 pm
Tues-Thurs: 11:30 am-10 pm
Fri: 11:30 am-10:30 pm
Sat: 4 pm-10:30 pm
GETTING THERE There is a free lot available right next door to the restaurant. The Jefferson Park terminal is right across the street (home to the Blue Line, Metra Union Pacific Northwest station, and the X54 Cicero Express, #56 Milwaukee and #56A North Milwaukee, #68 Northwest Highway, #81 Lawrence and #81W West Lawrence, #85 Central and #85A North Central, #88 Higgins, #91 Austin, and #92 Foster buses).
PAYMENT
POPULAR DISH The primary item, the one that is the "backbone of success" per the restaurant's menu, are the fall-off-the-bone ribs served with a savory barbecue sauce made in-house. Other yummy options include salmon, shrimp, steak sandwiches and some seriously outstanding steak fries and salads.
UNIQUE DISH The most unique dish is the chicken tortellini alfredo; most of the other selections were pretty typical. Delicious, but standard.
DRINKS Drinks include a selection of Argentinean, Chilean and Italian wines, as well as signature martinis (with names like Metratini and the Blue Line, in tribute to the transportation center available nearby).
SEATING The restaurant has a 200-person capacity. In the front, there are a series of large, comfortable, leather and wood booths right beside a long, well-stocked bar. In the back, there's a larger, more traditional dining area.
AMBIENCE/CLIENTELE A friend said, "I feel like I'm in New York, in some old, mysterious, historic lounge." Gale Street Inn is a

NORTHWEST SIDE

very warm, very friendly place that attracts all kinds of Jefferson Park locals, including commuters just getting off from work. The low lighting, red glass votives, classic jazz selections, wood paneling, upholstered seats and Tiffany-inspired lamps (especially in the front of the restaurant), lends an older, relaxed atmosphere where everybody feels welcome.

EXTRA/NOTES Every year around August, the restaurant has a Rib-stock celebration. They play music from 1969 and dip the restaurant in hippy decor under the tagline, "All We Ask is Give Pork a Chance!"

—*Whitney Greer*

Hops & Barley

Traditional neighborhood bar with a not-so-traditional hipster vibe.
$$$
4359 N. Milwaukee Ave., Chicago 60641
(at Montrose Ave.)
Phone (773) 286-7415 • Fax (773) 286-7413

CATEGORY American Bar & Grill
HOURS Sun: 11 am-2 am
Mon-Fri: 3 pm-2 am
Sat: 11 am-3 am
GETTING THERE Street parking is available and is relatively easy. The best two public transit methods are taking the Blue Line to Montrose or the #56 Milwaukee bus to Milwaukee and Montrose. Taxis are a bit hard to find. (As opposed to taking your chances and waiting, just calling one would be advisable.)
PAYMENT
POPULAR DISH The menu is a pretty traditional selection of bar food, including fried and grilled calamari, Buffalo wings, burgers (including a very delicious turkey version), salads and sandwiches.
UNIQUE DISH One particularly unique menu item is the fried cheesecake called Xango.
DRINKS Drinks include the standard selection of beer and cocktails in addition to some very popular microbrew selections.
SEATING The restaurant has a 75-person capacity. There are two levels—a larger main floor with wooden seats and a smaller lounge on the lower level with leather booths. During warmer weather, there's an outdoor seating area in front of the bar.
AMBIENCE/CLIENTELE Hops & Barley is in the historic Klafter building, which was originally built in the 1920s by David Saul Klafter. Mostly frequented by locals, the main floor has exposed brick, wooden floors, and high ceilings, all which help create a more relaxed atmosphere. There are also five plasma televisions. The lower level feels a little different. Wrap-around, black leather booths and a pool table add a little more elegance (and are generally rented out for parties and other special events).
EXTRA/NOTES Primarily, a computerized jukebox provides the music. T-shirts with the Hops & Barley logo are for sale.

—*Whitney Greer*

NORTHWEST SIDE

Sami Swoi
Live by the swoi!
$$
3550 N. Austin Ave., Chicago 60634
(at Addison St.)
Phone (773) 685-5005
www.samiswoi.us

CATEGORY	Polish Restaurant
HOURS	Daily: 10 am-11 pm
GETTING THERE	Located in a strip mall, Sami Swoi has free parking in front of the restaurant. The lot is shared with Dunkin Donuts, so parking can be tight at times. You can also get here via the #152 Addison or #91 Austin bus.
PAYMENT	
POPULAR DISH	You must get the potato pancakes! Deceptively greasy (but not grossly so), they are seasoned and served with sour cream. As an appetizer, the portion could easily feed two or three people. The pancakes are the perfect size and thickness. Sami Swoi's potato pancakes are fried, but not too crispy, allowing eaters to chew (not crunch) their way to heaven.
UNIQUE DISH	Borscht, a traditional vegetable stew made from beetroot (giving the soup its deep color), is a menu standout. Typically served on Easter, white borscht is made from the cooking water of white Polish kielbasa. The stew also has garlic, sliced hardboiled eggs, and sausage. Sami Swoi also serves red borscht with ravioli and tripe soup.
DRINKS	The restaurant also offers full bar service, including some favorite Polish beer and wine. The small but cute bar area is a nice spot to grab a quick drink alone or with a friend.
SEATING	The restaurant is spacious and airy and rarely crowded. Outdoor seating is available in the spring and summer months. The bar area also has high table seating.
AMBIENCE/CLIENTELE	The restaurant is laid-back and decorated with wood tables and ceramic tile floors. The clientele is mostly European and Polish-speaking but extremely friendly. I went in to pick up a lunch and ended up eating at the restaurant with a patron that had obviously been drinking since the place opened at 10am.
EXTRA/NOTES	Sami Swoi offers catering space to rent for special occasions as well.

—*Heather Calomese*

Sicilia Bakery
Serving an authentic Italian experience.
$$$
5939 W. Lawrence Ave., Chicago 60630
(at Austin Ave.)
Phone (773) 545-4464
www.siciliabakerychicago.com

CATEGORY	American Bakery
HOURS	Sun: 8 am-1 pm Tues-Fri: 8 am-6 pm
GETTING THERE	Free parking available for Sicilia Bakery customers only. You can also take the #81W West Lawrence, #85 Central, or #91 Austin bus.
PAYMENT	$
POPULAR DISH	The spinach and ricotta pizza is mouthwatering and they serve the best cannolis in the city.

NORTHWEST SIDE

UNIQUE DISH	They have a full bakery and deli, which makes it an ideal lunch spot for custom-made sub sandwiches. They offer a wide assortment of imported meats and cheeses and a variety of homemade bread.
DRINKS	Soda, water and juices are available.
SEATING	none
AMBIENCE/CLIENTELE	Sicilia Bakery is Chicago's best-kept secret. A member of the family greets you when you walk into the large bakery lined with old-fashioned deli counters. At first, the lack of ambience may throw you, but once you sink your teeth into the mouthwatering treats, you'll keep coming back for more!
EXTRA/NOTES	Joe started the company in 1958, soon after he moved to this country from Sicily. Not speaking any English, he started a business doing the one thing he knew like the back of his hand: baking. Today, he has a loyal clientele and continues to grow the establishment for future generations to enjoy. Just like their slogan says—bring home a taste of Sicily, today!

—Rachael Smith

Superdawg Drive-In

Retro decor and car-side service for an all-American combo.

$

6363 N. Milwaukee Ave., Chicago 60646
(between Devon Ave. and Nagle Ave.)
Phone (773) 478-7800 • Fax (773) 763-0660
www.superdawg.com

CATEGORY	American Fast food
HOURS	Sun-Thurs: 11 am-1 am Fri/Sat: 11 am-2 am
GETTING THERE	Parking is limited in the private lot, but it's a must for the true drive-in experience. If taking public transit, use the #56A North Milwaukee or Pace #270 bus.
PAYMENT	$
POPULAR DISH	A Superdawg is a must-have when visiting this drive-in. Placed in a poppyseed bun, this hot dog covered in mustard, piccalilli, pickle, Spanish onions and hot peppers sits on a bed of fries. Half the fun is the retro-looking box it comes in. It depicts Maurie and Flaurie and states "Your Superdawg Lounges Inside contentedly cushioned in...Superfries."
UNIQUE DISH	Besides the hotdog/hamburger fare, Superdawg offers Superonionchips (chip-shaped chunks of battered onions), Supervegggies (mixed battered veggies) and tamales battered in cornmeal.
DRINKS	Superdawg serves the standard sodas but is well known for its Supermalts and Supershakes. So thick you can't drink them through a straw, the staff offers to thin them down if preferred.
SEATING	Only the number of parking spots available and the size of your vehicle limit "seating." If you choose not to stay in your car, there is a counter to eat at inside.
AMBIENCE/CLIENTELE	Eating off a car-window tray might invoke feeling of nostalgia in older patrons. For a generation whose experience of ordering food from the car is limited to fast food drive-thrus, pulling into a parking spot to order off individual menu boards and waiting for a carhop to bring your meal will be exciting. They will also be entertained by the trademark male and female hotdogs atop the Superdawg roof, reminiscent of the

NORTHWEST SIDE

	Route 66 roadside giants, which flirtatiously wink their glowing eyes back and forth at each other.
EXTRA/NOTES	Superdawg is a popular hangout for car enthusiasts who stop in with their vintage automobiles, adding to the yesteryear ambience. Regular Superdawg cruises take place on Friday evenings in the summer. Winter cruises occasionally take place depending on when roads are dry. (See sidebar.)
OTHER ONES	Midway Airport's B Concourse, servicing Southwest Airlines.

—*Lisa Hede*

THE DRIVE-IN

A Look Back at a Popular American Tradition

The start of the fast food industry began when more and more Americans began choosing to eat outside their homes. Entrepreneurs took advantage of this by finding new ways to serve food fast and to make their service reliable for the convenience of the customer. One such concept was the drive-in restaurant. Although having been around since the twenties, it was decades later before drive-ins really peaked in popularity.

The idea behind the drive-in restaurants was that a patron could order and eat without ever having to leave the car. Drivers reviewed menus posted alongside the parking slots and met with carhops who took their order. Once ready, the carhop would then bring the meal out on a tray designed to hang from the car's window. Once finished, the patron would turn on their headlights to signal the carhop, who then returned to remove the tray. The need for these carhops later diminished with the invention of ordering through intercoms. This lead to the increase in popularity of fast food franchises and drive-through restaurants and the drive-in concept was soon lost.

—*Lisa Hede*

LINCOLN SQUARE

Barba Yianni
Seek the true treasure hiding behind a Greek façade!
$$$$
4761 N. Lincoln Ave., Chicago 60625
(at Western Ave.)
Phone (773) 878-6400 • Fax (773) 271-1316
www.barbayianni.com

CATEGORY	Greek Restaurant
HOURS	Sun-Thurs: 11 am-Midnight
	Fri/Sat: 11 am-2 am
GETTING THERE	There is a pay parking lot on Lincoln Ave., or a short walk from the Brown Line stop at Western Ave. You

NORTHWEST SIDE

can also take the #81 Lawrence, #49 Western, or CX49 Western Express bus.

PAYMENT

POPULAR DISH The combo plate is the best way to sample the most popular dishes, from dolmades to mousaka to roast lamb. For the more carnivorous, any of the grilled meat entrees will satisfy. The saganaki appetizer is a must-have, and most dishes come with the delicious lemon egg soup.

UNIQUE DISH If you're feeling adventurous, try cold Baby Octopus and Kalamari in oil & vinegar, served with chopped onions and carrots. Truly Greek, and truly out there.

DRINKS This restaurant's main feature is late night dining on the weekends. You can order off the full menu, but you might want to stick to appetizers and cocktails from the full bar while you dance or watch the show with a large group.

SEATING Multiple levels surround the dance floor with tables to seat couples or groups of four. These can easily be moved to seat larger groups. Up to 200 people can pack this taverna.

AMBIENCE/CLIENTELE You will find mostly locals during the week, and on the weekends, Middle Easterners come out for the live entertainment.

EXTRA/NOTES While the service is not always the quickest, on a Friday or Saturday night, you will enjoy waiting so you can enjoy the show. The live band plays for hours and dancers are welcome to enjoy, but at 11:30 pm and 1:30 am the true treat arrives. A stunning bellydancer shows you traditional Middle Eastern entertainment you will not want to miss. Bring your friends, order a few snacks and lots of drinks, and enjoy.

—Noe Quick

The Book Cellar

A whimsical hybrid bookstore, wine cellar and café.
$$
4738 N. Lincoln Ave., Chicago 60625
(at Lawrence Ave.)
Phone (773) 293-2665
www.bookcellarinc.com

CATEGORY American Cafe

HOURS Sun: Noon-6 pm
Mon: 10 am-10 pm
Tues: Noon-6 pm
Weds-Fri: 10 am-10 pm

GETTING THERE Lots of parking options, including two nearby parking lots. You can also take the Brown Line to Western or the #81 Lawrence bus.

PAYMENT

POPULAR DISH A chopped salad is on the menu all year, packed with crisp romaine lettuce, roasted vegetables, broccoli, radishes, feta cheese, parmesan and buttermilk herb dressing. The second salad is always seasonal, drawing inspiration from local fruits. A good rotating variety of seasonal soups are offered, especially in winter months, but the year-round, highly recommended specialty is the vegetarian chili. Each sandwich is made specifically to order with the freshest ingredients possible. The Italiano grilled cheese is a grown-up version of a childhood classic, served warm and oozing

NORTHWEST SIDE

with mozzarella, fresh basil and tomatoes grilled on a panini press. The "Etc." section of the menu offers a restaurant-quality cheese plate and hummus plate. Desserts are locally made, and a key option is an award-winning cupcake from Southport Grocery and Café in Lakeview.

DRINKS Traditional café fare—coffee, teas and espresso drinks—are provided by local Austrian coffee house Julius Meinl. Seasonal drinks include a root beer float and hot apple cider. Wines rotate throughout the year. The beer menu incorporates fine ales from Belgian-style brewery Unibroue (which is based in Chambly, Quebec) as well as options from local beloved brewpub Goose Island.

SEATING If you're not lucky enough to snag a comfortable armchair by the window, café seating is also available. Space is limited without feeling overcrowded. An expansive magazine rack with a good variety of options dominates one wall of the café area.

AMBIENCE/CLIENTELE The Book Cellar has been able to keep the balance of bookstore, wine cellar and cafe, creating a harmonious, inviting space. The store is community-oriented, not only through use of local ingredients, but also with a Chicago-author driven selection of titles and a wide selection of books focusing on the city. With its unique concept, Book Cellar has gained a following outside of Lincoln Square, offering an idyllic escape to a charming neighborhood.

EXTRA/NOTES Check out The Book Cellar for author signings and book club meetings. They are happy to order any book that they do not have in stock.

—Denise Peñacerrada

Chicago Brauhaus

Sausages that make Abe Froman, the Sausage King of America, jealous!

$$$

4732 N. Lincoln Ave., Chicago 60625
(at Leland Ave.)
Phone (773) 784-4444 • Fax (773) 784-2092
www.chicagobrauhaus.com

CATEGORY German Restaurant
HOURS Sun: 4 pm-Midnight
Mon: 11 am-10 pm
Weds-Thurs: 11 am-10 pm
Fri: 11 am-Midnight
Sat: 4 pm-Midnight

GETTING THERE For $1 you can park in the lot just across the street on Lincoln Ave. for up to two hours. Just steps away from the Brown Line (Western stop) and the #11 Lincoln or #49 Western bus.

PAYMENT
POPULAR DISH The most tried-and-true dish at the Brauhaus is the Wiener Schnitzel. A generous portion, lightly breaded and fried, will leave you and your guests full, happy, and with plenty of leftovers to keep the experience of this dish alive after you leave the restaurant. The Schnitzel is served with your choice of potato and the house vegetable, but I recommend you try the spaetzle with this dish for some added texture and flavor. The

NORTHWEST SIDE

	Gebackene Ente (roasted duckling) will leave even the most flavor-hungry patrons satisfied.
DRINKS	Chicago Brauhaus offers a delightful menu of beer, including: Stiegl, Spaten Lager, and their own Chicago Brauhaus Lager Bier. For the more avid beer drinker, or just some great memories, Chicago Brauhaus offers a gigantic boot from which you can drink your lager.
SEATING	Seating is set up around a dance floor, offering each guest a great spot to people-watch and listen to the live entertainment while dining. Tables are nicely spaced apart from each other, giving you enough breathing room between neighbors, but still allowing you to be in the midst of all the fun.
AMBIENCE/CLIENTELE	Chicago Brauhaus is a great place to go for a night of dinner and dancing. There is a live house band that plays everything from the chicken dance to classic German songs. Guests are always encouraged to dance, but there is certainly no harm in just people-watching while savoring your meal. There are pictures displayed wall-to-wall, offering guests a visual history of the Brauhaus and patrons over the years. No matter the day, the moment you step into the Brauhaus, you feel as though you are in the midst of Oktoberfest in Germany.

—*Jenna Noble*

Drew's Eatery

Fast food you can rave about with your Weight Watchers sponsor!
$$

2207 W. Montrose Ave., Chicago 60618
(at Lincoln Ave.)
Phone (773) 463-7397
www.drewseatery.com

CATEGORY	American Cafeteria
HOURS	Sun: 11 am-7 pm Tues-Thurs: 11 am-7 pm Fri/Sat 11 am-8 pm
GETTING THERE	Street parking: possible, but not always available. There are several metered parking spaces along Lincoln and Montrose. Pay lot: located on Lincoln between Sunnyside Ave. and Wilson Ave. Train: CTA Brown Line at Western or Montrose. Bus: #11 Lincoln or #78 Montrose.
PAYMENT	
POPULAR DISH	Drew's Eatery gives a unique and healthy twist to the hot dog. Whether you're a hard-core carnivore, a chickenarian, or a vegan, Drew has an organic, nitrate-free hot dog for you. Take your pick of beef, pork, chicken/turkey or tofu and they'll serve it up on an organic wheat bun with your choice of toppings. Check out their selection of organic Wisconsin-made ice cream or try one of the beautiful cookies on display from Sweet Dreams bakery.
UNIQUE DISH	They have a great selection of homemade soups and sandwiches. Both sandwiches and hot dogs can be added into Drew's combo (dog or sandwich with a side of kettle chips, soup, chili, or applesauce).
DRINKS	As you move through the line, grab a glass of Drew's organic flavored iced tea.
SEATING	Booths and tables line the walls of this bright, sunny, small eatery. While the interior of Drew's is nice, I prefer to get my meal and take it to the park.

NORTHWEST SIDE

AMBIENCE/CLIENTELE With its close proximity to Welles Park, Drew's Eatery is in the perfect spot to feed the masses after every T-ball, flag football, and soccer game. With all of the commotion surrounding it, Drew's keeps its quaint, neighborhood feel. You'll find local families, couples, and singles lining up for a fast, healthy, and delicious deal.

EXTRA/NOTES Drew's Eatery strives to serve all organic, regionally produced food that is 100% chemical-free. Drew's has been hailed as one of the greenest restaurants in Chicago, going above and beyond the call to support a more environmentally conscious city.

—Dana Bottenfield

Garcia's

The naked burrito and other late night feasts!
$$$
4749 N. Western Ave., Chicago 60625
(at Lawrence Ave.)
Phone (773) 769-5600

CATEGORY Mexican Restaurant
HOURS Sun: 10 am-Midnight
Mon-Thurs: 10 am-1 am
Fri: 10 am-3 am
GETTING THERE Garcia's is 1 block north of the Brown Line (Western stop), and there is metered parking along Lincoln or Western. You can also take the #81 Lawrence, #49 Western or CX49 Western Express bus.
PAYMENT
POPULAR DISH Burritos, enchiladas, and combo plates abound. The large portions are customizable, flavorful, and come with a wide variety of meat and sauces. Everything complements the free chips and fresh salsa. Enchiladas Suiza and the Two-taco plate are local favorites not to be missed. The naked burritos and other huge portions guarantee delicious leftovers.
UNIQUE DISH Avocado lovers rejoice! The aguacate ensalada is huge: a bed of greens and tomatoes with onions, topped by a whole sliced avocado, accented with lime wedges and ranch sauce. A meal in itself, it is not to be missed if you salivate at the word "guacamole."
DRINKS The margaritas are excellent, and any type of drink or beer can be had, but the one not to miss is the horchata, a rice drink spiced with cinnamon. Garcia's has the best in the city, but do order it sans ice if you want to truly appreciate this sweet concoction.
SEATING The long and narrow room is lined with tables, and during a dinner rush there can be a wait for a seat. During off-peak times you can seat yourself with ease.
AMBIENCE/CLIENTELE Locals of all ages and manners of dress flock here. At lunch expect a sea of suits; at dinner, families, groups, and couples; late at night you'll see barhoppers and the post-college crowd fresh from Lincoln Bowl for some good food. Tables are crammed together tightly, the lighting is low in the dining room and dim in the bar, which runs soccer matches almost constantly on the TVs. A jukebox is the sole provider of music. Expect at random intervals adult easy listening, Tejano, and Top 40 rising above the steady hum of conversation.
EXTRA/NOTES Everything is available for take-out.

—Noe Quick

NORTHWEST SIDE

ELI'S CHEESECAKE WORLD

Most of are familiar with **Eli's Cheesecake**. We have eaten it at the Taste of Chicago, the Magnificent Mile Festival of Lights and had it for dessert in some of Chicago's greatest restaurants.

So why is it that so many Chicagoans do not know about Eli's Cheesecake World?

Eli's has a retail store that is open to the public. Inside you can find a great variety of cheesecakes and pastries, from the decadent to diabetic-friendly products in a variety of sizes and prices. The retail store has a great a great sit-down or carry-out café with sandwiches, salads, single-serve deserts, coffee and light refreshments. The staff is always friendly and more often than not, the owner and president of the company is on hand.

Eli's offers super cool tours of their facility. Our small group took a tour of the bakery, got our picture taken in hairnets, tasted cheesecake and even decorated our own small cakes to take home!

The special events at Eli's seem limitless, from farmers markets to dock sales where you can get some serious bargains, cookie and cake decorating classes and grandest the event of all, the annual Cheesecake Festival. This festival is a weekend event with special cheesecake sales, a classic car show, culinary demonstrations, live music and special vendors, all to benefit the Greater Chicago Food Depository and the New Horizons Center for the Developmentally Disabled.

Don't be discouraged by the city address, Eli's has plenty of free parking!!

6701 W. Forest Preserve Dr., Chicago 60634, (773) 205-3800é, www.elicheesecake.com

—*Julie Owens*

San Soo Gab San

Fire, danger, thrills & chills await you at San Soo Gab San.
$$$
5247 N. Western Ave., Chicago 60625
(at Berwyn Ave.)
Phone (773) 334-1589

CATEGORY	Korean Restaurant
HOURS	Daily: 10 am-4:30 am
GETTING THERE	The small parking lot should be used with care; break-ins are frequent. You can also take the #92 Foster, #49 Western or CX49 Western Express bus.
PAYMENT	
POPULAR DISH	Bulgogi is traditional Korean BBQ, and San Soo Gab San has earned the many awards they have been honored with. Cooking it yourself allows you to have it bloody rare or crispy-critter-well-done.
UNIQUE DISH	With every order you get dozens of small side dishes free. No need to order an appetizer with all this! Traditional kimchee sits beside what can only be described as fish Jell-O amidst many other sauces and vegetables. Share with the whole table and try something new.

NORTHWEST SIDE

DRINKS Pop, coffee, and tea are served along with domestic beers, sake, and both domestic and Korean wines.

SEATING Large groups and couples are both easily accommodated. Up to 100 people can eat in, and on a Friday or Saturday night you might find that many. Each booth feels private. Although you can hear other diners and smell the charcoal, you feel like you're alone.

AMBIENCE/CLIENTELE The service is slow but friendly, though English is not the strong suit here. The customers are predominantly local Koreans, but all locals in the know come here for the city's best Korean BBQ.

EXTRA/NOTES You can get anything take-out, but dine in for all the extras.

—*Noe Quick*

Waba
Crouching Korean, hidden bar...
$$$$
5100 N. Western Ave., Chicago 60625
(at Carmen Ave.)
Phone (773) 728-3222

CATEGORY Korean Lounge

HOURS Daily: 6 pm-2 am

GETTING THERE There is plentiful free street parking, or take the #81 Lawrence bus or the Brown Line (Western stop).

PAYMENT ATM, Discover, MasterCard, VISA

POPULAR DISH Popcorn chicken, vegetable rolls, kimchee—any of their appetizers will please your group. Being more of a bar than a restaurant, focus on the great cocktails, the dance music, and the easily downed munchies late at night. Dishes range from giant to tiny, so treat it like a gamble. The huge menu certainly makes it a fun outing for a group.

UNIQUE DISH For the adventurous and insane only, there is the #36 super-spicy pork and calamari mix. If you like exotic calamari and pork mixed with vegetables and spiced until they are blazing red, this is the dish for you, but only if you can handle heaping helpings of suckers.

DRINKS The full bar can make you anything you'd like and has daily specials, but no traditional Korean drinks. Beware the rice wine...you don't realize how much bite it has until you're on your back in the middle of the dance floor.

SEATING Private-feeling booths line the dance floor/dining area and comfortably hold up to 100 people, but many hang around the bar lining one wall.

AMBIENCE/CLIENTELE Blink and you'll miss it. The exterior is drab, the entry is dark and hostess-free, but there is a great bar and restaurant hiding inside. Before midnight, expect to be the only customers there. Decorated in black and red like a generic Asian club, the mood is romantic for couples, but later affords the perfect dance club atmosphere for groups. Top 40 dance music is always playing and you never know if the TVs will show sports, news, or music videos. The food is great, but the service is a little slow, and when you first come in you'll have to make noise to summon the hostess/bartender/waitress.

—*Noe Quick*

WEST SIDE

WEST SIDE

HUMBOLDT PARK

Cemitas Puebla
¡Mira, mira, taqueria! This is Mexican food like none other in Chicago.
$$
3619 W. North Ave., Chicago 60647
(at Monticello Ave.)
Phone (773) 772-8435
www.cemitaspuebla.com

CATEGORY	Mexican Dive
HOURS	Daily: 11 am-9 pm
GETTING THERE	Metered street parking with limited parking in rear. You can also take the #72 North or #82 Kimball/Homan bus.
PAYMENT	
POPULAR DISH	The Cemitas sandwich. First of all, it shuns the ubiquitous tortilla for a fluffy sesame seed roll and adds sliced avocado, queso Oaxaca (a mozzarella-like white cheese), adobo chipotle peppers, homemade salsa roja, and when in season, fresh papalo, a pungent Mexican herb. The Cemitas Milanesa is made with a thinly pounded, breaded, fried pork loin. The tangy Cemitas carnitas is built around a healthy serving of stewed pork. Then there's the Cemitas asada offering a generous serving of steak.
UNIQUE DISH	If you're seeking something truly different, try the Cemitas pata featuring sliced cows' foot.
DRINKS	BYOB with no corkage fee. (Seriously!) There is no bar, but plenty of fruit-flavored Jarritos and standard Coke products.
SEATING	There are approximately 30 seats. No fancy white tablecloths. Just sit your rear in a chair, eat, drink, and be merry.
AMBIENCE/CLIENTELE	Keep an open mind about the decor and overall appearance of the restaurant. It's the ultimate example of a neighborhood dive that has one thing going for it: amazing food. Served with a broad, inviting smile, the staff makes you feel like you are the most important customer of the day. The extensive menu can seem intimidating so don't hesitate to ask questions. The atmosphere is family friendly, but it's also good for groups.

—*David Kravitz Marquis Tucker*

CJ's Eatery
A treasure hidden along a drab stretch of car repair shops.
$$
3839 W. Grand Ave., Chicago 60651
(at Avers Ave.)
Phone (773) 292-0990
www.cjs-eatery.com

CATEGORY	American Restaurant
HOURS	Thurs-Sat: 8 am-9 pm Sun: 9 am-8 pm
GETTING THERE	Free street parking can be difficult on Grand, so try one of the side streets nearby. The #65 Grand bus runs past the restaurant. If you're riding the El, take the Blue Line to Grand, transfer to the Grand Ave.

WEST SIDE

bus, exit at Hamlin (3800 W.) and walk one block west to Avers.

PAYMENT

POPULAR DISH Breakfast/brunch is the big draw here and, given the available choices, it's definitely a mix-and-match kind of a meal. Favorites include huevos rancheros and a satisfying egg-and-sausage casserole. Go Southern with shrimp and grits, catfish, or ethereal biscuits and gravy. Keep going—who says you can't have dessert at breakfast? Key lime pie is a standout, or check the chalkboard for the day's specials.

UNIQUE DISH Banana bread pudding with peanut-butter anglaise.

DRINKS CJ's offers a wide variety of Lavazza coffee drinks and outstanding homemade lemonade. The restaurant doesn't serve liquor, but you're welcome to bring your own bottle; there's a $2 corkage fee.

SEATING Four booths and a dozen or so tables seat about 50 in a brick-walled, wedge-shaped room that used to be a neighborhood social club.

AMBIENCE/CLIENTELE This is an owner-operated restaurant, and chef Charles Armstead is likely to pop out of the open kitchen to see how you're doing. Service can be a bit laid-back but is always very friendly and accommodating—these folks really want you to be satisfied and happy. You'll be eating with a mixed bag of families from the neighborhood and North Side hipsters in on the secret.

—*Veronica Wagner*

Coco

Coco: the Caribbean castle of love and food...but mostly just food.
$$$$
2723 W. Division St., Chicago 60622
(at California Ave.)
Phone (773) 384-4811 • Fax (773) 384-4812
www.cocochicago.com

CATEGORY Puerto Rican Restaurant

HOURS Mon-Weds: 11 am-10:30 pm
Thurs/Fri: 11 am-2 am
Sat: 11 am-3 am

GETTING THERE Parking is easy, especially on the side streets near Coco. Alternatively, the #70 Division or #52 California bus will drop you off very close.

PAYMENT

POPULAR DISH The Mofongo de Yuca is served with crabmeat in a flavorful tomato sauce and is something to be ordered over and over again. Lomo de Cerdo, a pork dish served with a subtle and slightly sweet mango sauce is the definition of simple elegance; the flavors of the pork and the sauce play off each other in an understated and ingenious way.

UNIQUE DISH Forget rice and beans—Mofong de Yuca is the new quintessential Caribbean dish.

DRINKS Coco features wines from the Southern Hemisphere. The list is short and sweet but expertly chosen. The martini and cocktail menus really shine here. Often the bartender will create a special for the night, and they'll even let you "try before you buy." The Coconut Martini has a surprisingly mild coconut flavor, but is clean and light and perfect for dinner.

WEST SIDE

SEATING The dining area is large enough to host large groups. The lively bar lines the right side of the restaurant but seems relatively separate from the dining area just across the room. There is enough space for the many people who file in throughout the weekend for lunch and dinner, but still maintains a semblance of a family-owned restaurant.

AMBIENCE/CLIENTELE The atmosphere is warm and modern, with hints of the Caribbean throughout. You know the food is good when locals from the surrounding Puerto Rican community flow in leisurely throughout the night. Summer, without a doubt, is the best time to visit.

EXTRA/NOTES There are live salsa bands that play every Thursday, Friday, and Saturday night starting at 10 pm. The restaurant turns into a great place to dance, drink, and party the night away without a cover.

—*April Schneider*

Streetside Bar & Grill

A great place to grab a bite and a brew, and hear great music.
$$

3201 W. Armitage Ave., Chicago 60640
(at Kedzie Ave.)
Phone (773) 252-9700
www.streetsidecafe.net

CATEGORY American Bar & Grill

HOURS Sun-Fri: 11 am-2 am
Sat: 11 am-3 am

GETTING THERE Free street parking. You can also take the #82 Kimball/Homan or #72 North bus or Blue Line to Armitage.

PAYMENT

POPULAR DISH As with many Chicago bar and grill combos, the burger is definitely the way to go. They're cooked to perfection every time! For those who are more health-conscious, the turkey burger and veggie burger are sure-fire winners as well.

DRINKS Streetside has a long beer list with all the standard choices and some great local options. They also do some specialty cocktails. Try the Tommy Bartlett, a pear/vodka concoction that is super refreshing (especially while on the patio on a hot summer day).

SEATING The bar has extensive seating with booths and tables scattered throughout two rooms. On colder days, get there early and shoot for a seat near the fireplace! In the summer, the patio has enough seating that there usually isn't a wait.

AMBIENCE/CLIENTELE Depending on the night of the week and the time of day, Streetside morphs easily from a corner bar to a place that you definitely want to be on a Saturday night, with enough people and music to make you feel like you are ruining your Sunday with a hangover for a good reason.

EXTRA/NOTES Streetside often hosts guest DJs and has special events. It is definitely a good idea to check out the website before you go.

—*Kimberly Nawara*

WEST SIDE

LOGAN SQUARE

Bonsoirée
A "Revolution in BYOB" is right!
$$$$
2728 W. Armitage Ave., Chicago 60647
(between Fairfield Ave. and Washtenaw Av)
Phone (773) 486-7511
www.bon-soiree.com

CATEGORY	French Restaurant
HOURS	Sun: 5 pm-10 pm
	Tues-Sat: 5 pm-9:30 pm
GETTING THERE	Parking is no problem. The nearest public transportation is the California stop on the Blue Line or the #73 Armitage, #52 Kedzie/California, or #56 Milwaukee bus.
PAYMENT	
POPULAR DISH	Bonsoirée has an ever-changing prix-fixe menu that reflects seasonal ingredients. The food is creative and innovative and always unexpected.
DRINKS	They bill themselves as a "revolution in BYOB" and they are just that. The menu is available in advance so you have plenty of time to plan your wine pairings. A small corkage fee applies.
SEATING	Bonsoirée is a tiny little spot that only seats 26 guests. Reservations are required.
AMBIENCE/CLIENTELE	Bonsoirée is very unexpected. From the outside it looks a bit seedy, but once you walk in, you forget all about the world outside. The decor is minimalist yet comfortable with tiny tables scattered about. Everyone is eating the same food and drinking their own wines, but before long strangers are talking to each other and sharing wines. The owner and chefs are on hand, not just in the kitchen, but also in the dining room. They bring the food out to your table and describe it in detail. Learning where your food comes from and how it was prepared adds so much to the experience and really sets Bonsoirée apart.
EXTRA/NOTES	They also run an amazing catering service with equally creative and delicious food.

—*Andrea Eisenberg*

Buona Terra
Delicious food and a huge wine list!
$
2535 N. California Ave., Chicago 60647
(at Logan Blvd.)
Phone (773) 289-3800
www.buona-terra.com

CATEGORY	Italian Restaurant
HOURS	Sun: 5 pm-9 pm
	Tues-Thurs: 5 pm-10 pm
	Fri/Sat: 5 pm-11 pm
GETTING THERE	Free street parking can usually be found on Logan, but it can be difficult depending on the time of day. You can also take the Blue Line to California or the #56 Milwaukee, #52 Kedzie/California or #74 Fullerton bus.

WEST SIDE

PAYMENT
POPULAR DISH Without a doubt, you should try everything on the menu, but for more realistic ordering advice I would suggest starting with a salad to share. The Panzanella Toscana is excellent. Buona Terra also does a beautifully traditional Carpaccio with big, clean, bright flavors. For dinner, you can't go wrong with the Rigatoni Buona Terra, which is rigatoni pasta tossed in a sun-dried tomato cream sauce topped with roasted walnuts and goat cheese.
DRINKS Extensive wine list, daily wine specials, and cocktails.
SEATING There are two dining areas facing bustling California that are both cozy and intimate. There is also a small bar with seating. In summer months, outdoor seating is available.
AMBIENCE/CLIENTELE Buona Terra is simultaneously romantic and lively. The extremely friendly and helpful staff and owners are also worth noting.
EXTRA/NOTES Buona Terra boasts a moderately priced prix fixe menu on Thursday nights. (Make a reservation on prix fixe Thursdays—it gets very crowded.)

—*Kimberly Nawara*

Friendship Chinese

Friendship raises the standard on your standard fare.
$$
2830 N. Milwaukee Ave., Chicago 60618
(at Kimball Ave.)
Phone (773) 227-0970 • Fax (773) 227-0999
www.friendshiprestaurant.com

CATEGORY Chinese Restaurant
HOURS Sun: 3 pm-10 pm
Mon-Thurs: Noon-10 pm
Fri/Sat: Noon-10:30 pm
GETTING THERE Plenty of metered parking is available. iAccessible via the #56 Milwaukee, #82 Kimball, or #76 Diversey bus. Just a ten-minute walk north-west along Milwaukee from the Logan Square Blue Line stop.
PAYMENT
POPULAR DISH The champagne lemon chicken is sublime with its sweet and savory balance, beautiful pale yellow sauce, and panko-breaded chicken breast. The honey walnut shrimp has big plump shrimp with crispy walnuts and a lightly sweet aioli sauce that you don't often find in traditional Chinese cuisine. The appetizer sampler gives you a taste of several unique options, such as bourbon-glazed spare ribs, lollipop shrimp, and cigar egg rolls.
DRINKS BYOB! Friendship has a nominal corkage fee. Their fare pairs perfectly with crisp, fruity white wines or Saison-style beers.
SEATING Seating is readily available more often than not. Since the restaurant tends to fill up on weekends, it bodes well to have a reservation on Friday and Saturday nights.
AMBIENCE/CLIENTELE You would never expect to find this restaurant with its non-assuming storefront and sign. The ambience is subdued, with warm tones, white tablecloths, and modern references to Buddhism, which combine to

WEST SIDE

form a comfortable but beautiful environment. The clientele is varied, drawing the local Logan Square artist community as well as businessmen and -women and families.

EXTRA/NOTES A fantastic way to experience many of the Friendship Chinese options is to partake in their lunch specials. They provide 10 or so entree options with rice and soup. For around $10, this makes a fantastic introduction that warms the palate.

—Joshua Arons

Kuma's Corner
Burgers with heavy metal mentality.
$$
2900 W. Belmont Ave., Chicago 60618
(at Francisco Ave.)
Phone (773) 604-8769 • Fax (773) 604-8768
www.kumascorner.com

CATEGORY American Restaurant
HOURS Sun: Noon-Midnight
Mon-Fri: 11 am-2 am
Sat: 11:30 am-3 am
GETTING THERE There is a very small free parking lot on the north side of the restaurant, and a mixture of permit and metered parking. Alternatively, you can take the #77 Belmont bus that goes just past the restaurant.
PAYMENT ATM
POPULAR DISH If you need a fantastic burger, go for the Lair of the Minotaur, a 10 oz. burger topped with caramelized onions, pancetta, brie, and bourbon-soaked pears. For more traditional foodies, the Clutch is another excellent choice, featuring a 10 oz. burger with cheddar, Swiss, Jack, and smoked Gouda cheeses.
UNIQUE DISH Go for the Make Your Own Mac & Cheese, which gives you a wide range of ingredients to custom-build the mac & cheese of your dreams!
DRINKS Kuma's Corner serves soda and martinis, but the beer is really where it's at in the beverage department. You'll find some pretty great beers at all price ranges, from the $2.50 PBR to the 750 ml Allagash for $25.
SEATING I recommend sitting in the beer garden during the summer since the indoors can get very cramped. Seating is extremely tight and extremely limited. You must be prepared to wait well over an hour to be seated; depending on the time of day you go, your wait time can be well over two hours (and Kuma's Corner does NOT have a seated waiting area).
AMBIENCE/CLIENTELE The interior looks exactly how a heavy-metal bar should look and the appearance of the staff members follow the trend. The tattooed and pierced staff is comprised of a group of extremely talented and friendly people that devote a lot of time and energy to ensuring you have a fantastic burger and experience. It's a good idea to order an appetizer or two while you wait, because it will take approximately 30-45 minutes for your food to be served.

—Jenna Noble

WEST SIDE

Lula Café
Downtown upscale food without the attitude. It's organic with a twist.
$$$
2537 N. Kedzie Blvd., Chicago 60047
(at Logan Blvd.)
Phone (773) 489-9554
www.lulacafe.com

CATEGORY	American Restaurant
HOURS	Sun/Mon: 9 am-10 pm Weds-Thurs: 9 am-10 pm Fri/Sat: 9 am-11 pm
GETTING THERE	Metered parking is available in a small lot in front of Lula Café and the adjacent building. There is usually an abundance of metered spots along Milwaukee Ave. Lula is a short walk from the Blue Line (Logan Square stop) and the #76 Diversey, #56 Milwaukee and #74 Fullerton bus routes. Biking is popular in this area.
PAYMENT	
POPULAR DISH	Probably best known for breakfasts and brunches, the standout selections from Lula's early-day menu include brioche french toast served with different seasonal fruits, a breakfast burrito, and a delectable tofu scramble. The Café menu is available all day and includes traditional soups, salads and sandwiches with signature embellishments. The Tineka sandwich is spicy peanut butter on multigrain bread with tomato, cucumber, red onion, sprouts, sambal and Indonesian soy sauce. The beet bruschetta comes marinated in olive oil and served with arugula, goat cheese, red onion and roast garlic vinaigrette. The spaghetti is a spicy-sweet take on your favorite childhood dish, and the Gunthorp roast chicken is succulent with red potatoes, sautéed spinach and pan jus.
DRINKS	Lula has a full bar with a wide selection of fruity brunch drinks including the traditional Mimosa and Bloody Mary. Intelligensia Coffee supplies a specially made Lula House Blend.
SEATING	Seating provides more than adequate room to hold private conversations without bumping elbows with a neighboring table. Lula has a long room complete with a wall-length banquette of tables on one side and a cluster of four-top tables on the other side. There are a small number of stools for comfortable bar seating.
AMBIENCE/CLIENTELE	Tucked into a storefront just off the Square, Lula is everything you would expect for a trendy, up-and-coming neighborhood. Neighborhood folks are drawn to their neighborhood places, but loyal devotees arrive from locales far and wide to have what is now a well-renowned Lula experience. The waitstaff is low-key, friendly and always dressed in the hipster style du jour.
EXTRA/NOTES	Get an early start on Saturday and Sunday because the wait can be somewhat shocking if you arrive during traditional brunch hours.

—Denise Peñacerrada

WEST SIDE

CHICAGO'S GREEN PARTY

The 20-below temps in the dead of winter aren't exactly conducive to year-round farm-fresh produce. Believe it or not, Chicago is a top-notch city for sustainable, seasonal and local eating, even raising the bar with certified organic restaurants, and for one local spot, the country's first certified organic rooftop farm. From a highly lauded farmers' market to forward-thinking restaurants, a Chicago diner who thinks globally and acts locally need not travel far to feel good about the food they eat.

For restaurants and localvores alike, the source for fresh vegetables, fruits, meat, dairy and other foodstuffs is Lincoln Park's Green City Market, which is hailed as one of the top ten farmers markets in the US. by the queen of eating seasonally and locally, Alice Waters. This market went to a year-round schedule in 2009 for the first time. Aside from market stands, there are vendors selling savory snacks such as crêpes, juicy burgers, and sweets to hungry shoppers. Among the supporters of the market is Rick Bayless, one of the city's celebrity chefs.

With **Frontera** and **Topolobampo**, Bayless is active in Chicago's sustainable and local movement. Bayless' restaurants produce many of their greens in the Bayless Family Garden. During the summer, they grow rooftop tomatoes and chiles for summer salsa. Poultry, lamb, and beef are procured through farms such as Gunthorp and Bill Kurtis' Tall Grass Ranch. Most importantly, Bayless touts a spirit of cooperation among the region's restaurants, farms and other like-minded entities.

 Frontera Grill—449 N. Clark St., Chicago; (312) 661-1434
 Topolobampo—445 N. Clark St., Chicago; (312) 661-1434

Like Bayless, there are many restaurants—**Big Jones, Blackbird, Lula Café**, and **Sola** among many others—that are focused on sustainability and locally sourced goods. But for **Uncommon Ground** (1401 W. Devon Ave.), they take this pledge to new heights—literally. Not only do they grow vegetables on the roof, but they also use five solar panels that heat up to 70 percent of the new American restaurant's water supply and house two beehives that produce more than 40 pounds of honey, according to a statement from the restaurant.

 Big Jones—5347 N. Clark St., Chicago, (773) 275-5725
 Blackbird—619 W. Randolph St., Chicago, (312) 715-0708
 Lula Café—2537 N. Kedzie Blvd., Chicago, (773) 489-4554
 Sola—3868 N. Lincoln Ave., Chicago, (773) 327-3868

Even pizza can be sustainable, locally sourced, and organic. Take **Crust** (2056 W. Division St.), for example. This Wicker Park eatery is the city's first certified organic restaurant. They source local flour, yeast and vegetables and compost food waste. Even the countertops (tables, bar and host stand) are made from recycled products. And localvores can toast to the beers, most of which are produced locally.

Chicago's dining scene is known for a lot of things. As the terms sustainable, localvore and seasonal become more mainstream, you can count on Chicago to be at the forefront of this movement.

— *Dorothy Hernandez*

WEST SIDE

Taqueria Moran
Specializing in making typical Mexican food anything but.
$$

2226 N. California Ave., Chicago 60647
(at Milwaukee Ave.)
Phone (773) 235-2663

CATEGORY	Mexican Restaurant
HOURS	Daily: 6 am-10 pm
GETTING THERE	There is metered parking on Lyndale St. and general street parking in the area. Do not park in the grocery store parking lot across California; they will tow you with unspeakable speed and efficiency. You can also take the #56 Milwaukee, #74 Fullerton or #73 Armitage bus or the Blue Line to California.
PAYMENT	
POPULAR DISH	This may sound pedestrian, but the carne asada tacos are the best you will ever find. The addition of cilantro prevents this from being your typical steak taco, but it is the presence of thinly sliced radishes that leaves an impression. The cold, crunchy texture is a nice change and a surprisingly wonderful complement that might prevent you from ever again ordering a steak taco without them. For breakfast, try the chilaquiles con carne de puerco en salsa (fried tortilla with pork in tomatillo sauce with sour cream and cheese on top). Not to be overlooked, chips and unbelievable salsa with a bowl of hot carrots/peppers are brought to your table as soon as you arrive. They are wonderful (and spicy!) and constantly replenished.
DRINKS	We've all heard the exclamation, "The best margarita in the city!" The margarita here appears to have a carbonated element to it—a new twist to an old familiar friend that will leave you adding Sprite to homemade margaritas in an effort to duplicate. Don't leave Taqueria Moran without one!
SEATING	This is your neighborhood Mexican restaurant with casual plastic picnic bench seating. I've never seen a shortage of seating in the afternoons, but it can get pretty full for the breakfast crowd. Carry-out is always available.
AMBIENCE/CLIENTELE	Substance over style: more effort is expended on the food than on the atmosphere. It is very casual, very comfortable, and full of bright colors.

—Liz Walker

SOUTHWEST SIDE

SOUTHWEST SIDE

ASHBURN/MOUNT GREENWOOD

Grant's Wonderburger Grill

Wondering where to eat? Grant's Wonderburger!
$$
11045 S. Kedzie Ave., Chicago 60655
(at 111th St.)
Phone (773) 238-7200

CATEGORY	American Restaurant
HOURS	Mon-Sat: 10:30 am-8 pm
GETTING THERE	Street parking and two spaces behind the restaurant. You can also take the #112 Vincennes/111th bus.
PAYMENT	
POPULAR DISH	Order the Wonderburger (double with cheese is best) in a basket with curly fries. A tasty tomato sauce, known as the "secret sauce," is spooned over the burger. An order of curly fries cut into those long loops on a hand-cranked potato gizmo-fondly known as the potato screwer will round out your meal. The fries are always cooked to crispy perfection and are never burnt or soggy.
UNIQUE DISH	The grilled Reuben is very popular as is their chili. Another favorite is the grilled cheese, known to the cooks as a "GAC"—grilled add cheese.
DRINKS	Soft drinks are on tap as well as coffee.
SEATING	Wonderburger is a small place that is home to a wonderful eight-seat counter. There are also small tables for two to four patrons (capacity of 50 total). When the weather warms, the owner opens the back beer garden, which seats another 40.
AMBIENCE/CLIENTELE	Whether it is a cold winter day or a hot summer afternoon, you will find Wonderburger to be a cozy reprieve. Since its founding, the owners have hung artwork by local artists and the work adds kitsch to the dark wood walls. The simplicity of Wonderburger, its non-chain aspect and staff from the neighborhood make it feel as if you're in your own house.

—*Lori Rotenberk*

Groucho's Bar & Grill

Sports, music and great food—open late!
$$
8355 S. Pulaski Rd., Chicago 60652
(at 84th St.)
Phone (773) 767-4838
www.grouchosbarandgrill.com

CATEGORY	American Bar & Grill
HOURS	Sun: Noon-4 am
	Mon-Fri: 2 pm-4 am
	Sat: Noon-5 am
GETTING THERE	Free parking, but it's limited. You can also get to Groucho's via the #53 South Pulaski or #87 bus, the Metra Southwest line to Ashburn, or bicycle.
PAYMENT	
POPULAR DISH	The buffalo wings! Meaty and flavorful, the Buffalo sauce stays true to an original recipe. Hot and spicy, these wings are complemented by blue cheese dress-

SOUTHWEST SIDE

ing and celery as a welcome reprieve from the heat! The pizza is good and the quesadillas are fantastic. Try the various wraps (the buffalo shrimp wrap in particular) and the paninis for a late night snack.

UNIQUE DISH The shrimp diavolo is a great dish, served with a wickedly hot marinara over a bed of linguini and a side of garlic toast. An order of deep fried macaroni and cheese wedges is an absolute must.

DRINKS Groucho's has everything from Coke and Sprite to beer, wine, and cocktails. An adult must accompany patrons under 21, and I would not recommend you bring in the family after 9 pm on the weekends.

SEATING Seating is adequate and the place is seldom packed except for Friday and Saturday nights. You can eat at the bar, too. Groucho's is available for small parties.

AMBIENCE/CLIENTELE Buffets are the place to be for the rabid Chicago fan, with great food, a build-your-own Bloody Mary bar and half-time giveaways. The staff is very friendly and great on the eyes, as are the patrons. Groucho's is great for people-watching, without the pretentiousness of downtown bars. Regulars here will strike up a conversation with you and before you know it, you're one of them. The DJs play a wide variety of music and the bands are usually local favorites and cover bands.

EXTRA/NOTES Sweatshirts and T-shirts are available for purchase. Groucho's also has a catering menu—I highly recommend the sausage and peppers for any party.

—*Crage Kentz*

Original Rainbow Cone

When you attack a Rainbow Cone, it is like eating five different cones!

$

9233 S. Western Ave., Calumet Park 60643
(at 92nd Street)
Phone (773) 238-7075 • Fax (773) 238-8753

CATEGORY Ice Cream/Gelato/Frozen Yogurt Fast food
HOURS Mon-Thurs: Noon-9 pm
Fri-Sun: Noon-10 pm
GETTING THERE There's a free parking lot just south of the shop. There's the CX49 Western Express or Pace #349 or #381 bus.
PAYMENT $
POPULAR DISH You can't go to Rainbow Cone and not have a Rainbow Cone. It is always difficult to decide what flavor tastes the best until you realize it is the combination of all five that makes it unique.
DRINKS Soft drinks and really good, thick milkshakes and malts are available.
SEATING There are some tables at Rainbow Cone, but in summer the owners put several tables outside under a large green canopy.
AMBIENCE/CLIENTELE Rainbow Cone has been at this site since the early 1920s, so it has that well-worn comfortable feel. The exterior is white stucco and atop the structure is a large rainbow cone. There's nothing fancy about the place, but the history and the activity of scooping hundreds of cones a day makes the place joyous.
EXTRA/NOTES You can buy Rainbow cakes, packed quarts and gallons to go, or even order a Rainbow wedding cake. There are also T-shirts and hats for sale.

—*Lori Rotenberk*

SOUTHWEST SIDE

GARFIELD RIDGE/MIDWAY

Mini Hut Chicken
Success in the Midway neighborhood for 36 years.
$$
6659 W. Archer Ave., Chicago 60638
(at Normandy Ave.)
Phone (773) 586-2115

CATEGORY	American Fast food
HOURS	Sun: 11:30 am-7 pm Mon-Sat: 11 am-8 pm
GETTING THERE	Diagonal street parking is available on Normandy. You can also take the #62 Archer or Pace #307 bus.
PAYMENT	
POPULAR DISH	Mini Hut's fried chicken is the best. The outside is crunchy, flavorful, and not greasy. The inside is juicy, moist, and tender. You can order a boat, which comes with your choice of a breast wing or a leg thigh, fries, and a roll. Chicken dinners come in 4, 6, 8, 12, 16, or 20 pieces. If you're dining in, be prepared to wait half an hour because all the chicken is cooked to order.
UNIQUE DISH	Don't forget all the sides like onion rings, breaded mushrooms, and potato salad Try a "Mother-in-Law," which is a tamale served right in a cup of chili.
DRINKS	No alcohol served.
SEATING	Seating is ample for this fast food place, but delivery and pick-up seem to be the more popular options.
AMBIENCE/CLIENTELE	Mini Hut is a very casual place with people dropping in to pick up a quick bite or dinner for their families.
EXTRA/NOTES	Mini Hut also delivers. If you're in the area, next time you're having friends over for the Bears game, get some chicken delivered and your party will be a hit!

—*Kristen Campagna*

Parisi's
Parisi's simple, but tasty fast food makes it a local favorite.
$
6216 W. 63rd St., Chicago 60638
(between Melvina Ave. and Merrimac Ave.)
Phone (773) 586-5611

CATEGORY	American Fast food
HOURS	Daily: 11 am-10 pm
GETTING THERE	There is a huge free parking lot surrounding Parisi's. The #63 bus stops right in front, and the #55 stops only two blocks west.
PAYMENT	$
POPULAR DISH	A piece of soft French bread dipped in classic marinara sauce, or a genuine Chicago-style hot dog cooked to perfection with a steamed bun, Vienna dog, and all the right toppings. The French fries are deliciously crispy on the outside and soft in the middle. For a heartier fill, the Italian beef sandwich is out of this world. Try a combo, which is an Italian beef with Italian sausage in the mix. Ask for it topped with red sauce and mozzarella cheese.
UNIQUE DISH	The soup is very tasty, but it's seasonal, it is only available for a limited time.

SOUTHWEST SIDE

DRINKS Shakes and ice cream! The specialties are the strawberry sundae and mint shakes in March.

SEATING Seating is not an option at Parisi's, so it's probably best to take your food to go. There is a counter facing the windows so you can scarf down a quick bite while watching the cars go by on 63rd, or you can do what generations of Midway kids have been doing and go eat on the bleachers at Hale Park!

AMBIENCE/CLIENTELE If you didn't know any better, you would easily drive by this tiny, neighborhood staple. Anyone waiting in line is from this neighborhood or has been introduced by a local. With its concrete floors and orders taken on the bag you will receive your food in, it's definitely what you would call "fast food."

EXTRA/NOTES Parisi's is closed for the month of February.

—*Kristen Campagna*

Villa Rosa Pizza
Simple and authentic Italian dishes for a reasonable price.
$$

5786 S. Archer Ave., Bedford Park 60638
(at Long Ave.)
Phone (773) 585-8367 • Fax (773) 585-9100
www.villarosapizza.com

CATEGORY Italian/Pizzeria Fast food

HOURS Sun: 3 pm-10 pm
Tues-Thurs: 3 pm-Midnight
Fri: 11 am-1 am
Sat: 3 pm-1 am

GETTING THERE Street parking is available on Long and Archer, though it depends the on time of day, day of the week, and weather conditions, so be aware of signs. You can also take the #62 Archer bus.

PAYMENT

POPULAR DISH All of the pasta dishes are delicious, but the baked mostaccioli takes top prize. It is filled with homemade marinara sauce and ricotta cheese smothered in mozzarella with a large meatball on top. The baked eggplant sandwich is crispy and hidden under a layer of gooey mozzarella cheese. The fried panzerotti is a lot like a calzone. The cheese oozes out instantly after cutting into the light, buttery dough. Make sure you order it fried because the baked just isn't the same.

UNIQUE DISH Every Wednesday night is the all-you-can-eat spaghetti or mostaccioli dinner with a choice of meatball, sausage, or meat sauce. You also get your choice of salad or soup and French or garlic bread.

DRINKS No alcoholic drinks are served at Villa Rosa.

SEATING When you walk in, the person behind the counter assumes you have come to pick up food and asks for your name. After clarifying you are here to sit, they will just point towards the dining area. There are only eight tables, but it is definitely not cramped.

AMBIENCE/CLIENTELE Notice the pictures of softball teams sponsored by Villa Rosa and you will realize this is a true neighborhood joint. Customers come in their work clothes or jeans, and nobody seems to mind the limited seating. It's a warm, genuine, and family friendly place.

EXTRA/NOTES Villa Rosa also offers a terrific catering menu.

—*Kristen Campagna*

SOUTH SIDE

SOUTH SIDE

BEVERLY

Koda: A Unique Bistro and Wine Bar
Prepared from scratch, this French food is worth coming back for.
$$$$
10352 S. Western Ave., Calumet Park 60643
(at 104th St.)
Phone (773) 445-5632
www.kodabistro.com

CATEGORY	French Restaurant
HOURS	Tues-Thurs: 11:30 am-2 pm, 5 pm-9 pm
	Fri: 11:30 am-2 pm, 5 pm-10 pm
	Sat: 5 pm-10 pm
	Sun: 3:30 pm-7:30 pm
GETTING THERE	There is a free parking lot. On busy days, you might have to park on the street. You can also take the #49A South Western or #103 bus.
PAYMENT	
POPULAR DISH	The short ribs keep people coming back. The meat is melt-in-your-mouth tender and they're served over slightly spicy wasabi mashed potatoes. They come with fall vegetables like rutabagas and turnips and a rich demi sauce. As for appetizers, I recommend the beet salad or seared sea scallops. The scallops come with a risotto that changes as often as the rest of the menu. You can sometimes find hangar steak flambé or a lentil and bacon soup on the specials.
UNIQUE DISH	Try eating the skate wing, a traditional French dish, if you have never had it. The meat is light and buttery and served with spinach, garlic mashed potatoes, and a brown butter caper sauce. Koda serves escargot with an aromatic and flavorful green garlic butter. Chef Aaron Browning makes an amazing bouillabaisse (a French fish dish served in a saffron and pernod broth) that he learned at Le Vichyssoise, and served it with a non-traditional angel hair pasta.
DRINKS	They have a full bar with a lot of variety. There are about six beers on the menu, including a few imports. The wine menu is a little on the pricier side, especially if you're buying by the glass. The staff is more than willing to let you try a sip of a couple before you make a final choice. On Sundays, there is a Bloody Mary bar in the morning along with a smaller menu.
SEATING	The main dining room has space for between 50 and 60 people. It can get really crowded and lively on weekend nights. The bar is smaller, but has a long counter with plenty of space. There is also a back room that can be reserved for parties. It is better to make a reservation for busier nights, but most times they can accommodate you if you wait in the bar.
AMBIENCE/CLIENTELE	Koda feels like it is in a small town where everybody knows each other. The service style is not upscale. The decor is cozy, with white tablecloths, dim lighting, flowers on the tables, and French art scattered on the walls. Koda has a small crowd during lunch and early on Sundays but it gets busier at night.
EXTRA/NOTES	See website for special events. Catering is available.

—*Araceli Valenciano*

SOUTH SIDE

Top-Notch Beefburgers
The best burgers on the south side; worth a detour off the Dan Ryan.
$$
2116 W. 95th St., Calumet Park 60643
(at Hoyne Ave.)
Phone (773) 445-7218
www.topnotchbeverly.com

CATEGORY	American Diner
HOURS	Mon-Sat: 8 am-8 pm
GETTING THERE	Metered parking is not too difficult. Top-Notch is a few blocks away from the 95th/Beverly stop of the Rock Island Metra line. You can also take the CX49 Western Express or #49 South Western bus.
PAYMENT	$ ATM
POPULAR DISH	The Beefburgers are absolutely delicious and are worth the trip. The burgers come in quarter-pound and half-pound "king sizes" on soft, huge buns and are not to be missed. Even the turkey burgers here are delicious and have a lot of flavor. The fries are fantastic here too—they are hand-cut with the skin on, cooked in beef tallow to give them a rich, almost buttery flavor.
UNIQUE DISH	The western burger is the most popular, with three strips of bacon, three different kinds of cheese, your choice of grilled or raw onions, and barbecue sauce. The Mexican burger is another great option to satisfy a south-of-the-border craving. This burger is served with jalapeño cheese, salsa, guacamole, green peppers and onions.
DRINKS	Diners wash down the gigantic burgers with pop or a milkshake. The milkshakes are rich, thick, and the perfect complement to a dinner of burgers and fries. The Oreo milkshake is not to be missed.
SEATING	There is plenty of seating at Top-Notch, including counter stools and about 20 tables.
AMBIENCE/CLIENTELE	The exterior of Top-Notch looks like an old-fashioned burger and milkshake joint, complete with a large art deco-inspired sign outside. When you step inside, it looks like the interior hasn't been updated in decades, with a pretty homely decor. The ambience is almost endearing, and once you step inside the restaurant and the smell of beef and deep fried food hits you.
EXTRA/NOTES	Top-Notch also offers carry-out with a convenient on-line form. During the week, you'll see people stopping by to pick up a quick, cheap, delicious dinner.

—*Jen Tatro*

CHATHAM

Soul Vegetarian East Restaurant
As much soul as James Brown.
$$
205 E. 75th St., Chicago 60619
(at Indiana St.)

SOUTH SIDE

Phone (773) 224-0104 • Fax (773) 224-6667

CATEGORY Vegan Restaurant

HOURS Sun: 8 am-9 pm
Mon-Thurs: 8 am-10 pm
Fri/Sat: 11 am-10 pm

GETTING THERE Parking can be a bit tight on 75th st. Circle around until you can find one in front; the side streets are permit only. Public transportation is easy—take the #75, #3 King Drive, or #29 State bus. From the Red Line, take the #75 bus northeast.

PAYMENT MasterCard VISA

POPULAR DISH For starters, the BBQ protein tidbits (fried nuggets of meat substitute with tangy barbecue sauce for dipping) are a must. Many dishes and entrees come with soup or salad (Romaine lettuce, sprouts, tomatoes, purple cabbage and cucumbers). Try the garlic and cucumber dressing. As for entrees, baskets of battered veggies and tofu aren't heavy and have a spicy kick to them. The sides here are not an afterthought—the Down Home Greens (tender kale or collards cooked with onions and tomatoes)—are so popular that it's offered as an entree with fresh cornbread. The mac 'n' cheese is only offered on certain days, but make sure to order it when you can. Desserts are also a specialty—the lemon pie and carob cake are favorites.

UNIQUE DISH There's a Jerusalem (protein) steak sandwich, Hebrew fries, Hebrew toast (a French toast alternative dipped in soy milk) and the Prince Elkannonn burger made of textured veggie protein topped with mushrooms. The BBQ Twist—a soybean patty in steaklike form slathered with barbecue sauce—gets its name because the seitan has peanut butter in it.

DRINKS Herbal teas, juices and sodas are available. But the real draw is the shakes and fruit and vegetable drinks from the juice bar. Some are geared toward detoxficiation (Apple Detox) and some are simply treats (Strawberry Heaven, Peanut Butter Surge). There's many to choose from on the vegetable menu. Try the Eternity Energizer or Sunrise Spirulina.

SEATING Soul Vegetarian has limited seating—the main dining room's occupancy is only 22. In the cash register/waiting area, there are two tables by the window. On Sundays and at dinnertime, prepare to wait. Lunchtime usually sees brisk take-out business so this might be a good time to dine.

AMBIENCE/CLIENTELE Soul Vegetarian's connection to the African Hebrew Israelite community doesn't mean it's exclusive. The crowd here varies from young couples to families to regulars. Hungry diners flock to this south side institution from all over the Chicago area, even as far as the north suburbs. Service can be slow so don't expect a fast meal. The space itself is warm and inviting. The natural sunlight during the day brightens the place, and at night the gorgeous glass chandeliers take over. The walls are adorned with colorful African art. In the waiting area you'll see posters of jazz greats like Dizzy Gillespie and Miles Davis.

—Dorothy Hernandez

SOUTH SIDE

HYDE PARK

Calypso Café
Island cuisine fit for a king...or a President!
$$$
5211 S. Harper Ave., Chicago 60615
(at 52nd St.)
Phone (773) 955-0229 • Fax (773) 955-3500
www.calypsocafechicago.com

CATEGORY Caribbean Restaurant

HOURS Sun: 11 am-4 pm
Mon-Thurs: 11 am-10 pm
Fri/Sat: 11 am-11 pm

GETTING THERE Calypso is adjacent to a large, reasonably-priced, pay-at-the-box parking lot. Ample free parking is available on 53rd and metered street parking is found on Harper. It's steps from the Metra Electric line (51st/53rd Street/Hyde Park station) and the #6 Jackson Park Express and #15 Jeffrey Local bus.

PAYMENT

POPULAR DISH Calypso is famous for Jerk dishes—chicken, tilapia, and wings—and for the famous fan of those Jerk dishes: President Obama. Obama favored the Jerk Tilapia and Jerk chicken, both soaked in a flavorful marinade of nutmeg, cinnamon, and a kick of cayenne. The First Lady opted for the jerk chicken Caesar salad. Fish dishes—from grouper and tilapia to salmon and trout are served glazed, blackened, deep-fried, jerk, or even crusted with crushed plantains. Save room for the key lime pie with a homemade crust.

UNIQUE DISH The Plantain Nachos, a towering hill of crispy, fried plantains drenched with black bean sauce and topped with mounds of cheddar, mozzarella, and pico de gallo sauce is billed as an appetizer but it's big enough for a meal for two, although you might not wish to share.

DRINKS There's a great selection of wine by the glass and bottle, as well as bottled beer. Try a Funky Monkey, Calypso Mudslide, or Island Viagra. The Mojito, with your choice of five kinds of rum, contains more than a hint of mint, judging from bundles of fresh leaves drowning in the lime-green liquid. If you love fruit juice with a kick, The Marley delivers, with Bacardi Peach Red, orange and pineapple juices, Créme de Banana and grenadine.

SEATING Of the 29 tables here, almost every seat is a good one. The main dining room is light and airy, with large tables and private booths overlooking an entire wall of windows. An adjacent room houses another eleven tables hiding under thatched umbrellas.

AMBIENCE/CLIENTELE Walking into Calypso is a bit like escaping to a Caribbean island oasis. With its friendly staff, hanging wicker lamps, tropical shade plants, bright toucan statues, and danceable reggae beat spilling out from the speakers, the urban and urbane crowd is the sole reminder of city life. It's this well-dressed, diverse clientele that keeps the place from feeling like a theme park. Hyde Parkers and other city dwellers in the mood primarily frequent Calypso for a mini-vacation.

—*Lori Hile*

SOUTH SIDE

Cedars Mediterranean Kitchen

Authentic Mediterranean in a relaxing atmosphere.
$$$
1206 E. 53rd St., Chicago 60615
(at Woodlawn Ave.)
Phone (773) 324-6227 • Fax (773) 324-4071
www.eatcedars.com

CATEGORY	Greek Restaurant
HOURS	Sun-Thurs: 11:30 am-10 pm
	Fri/Sat: 11:30 am-11 pm
GETTING THERE	This storefront is in a strip mall with a small, free parking lot. There are meters available across the street if the lot is full, which doesn't happen often. The restaurant is only two blocks from the #15 Jeffrey Local and #2 Hyde Park Express buses, and it's a short walk from the 51st-53rd St. stop of the Metra Electric line.
PAYMENT	
POPULAR DISH	Cedars does a great job of making all their dishes unique. I particularly like the pomegranate-braised short ribs. These have been cooked in a rather sweet sauce all day, so by the time you get them, they're extremely tender and flavorful. Served with a soup or salad, sautéed vegetables, and your choice of a second side, you will not leave hungry. However, it is wise to save room for dessert, as their baklava served with vanilla bean ice cream is not to be missed.
DRINKS	Cedars does not sell alcohol, but they have a BYOB policy and are located in the same shopping center as a liquor store. Buying your own bottle of wine decreases your bill and increases the flexibility of your evening.
SEATING	There is plenty of seating available, so reservations are rarely necessary. Most are tables are two-tops, but they can be easily pushed together for larger parties.
AMBIENCE/CLIENTELE	The ambience is cool and slightly trendy. The decor in the venue provides a feeling of calm, and the semi-open kitchen adds a sense of openness in the entire dining room. The clientele ranges from University of Chicago students and professors to families and couples on dates.
EXTRA/NOTES	Cedars makes excellent hummus, available on the menu or for sale at the nearby Treasure Island grocery.

—Benjamin Coy

La Petite Folie

Classic French cuisine near the University of Chicago.
$$$$
1504 E. 55th St., Chicago 60615
(at Lake Park Ave.)
Phone (773) 493-1394 • Fax (773) 493-1450
www.lapetitefolie.com

CATEGORY	French Restaurant
HOURS	Sun: 11:30 am-11 pm
	Tues-Sat: 11:30 am-11 pm
GETTING THERE	A free lot shared with Treasure Island grocery store and other businesses. You can also take the #55 Garfield, #6 Jackson Park Express, or #28 Stony Island bus or the Metra Electric line to the 55-56-57th St. Stop.
PAYMENT	
POPULAR DISH	The chicken braised with tarragon is quite excellent. I often avoid chicken dishes because they tend to be

SOUTH SIDE

bland and uninspired, but this chicken is special. The herb flavor is distinctive and savory, and the texture of the chicken is moist and succulent.

UNIQUE DISH There aren't many classic French restaurants in Chicago. French techniques and influences are found in many kitchens, but for straightforward French fare, this is one of the only places in the city. Furthermore, while it's pricier than some of the other dinner options in the area, it's really pretty inexpensive for the quality of the food offered.

DRINKS An all-French wine list perfectly complements the menu.

SEATING There's plenty of seating, but a reservation is advised if you intend to go before the theater.

AMBIENCE/CLIENTELE The ambience is a bit old-fashioned. The main dining room feels like you might be in your grandmother's formal parlor. The demographic of the patrons changes over the course of the night. At the beginning of dinner service, the average age is somewhat older, as the pre-theater crowd moves through. Later in the service, younger professors and graduate students start to arrive.

EXTRA/NOTES A three-course pre-theater prix fixe menu is offered from 5 pm to 6:30 pm.

—*Benjamin Coy*

Medici on 57th
Good enough for heads of state, cheap enough for college students!
$$$
1327 E. 57th St., Chicago 60637
(at Kimbark Ave.)
Phone (773) 667-7394 • Fax (773) 667-9226
www.medici57.com

CATEGORY Italian Restaurant
HOURS Sun: 7 am-11 pm
Mon-Thurs: 11 am-11 pm
Fri: 11 am-Midnight
GETTING THERE Metered parking is available all along 57th St. directly in front of the restaurant, and unmetered street parking is available beyond. Or take the #55 Garfield bus to 55th St. and Kimbark. A bike rack out front guarantees a safe place for your metal horsey. The Metra Electric line to the 55-56-57th St. stop is only a half mile east of Medici.
PAYMENT
POPULAR DISH Try Ham's smoked German ham pizza, which includes Granny Smith apples, red onions, sun-dried tomatoes and, ham. The burgers are a sight to behold—giant, half-pound, sloppily delicious behemoths covered in toppings. The grilled tuna steak sandwich is fantastic, served with ginger-sesame mayo on a potato bun straight from their bakery next door. For breakfast nothing beats squeezing yourself a glass of fresh orange juice, then sitting down to a chocolate croissant and the best eggs benedict in the city.
UNIQUE DISH The bread pudding, advertised as "the most cholesterol for your dollar," requires a 15-minute wait while they heat up your serving in an oven, as opposed to a microwave. The chilled, velvety smooth mocha pie that melts in your mouth, served with fresh rum

SOUTH SIDE

whipped cream on top. Each bite seems to evaporate as it touches your lips.

DRINKS Medici is BYOB, but you've gotta try an orzata float. Their extensive beverage menu is the stuff of legend; all manner of shakes and floats (13 varieties altogether) are topped with fresh whipped cream. A full coffee bar guarantees you'll get your caffeine fix, and their lemonade menu comes in handy in the summertime. In addition to this, there are soft drinks, a large variety of organic/fair trade teas, and hot chocolate.

SEATING The main dining room seats close to 100 people, with cozy hardwood booths lining the walls and two- and four-seat tables in the center. During busy periods an upstairs dining area is opened up, and during the warmer months an outdoor patio is available. The feel is comfortable and never crowded, though during peak dining hours (especially on weekends) the wait can be a half an hour to an hour.

AMBIENCE/CLIENTELE Though you'll see your fair share of poor college types, this is no cheap dive. These are serious eats in a laid-back atmosphere. The tables, booths, and walls are covered with the scribblings of customers; everything from graffiti to cartoon characters to witty comments can be found, and contributing your own is a Hyde Park tradition. The restaurant is staffed with about a half-and-half mix of college students just trying to earn a buck and people who seem to actually care about their job. In addition to college students, you'll find families, professionals and locals.

EXTRA/NOTES They're also committed to fair trade and sustainability, using fair trade teas and coffees. T-shirts, hats and mugs are available for sale. During the last election, the restaurant started selling shirts pronouncing OBAMA EATS HERE on the back. This is no joke; President Obama's Hyde Park home is just blocks away.

—*Dave Shapiro*

MEDICI BAKERY

Medici Bakery is located adjacent to the main restaurant. Not only does it provide all baked goods for the restaurant, but local establishments like the inimitable Hyde Park Produce stock their breads, and with good reason. The diversity and quality of baked goods has no equal on the South Side.

The space is small with only a couple of tables, so getting your goods to go is the way to do it, though taking a seat does have its advantages if you're a people-watcher; recently, as I drank my cup of coffee (they have a full coffee bar), the staff and I watched out the front window as people tried to park on the snow-covered streets.

I've already mentioned the chocolate croissants in the review of the restaurant, but allow me to reiterate: chocolate croissants. Seriously, they're amazing. Get there early enough and they'll still be nice and warm; show up later and they'll warm it up for you. If chocolate's not your thing, there are five other varieties to choose from, including plain, apple, and spinach and feta. The croissants, along with bagels, muffins, cinnamon rolls, baguettes,

SOUTH SIDE

ciabatta and many of their other items are all baked fresh daily. The full spectrum of goods is too great to list here, but you'll find everything from cream puffs to pecan pie, from onion rye to cinnamon raisin bread to ridiculously delicious fruit tarts.

1327 E. 57th St., Chicago 60637, (773) 667-7394

—*Dave Shapiro*

Rajun Cajun
Indian food and Southern food. How could you possibly go wrong?
$$
1459 E. 53rd St., Chicago 60615
(at Blackstone Ave.)
Phone (773) 955-1145

CATEGORY	World/International Restaurant
HOURS	Sun: 11:30 am-8 pm Mon-Sat: 11 am-9 pm
GETTING THERE	Street parking in the area can be unpredictable. Ride the #28 Stony Island or #6 Jackson Park Express bus. Or take the Red Line to the Garfield stop, hop on the #55 bus east to 55th and Blackstone. Or take the Metra Electric line to the 55-56-57th St. station.
PAYMENT	American Express, Mastercard, Visa
POPULAR DISH	Go with the Indian food. The samosas are tasty and you just can't go wrong with the butter chicken. Try an Indian combo that features one meat dish, a vegetable dish, a samosa, paratha and rice. They also feature vegetarian dishes such as Saag Paneer (spinach and cheese curry), Mutter Paneer (pea and cheese curry), and Alu Bengan (potato and eggplant curry).
DRINKS	The usual sodas and coffee. Wash your Indian food down with a delicious mango lassi.
SEATING	Since Rajun Cajun often serves take-out or delivers, there is generally plenty of seating. Five four-person booths are available for those dining in.
AMBIENCE/CLIENTELE	Rajun Cajun offers a decidedly sunny interior. The bright yellow walls and the cheery Indian pop music go a long way towards helping you forget the blizzard going on outside. In general, the staff is extremely helpful and friendly. This establishment is particularly popular with Indian students of the University of Chicago since it was the only place to get Indian food in the neighborhood until recently. You're likely to run into any number of Indian graduate students here on any given day.

—*Alexander Moore*

Ribs 'N' Bibs
Burning down the business to provide the best barbecue in town.
$$$
5300 S. Dorchester Ave., Chicago 60615
(at 53rd St.)
Phone (773) 493-0400

CATEGORY	Barbecue Dive
HOURS	Sun-Thurs: 11 am-Midnight Fri/Sat: 11 am-1 am

SOUTH SIDE

GETTING THERE Street parking in the area can be unpredictable. The best way is to ride the #28 Stony Island or #6 Jackson Park Express bus and walk a few blocks. Alternately, take the Red Line to Garfield, hop on the #55 bus east to 55th St. and Dorchester. You can also take the Metra Electric line to the 51st-53rd St. station.

PAYMENT

POPULAR DISH They specialize in barbecue. Try either the barbecue chicken or the ribs, both cooked on a wood-fired oven. Both dishes are slathered in a barbecue sauce slightly sweeter and featuring a heavy smoky taste. For a little over $10 you can get a combination of ribs, fries, bread, and coleslaw that is sure to fill you up. If you're in need of a more extreme eating experience, go for "The Boss," which features a heaping pile of ribs fit for anyone who refers to himself as The Boss.

DRINKS The usual sodas and coffee.

SEATING Seating in this establishment is sparse, particularly in the winter when you can't sit outside. There are a handful of seats at the counter that are nice if you're eating alone. Outside, there are a few dingy picnic tables that might seat 20 people total. You're probably better off just taking the food and eating elsewhere.

AMBIENCE/CLIENTELE You're as likely to run into lifelong Hyde Park residents as Nobel Prize winners from the nearby University of Chicago here. Most people don't eat in. The most notable feature of Ribs "N" Bibs is the smell. As you walk in, you'll be greeted by the wafting smell of their sweet barbecue sauce. The floor and the wood-paneled walls look like they probably haven't been replaced since the '60s. The back wall is littered with a series of signed photographs of local celebrities.

—*Alexander Moore*

Valois

Satisfying home-cooking is served faster than a drive-thru.
$$
1518 E. 53rd St., Chicago 60615
(between Harper Ave. and Lake Park Ave.)
Phone (773) 667-0647

CATEGORY American Cafeteria

HOURS Daily: 5:30 am-10 pm

GETTING THERE Metered parking on 53rd is tricky. There's a city-owned lot just east of Valois. The Metra Electric 51st-53rd stop is a couple of blocks east, or take the #6 Jackson Park Express or #28 Stony Island bus.

PAYMENT $ ATM

POPULAR DISH Pancakes with fruit topping, French toast and anything made with eggs. An omelette the size of a fluffy hand towel comes with a mountain of buttery hash browns. Grits with cheese and anything meaty are extremely popular. For a hearty, meaty meal, try the short ribs of beef or ham off the bone. Their chicken pot pie, served up in a stone bowl with a flaky crust, is as good as anything you'd get at home.

UNIQUE DISH Their biscuits are more like cornbread and shaped like dinner rolls. If you want to have the breakfast of Presidents, try out Barack Obama's favorites: egg whites, poached eggs, and steak and eggs.

159

SOUTH SIDE

DRINKS The usual suspects—soda, juices, coffee. Even if you're dining solo, you'll get not one but two glasses of water brought to you at the table.

SEATING You'll fare better coming during the week during off-peak times. On the weekends, the line is out the door, but it moves quickly because this roomy restaurant seats about 150. Snag a table and people-watch for hours, or grab a seat by the window and watch the hustle and bustle of Hyde Park.

AMBIENCE/CLIENTELE Representative of the diverse neighborhood. The space itself is clean and bright—the walls boast brightly painted murals of the cityscape. The efficient, no-nonsense employees are friendly, welcoming and call ladies "sweetheart." Just don't show up at the counter without cash or a clue on what you're going to order. Anyone from girlfriends gabbing over lunch to community leaders grabbing a quick bite to local workers and solo diners sipping coffee and nibbling sandwiches can be found here.

—Dorothy Hernandez

Z&H MarketCafe
An upscale market and coffee shop.
$$
1126 E. 47th St., Chicago 60653
(at Woodlawn Ave.)
Phone (773) 538-7372 • Fax (773) 538-8151
www.zhmarketcafe.com

CATEGORY American Market/Grocery

HOURS Sat/Sun: 8 am-6 pm
Mon-Fri: 7 am-7 pm

GETTING THERE Plenty of street parking on 47th St. An easy walk from the 47th St./Kenwood stop of the Metra Electric line. The #2 Hyde Park Express, #6 Jackson Park Express, #28 Stony Island, and #47 buses stop nearby.

PAYMENT

POPULAR DISH Most patrons come for coffee, soups, and sandwiches. The menu constantly rotates depending on what ingredients are in season or appealing. The sandwiches are always made with the unique cheeses and meats in the deli case and are well worth trying.

UNIQUE DISH In addition to food, this small storefront sells specialty food products you are unlikely to find elsewhere. From imported preserves to pastas and sauces to local products, Z&H offers the ingredients that give your kitchen that extra special touch.

DRINKS A full coffee, tea, and espresso bar. Seasonally, items such as hot cider and smoothies are also available.

SEATING There are a few small tables by the window in the front of the shop.

AMBIENCE/CLIENTELE Eating at Z&H is a very casual affair. People will come to have coffee, read the paper, or watch people pass by outside. At lunch time, the tables fill up, and people will often order food to take back to their office.

—Benjamin Coy

SOUTH SIDE

SOUTH CHICAGO

Mexican Inn
Extremely addictive, short order Tex-Mex you will crave for life!
$$
9510 S. Ewing Ave., Chicago 60617
(between 95th St. and Ave. L)
Phone (773) 734-8957

CATEGORY	Tex-Mex Restaurant
HOURS	Sun: 11 am-8 pm
	Tues-Thurs: 11 am-8 pm
	Fri/Sat: 11 am-9 pm
GETTING THERE	Avoid the small parking lot and get a spot on Ave. L. If it is a weekday, try St. George's parking lot half a block down. You can also take the #30 South Chicago or #26 South Shore bus.
PAYMENT	$
POPULAR DISH	The #1 combination dinner. The Soft Cheese is a tortilla smothered in a smooth homemade nacho sauce. On its own, it is creamy and salty and not very compelling, but the vinegar and pepper salad served with it brings out the flavors of the dish. It blends perfectly with thick and fluffy refried beans, sweet onion-packed enchiladas in spicy gravy, and maize-infused Spanish rice.
UNIQUE DISH	Fried tacos: the corn tortillas are fried, stuffed with ground beef, chicken, or spicy pork and topped with lettuce, tomato, and their homemade taco sauce.
DRINKS	Soda, coffee. and tea.
SEATING	The seating area is small, but there are a few tables for parties of six or more, and they always accommodate you when you have any special needs. Generally, it isn't hard to get a table, but you may have to stand while waiting for take-out if it's busy.
AMBIENCE/CLIENTELE	Oldies on the radio from the kitchen, orange walls and powder blue pipes can't compete for attention with the huge bronze Aztec warrior head and calendar above a row of reddish booths. Families from the suburbs, couples from the city, and regulars from the neighborhood all gather here. It's a place to relax and have a good meal.

—*Gina Holechko*

NORTH SUBURBS

NORTH SUBURBS

EVANSTON/SKOKIE

Al's Deli
The best baguette sandwich served from a hole-in-the-wall in Evanston.
$$
914 Noyes St., Evanston 60201
(at Maple Ave.)
Phone (847) 475-9400
www.alsdeli.net

CATEGORY	American Deli
HOURS	Sun-Tues: 11 am-4 pm
	Thurs-Sat: 11 am-4 pm
GETTING THERE	There's metered parking along Noyes and two metered lots nearby (one across the street and one just to the south). Free neighborhood parking can be found a few blocks away. Alternatively, Al's is steps away from the Noyes stop of the Purple Line. You can take the #93 California/Dodge bus and walk half a mile north.
PAYMENT	$
POPULAR DISH	The soup is homemade, of course, but the real treat is the bread. This authentic taste of Paris can be found in the northern suburbs of Chicago. They fill it with fresh meat, cheeses and vegetables to serve up an incredible (and huge) European-style sandwich.
UNIQUE DISH	The cookies are some of the best treats at Al's Deli. Just like everything else, they're baked fresh and spectacular. They tend to lean toward the large side and a few of the flavors are even covered in a quarter inch of buttercream frosting. Their selection includes chocolate chip, oatmeal raisin, butter cookie with frosting, spice cookie with frosting, pumpkin cookie with frosting and Belgian chocolate with frosting.
DRINKS	Aside from the usual soda, Al's offers Arizona iced teas, Nantucket Nectars and Honest Tea. You can also choose Dr. Brown's soda or Orangina.
SEATING	A few tables, each with a few chairs are all pushed up against the wall of this narrow rectangular space. You have to duck quite frequently to avoid getting brained by the elbows of the folks in line. It's generally cold in the winter.
AMBIENCE/CLIENTELE	Though the seating and the decor are not welcoming, the atmosphere is. Al's is always full of students and Northwestern professors who fill the place with bright conversation. While the floor is concrete, there are beautiful photographs of Paris on the wall. Each day, the display window in front shows the cookies they have left and the old-time fridge in back is where they hide the cheese.

—*Charles Jensen*

Bagel Art
Bagels like back home.
$$
1307 1/2 Chicago Ave., Chicago 60201
(at Dempster St.)
Phone (847) 864-8700
www.bagelartevanston.com

CATEGORY	American Bagelry

NORTH SUBURBS

HOURS	Sun: 8 am-3 pm Mon-Fri: 7 am-5 pm Sat: 7 am-4 pm
GETTING THERE	There is metered parking on Chicago, or pull down a side street to find free parking. By train: take the Purple Line (Evanston Express) to Dempster. By bus: take the Pace #201.
PAYMENT	
POPULAR DISH	Try the incredible bagels that are freshly baked daily on premises each morning and throughout the day.
UNIQUE DISH	Try the organic vegetarian soups and the Rococo sandwich (turkey, chive cream cheese, tomatoes, cucumbers and sprouts). The spinach/artichoke with fresh garlic cream cheese is a savory addition to the roster of cream cheese options. And don't forget to try the Fat Frank—a salami, tomato, red onion and chive cream cheese sandwich squeezed between two freshly made bagel halves.
DRINKS	Wonderful Fair-Trade Intelligentsia coffees, teas and juices.
SEATING	Counter seating by the window overlooking quaint Chicago Ave. Magazines are left out for customers to peruse while sipping coffee and grabbing a breakfast or lunch bite. Outdoor seating is offered in the warmer months.
AMBIENCE/CLIENTELE	Bagel Art is a cute, crafty morning or lunch spot that maintains the nostalgic crunchy feel of the Dempster hippie era. It's a wonderful spot for us native Northeasterners who miss fresh, delicious bagels and the cozy shops that sell them!
EXTRA/NOTES	Note the strange "Being John Malkovich" street address. Weekend delivery is available. You can also set up a weekly regular bagel day at the office.

—Lindsay Valentin

The Celtic Knot Public House

A quaint neighborhood pub with great food and tradition.
$$

626 Church St., Evanston 60201
(between Chicago Ave. and Orrington Ave.)
Phone (847) 864-1679 • Fax (847) 864-3079
www.celticknotpub.com

CATEGORY	Irish Pub
HOURS	Sun: 10 am-Midnight Mon-Thurs: 11:30 am-1 am Fri/Sat: 11:30 am-2 am
GETTING THERE	There's metered street parking in front of the pub, or take the Purple Line to Davis. You can also take the Metra Union Pacific Line to Evanston/Davis or the #93 California/Dodge, Pace #250 or Pace #208 buses.
PAYMENT	ATM
POPULAR DISH	Celtic Knot is best known for the fish & chips, corned beef and cabbage, and shepherd's pie. The Knot also makes a mean half-pound burger, with toppings like Stilton, Irish cheddar, and port-caramelized onions. Look for well-prepared standards like chicken marsala and grilled salmon. Don't forget to ask about the Knot's decadent cupcake of the month. Who can pass

NORTH SUBURBS

	up a flavor like Guinness chocolate with Bailey's mint frosting?
UNIQUE DISH	Try Irish lamb stew and bangers and mash. Go for the Guinness beef pasty (beef tenderloin and mushrooms cooked in Guinness and wrapped in puff pastry), or dare to try the black and white Pudding that comes with the Full Monty Irish breakfast. At brunch, try one of The Knot's Irish classics, such as sausage on toast or "bubbles and squeak" (sautéed cabbage and potatoes), or just stick with the irresistible lemon meringue pancakes with raspberry sauce.
DRINKS	The Celtic Knot has a full bar, but most folks come for the beer. There are eight beers on draught, including imports like Smithwick's and Boddington's, plus five beer cocktails. The Knot has a moderate international wine list, too, and regulars laud the bartender for her Bloody Mary.
SEATING	The Celtic Knot's bar seats about 40 between tables and barstools. The main dining room is separated from the bar area and seats over 60, which is plenty during the later hours but can get crowded at mealtimes. The Knot's private room, affectionately called "The Snug," fits 50 and is also used for a storytelling event once a month.
AMBIENCE/CLIENTELE	With low lighting and dark wood, the Knot feels warm and authentic, whether it's your first time or your second home. Its inviting atmosphere attracts locals from all over Chicago, as well as Northwestern students and families. It also has a large following among foreigners, perhaps partially because The Knot's one TV shows soccer when it's in season (and nothing else). As a public house, The Celtic Knot encourages its customers to stay as long as they want, and even to borrow a book from the stocked bookshelf along the back wall of the dining room.
EXTRA/NOTES	The Knot hosts lots of live performances. Its most popular nights for entertainment are Tuesdays for the "Celtic Seisiun" (a Celtic band plays familiar, kid-friendly tunes, and dancing is encouraged), and Saturdays, for a different up-and-coming or local favorite band each week, and there's bluegrass on Mondays. Afternoon tea is served every Wednesday and Saturday. The Knot holds seasonal events like a reading of A Christmas Carol for charity.

—*Hillary Proctor*

Cross-Rhodes
Authentic Greek at a price that pleases the palate.
$$
913 Chicago Ave., Evanston 60202
(between Main St. and Lee St.)
Phone (847) 475-4475
www.crossrhodes.biz

CATEGORY	Greek Restaurant
HOURS	Sun: 4 pm-9 pm Mon-Sat: 11:30 am-10 pm
GETTING THERE	Cross-Rhodes does not offer valet, and parking can be hard on the street. There are meters lining Chicago Ave., but it can be hard to get one in the evening. The Purple Line Train drops you off at South Blvd., just a

NORTH SUBURBS

	block from this wonderful Greek eatery. Or, you can take the Pace #205 or #201 bus to Main.
PAYMENT	$
POPULAR DISH	The Gyro and Souvlaki are classic: charred, sliced, and diced to perfection. At around $10, you receive a gyro or souvlaki skewer with Greek fries or rice, a tossed salad or egg lemon soup, pita, and a choice of tsatziki or red sauce. Additionally, the Spanakopita is a perfect Greek-style spinach pie with layers of flaky, browned phyllo stuffed with a balanced mix of spinach and crumbled feta, seamlessly intermingling with spicy hints of nutmeg, cinnamon and Greek spices.
UNIQUE DISH	Pastitsio is a dish common to Greek family dinners and get-togethers but not so common to Greek restaurant menus. Cross-Rhodes presents us with a particularly superb Pastitsio complete with a firm cheese and egg custard top layer, plentiful penne, nutmeg, cinnamon. Even more unique is the chicken with red sauce, a tenderly cooked half chicken coated in a thin, BBQ-like sauce that is a bit hotter and contains an extra zing of spice. The vegetarian versions of Pastitsio and Mousaka are vegetable-stuffed and divine, soaked in the same sweet spices as the meat-filled version.
DRINKS	Cross-Rhodes has a small, basic beer and wine list.
SEATING	There is a small yet decently sized dining room with a scattering of tables.
AMBIENCE/CLIENTELE	Cross-Rhodes is a bit barebones and yet somehow authentic in its lack of effort to appear trendy. Eating here is almost like dining in a Grecian taverna, with just a few Greek knickknacks on the walls. And much like a taverna, Cross-Rhodes is a very family-friendly place. People of all types frequent this establishment as the food is downright great and take-out is also popular.
EXTRA/NOTES	Call in to pick up for take-out.

—Lindsay Valentin

THE SPICE HOUSE

Looking for hard-to-find spices? Need a few ounces of cinnamon or just one vanilla bean for a recipe? Look no further than **Old Town's Spice House**. Established in 1957, this family-owned store offers a wide range of herbs, spices, and seasonings. Their knowledgeable staff is eager to answer questions and give advice about recipes and cooking techniques. Large canisters of herbs and spices line the store shelves and a mouth-watering aroma greets customers when they open the door. Spices are available by the ounce, and staffers measure the ingredients in front of customers before pouring them into clear plastic bags. Each label explains the flavor profile of the spice along with recipe tips. Periodically, the Spice House hosts book signings and events. With other stores in Evanston, IL; Geneva, IL; and Milwaukee, WI, the Spice House has something for everyone.

1512 N. Wells St. @ North Ave., Chicago, 60610,
(312) 274-0378, www.thespicehouse.com

— Emily Olson

NORTH SUBURBS

Dixie Kitchen & Bait Shop

Southern-style home cookin' in Chicago's North Shore.
$$$
825 Church St., Evanston 60201
(at Benson Ave.)
Phone (773) 363-4943
www.dixiekitchenchicago.com

CATEGORY	Southern Restaurant
HOURS	Mon-Thurs: 8 am-10 pm
	Fri: 8 am-11 pm
	Sat: 9 am-11 pm
	Sun: 9 am-10 pm
GETTING THERE	Metered street parking on Church, Benson, and the surrounding streets. Via bus: take the #201 Central/Ridge, #205 Chicago/Golf or Pace #250. Via train: take the Metra Union Pacific North to Evanston/Davis Street or the Purple Line to Davis.
PAYMENT	
POPULAR DISH	As far as appetizers go, you can't go wrong with the fried green tomatoes. Perfectly breaded and seasoned, they're served up piping hot and topped with lettuce and green onions. For main dishes, there's nothing less than good eatin' here. Their variety of po' boys (oyster, catfish and shrimp) are all delicious, and the pulled pork sandwich (served up low country style, with a little bit of kick to it) is incredible. The country fried steak and jambalaya are also delicious.
UNIQUE DISH	Finding great down-home southern cooking in the north shore is amazing in and of itself, but sitting down for the first time at Dixie Kitchen popping a complementary mini johnnycake with sweet cream butter in your mouth is an experience you might not be able to find anywhere else in the city. Likewise, ordering up a side of collard greens and black-eyed peas is a treat. But save enough room for the bread pudding topped with warm whiskey sauce.
DRINKS	There's a decent selection of beer and wine. They've also got a selection of eight specialty drinks. Some are served in mason jars, like the Louisiana Lemonade (vodka with home style lemonade and fruit punch).
SEATING	The restaurant seats about 75, mostly at two- and four-seater tables and booths, with a couple of larger tables for bigger groups. The restaurant isn't huge, so you may find yourself packed in a little bit during peak hours.
AMBIENCE/CLIENTELE	The restaurant is often jumping, and more often than not you'll have to wait a bit to get a table. The decor—with its nostalgic signs, southern memorabilia, and hanging light fixtures made from old coffee cans—is homey and comfortable. This is a place where people come to eat with family and friends, have a drink and some gumbo, and laugh. This is a great place for people-watching.
EXTRA/NOTES	This is the north suburban location of yet another of President Obama's favorite places to eat.
OTHER ONES	2352 E. 172nd St., Lansing 60438, (708) 474-1378

—Dave Shapiro

NORTH SUBURBS

Linz and Vail
Gelato, java and free Wi-Fi give this cozy Evanston spot its buzz.
$

922 Noyes St., Evanston 60201
(at Maple Ave.)
Phone (847) 491-1381
www.linzandvail.com

CATEGORY	Ice Cream/Gelato/Frozen Yogurt Coffee Shop
HOURS	Sun: 9 am-9 pm Mon-Thurs: 7 am-9 pm Fri: 7 am-10 pm Sat: 8 am-10 pm
GETTING THERE	There are meters right in front and nearby parking on side streets. Your best option is to take the Purple Line to Noyes and you're less than a block away. You can also take the Pace #201 Central/Ridge bus.
PAYMENT	
POPULAR DISH	Linz and Vail is best known for its rich gelato, serving up to 18 flavors each day. Metal pans are piled high with thick, creamy goodness and garnished with vibrant flowers or fruit. The most popular flavors are Belgian chocolate (a decadent must-try), Hazelnut, Pistachio and Lemon Sorbetto. But you really can't go wrong, so taste a mix of fruity and non-fruity options before you decide! The shop sells a smattering of croissants, muffins, biscotti and occasionally cookies at the counter, in case its coffee-drinking customers aren't in a gelato mood.
UNIQUE DISH	Some of the more intriguing gelato flavors include Brazilian Mixed Berry, Amaretto, and Lemon Curd—a silky and refreshing alternative to the Lemon Sorbetto. In addition to regular- and large-sized cups, you can buy gelato by the pint or even an entire 5-liter pan.
DRINKS	Enjoy Intelligentsia's sweet Black Cat Espresso in the usual lattes and Americanos. Or be a little bolder—Linz and Vail uses dark, decadent Ghana Single-Origin Chocolate in mochas and hot chocolate. The shop's signature drink is the Iced Evanstonian, a frothy iced latte that's sweetened by agave nectar, giving it a mild taste. Linz and Vail also offers house chai, a variety of teas, Italian soda and fruit smoothies.
SEATING	Seating is cozy but limited. Choose between a few window seats in the front room or the tables and comfy armchairs in the back room. Linz and Vail is usually busiest in the afternoon, so get there early to snag a long-term spot. On summer evenings, when the gelato line is out the door, eat across the street in the park instead.
AMBIENCE/CLIENTELE	The brown walls and pink ceiling give Linz and Vail a whimsical feel. An antique armoire holds all the coffee fixings, and menu items are scrawled on antique framed mirrors. Three flat-screen TVs keep the place modern, and board games in the back room help entertain younger customers. It's a popular study spot for Northwestern students, but Linz and Vail also has its morning coffee regulars and is a hit with families.
OTHER ONES	2012 Central St., Evanston 60201 (847) 475-1381

—Hillary Proctor

NORTH SUBURBS

Tapas Barcelona
Spain with a twist of Illinois.
$$$
1615 Chicago Ave., Evanston 60201
(between Church St. and Davis St.)
Phone (847) 866-9900
www.tapasbarcelona.com

CATEGORY	Spanish Restaurant
HOURS	Sun: 5 pm-9 pm Mon-Thurs: 11:30 am-10 pm Fri/Sat: 11:30 am-11 pm
GETTING THERE	Plenty of metered street parking along Chicago Ave., or on the side streets for free. By train: take the Purple Line or the Metra Union Pacific North line to the Evanstony Davis stop. By Bus: take the Pace #205 or #201 bus.
PAYMENT	
POPULAR DISH	Try pollo relleno (stuffed chicken breast with spinach and cheese), Avocado con Cangrejo (half an avocado with fresh crabmeat salad), tortilla (Spanish-style omelette with potatoes and onions) or parillada de vegetales (grilled seasonal vegetables with balsamic vinaigrette) if you want flavorful, savory and more basic Spanish dishes. The paella is creamy and stocked with palate-pleasing flavors. Pizza and the bocadillos (sandwiches) are crowd-pleasers.
UNIQUE DISH	You can find incredible Spanish favorites such as aceitunas rellenas (fried Spanish olives stuffed with Spanish chorizo), queso de cabra con tomate (baked goat cheese in tomato sauce, olives, and garlic bread) and datiles con tocino (baked fresh dates wrapped with bacon, served with bell pepper sauce).
DRINKS	Wonderful homemade sangria, Spanish-influenced house cocktails, brandy, and cordials, and a large yet distinct wine list including a huge Spanish vineyard base, as well as a full bar.
SEATING	Spacious and suburban, yet scenic outdoor seating is available on their large, tree-skirted patio. The dining room is full of nuanced tables beneath contemporary lighting reminiscent of Barcelona's urban style, combined with the colorful, artsy, funky, gothic decor of that wonderful Spanish city, replete with Spanish posters and a TV showing fútbol.
AMBIENCE/CLIENTELE	There is usually a mixed crowd of professionals in for after-work cocktails, tapas lovers of all varieties, families, couples, friends, and shoppers coming in from Chicago Ave. for a lunch break. The restaurant can get very crowded at dinner/cocktail hour.

—Lindsay Valentin

UBAA & Old Crawford Inn
Skirting the "anti-bar-in-the-name" ordinance.
$$
9956 N. Crawford Ave., Skokie 60076
(at Harrison St.)
Phone (847) 673-3080 • Fax (847) 673-3090

CATEGORY	American Bar & Grill
HOURS	Sun: 11 am-8 pm Mon-Thurs: 11 am-2 am Fri/Sat: 11 am-3 am

NORTH SUBURBS

GETTING THERE — The free, large parking lot is adjacent to UBAA. The best way to get to UBAA is by car. You can also take the Pace #201 bus.

PAYMENT — ATM, Discover, American Express, MasterCard, VISA

POPULAR DISH — UBAA is known for its charbroiled ten ounce burgers and cottage-cut fries and sweet potato fries. The burgers come with a choice of toppings such as sauerkraut, honey mustard sauce and sour cream along with the standard lettuce, tomato and onion. They come served on your choice of a freshly baked bun or dark or light rye. The cottage fries are always perfect.

UNIQUE DISH — An eclectic menu offers everything from homemade meatloaf, salmon, bratwurst, award-winning chili and beef stroganoff.

DRINKS — UBAA offers imported, local draft and bottled beers as well as wine. Non-alcoholic beverages include coffee and soft drinks.

SEATING — The restaurant capacity is for 50. There are nine small wooden booths in the dining area and three tables. About 35 tall chairs circle the U-shaped bar. The tables are covered in simple oil cloth. There is nothing fancy about this haunt, but you're guaranteed to feel right at home. It's common to see single diners as well as large families. Even though everyone sits in close quarters, the place never seems too loud.

AMBIENCE/CLIENTELE — It is cozy, plain and simple. Stopping in for a bite to eat is much like popping in at a friend's house and hanging in the kitchen. On most nights, you will find a mad mix eating at UBAA, from elderly couples to young couples with children to college students or dates. The bar side of UBAA is reminiscent of a small town bar where guys in flannel shirts sit shoulder to shoulder. This is a bar where people go to chew the fat rather than be seen.

—*Lori Rotenberk*

Va Pensiero

Extravagant Italian fare with a wine list covering all of Italy!
$$$$
1566 Oak Ave., Evanston 60201
(at Davis St.)
Phone (847) 475-7779 • Fax (847) 475-7825

CATEGORY — Italian Restaurant

HOURS — Sun: 5:30 pm-9 pm
Tues-Thurs: 5:30 pm-9 pm
Fri/Sat: 5:30 pm-10 pm

GETTING THERE — Parking is usually very easy on this side street. If you can't find parking on Oak, then look on Davis. Valet parking is always available. Or take the Purple Line or Metra Union Pacific North line to Davis.

PAYMENT — Discover, American Express, MasterCard, VISA

POPULAR DISH — Try the risotto with rosemary roasted pork and roasted garlic for your first course. The parmesan-crusted sweet breads over wilted radicchio trevisano doused in nebbiolo glaze is also a choice appetizer. Seafood lovers can indulge in the Prince Edward Island mussels with saffron shellfish broth. For vegetarians, the roasted shiitake mushroom salad with red onion and organic baby arugula is a flavorful, sensory treat. The

NORTH SUBURBS

	steak for two is, adversely, a meat-lovers dream, with a porterhouse and roasted red onions and asparagus.
UNIQUE DISH	If you are an adventurous eater, try the gorgonzola-caramelized onion tart or grilled baby octopus with canellini beans and broccoli rabe featuring sun-dried tomatoes. Then move on to the house made semolina tagliatelle or saffron-infused linguine. For an entree, sample the braised beef short ribs with gorgonzola-infused polenta.
DRINKS	Try the Tocai Friulano—a classic and yet little-known grape varietal or the Salice Salentino from Puglia for a lovely red. For something truly unique, obtain a small bottle of the Frecciarossa Uva Rara. For a classic Sicilian wine, go with the Villa Calcinaia Chianti Classico from Tuscany if you're into reds, or the Donati Pinot Grigio by Ermacora if you like crisp whites.
SEATING	Va Pensiero is fancy dining: white tablecloths and napkins on laps. As you wait for your meal, snack on your first course and take in the artwork of a local painter who perfectly captures the sights of Italian culture. Sip on a glass of Italian wine and chitchat with friends, family or a date, almost convinced that you are in a ristorante in Italy.
AMBIENCE/CLIENTELE	Va Pensiero is a pure classic. Complete with Corinthian columns, its architecture is reminiscent of old Rome and creates an intimate ambience. Their dining rooms are choice for romantic dinners, and its location within the historic Margarita Europe Inn on a lush, residential Evanston side street makes it all the more intriguing. This restaurant is elegant, antique, and perfect for a special night out.
EXTRA/NOTES	Va Pensiero also offers private dining rooms for events on premises as well as catering services for outside events. Make sure to check the website for special events. You'll find listings for cooking classes, wine tastings, and special menu offerings. Or sign up for their newsletter to receive recipes and VIP Invitations.

—Lindsay Valentin

DEERFIELD/NORTHBROOK/WINNETKA

Boris Café
An inexpensive, no-frills diner infused with neighborhood charm.
$$
972 Green Bay Rd., Winnetka 60093
(at Gage St.)
Phone (847) 446-5595

CATEGORY	American Diner
HOURS	Sun: 7 am-2 pm Mon-Sat: 6 am-8 pm
GETTING THERE	There's street parking located in downtown Hubbard Woods, a part of Winnetka. By Metra, take the Union Pacific North Line to Hubbard Woods, then walk east. You can also take the Pace #213 bus.
PAYMENT	

NORTH SUBURBS

POPULAR DISH The selection is exactly what you'd expect from a diner—sandwiches, salads, three-egg omellettetes, pancakes, milkshakes, malts and fresh handmade pies. The homemade soup is always flavorful, and I recommend the breakfast potatoes or the French fries.

UNIQUE DISH Boris Café does have some unusual items on the menu like omelettes filled with jelly, cream cheese or salami. In fact, there are over 20 types of omelettes or you can customize your own.

DRINKS Malts and milkshakes are available in vanilla, chocolate, cherry, cookies and cream, and mint chocolate chip, or try a root beer float. Coffee, tea, milk, lemonade, Pepsi products and flavored colas (with a dash of chocolate, cherry or vanilla) make the cut as well.

SEATING This diner features fewer than ten barstools and five shiny red-and-silver booths you always associate with diners, and about nine tables separated from the booths by a wall of glass blocks. Overall, it probably can't handle more than 60 patrons at a time, though crowding is not usually a problem.

AMBIENCE/CLIENTELE Look for the glass storefront with a run-down maroon awning. It's usually fairly quiet and pleasant for conversation. The small restaurant's decor is quirky but unassuming. The walls are decorated with pictures provided by the Wilmette Arts Guild. Each of these photos or paintings is available for purchase. The service is friendly and personal.

—*Helen Lee*

Charlie Beinlich's Food and Tap

Come for the burger, stay for the…shrimp cocktail?
$$

290 Skokie Blvd., Northbrook 60062
(between Frontage Rd. and Vermont Ave.)
Phone (847) 714-9375
www.charliebeinlichs.com

CATEGORY American Restaurant
HOURS Tues-Sat: 11:30 am-10:45 pm
GETTING THERE A free parking lot.
PAYMENT $
POPULAR DISH Charlie Beinlich's burgers are worth the drive. They are huge, juicy burgers topped with the cheese of your choice and, upon request, grilled or raw onions. It does not get much better then Beinlich's. The fries are ridge-cut, always fresh, and very good.
UNIQUE DISH The shrimp cocktail sounds odd, but it is the best shrimp cocktail around. I did not eat shrimp until I experienced the glory that is Charlie Beinlich's shrimp cocktail. The cocktail sauce is perfect and the shrimp are perfect.
DRINKS Full bar plus beer on tap. They try to keep it old school serving Old Style and Miller Lite.
SEATING It is a small place with about 15-20 tables. It is a place where they try to feed as many people as possible so the service is good but fast. They do not want you to stay long because there is always a wait.
AMBIENCE/CLIENTELE There are stuffed fish surrounding the bar and on the wood-paneled walls. It has the feel of a Northwoods lodge. The clientele is pretty much all locals. You may even notice some local celebrities like John Paxson,

NORTH SUBURBS

the general manager of the Bulls, and ex-Bulls players. It is a family setting but keep in mind it is also a bar, so unless accompanied by someone who is 21 years old, you may be asked to leave.

EXTRA/NOTES T-Shirts, sweatshirts, and hats are for sale. They close twice a year for two weeks at a time for annual fishing trips, once around Christmas and once in the summer.

—*Donny Farrell*

Francesco's Hole in the Wall

A cash-only policy, no written menu and long waits never deter foodies.
$$$
254 Skokie Blvd., Northbrook 60062
(at Lake Cook Rd.)
Phone (847) 272-0155

CATEGORY Italian Restaurant
HOURS Sun: 4 pm-8:45 pm
Mon: 11:30 am-9:15 pm
Weds-Thurs: 11:30 am-9:15 pm
Fri: 11:30 am-10:15 pm
Sat: 5 pm-9:15 pm
GETTING THERE There are a few spaces out front, but a larger free parking lot hides in the back. Pace bus route #626 will get you there as well.
PAYMENT $
POPULAR DISH The daily menu on the board usually includes over 20 traditional Italian dishes, including famous chicken entrees like chicken vesuvio, chicken parmigiana and chicken francesco. My favorites include pasta dishes like gnocchi with artichokes, mushrooms, goat cheese and a light tomato sauce. Try the fried mozzarella appetizer. Their desserts include cheesecake, tiramisu, spumoni, carrot cake and cannoli.
DRINKS The usual soft drinks are available, along with milk and Pellegrino Snapple. A small but decent wine list is available, with house wines being provided by the Robert Mondavi vineyards of Napa Valley.
SEATING The dining room here is tiny, which makes for an intimate and lovely setting but also a lively and often packed one. There's room for about 50 guests, with one long red cushioned bench along the north wall to provide partial booths. Francesco's Hole in the Wall fills up at lunchtime, and, depending on the time of year, there can be an hour wait or more for dinner. The small size of the restaurant makes it impossible to sit down while you're waiting, or even be indoors for much of the time.
AMBIENCE/CLIENTELE The upscale atmosphere is quite romantic, with faux stucco and exposed brick. Framed photos of famous visitors line the wall; during the wait to get in you'll become quite familiar with some of these. Francesco's creates an Old World mood with wicker ceiling fans, iron light sconces, collages, light tablecloths, colorful furniture, two large windows facing east and attractive displays of wines and grapes and ivy. Some families come here, but it's usually business folks during the lunch hour and locals in the evening.
EXTRA/NOTES Francesco's doesn't accept reservations.

—*Helen Lee*

NORTH SUBURBS

Kevin's Place
This little diner with personality appeals to kids of all ages.
$$
808 Waukegan Rd., Deerfield 60015
(at Deerfield Rd.)
Phone (847) 945-4577
www.kevins-place.com

CATEGORY	American Diner
HOURS	Sat/Sun: 8 am-2 pm
	Mon-Fri: 7 am-2 pm
GETTING THERE	There's a busy parking area in back that it shares with the businesses around it. The restaurant is close to the Deerfield Metra station; take the Milwaukee District North Line. You can also take the Pace #471 bus.
PAYMENT	$
POPULAR DISH	For kids, the Mickey and Minnie Mouse pancakes are a must. Any dish that comes with Kevin's perfectly cooked breakfast potatoes is a must—KP potatoes are crispy outside, hot and yummy inside. Offerings for the most important meal of the day include the Crunchy Deerfield Toast (which is coated with honey nut and oats cereal), omelettes, pancakes and a Chorizo Skillet with KP Potatoes, scrambled eggs, jalapeño peppers, onions, tomatoes and cheddar cheese.
DRINKS	Milkshakes and malts are a staple here, of course, and they come in banana as well as the usual vanilla, chocolate and strawberry triumvirate. You can also get floats, iced tea, lemonade, the usual selection of soft drinks, juices including tomato and cranberry, and Arnold Palmers (half iced tea, half lemonade).
SEATING	When you walk into Kevin's Place, you'll immediately see the narrow but cheerful front room with a long counter and about 15 stools. Walk past that to find a dining room that seats about 50-60 people. From here you can watch the cooks in action at the grill.
AMBIENCE/CLIENTELE	The eatery is filled with knickknacks, community bulletin boards, coat racks in the shapes of bowling pins, and a colorful checkerboard theme. Decorative plates and shadowboxes contain mementos of owner Kevin Quigley's acting accomplishments at the Deerfield Family Theater. Kevin has created a small community in this diminutive little storefront, which feels a bit like Cheers sometimes.

—*Helen Lee*

HIGHLAND PARK/HIGHWOOD/LAKE FOREST

Bella Via
Exquisite Sicilian food in a warm, charming atmosphere.
$$$
1899 Second St., Highland Park 60035
(at Elm Pl.)
Phone (847) 681-8300 • Fax (847) 681-8335
www.bellaviahighlandpark.com

NORTH SUBURBS

CATEGORY	Italian Restaurant
HOURS	Sat: 11:30 am-2:30 pm, 4:30 pm-11 pm Sun: 4:30 pm-9:30 pm Mon-Thurs: 11:30 am-2 pm, 4:30 pm-9:30 pm Fri: 11:30 am-2:30 pm, 4:30 pm-11 pm
GETTING THERE	Street parking is somewhat hard to come by, but there's an underground parking lot right across the street with three hours free. Or take the Metra Union Pacific North line to the Highland Park stop or the Pace #213 bus.
PAYMENT	
POPULAR DISH	The masses love the vodka cream sauce and tiramisu. The sauce is a cut above the competition. The tiramisu is one of the lightest and tastiest you'll find. An honorable mention has to go to the Pollo alla Parmigiana. Of course they do the usual things better than the competition as well—the Alfredo sauce, pizza and minestrone soup to name just a few.
UNIQUE DISH	If you're there on a night when the specials include the chicken saltimbocca, you're in for a treat. It sounds innocent—a plate-sized chicken breast sautéed with lemon butter wine sauce, spinach, prosciutto and baked, mozzarella—but it's not.
DRINKS	Bella Via has a spectacular display of wine. Their list includes bottles in the $30 range all the way up to $450 for a 1998 Gaja Sori San Lorenzo. They also have coffees spiked with Bailey's or Kahlua and a choice of dessert drinks.
SEATING	Bella Via is a very warm restaurant. Exposed brick and ruddy, earth-tone walls make it a very inviting place to eat. The dining room seats just over 100 and the tables are fairly close together. When the restaurant is full, it is a chatty place. Take a moment on the way in to look at the wine display that reaches up towards the ceiling.
AMBIENCE/CLIENTELE	The clientele includes both the North Shore hip and the family crowd. Stuffy posers in suits and pearls go to Rosebud across the street while those in the know come to Bella Via. It's a great place to impress a date.
EXTRA/NOTES	Bella Via has banquet facilities. They can accommodate 20 to 200 and they do everything from baby showers to bar mitzvahs. There's even an outdoor terrace that can be used in conjunction with the banquet rooms in the summertime.

—*Charles Jensen*

Curry Hut Restaurant

Glorious relief from Highwood's upscale European-style eateries.
$$$
410 Sheridan Rd., Highwood 60040
(at Highwood Ave.)
Phone (847) 432-2889 • Fax (847) 432-2986
www.curryhutrestaurant.com

CATEGORY	Indian Restaurant
HOURS	Sun-Thurs: 11:30 am-9:30 pm Fri: 11:30 am-10 pm
GETTING THERE	There's a few extra spaces on the south side of the building and in back. It shares the back lot with the Metra Union Pacific North Line (Highwood station).
PAYMENT	

NORTH SUBURBS

POPULAR DISH Curry Hut features a lunch buffet with a tasty spread of novice-friendly Indian dishes. Offerings usually include several choices of chicken, as well as poppadoms, fried samosas, pakoras, saffron rice, vegetarian entrees and two kinds of dessert. A plate of warm naan, an especially comforting Indian flatbread, comes with the meal. For dinner, order à la carte from northern Indian entrees and a smattering of Nepalese options. For dessert I recommend the Gulab Jamun, fried dumplings served hot and covered in a delicate saffron syrup.

UNIQUE DISH Some Nepalese dishes include Khasi ko Masu, goat meat cooked in a traditional style with Nepalese herbs and spices, and Aloo Tama Bodi, a combination of potatoes, bamboo shoots and black-eyed peas with Himalayan accents. If you'd like to try a Nepalese appetizer, I recommend the Mo Mo—minced chicken mixed with spices steamed inside bread and served with an Indian pickle called achaar.

DRINKS A full bar is available here, along with the usual non-alcoholic beverages and a small selection of beers and wines. This list includes four Indian beers as well as domestic and imported labels.

SEATING The small but elegant dining room at Curry Hut includes fewer than 20 tables and four booths. There's room for just under 100 guests. In nice weather they have a small amount of outdoor patio seating as well.

AMBIENCE/CLIENTELE You can spot Curry Hut easily because of its bright red awnings. Inside, the space features an understated, modern, Indian-inspired decor with curry-colored maroon and purple accents. Indian music is played unobtrusively to create atmosphere and several pieces of Himalayan art line the walls. It's a pleasant place to take a date, have civilized conversation, or just enjoy the evening. Service is always friendly, fast and efficient.

OTHER ONES 899 W. Plymouth Ct., Chicago 60605, (312) 362-9999

—*Helen Lee*

Maria's Bakery

Mouthwatering Sicilian delicacies served with care.
$

530 N. Sheridan Rd., Highwood 60040
(at Clay Ave.)
Phone (847) 266-0811 • Fax (847) 266-1574

CATEGORY Italian Bakery
HOURS Sun: 8 am-2:30 pm
Mon: 9 am-9 pm
Tues-Fri: 8 am-6:30 pm
GETTING THERE There is a free parking lot. You can also take the Metra Union Pacific North line to the Highwood station or the Pace #472 bus.
PAYMENT
POPULAR DISH Known for the fresh cannoli, they will fill them for you on the spot. A variety of Italian breads, cookies and cakes are also available, as well as savory items like calzones and sandwiches.
UNIQUE DISH Ask for the Genovese, a delightful round pastry filled with sweetened ricotta cream. Seemingly plain on the outside, it is a surprising find.

NORTH SUBURBS

DRINKS	Regular coffee is available, but this is the place to sit down and enjoy a fresh hot espresso, cappuccino or latte. It may take a moment to prepare, but you're on Italian time now.
SEATING	Seating is limited to six to eight, as there are only a couple of tables available. Most of the regulars breeze in and out, picking up trays of freshly baked cookies and boxes of biscotti, so you should have no difficulty in snagging a spot to snack.
AMBIENCE/CLIENTELE	Cozy and warm, Maria's welcomes a variety of customers in a small, nondescript storefront tucked in a corner off Sheridan. It can be easy to miss, so keep your eyes out for the red, white and green sign and follow your nose. You'll feel immediately at home the minute you cross the threshold.
EXTRA/NOTES	Also a mini Italian grocery store, this is the place to snag bags of authentic pastas, unique bottles of olive oil and hard-to-find sauces.

—*Erika Jones*

Max's Deli & Restaurant

Enormous homemade portions, multiple sides and pickles!

$$

191 Skokie Valley Rd., Highland Park 60035
(at Lake Cook Rd.)
Phone (847) 831-0600 • Fax (847) 831-2345
www.maxs-deli.com

CATEGORY	American Deli
HOURS	Daily: 7 am-9 pm
GETTING THERE	Max's is in a large strip mall with plenty of empty parking spots at all times. You can also take the Pace #213 bus.
PAYMENT	
POPULAR DISH	It's a requirement to start with the homemade soup. You go to Max's for the sandwiches. An open-faced Reuben or corned beef is also a requirement. Some double-layer chocolate cake for dessert and you've just scratched the surface of their enormous menu! Their breakfast selections are just as good and the bakery has shelves and shelves of take-home items.
DRINKS	Max's has a beer and wine menu so you can relax and have a drink with your enormous meal.
SEATING	There's always plenty of seating. Max's has a large dining area with both tables and booths. It's open and spacious and never empty, though don't run away if there's a wait. The line moves quickly because of the ample seating.
AMBIENCE/CLIENTELE	The clientele is a mix of North Shore seniors, families and couples. Businesspeople flock to the place during the week because of the high quality and quantity-to-price ratio.
EXTRA/NOTES	If you're in a real hurry or going on a weekday for lunch, you can "Fax Max" and pick up your food. Max's also offers special meals for dine-in and take-out during Passover and other special occasions.

—*Charles Jensen*

NORTH SUBURBS

Miramar Bistro
French bistro cuisine with a Cuban twist.
$$$$
301 Waukegan Ave., Highwood 60040
(at Temple Ave.)
Phone (847) 433-1078 • Fax (847) 579-4753
www.miramarbistro.com

CATEGORY	French Bistro
HOURS	Sun: 10 am-9 pm
	Mon-Thurs: 11:30 am-10 pm
	Fri/Sat: 11:30 am-11 pm
GETTING THERE	Street parking is available but can be difficult on busy weekend evenings. Valet parking is also an option. You can also take the Metra Union Pacific North line to the Highwood stop or the Pace #472 bus.
PAYMENT	
POPULAR DISH	The salad Lyonnaise with frisee lettuce, salty croutons and crisp lardons is as authentic as any you'd find in Paris. Skate grenobloise is another favorite, as is the shrimp de jonghe. For an appetizer, try the country liver pâté and chicken liver mousse, excellent accompaniments to the chunks of crusty whole grain bread served in generous baskets.
UNIQUE DISH	You can't go wrong with a croque monsieur, the epitome of comfort food. This "French grilled cheese" may be considered late night bar food in Paris, but here it is simply exquisite and a perfect way to blow your diet after a bad day at work. Layers of grilled ham, melted Gruyère, and creamy bechemel sauce is toasted and served on thick slices of bread alongside crispy matchstick frites. Pair it with one of Miramar's house red wines and all will once again be right with the world.
DRINKS	Full bar (the Mojito packs a punch), a fairly robust wine list, soft drinks, coffee and tea.
SEATING	Indoor seating for 300. Outdoor tables seat around 50.
AMBIENCE/CLIENTELE	Wooden tables, vintage subway-tiled walls and giant candles left to drip their wax make for rustic elegance. While some show up for the "scene," the rest of us simply come for consistently good food, atmosphere and conversation. The staff is attentive and the dress code is not terribly uptight.

—Erika Jones

Nite 'N Gale
Old-school ambience, classic cocktails and surf and turf.
$$$
346 Sheridan Rd., Highwood 60040
(between Temple Ave. and Walker Ave.)
Phone (847) 432-9744
www.nitengale.com

CATEGORY	American Restaurant
HOURS	Mon-Fri: 5 pm-10 pm
	Sat/Sun: 5 pm-11 pm
GETTING THERE	On-site parking is free and plentiful. The Metra Union Pacific North line (Highwood station) is just west of the restaurant. You can also take the Pace #342 bus.
PAYMENT	

NORTH SUBURBS

POPULAR DISH Try the BBQ ribs, pork chops, and filet medallions. You can't go wrong with the onion rings served hot and crunchy. Salads are basic but crisp and cool, and you're guaranteed to be served a warm roll straight from the oven (served strategically on top of the Rye Krisp and pre-packaged breadsticks that come in every basket).

UNIQUE DISH Try Marvin's shrimp appetizer (bite-size pieces of fried shrimp served with drawn butter and BBQ sauce).

DRINKS Full bar, soft drinks (including caffeine-free diet cola), coffee and tea. Try a Manhattan on the rocks—the pour is generous and the price is light.

SEATING Seating is plentiful; there are two rooms with space for 180. Choose the bar room for a cozier feel and better view of the TV. Plenty of dark booths in the corners means it's perfect for first dates.

AMBIENCE/CLIENTELE If you're in the mood to be in the mood, this is the place for you. So what if the average age of the clientele hovers closer to salt and pepper? The smoked glass, dim globe lights, and tufted vinyl booths are straight out of the '80s and will have you ready for romance and nostalgia for all those high school dinner dates at the local supper club.

—Erika Jones

South Gate Café

Beautifully executed comfort dishes with creative twists.
$$$$
655 Forest Ave., Lake Forest 60045
(at Deerpath Rd.)
Phone (847) 234-8800 • Fax (847) 234-8837
www.southgatecafe.com

CATEGORY American Restaurant

HOURS Mon-Thurs: 11:30 am-8:30 pm
Fri/Sat: 11:30 am-9 pm
Sun: 11:30 am-8 pm

GETTING THERE There is street parking and a parking lot directly across from the restaurant. Via Metra, take the Union Pacific North Line to Lake Forest. Head west on Deerpath and turn right on Forest (about a two-minute walk).

PAYMENT

POPULAR DISH The beef Stroganoff, made with short ribs instead of the traditional cubed steak, is very popular and for a very good reason. Other entrees such as grilled filet mignon with bacon-scallion whipped potatoes, Myer's rum butter and veal reduction and oven-roasted chicken with wild rice pilaf and demi-glace reduction are also great choices.

UNIQUE DISH The dessert menu offers mini desserts. I recommend the vanilla rum créme brulée and the key lime pie. Another great reason that South Gate is so great is the self-service bakery that's open for breakfast, lunch and dinner. All the bread for the café is made daily.

DRINKS There is a full wine list and bar in the café.

SEATING There is seating in the bar, the cozy dining room, and the gorgeous patio (open except in winter).

AMBIENCE/CLIENTELE If you come for lunch, you are likely to see a lot of businesspeople or parents with their kids. If you come for dinner you will tend to see families or groups of friends eating.

—Julie Harber

NORTH SUBURBS

Walker Brothers Pancake House

Once you've had an omelette here, you'll never eat them anywhere else.
$$$
620 Central Ave., Highland Park 60035
(at Second St.)
Phone (847) 432-0660
www.walkerbros.net

CATEGORY American Restaurant

HOURS Sun-Thurs: 7 am-10 pm
Fri/Sat: 7 am-11 pm

GETTING THERE There are city garages in most of the downtown area and many of them are free, or at least for the first few hours. It's not too far from the Highland Park stop of the Metra Union Pacific North line as well, or you can take the Pace #213 bus.

PAYMENT

POPULAR DISH The bacon is so thick it can be used to side houses. The omelettes are divine, so light and fluffy, as opposed to the greasy pile you often get at other restaurants. The German pancake is an enormous bakery item that stands inches high off the plate, and of course the regular pancakes are perfect. But wait, there's more: there are crêpes, salads and sandwiches as well!

UNIQUE DISH A real treat is their apple pancake. Don't let the name fool you—this is not breakfast, this is dessert. The only part of it that resembles a pancake is the shape. There's a good deal of sweet, syrupy, sugary topping involved. The demand is so high that they have frozen ones you can take home and cook in your own oven.

DRINKS They offer award-winning coffee made from Royal Kona select coffee beans, breakfast juices, sodas, etc.

SEATING There are lots of comfy booths at this location and lots of tables too. In fact, there's a large enough capacity that most days you can be seated immediately at just about any time. Just don't go on Sunday. The tradition in the northern suburbs is to go to church, then Walker Brothers, so waits are long.

AMBIENCE/CLIENTELE Each location is decorated from floor to ceiling in real honey oak and stunning, oversized stained glass windows, chandeliers and panels covering most of the restaurant. In addition, the Highland Park location has a beautiful and enormous glass sunroom that seats about 100 and overlooks Port Clinton square and fountain.

OTHER ONES Check the website for more locations!

—Charles Jensen

NORTHWEST SUBURBS

NORTHWEST SUBURBS

ARLINGTON HEIGHTS

Birch River Grill
Home of the bison, boar and andouille chili.
$$$
75 W. Algonquin Rd., Arlington Heights 60005
(at Arlington Heights Rd.)
Phone (847) 427-4242 • Fax (847) 427-4244
www.birchrivergrill.com

CATEGORY	American Restaurant
HOURS	Mon-Thurs: 6 am-10 pm
	Fri: 6 am-11 pm
	Sat: 7 am-11 pm
	Sun: 7 am-10 pm
GETTING THERE	There's a huge free parking lot. You can also take the Pace #606 bus.
PAYMENT	Discover, American Express, MasterCard, VISA
POPULAR DISH	Try Granny apple and onion soup to start. It gives you everything you want out of a French onion soup, but adds a touch of something new and somewhat unexpected. Next move on to the portobello mushroom ravioli. The marsala cream sauce is the perfect addition to the chunky mushroom ravioli. Or try one of their signature dishes like the broasted chicken.
UNIQUE DISH	This establishment is best known for the chili filled with wild game like bison and boar. And if that isn't enough meat, they add andouille sausage—fantastic for a cold winter day.
DRINKS	Birch River offers a well-varied wine list containing six to ten wines in each category which is grouped by level of intensity. If you like a good cab, try the Cellar No. 8. There is also a lounge menu at the bar offering appetizers, mixed drinks, beer and wine.
SEATING	There is plenty of seating in this large, well-appointed room; if you visit on a weekday, you will likely not need a reservation. However, I would suggest making a reservation on a Friday or Saturday night just to make sure. In the event you do find yourself waiting, have a seat at the bar and try a chocolate martini.
AMBIENCE/CLIENTELE	This is a large room with stalks of birch scattered throughout. It is a bit too large to be considered cozy, but it is warmly lit and very comfortable. There are a lot of natural materials in the room:, a stone fireplace that sits across from the bar, wooden oars mounted on the walls, leather-backed chairs, and wood tables. The clientele is often business people that may be staying at the Doubletree next door as well as residents of all ages in the Arlington Heights/Schaumburg area.
EXTRA/NOTES	Birch River Grill will post at least one recipe at a time on its website, so keep watch!

—Liz Walker

Carlos & Carlos
White tablecloths and black pasta—a perfectly balanced yin and yang.
$$$
115 W. Campbell St., Arlington Heights 60005
(at Vail Ave.)
Phone (847) 259-5227 • Fax (847) 259-5270

NORTHWEST SUBURBS

www.carlosandcarlosinc.com

CATEGORY	Italian Restaurant
HOURS	Mon-Thurs: 5 pm-9 pm Fri-Sun: 5 pm-9:30 pm
GETTING THERE	There is metered street parking when you can find it. However, there is also a parking garage just south of the building where you'll find plenty of free parking. You can also take the Pace #696 bus or the Metra Union Pacific Northwest line to Arlington Heights.
PAYMENT	
POPULAR DISH	Start with the fried calamari and/or the Bella salad (arugula, pears, dried figs and goat cheese). Your main course should undoubtedly be the specialty, black pasta! What is black pasta? Angel hair pasta colored with squid ink, tossed with shrimp, scallops, peppers, and mushrooms in a lobster cream champagne sauce. There is also a full dessert tray from which to choose your poison.
DRINKS	A small, but quality wine list designed to pair nicely with their signature dishes. Try a glass of Zinfandel with your fried calamari. They also have impressive after-dinner drinks complete with a selection of Scotch and port. Order a coffee or espresso and enjoy the flavored sugars made in France. I recommend the coconut sugar in your espresso!
SEATING	This is a very cozy, somewhat small room. Definitely make reservations.
AMBIENCE/CLIENTELE	Carlos & Carlos has an old-world charm with tables covered in white tablecloths and appointed with blue glasses and linens. There is a very elegant feel to the room. Knowing that they pack a flavorful and filling punch, you will not be rushed to finish your meal. In addition to the crowd of business-casual and casual-chic locals, they also attract a good pre-theatre crowd of Metropolis Performing Arts Centre patrons.

—Liz Walker

Chowpatti

Think vegetarian food is bland and boring? Think again!

$$$

1035 S. Arlington Heights Rd., Arlington Heights 60005
(at East Central Rd.)
Phone (847) 640-9554
www.chowpatti.com

CATEGORY	World/International Restaurant
HOURS	Sun: 11:30 am-9 pm Tues-Thurs: 11:30 am-9 pm Fri/Sat: 11:30 am-10 pm
GETTING THERE	Chowpatti is located in a small strip mall with parking right out front. You could get within about a mile or so using Pace bus routes #208, #694, or #696.
PAYMENT	
POPULAR DISH	One of my favorites is Bombay sev batata puri, what the menu describes as "loaded Indian nachos." This finely diced vegetable dish includes crispy puffed rice, tiny chickpea noodles and three types of chutney. Feast your eyes on four varieties of garlic bread, three salads, five kinds of rice, four types of quesadillas, five kinds of burritos, eight kinds of curries, hummus, spaghetti, grilled veggie burgers, pizza, and Mexican-

UNIQUE DISH	style nachos. Pizza toppings include apple, beet, cauliflower, eggplant, zucchini and much more. You'll be hard-pressed to find items like gluten-free aloo wada potato dumplings elsewhere in the area. Finish off your meal with desserts like vegan brownies and cinnamon rolls, Indian ice cream (saffron-pistachio or vanilla), carrot pudding or gulab jamun, balls of pastry coated with saffron syrup.
DRINKS	An entire page of freshly squeezed juices resides in the back of the menu, from simple orange to more exotic selections. You can get a shot of ginger with any one of these fruit concoctions. Other drinks include four types of lassi (yogurt drink) including salty and rose, mango milk, rose milk, sodas, and three types of freshly brewed iced tea. If you want something warm, the masala chai and Indian coffee are good choices.
SEATING	Chowpatti includes seating for about 50 in semi-booth setups that include chairs and cushioned benches. Cross-shaped partitions create privacy for guests at almost every table. Usually you can seat yourself, as there are plenty of tables available.
AMBIENCE/CLIENTELE	The restaurant is small and unassuming, but clean and comfortable. Service is friendly, and if you come more than once, the staff will remember you. One nice touch the staff always provides is a pitcher of water at the table, which is especially helpful if you overestimate your ability to take in the spices.
EXTRA/NOTES	When you walk in, you'll see a display of vegetarian cookbooks, a glass display of Chowpatti T-shirts for sale and a small homage to Chowpatti founder Anil Kapadia, whose family still runs the place. The success of Chowpatti here has spawned a few copycats across the country with similar logos and ideas, but this one is the original.

—*Helen Lee*

Fuego Mexican Grill & Margarita Bar

Mexican food complemented by smooth cocktails and 180-plus types of tequila.

$$$

17 W. Campbell St., Arlington Heights 60005
(at Dunton Ave.)
Phone (847) 590-1122 • Fax (847) 590-1144
www.fuegomexicangrill.com

CATEGORY	Mexican Restaurant
HOURS	Sun: Noon-10 pm Mon-Thurs: 11 am-11 pm Fri/Sat: 11 am-1 am
GETTING THERE	Street parking is available, and it's usually not difficult to find a space less a block away. You can also take the Union Pacific Northwest line to the to the Arlington Heights stop and walk one block south, or take the Pace #696 bus.
PAYMENT	
POPULAR DISH	Guacamole made tableside from fresh ingredients is an attraction here. Not only is it fun to watch, it's a tasty way to start out any meal. Also, don't miss out on the complex and flavorful mole sauces, which can include 20 to 30 ingredients. Unlike other Mexican-style restaurants, there are at least five moles offered

NORTHWEST SUBURBS

daily. Seafood entrees and antojitos, small plates that resemble Spanish tapas, are also popular choices.

UNIQUE DISH The menu at Fuego provides an awe-inspiring selection, with dishes like quesadillas de camaron y callo de hacha (seafood quesadillas), camarones enchipotlados (jumbo gulf shrimp in garlic chipotle sauce) and tamales de frijoles (black bean tamales with garlic, spinach, goat cheese, squash and shiitake mushroom tomato sauce).

DRINKS Fuego boasts over 180 types of tequila and cocktails including tasty temptations like chocolate frio and la jarocha with horchata, offered alongside a grand selection of frozen and regular margaritas. Other popular cocktails include flavored mojitos and yerbabuenas (the tequila version of mojitos), Brazilian caipirinhas and the rosa colada with strawberries, pineapple and coconut. Mezcal and Mexican beer naturally make the list, along with some choice red and white wines. You can even get your favorite brand of beer in the Chelada style—over ice, with lime and a salted rim—or as michelada with cholulu and worchestershire sauces, lime and salt. There are also fresh fruit smoothies, flavored lemonades, Jarritos and Mexican hot chocolate. The horchata is made fresh every morning.

SEATING Fuego seats around 100 to 125 people comfortably in one long dining room. Some of those seats are at the bar, which takes up one entire side of the restaurant. You'll find mostly tables here, although along one wall a long cushioned bench provides partial booth setups.

AMBIENCE/CLIENTELE Fuego's vibrant atmosphere and eclectic design provide a festive dining experience. The walls are lined with fresco-like murals that sport the names of beers and monumental faces of entertainers. Lanterns spaced between arched windows provide atmospheric lighting; wrought iron, dark wood, mosaic tiles, iron chandeliers, an exposed ceiling and framed historic photos accent the room. A couple of flat screen TVs at the bar show sporting events such as soccer. During the week, Wednesdays tend to be the most popular night, thanks to a live mariachi band. It can be loud here, and it often seems like everyone here is celebrating something.

EXTRA/NOTES Fuego hosts monthly tequila-tasting dinners, in case you'd like to learn more about tequila.

OTHER ONES 2047 N. Milwaukee Ave., Chicago 60647, (773) 252-1122

—Helen Lee

GLENVIEW

Dragon Inn North
Generous portions of flavorful, yet American friendly, Chinese food featuring homemade sauces and an authentic vibe.
$$$
1650 Waukegan Rd., Glenview 60025
(at Glenwood Ave.)
Phone (847) 729-8383

NORTHWEST SUBURBS

CATEGORY Chinese Restaurant
HOURS Sun: Noon-8:30 pm
Mon-Thurs: 11:30 am-8:30 pm
Fri: 11:30 am-9:30 pm
GETTING THERE There's a free parking lot north of the restaurant. You can also take Pace bus #422.
PAYMENT
POPULAR DISH Love the savory Moo Shu pork (complete with plum sauce and thin pancakes), the large and meaty Kwoh Te (potstickers) and General Tso's Hunan chicken. Mongolian beef, orange beef, Manchurian sizzling dishes and Szechuan string beans are favorites as well. Kids will enjoy the generously portioned dishes of fried rice.
UNIQUE DISH Try the tofu hot pot. Or call ahead for some real Chinese delicacies, including shark's fin soup and thousand-year-old eggs. Dragon Inn North also makes many of its own sauces, unlike other restaurants of its type.
DRINKS A full bar is available here, along with domestic and Chinese beer. The house offers one type of white wine and one type of red wine to complement your meal.
SEATING The small, windowless dining room features seating for fewer than 100 people. A private room near the entrance can hold a maximum of 40 more. It's rarely crowded here, though— it's a perfect spot for intimate conversation and a friendly dining experience.
AMBIENCE/CLIENTELE This unassuming one-story restaurant along a busy suburban thoroughfare looks like a little white pagoda with red and green trim. Inside, tasteful Chinese trim and decorations give the space a casually elegant yet unpretentious feel. Local businesspeople walk in for lunch and families come for dinner; Dragon Inn North is a regular spot for locals and has been for many years.
—*Helen Lee*

fRedhots and Fries

Part hot dog stand, part avant-garde eatery and completely a neighborhood favorite.

$

1707 Chestnut Ave., Chicago 60025
(at Waukegan Rd.)
Phone (847) 657-9200
www.fredhots.com

CATEGORY American Fast food
HOURS Sun: Noon-3 pm
Mon-Thurs: 10:30 am-7 pm
Fri: 10:30 am-8 pm
GETTING THERE There is a free lot right off Chestnut and parking is no problem. You can also take Pace bus #422.
PAYMENT
POPULAR DISH Chicago-style dogs (mustard, pickle, tomato, relish, sport peppers, celery salt, onion) are always a draw, of course. You can also get kraut and ketchup on your dog. Or try a foot-long hot dog, a half pound Bigfoot or a trio of mini hot dogs called "Pups." fRedhots and Fries serves excellent veggie burgers, third pound hamburgers and other sandwiches. Even the grilled cheese is drool-worthy, made with soft multigrain bread and your choice of cheese. But the crispy yet substantial fresh-cut Belgian frites turn fRedhots and fries into something special. These fries come with

NORTHWEST SUBURBS

	one of a variety of savory dipping sauces, including garlic, wasabi, chipotle, spicy aioli, artichoke, pesto, Filipino red banana pepper or Thai peanut.
UNIQUE DISH	There's always a selection of hot dog, sandwich and burger specials and the wild game sausage of the day, which in the past has included boar, alligator and venison. The regular menu includes a salmon hot dog, tamales and a vegetarian sausage. After 3 pm you can try sweet potato fries.
DRINKS	Self-serve Pepsi products are available. A refrigerator includes cool treats like bottled root beer and grape soda along with energy drinks and water.
SEATING	The restaurant is small, with seating for about 25 to 30, which includes several tables, stools looking out onto Waukegan and a couple of petite, two-person booths. Two wooden picnic tables are set up outside in the parking lot, but it's not particularly scenic out there—you get a great view of the covered dumpster.
AMBIENCE/CLIENTELE	fRedhots and Fries is located in a small brick building with a cheerful decor. It features red tables with green-upholstered seating, brick and paneled walls, and framed newspaper articles and other critical kudos on the wall. A small newspaper stand by the door provides reading material if you're there alone. There's often a decent lunch crowd of locals, but it's usually not too packed.

—*Helen Lee*

Lalo's

Indulging in rich Lalo's cuisine may prompt a sudden siesta urge.
$$$
1432 Waukegan Rd., Glenview 60025
(at Lake Ave.)
Phone (847) 832-1388
www.lalos.com

CATEGORY	Mexican Restaurant
HOURS	Sun/Mon: 11 am-9 pm Tues-Thurs: 11 am-10 pm Fri/Sat: 11 am-11 pm
GETTING THERE	Parking is free and ample. Since the Glenview location is in a strip mall, you will almost always have a spot. You can also take the Pace #422 bus.
PAYMENT	
POPULAR DISH	Lalo's Ultimate Skillet is a meat lover's absolute must! Served on a sizzling skillet, this dish will have you full in no time with skirt steak, chicken, and shrimp. To top off this already scrumptious skillet, sautéed mushrooms, green and red peppers and onions, Spanish rice and beans make it the perfect Mexican dish. The side of tortillas means you can eat straight out of the skillet.
UNIQUE DISH	If you like cheese, the queso fundido appetizer will have you melting. This perfect blend of cheese, sausage and beans can be dipped with your chips or spread on a tortilla.
DRINKS	Lalo's offers a wide variety of cervezas, including domestic, imported, and of course, Mexican. However, you must try one of the delicious, exotic margaritas that are also on the menu.
SEATING	Plenty of seating guarantees you will not have to wait long for a table. Larger groups are accommodated, the tables can quickly be put together. Booth seating is

NORTHWEST SUBURBS

just as comfortable and one is usually available. A private room in the back is open during busier times and is also used as a private party room. Outside dining is available in the summer, but is not very private.

AMBIENCE/CLIENTELE Every wall is decorated with drawings depicting Mexican landscape or lifestyle. Vibrant colors bring out a vibrant culture. Tiles are uniquely decorated and even the tables and chairs match the walls. Daters are plenty and families usually become regulars as they find it a friendly and pleasant atmosphere with good food and great variety. The waiters are friendly and take the time to explain the menu and answer questions.

OTHER ONES See website for more locations!

—May Gruia

Pita Inn
Get in to Pita Inn!
$$

9854 N. Milwaukee Ave., Chicago 60016
(at Golf)
Phone (847) 759-9990
www.pita-inn.com

CATEGORY Middle Eastern Restaurant
HOURS Sun-Thurs: 11 am-11 pm
Fri/Sat: 11 am-Midnight
GETTING THERE Free parking lot. Also accessible by the Pace #272 bus.
PAYMENT Discover, MasterCard, VISA
POPULAR DISH For about $5 Mon-Fri from 11 am-3 pm (non-holidays), you can get the business lunch special. This is an amazing combination of shish kabob, kifta kabob, shawarma, and falafel with a generous side of yellow rice pilaf, salad and pita bread.
UNIQUE DISH I highly suggest the kinafa, sweet cheese layered and soaked in honey. It's orange like a carrot cake and peppered with pistachios.
DRINKS The mint iced tea comes unsweetened, but with a little sugar it compliments all the dishes well. They have the usual coffee and fountain drinks, and no alcohol (sold or BYOB).
SEATING After you order your food and pick it up, seat yourself in the dining room. A series of tables free for the taking all sport napkin dispensers. Collect all your flatware and other extras with your food at the counter. It can get crowded, but turnover is fast, and up to 100 people can sit and enjoy.
AMBIENCE/CLIENTELE Outside on the patio, sit beside the bubbling fountain or under the trellis, or enjoy a great atmosphere inside. With Mediterranean disco music pumping and busboys circulating to clear the tables, the pace is brisk but comfortable. There is a nice mix of people there, varying from businessmen to singles to families.
EXTRA/NOTES The portions are all large. I usually need a take-home box. Not only a Silver Platter Award Winner, it has also been given good reviews by James Ward, North Shore Magazine and Chicago Magazine.
OTHER ONES • 3910 Dempster St., Skokie 60076, (847) 677-0211
• 122 South Elmhurst Rd., Wheeling 60090, (847) 808-7733

—Susan "Devin" Droste

NORTHWEST SUBURBS

Pizano's Pizza & Pasta
Chicago-style pizza from the family that originated it.
$$$
1808 N. Waukegan Rd., Glenview 60025
(at Chestnut Ave.)
Phone (847) 486-1777
pizanoschicago.com

CATEGORY	Italian/Pizzeria Restaurant
HOURS	Mon-Thurs: 11 am-Midnight Fri/Sat: 11 am-1 am
GETTING THERE	Free parking lot has entrances on both Waukegan and Chestnut, but often the Waukegan entrance is blocked off. They offer free valet parking, and special spaces are available for those who order carryout only. You can also take Pace bus #422 to Northbrook Court.
PAYMENT	
POPULAR DISH	When you're talking about Chicago-style pizza, sausage is the operative word. But Pizano's is no one-note wonder—sandwiches, homemade pasta, chicken and salads are all done in a tasty traditional Italian style. If you can resist ordering a pie, homemade ravioli or chicken scaloppine are delicious alternatives. And you can't go wrong with dishes like Anthony's Italian sandwich and Vincent's favorite pasta with shrimp, garlic, parmesan, and olive oil.
UNIQUE DISH	For dessert, try the heavenly Holly & Little Rudy's chocolate chip cookie, a warm and gooey treat smothered in vanilla ice cream, chocolate syrup and a mountain of whipped cream. This dish takes ten minutes prepare, but it's worth the wait.
DRINKS	Pizano's offers a full bar along with a selection of white and red wines and champagnes. A large variety of bottled and draft beers is available, as well as soft drinks and coffee.
SEATING	The restaurant can easily hold around 150 guests in comfort. The main dining room features red and white checked tablecloths, a full bar with stools, a piano in one corner and two full walls of windows facing south and east. Two smaller dining rooms include a fireplace, forest green tablecloths and additional space. Both booths and tables are available.
AMBIENCE/CLIENTELE	Pizano's likes sports; you can see it in the many framed photos, jerseys, signed items and other memorabilia that decorate the walls. Even the doors with frosted glass panes display Chicago team logos, and flat-screen television sets can be found in almost every corner. Add dark brown wood, brass accents, and tin ceilings, and you get true Chicago-branded coziness mixed with a lively and conversation-friendly atmosphere. A pianist is on hand Wednesday through Saturday evenings to provide mood music.
OTHER ONES	• 864 N. State St., Chicago, 60610, (312) 751-1766 • 61 E. Madison St., Chicago, 60603, (312) 236-1777

—Helen Lee

NORTHWEST SUBURBS

NILES/LINCOLNWOOD/MORTON GROVE

Booby's Charcoal Rib
No blue feet at Booby's!
$$
8161 N. Milwaukee Ave., Niles 60714
(at Monroe St.)
Phone (847) 966-4733

CATEGORY	Barbecue Fast food
HOURS	Daily: 11 am-9 pm
GETTING THERE	Free parking lot. Booby's is five minutes north of the Jefferson Park Blue Line stop; take the #56 Milwaukee or Pace #270 bus from there.
PAYMENT	ATM
POPULAR DISH	Standard gyros and Chicago-style kosher beef dogs are popular, but the BBQ ribs and chicken are amazing. A sandwich not to miss is the wet Italian beef, equaled by no other in the Chicagoland area. My mother swears by their Italian sausage and banana shakes, but I always fall for breaded jumbo shrimp.
UNIQUE DISH	Try the char-broiled salami. For only 50 cents more you can get it with cheese.
DRINKS	Be sure to grab a shake in a variety of flavors here, or indulge in a malt.
SEATING	Seating is plentiful, but the place is almost always busy. Expect to strike up a conversation with your neighboring table, or your neighbor in line if you're getting your food to go.
AMBIENCE/CLIENTELE	The staff seems to have a good time, laughing, joking, speaking their native tongue. All kinds of people frequent this establishment, from families to older men and groups of older women out for a night with the girls.

—*Susan "Devin" Droste*

Burt's Pizza
Pizza for adults.
$$$
8541 N. Ferris Ave., Chicago 60653
(at Lincoln Ave.)
Phone (847) 965-7997

CATEGORY	Italian/Pizzeria Restaurant
HOURS	Sun: 4:30 pm-9 pm Weds-Thurs: 11 am-9 pm Fri: 11 am-10 pm Sat: 4:30 pm-10 pm
GETTING THERE	Street parking is plentiful. You can also take the Metra Milwaukee District North line to Morton Grove or the Pace #210 or #250 bus.
PAYMENT	$
POPULAR DISH	A pleasant change-up from usually heavy-handed, cheesy deep-dish Chicago pizza, Burt's signature spin on an old classic somehow manages to accomplish a lightweight, chewy texture without sacrificing richness and flavor.
UNIQUE DISH	With a caramelized cheese crust made popular at establishments such as Gulliver's and Pequod's in Lincoln Park, Burt's crust sets his pizza apart from the crowd.

NORTHWEST SUBURBS

DRINKS	There is a limited menu of alcoholic beverages. The usual fountain beverages are available.
SEATING	The seating area is small but not cramped, and it's only able to accommodate about 30 people. Be sure to call ahead with your order, because there is not only limited space, but limited handmade dough as well.
AMBIENCE/CLIENTELE	Tucked into a dark side street in unassuming Morton Grove, Burt's is the stuff foodie dreams are made of. Small and dark, the decor is kitschy—bobble heads, old ham radios and headshots signed by celebrities pepper the interior. Burt and his wife Sharon are proprietors, kitchen staff and waitstaff all rolled into one, which on occasion makes for bumpy service, but anyone who knows good food knows that patience is truly a virtue at this gem.
EXTRA/NOTES	If you want unconventional toppings, Burt allows customers to bring some in.

—Denise Peñacerrada

Mykonos

Flaming cheese and wine-marinated dishes abound.
$$$$
8660 W. Golf Rd., Niles 60714
(at Greenwood Ave.)
Phone (847) 296-6777 • Fax (847) 296-7339
www.greekrestaurantschicago.com

CATEGORY	Greek Restaurant
HOURS	Daily: 11 am-11 pm
GETTING THERE	Free but limited parking is available seven days a week and free valet parking is offered on the weekends. You can also take the Pace #208, #240, or #412 bus.
PAYMENT	
POPULAR DISH	For all lemon or wine lovers, the chicken breast a la Dimitri is a must! Grilled chicken strips prepared with a light white wine and drizzled with lemon juice. Spices are added to compliment the flavors and each bite releases a fresh, crisp lemon and wine sauce. The chicken is served with rice that further compliments the rich flavors.
UNIQUE DISH	The Saganaki is described as "flaming cheese" and there is no better way of putting it! This appetizer is a simple portion of cheese drenched in wine and set ablaze right at your table. The waiter jubilantly exclaims the traditional Greek opaa! before smothering it with fresh lemon juice to calm the flames.
DRINKS	Mykonos specializes in a variety of wines but also offers the usual beers and specialized drinks.
SEATING	There are plenty of tables at Mykonos and generally there is little or no waiting time to be seated. The tables are far away enough from each other so that you do not hear your neighbors' conversations, yet not so far away that you feel isolated. The booths are even more comfortable and not overwhelmingly tall. The outdoor terrace space, which is open during the summer, is a great, relaxing way to dine. Dates, families and groups of friends will appreciate the cozy and comfortable seating arrangements.
AMBIENCE/CLIENTELE	The casual atmosphere of Mykonos is a soothing and relaxing way to enjoy a meal. You never feel rushed and the waiters are never stressed or hurried.

—May Gruia

NORTHWEST SUBURBS

Wholly Frijoles Mexican Grill

Mexican food with a gourmet twist.
$$$
3908 W. Touhy Ave., Lincolnwood 60712
(at Crawford Ave.)
Phone (847) 329-9810 • Fax (847) 329-9811
www.whollyfrijoles.net_

CATEGORY	Mexican Restaurant
HOURS	Mon-Thurs: 11 am-9 pm Fri: 11 am-9:30 pm Sat: 11 am-10 pm
GETTING THERE	Parking is a nightmare. Since it's located in a strip mall with a limited amount of spots, be prepared to circle around. Take the Pace #290 or #215.
PAYMENT	
POPULAR DISH	Wholly Frijoles' tortilla soup is a must. It's soul-satisfying and bursting with flavor, garnished with fresh tomatoes, tortilla strips and sour cream. The ensalada Wholly Frijoles, mixed baby lettuce, tortilla strips, red onion, diced tomato, cilantro, corn and radishes tossed in a unique, creamy cilantro ranch dressing, is hearty enough to be eaten on its own. Add chicken for a complete meal. The chipotle mashed potatoes make loyal customers out of anyone who tries them.
UNIQUE DISH	Try the filete de pescado—a tilapia filet crusted with pecans and served with spicy tartar sauce. For a special presentation, try the huachinango entero—whole red snapper with head and tail on, either pan-fried or grilled. The varied carnes rojas y aves dishes are sure to please any palate. The borrego en salsa colorada is a tender braised leg of lamb served in three signature sauces: ancho, guajillo (a mild to moderate spicy pepper) and red mole.
DRINKS	BYOB. Cold drinks include limonada, horchata (the famed rice water drink), agua de Jamaica con naranja (hibiscus flower with orange), Mexican sodas (tamarind or mandarin flavors), agua de piña con menta (pineapple with fresh mint), sangria (not the red wine kind, but the grape-flavored bottled variety). On the hot side, there are cafés (coffee) and chocolate con leche (Mexican hot chocolate). For a special treat, make sure to get one of the esquimos de frutas naturales (fresh fruit slushies/smoothies made with mango, guava, strawberries, or pineapple).
SEATING	Both sections to the dining area have fewer than ten four-tops. If you come on the weekends, prepare to wait up to an hour. Beware that they also don't take reservations, but they do accept calls to be placed on a waiting list. In warmer weather there is a cozy patio, but with only a handful of tables that can have even longer wait times. Slow periods like after lunch on weekdays are your best bet.
AMBIENCE/CLIENTELE	Don't let the strip mall/suburban/next-to-a-Dunkin'-Donuts locale fool you. Wholly Frijoles is a hidden gem, and if you're willing to venture out to the off-the-radar 'burb of Lincolnwood, you will be rewarded. The waiters are attentive and friendly.

—*Dorothy Hernandez*

NORTHWEST SUBURBS

PALATINE/ROLLING MEADOWS/SCHAUMBURG

Lamplighter Inn Tavern & Grille

Great restaurant in a charming historic building in downtown Palatine.
$$

60 N. Bothwell St., Palatine 60067
(at Wilson St.)
Phone (847) 991-2420
www.lamplighters.com

CATEGORY	American Bar & Grill
HOURS	Sun: 11 am-9 am
	Mon-Thurs: 11 am-9 pm
	Fri/Sat: 11 am-10 pm
GETTING THERE	The parking lot is across the street. It's also one block from Palatine Metra train station (Union Pacific Northwest line).
PAYMENT	
POPULAR DISH	Sandwiches, pizza, chili, burgers, and beer are all good bets.
UNIQUE DISH	The wraps are their specialty. Try the cheeseburger, gyros, or Italian beef wrap.
DRINKS	There is a full bar and fountain drinks, coffee, and tea. This is the neighborhood bar for the local residents of Palatine.
SEATING	There is a restaurant area in the back of the building that is quiet and great for families. The tavern portion is in the front and there is an outdoor beer garden available.
AMBIENCE/CLIENTELE	The restaurant is in a historic building built in the late 1850s. The building itself is a rich part of Palatine's history and has previously been home to different types of businesses. It was used as a meeting hall before its current use as a tavern.

—*Carrie Kirsch*

Sushi Station

"Train-style" sushi gives diners something unique to choo on!
$$$$

1641 Algonquin Rd., Rolling Meadows 60008
(at Golf Rd.)
Phone (847) 593-2450 • Fax (847) 593-2421
www.sushistation.us

CATEGORY	Japanese Restaurant
HOURS	Sun: Noon-9 pm
	Mon-Fri: 11 am-2 pm, 5 pm-10 pm
	Sat: Noon-10 pm
GETTING THERE	Parking is free, and if the spaces in front are full, there is ample parking to the side or in the rear. (Public transit is not suggested.)
PAYMENT	
POPULAR DISH	In this Kaiten-zushi sushi bar, patrons are entertained by moving plates of sushi that ride around the restaurant in a refrigerated tube. This conveyor belt winds through the restaurant past every table and counter seat. Diners make their selections either by lifting a little door when their choices come by or by ordering off the menu.

NORTHWEST SUBURBS

UNIQUE DISH	Boasting a wide array of traditional rolls and nigiri, the Sushi Station also has a variety of specialty rolls and unique foods. Stop in for their original Station Roll (crab salad with masago) or some jellyfish salad.
DRINKS	Hot tea, juice, and soft drinks are available but, more daring diners may choose from their list of traditional drinks including ramune (Japanese soda), sake, or Japanese beers.
SEATING	A short wait is usually required as seating is a bit limited. Tables are reserved for larger parties while counter seats are available for couples or those dining solo.
AMBIENCE/CLIENTELE	Walking in to a chorus of "irashai!", diners will quickly note they are not in a typical sushi house. Walls are adorned with larger-than-life-size images of sushi. In the middle of the room is a dome housing the sushi conveyor belt, which snakes its way out of the kitchen and through the restaurant. The atmosphere of this sushi bar lends itself to lingering as patrons, deep in conversation, wait patiently for their next choice to work its way by their table. Even this is a good place for conversation as other sushi aficionados file in looking to discuss the merits of each type as the plates lumber by.
OTHER ONES	2486 Randall Rd., Elgin 6012, (847) 783-0040

—*Lisa Hede*

Vittorio De Roma
Italian food at its best!
$$$
154 W. Northwest Hwy., Palatine 60067
(at Smith Rd.)
Phone (847) 991-7006
www.vittorioderoma.com

CATEGORY	Italian Restaurant
HOURS	Mon-Fri: 11:30 am-2 pm, 5 pm-10 pm Sat: 5 pm-10 pm Sun: 5 pm-9 pm
GETTING THERE	The restaurant is in a shopping center, so there are plenty of parking spaces available. If you come by Metra (Union Pacific Northwest line to the Palatine stop), consider taking a cab or be prepared to walk for about one mile.
PAYMENT	
POPULAR DISH	Pasta, like the fettucine alla Harry's Bar (spinach fettucine in a light cream sauce with peas and prosciutto). There are also some tasty meat and fish offerings like steak and salmon.
DRINKS	There is a full bar with several wines to choose from.
SEATING	All seating is indoor in the dining room. The spacing of tables is comfortable.
AMBIENCE/CLIENTELE	This is a local restaurant for those near Palatine. Mostly adults come here for a nice meal.
EXTRA/NOTES	There is a separate banquet hall that can be rented out for private events.

—*Carrie Kirsch*

WEST SUBURBS

WEST SUBURBS

CICERO/RIVERSIDE

Riverside Family Restaurant

"Czech" your carb-counter at the door!
$$
3422 Harlem Ave., Riverside 60546
(at 34th St.)
Phone (708) 442-0434

CATEGORY	World/International Restaurant
HOURS	Sun: 11 am-7 pm Tues-Sat: 11 am-8 pm
GETTING THERE	There is free parking lot in front of restaurant with overflow parking on Harlem or side streets. You can also take the Pace #307 bus or the Metra Burlington Northern Santa Fe line to Harlem Ave.
PAYMENT	$
POPULAR DISH	Entrees include baked ham, roast beef, and meatloaf, and breaded pork tenderloin. Another staple are the knedliky, which resemble the slices of bread they are made with: white, spongy, and oval-shaped. Usually smothered with homemade gravy, these moist and slightly sticky dumplings are just as yummy plain. No one can leave without a taste (or a tray) of homemade kolacky. Made daily with soft, sweet, raised dough, topped with warm ricotta cheese and filled with a dollop of fruit or poppyseeds.
UNIQUE DISH	A uniquely Bohemian dish on the menu: Smoked Butt. Perhaps its name loses something in translation, but the recipe for this traditional sweet and salty pig posterior has been passed down straight from the owners' Slovak relatives.
DRINKS	You can transport yourself back to the old country by sipping a sudsy stein of Czech Pilsner Urquell one of the handful of other beers and wines, or enjoy a more modern, cosmopolitan espresso or cappuccino. A selection of sodas, hot tea, raspberry iced tea, and lemonade round out the beverage list.
SEATING	Riverside seats 140 people. The front room, divided into two parts, is cozy and casual with a combination of booths and tables under Tiffany lamps and wood-framed windows that allow a peek into the bigger back room. More open and barn-like, the rear room's 20 tables are framed by white walls adorned with blue-stenciled flowers, reminiscent of a Czech country china pattern. Reservations are accepted for parties of six or more.
AMBIENCE/CLIENTELE	A light brick building with an old-fashioned sign looks like a remnant of Riverside's old Bohemian neighborhood? Czech. Large paintings of the Bohemian countryside? Czech. A display of Bohemian crystal plates, goblets, and vases? Czech. The aroma of roast pork and fresh-baked kolacky wafting through the homey, wood-paneled rooms? Czech. Fair-haired waitresses with indecipherable Eastern European accents? Czech.

—*Lori Hile*

WEST SUBURBS

Xni-Pec
Authentic Mayan food 1500 miles north of the Yucatán Peninsula.
$$$
5135 W. 25th St., Cicero 60804
(at Laramie Ave.)
Phone (708) 652-8680 • Fax (708) 652-8681
www.xnipec.us

CATEGORY	Mexican Restaurant
HOURS	Tues-Sat: 4 pm-10 pm
	Sun: 10 am-2 pm, 4 pm-10 pm
GETTING THERE	There is a free parking lot in the rear, a gravel parking lot directly across the street, and a few parking spots available on the street. There is a parking lot next to the building, but it is for a different restaurant, so do not park in this lot or you will get towed! You can also take the Pace #305 bus. The #54 Cicero and CX54 Cicero Express buses stop just half a mile east.
PAYMENT	
POPULAR DISH	Combinado Yucateco includes delicious Mayan versions of a marinated pulled pork taco, pork tamale, fried fish taco with chipotle mayo dressing, and tilapia taco with mixed spices.
DRINKS	The restaurant offers a variety of beer, wine and liquor. The waitstaff is friendly and will recommend a great beer to accompany your spicy food. You may get a raised eyebrow if you order a Corona. The staff at Xni-Pec will recommend a better alternative, Pacifico, to go with your meal.
SEATING	Seating at Xni-Pec is cozy with only about 15 tables. It can get pretty crowded on a Saturday night. While there isn't a private room, there is a separate area for small groups to dine with a little more privacy from the main dining room. The tables and chairs have the feel of a late night diner, but the food is top-notch.
AMBIENCE/CLIENTELE	The clientele at Xni-Pec runs from locals to true food lovers that come from all over the city and the suburbs. On the weekends, the restaurant pulls down a large screen on the wall and plays music videos from Mexico.

—*Jen Tatro*

ELMWOOD PARK/OAK PARK

Cucina Paradiso
Cozy, casual, and contemporary Italian.
$$$$
814 North Blvd., Oak Park 60301
(at Oak Park Ave.)
Phone (708) 848-3434
www.cucinaoakpark.com

CATEGORY	Italian Restaurant
HOURS	Sun: 5 pm-9 pm
	Mon-Thurs: 5 pm-9:30 pm
	Fri/Sat: 5 pm-10:30 pm

WEST SUBURBS

GETTING THERE	Limited metered street parking available. The Oak Park Ave. parking garage (first hour free) is about one block east. Or take the Green Line to the Oak Park stop, then walk north under the viaduct to North Blvd. You can also take the Pace #311 or #313 bus.
PAYMENT	
POPULAR DISH	The stromboli is a must-have. Much like a calzone, this tasty treat is stuffed with sautéed spinach, Asiago, provolone, Romano and ricotta cheeses, mushrooms and tomato sauce.
UNIQUE DISH	Stone baked pizzas, a wide variety of pastas (with whole wheat options), and a carefully considered list of upscale entrees fill the menu. You can try a pizza with sliced pears, caramelized onions, gorgonzola and balsamic vinegar.
DRINKS	A lengthy wine list featuring a wide selection of Italian wines, French champagne, cordials, cocktails, and both domestic and imported beers.
SEATING	There is room for approximately 75 dinner guests in the dining room and another ten or so at the bar. Long waits are seldom a problem although reservations are always recommended.
AMBIENCE/CLIENTELE	Italian dining even at its finest is a family affair. While it's a perfect spot for a quiet, intimate dinner, don't be surprised to find a family across the room. Bright and upscale in design and contemporary in execution, the restaurant is a warm and welcoming place. The service seems to match the style: comfortable, attentive, and more than willing to let you sit and enjoy.

—David Kravitz

Five Guys Burgers and Fries

Hamburgers, hot dogs and fries, oh my.
$$
1115 Lake St., Oak Park 60301
(at Marion St.)
Phone (708) 358-0856 • Fax (708) 358-0906
www.fiveguys.com

CATEGORY	American Fast food
HOURS	Daily: 11 am-10 pm
GETTING THERE	Use the Holly Court Parking Garage. You can also take the Green Line to the Harlem stop. Or take the #90 Harlem, Pace #313, or Pace #307 bus.
PAYMENT	
POPULAR DISH	First start with a fresh, hand-made all beef hamburger hot off the grill, then add your choice of toppings including mustard, ketchup, mayo, classic pickle relish, onions, lettuce, pickles, tomatoes, fried onions and sautéed mushrooms. Or ask for jalapeño peppers, green peppers or even A-1 sauce if you feel especially iconoclastic.
UNIQUE DISH	Hand-cut French fries, regular or Cajun. The servings are bountiful—a small order is enough for two. Still, fat is flavor.
DRINKS	Coca-Cola products (free refills), iced tea, and water.
SEATING	There is table seating for approximately 50 and counter seating for approximately 15. There is no table service. Pick-up, carry out or eat-in…it's the same brown bag for all. Tables turn pretty quickly so there's seldom a wait.

WEST SUBURBS

AMBIENCE/CLIENTELE	Clean, bright, and to the point, Five Guys features a simple menu of burgers and dogs.
OTHER ONES	See website for other locations.

—*David Kravitz*

Johnnie's Beef
Best of the best Chicago Italian beef and more.
$
7500 W. North Ave., Elmwood Park 60707
(at 75th St.)
Phone (708) 452-6000

CATEGORY	American Sandwich Shop
HOURS	Sun: Noon-Midnight Mon-Sat: 11 am-Midnight
GETTING THERE	There is a parking lot on-site, but you can also take the #72 North Ave. or Pace #318 bus and walk half a mile west.
PAYMENT	$
POPULAR DISH	Italian beef sandwiches, that is, juiced up on a slab of crisp Italian bread. Most people will agree that it's better if you flavor yours with hot peppers, sweet peppers or both. Of course, you'll also find great sausage sandwiches as well, so maybe the best way to get the real taste of Johnnie's is with a beef and sausage combo. And don't overlook the fries!
UNIQUE DISH	Green pepper & egg sandwich (served on Friday).
DRINKS	Soft drinks. To complete the experience go for the homemade lemon Italian Ice, even in winter.
SEATING	There is no indoor seating, but outside picnic tables are available.
AMBIENCE/CLIENTELE	If you remember the Soup Nazi from Seinfeld, you have an idea of the fast-paced manner at Johnnie's. But though you won't be as pressured, it's good to know what you want when it's your turn at the counter. The menu is clearly displayed on an ancient board. There probably will be a line snaking out the door, but don't worry, it moves quickly. Newcomers and regulars alike make great company here.
OTHER ONES	1935 S. Arlington Heights Rd., Arlington Heights 60005, (847) 357-8100

—*David Kravitz*

Marion Street Cheese Market
The cheese here will not stain your fingers.
$$$
100 S. Marion St., Oak Park 60302
(at South Blvd.)
Phone (708) 725-7200 • Fax (708) 725-7210
www.marionstreetcheesemarket.com

CATEGORY	American Restaurant
HOURS	Sun: 9 am-9:30 pm Mon-Thurs: 8 am-10 pm Fri/Sat: 8 am-11:30 pm
GETTING THERE	Parking meters are plentiful along Marion and South Blvd. The restaurant is located just one block east of the Harlem stop of the Green Line. You can also take the #90 Harlem bus or Pace #311 or #307 bus.

WEST SUBURBS

PAYMENT	
POPULAR DISH	The Swiss fondue is the star, served with bread, broccoli, and "crispy" potatoes. They also offers two wildly popular crêpes as well. The warm whole wheat crêpes feature Nueske's ham, caramelized onions, and antique Gruyère, or roasted mushrooms, baby spinach, and fresh Chèvre.
UNIQUE DISH	Past specials have included homemade elk sausage, which was perfectly seasoned with a nice texture.
DRINKS	A stellar selection of wines and beers from around the world. The wine shop offers bottles for sale. The wine and beer bar offer wines and beer by the bottle or glass. Because wine and beer menu is so eclectic, ordering a flight is the way to go.
SEATING	Space is limited and the restaurant tends to get crowded at times. There are a few stools for counter service at the wine and beer bar. Three high tables facing the street are great for people-watching. While the dining room can get noisy, it is never frustrating. Outdoor seating is available during warm weather.
AMBIENCE/CLIENTELE	The decor is simple and tasteful with clean lines, modern, eco-friendly furniture, greens, khakis, and wood floors. It attracts a fairly diverse crowd, so expect to see everything from young families to older couples. Even though the restaurant is casual, most clientele forgo jeans or super trendy looks.
EXTRA/NOTES	Marion Street Cheese Market offers culinary classes that range from "Wine and Chocolate Pairings" to "Curds and Beer." The restaurant also has live music on the second Friday and Saturday and third Sunday of the month.

—*Heather Calomese*

Marion Street Grille
Cozy, casual, and contemporary.
$$$
189 N. Marion St., Oak Park 60302
(at Ontario St.)
Phone (708) 383-1551
www.marionstreetgrille.com

CATEGORY	American Bistro
HOURS	Tues-Sun: 5 pm-10 pm
GETTING THERE	Limited metered street parking available. The Holly Court parking garage (first hour free) is approximately 100 feet south. Or take the Green Line to the Harlem stop. You can also take the #90 Harlem, Pace #307 or Pace #313 bus.
PAYMENT	
POPULAR DISH	The barbeque baby back ribs are the best in town. Sweet, succulent, meaty and tender, they fall away from the bone. Pair them with the creamy cheddar and bacon twice-baked potatoes and red wine.
UNIQUE DISH	Try the blackened yellow fin tuna cajun-style or the lightly herb-crusted Holland sole with lemon-basil sauce. The black truffle ravioli comes in a light Marsala cream sauce, while the classic big-bowl fettuccine and sweet italian sausage is graced with a bountiful alfredo sauce. The Steaks & More menu that includes New Zealand baby rack of lamb, the luxurious. center

WEST SUBURBS

cut New York Strip, or Moulard breast of duck with a Grand Marnier glaze.
- **DRINKS** A full service cocktail bar as well as an extensive wine list hand-picked by the owner.
- **SEATING** There is table service for approximately 50 with limited seating for six at the cozy bar.
- **AMBIENCE/CLIENTELE** Casual fine dining describes this place perfectly. It's a friendly gathering place for regulars and newcomers. More like family than customers, diners here are greeted warmly. While tables are a little too close together, it only means owner Terry Thulis has less territory to cover when personally greeting each guest.

—*David Kravitz*

Maya del Sol
Unique south-of-the-border excitement at home in Oak Park.
$$$$
144 S. Oak Park Ave., Oak Park 60302
(at South Blvd.)
Phone (708) 358-9800
www.mayadelsol.com

- **CATEGORY** Latin American Restaurant
- **HOURS** Sun: 10 pm-9 pm
 Mon-Thurs: 4 pm-9 pm
 Fri/Sat: 4 pm-10 pm
- **GETTING THERE** Street parking is generally available. Valet parking is very inexpensive. You can also take the Green Line to the Oak Park stop and walk half a block south, or take the Pace #311 or #313 bus.
- **PAYMENT**
- **POPULAR DISH** Chef Beltran's favorite dish is cochinita pibil, slow-roasted pork in an achiote marinade served with pickled red onions, black bean gratan, and a side of habañero salsa.
- **UNIQUE DISH** Other highlights on the menu include Baja California-style enchiladas with shrimp and blue crab, wild mushroom ceviche with oyster and shiitake 'shrooms, a mixed serving of perfectly seared Salvadorian callos de acha (sea scallops) alongside sweet bay scallops, and a constantly changing offering of full-flavored beef dishes including chipotle-marinated carne asada.
- **DRINKS** Maya del Sol features a complete, well-stocked bar. High on the list of favorites is their CoyOpa margarita which is mixed and poured with great style at your table.
- **SEATING** The dining room seats 175, the bar seats 50, and the private room and patio each seat 70.
- **AMBIENCE/CLIENTELE** The restaurant is fun and casual. The house is lively and upbeat and the decor is modern with a subtle south-of-the-border style. Service is attentive. The bar area is often a regular meet-and-greet location for friends. In season, the patio is a great place to linger over a beer or cocktail and is also available, along with a private room, for receptions and parties. Live music is a highlight to the extensive Sunday Brunch.

—*David Kravitz*

WEST SUBURBS

The New Rebozo
Ask for Paco and learn why he says "Oh my God."
$$$$
1116 Madison Ave., Oak Park 60302
(at Maple Ave.)
Phone (708) 445-0370 • Fax (708) 445-7372
www.newrebozo.com

CATEGORY	Mexican Restaurant
HOURS	Mon-Sat: 11 am-3 pm, 4 pm-10 pm
GETTING THERE	Street parking is generally available. Take the Green Line to the Harlem stop, or take the Blue Line to the Harlem Ave. stop. You can also take the Pace #320, #307, or #305 bus.
PAYMENT	
POPULAR DISH	Delicious tacos, burritos, enchiladas and tortilla soup.
UNIQUE DISH	Some favorite "Oh my God" specials include a homemade tamale appetizer wrapped in corn leaf and smothered in sweet mango sauce; an entree of mini enchiladas, each bathed in one of 12 homemade moles ranging from pistachio to classic puebla chocolate; or when pomegranates are in season, Paco's chiles enogada. A fresh green chile, brimming with ground beef cooked with eight different dried fruits is smothered in a pecan cream sauce sparkled with a cascade of tart, juicy, pomegranate seeds.
DRINKS	A full bar including Mexican and domestic beers. The specialty of the house is a menu of exuberant and generous mango, strawberry, and lime margaritas, not to mention the handmade classic shaken to perfection.
SEATING	Recently remodeled, seating is comfortable and cozy. The restaurant features a some small intimate tables, as well as comfortable booths, and a patio perfect for a warm evenings. The clean, comfortable, and modern appearance complements the unique food served.
AMBIENCE/CLIENTELE	Walking into The New Rebozo is more like joining a family than entering a restaurant. For starters, Chef Paco is certain to gladly greet you, often with a generous and heartfelt hug. He makes everyone feel comfortable and welcome. Never do you feel rushed or overlooked.

—David Kravitz

Russell's Barbecue
Old school barbecue you and your grandfolks can love.
$$
1621 N. Thatcher Ave., Elmwood Park 60707
(at North Ave.)
Phone (708) 453-7065
www.russellsbarbecue.com

CATEGORY	Barbecue Restaurant
HOURS	Sun-Thurs: 10:30 am-10 pm Fri/Sat: 10:30 am-11 pm
GETTING THERE	There is parking on-site, but you can also take the #72 North bus to Harlem Ave. or the Pace #318 Pace to Thatcher.
PAYMENT	
POPULAR DISH	From BBQ pork or beef sandwiches on plain white bread to BBQ Ribs and on to roasted chicken, the menu here is extensive. Also available are krab cakes, salmon

WEST SUBURBS

or white fish sandwiches, fried shrimp and burgers. Want corn on the cob, jalapeño poppers, spicy chicken wings or just a simple salad on the side? It's all here. Desserts are limited to gourmet cookies, brownies and Eli's Cheesecake (plain or chocolate chip).

DRINKS Soft drinks, shakes, coffee, tea and beer.
SEATING Simple tables throughout ample rooms.
AMBIENCE/CLIENTELE A trip to Russell's in Elmwood Park is like a ride in a time machine. Not much has changed since the place opened. Enter to find a line-up of everyday folks waiting to place their order at a small cash register stand while their families are off to find an open table. Within minutes, your order appears across the expansive bar and, tray in hand, you're off. As you might expect, people here are eating, not dining. But the prices are right, the food solid, and the experience is one for your blog or Facebook page.
OTHER ONES 2885 Algonquin Rd., Rolling Meadows 60008, (847) 259-5710

—*David Kravitz*

NAPERVILLE

White Chocolate Grill
Best dirty martini and bread pudding in the Western suburbs!
$$$

1803 Freedom Dr., Naperville 60563
(at Diehl Rd.)
Phone (630) 505-8300 • Fax (630) 505-8333
www.whitechocolategrill.com

CATEGORY American Restaurant
HOURS Daily: 11 am-10 pm
GETTING THERE There is a huge free parking lot.
PAYMENT
POPULAR DISH The last time I ordered the rib eye sandwich, it was perfecto; the meat was tender and succulent. The au jus was good and the fries were to die for. They came wrapped so they stayed warm. My friend and I shared the Ahi tuna salad, which consisted of seared rare tuna with greens, mango, avocado and a fabulous champagne vinaigrette.
UNIQUE DISH The dancing crab cake was delicious.
DRINKS The fabulous bar had a very cool retro feel, and the bartenders were personable and guided us through the menu selections.
SEATING The bar is comfortable enough to eat in. The whole restaurant has a casual atmosphere. I love the Frank Lloyd Wright retro feel. The booths are intimate and not meant for large crowds but there is enough room for a party of three or four.
AMBIENCE/CLIENTELE It's low lighting but would you want glaring lights if you're having an intimate dinner? During lunch, the crowd seemed to be mostly younger professionals lingering with their business associates.

—*Susan Ball*

SOUTHWEST SUBURBS

SOUTHWEST SUBURBS

BLUE ISLAND

Wheaton's Soul Food Cafe
Southern-style café and bar with food full of soul and bacon fat.
$$
13023 Western Ave., Blue Island 60406
(at New St.)
Phone (708) 388-9551

CATEGORY	Soul Food Restaurant
HOURS	Daily: Noon-1 am
GETTING THERE	There is a free parking lot behind the building that can be used if there are no street spots. You can take the Metra Rock Island District line to the Blue Island/Vermont stop, which is only three blocks from the café. The #12 Vincennes/111th bus stops only a block away.
PAYMENT	
POPULAR DISH	Anything smothered is very worth getting. They make smothered chicken or pork chops, but they are only offered on Tuesday and Sunday. Another favorite is the homemade meatloaf. Every day, there is a special offered, and they are constantly adding new items to the menu as they go. They offer a fail-proof burger, seasoned and made fresh in their kitchen. Recently, they started serving a turkey and a beef chili as well as a chicken salad sandwich that are all very tasty, affordable, and quick.
UNIQUE DISH	The ham hock with red beans and rice is full of smoky, tender ham meat and a lot of fat on the bone.
DRINKS	There is a full bar where people can get their choice of a few beers or a cocktail.
SEATING	The restaurant seats about 50 with room for dancing.
AMBIENCE/CLIENTELE	At nights and on weekends it can get busy and it feels lively and fun. Since the bar is open until 2 am on weekdays and 3 am on weekends, you can go with friends for a few drinks and have some food to go along with it. The decor is simple with paintings of Africa and musicians' faces. It is a neighborhood kind of place with a menu that is much bigger and has more "soul" than a lot of places on the South side.
EXTRA/NOTES	On Wednesdays, they feature karaoke and the singers are pretty good. They also have specials on buckets of beer during Bears games.

—*Araceli Valenciano*

BRIDGEVIEW/BURBANK

Chuck's Southern Comfort Café
Where the South meets your mouth!
$$$
6501 W. 79th St., Burbank 60459
(at Central Ave.)
Phone (708) 229-8700 • Fax (708) 229-8672

SOUTHWEST SUBURBS

www.chuckscafe.com
- **CATEGORY** Southern Restaurant
- **HOURS** Sun-Thurs: 11 am-9 pm
 Fri/Sat: 11 am-10 pm
- **GETTING THERE** Free parking is limited. You can also get to Chuck's via Pace #379, #382, or #384 bus or bicycle.
- **PAYMENT**
- **POPULAR DISH** It's difficult to pick favorites. Try Chuck's special: a smoked brisket sandwich with onions, smoked peppers and monterey jack cheese. The seafood jambalaya could give New Orleans' best a run for its money! Crab cakes, chicken creole and the smoked corned beef are all mouthwatering delights. Sides like homemade macaroni and cheese or mashed potatoes and gravy are a must.
- **UNIQUE DISH** The specials and theme-based dishes rotate around holidays such as Mardi Gras and Cinco de Mayo. Try the Oaxacan cochinita pibil (slow cooked adobo-marinated pork shoulder wrapped in banana leaves) or tacos escuinapas (shrimp, tomato, onion and jalapeño-filled crispy taquitos served with a tangy roasted tomato sauce).
- **DRINKS** Soda, Blumers root beer, Orange Cream or Classic Cream, coffee, hot tea, milkshakes and malts.
- **SEATING** Ample seating in the dining area accented with a southern motif. Light blues music plays overhead and the atmosphere is very relaxed and casual, yet festive.
- **AMBIENCE/CLIENTELE** The clientele is a warm mix of cultures and classes—street crews eat alongside businessmen. Burbank residents and out-of-towners alike keep the cooks jumping and Chuck will frequently appear to shake hands and chat with customers old and new.
- **EXTRA/NOTES** Two of the most popular events in Burbank are Chuck's two-day Mardi Gras parties (accompanied by a week-long Cajun menu filled with delicious dishes seldom served anywhere in Chicago!) and the newly formed annual Chuckfest. This inaugural street fair is held in a church parking lot and lasts three days.

—*Crage Kentz*

Duke's Drive-In

Cruisin' Duke's on a Saturday night.
$$
8115 S. Harlem Ave., Bridgeview 60455
(at 81st St.)
Phone (708) 599-0576
www.dukesitalianbeef.com
- **CATEGORY** American Restaurant
- **HOURS** Daily: 11 am-10 pm
- **GETTING THERE** Free parking is readily available (it's a true drive-in), except for "Car Show" nights in the summer. (Weekend nights vary.) You can also get to Duke's via the Pace #379 bus, bicycle, or your own two feet.
- **PAYMENT**
- **POPULAR DISH** The Italian beef sandwich. Order it "juicy" with mozzarella and giardinera. During Lent, Duke's pepper and egg sandwich on Italian bread is a well-kept delicious secret. For the hearty meat-eater, grab a Duke's combo—Italian sausage smothered in Italian beef. Order it with sweet peppers and you won't regret

SOUTHWEST SUBURBS

this savory celebration. Balance any sandwich with the fresh-cut fries! Their steamed David Berg hot dogs (don't skip the sport peppers!) and homemade chili are second to none.

DRINKS Pepsi, Diet Pepsi, Bubble-Up, Root Beer, Lemonade, Fruit Punch and Sun Tea (seasonal), milkshakes, malts, and floats.

SEATING There is very limited counter seating area inside. There are concrete picnic tables in the drive-up area and you can always eat in your car.

AMBIENCE/CLIENTELE There is a throwback quality to the place, yet it's clean and inviting. The food is blue-collar street chow and the patrons range from truck drivers to cops, nurses to businesswomen, little old men to the local high school baseball team. While there is no curb service at this drive-in, the staff is always fast and friendly.

EXTRA/NOTES "Cruisin' Duke's" is a '50s style party that you should experience at least once. T-shirts are available. Duke's ships beef and sausage to fans all over the US and has catering services for parties, too.

—*Crage Kentz*

Little Frank's Pizzeria
You've tried the rest....now try the best!
$$$
6355 W. 79th St., Burbank 60459
(at Narragansett Ave.)
Phone (708) 598-8660

CATEGORY Italian/Pizzeria Restaurant
HOURS Daily: 11 am-11:30 pm
GETTING THERE A very small parking lot lies to the east. Little Frank's can be accessed by the Pace #384 or #379 bus, bicycle or your own two feet.

PAYMENT
POPULAR DISH Once you've had a Little Frank's Special with sausage, mushrooms, onions and green peppers, resistance is futile. The flavor gets under your skin and into your blood, a delicious addiction you'll love to feed. Order your pizza with a side of deep-fried zucchini and enjoy a taste of heaven!

DRINKS Pepsi, Diet Pepsi, Sierra Mist, Dr. Pepper, and iced tea.

SEATING This place is carry-out only, unless you want to go next door to Frank's Bar to enjoy your meal with a beer or cocktail.

AMBIENCE/CLIENTELE Frank's is a traditional neighborhood place adorned with White Sox and NASCAR paraphernalia. The guys and dolls behind the counter call you by name and greet you like an old friend. A small television blares with the sound of the day's game and delivery-men hustle in and out, shuffling their precious cargo delicately to their running cars out front. The smell will set your salivary glands into overdrive from the moment you walk in to pick up your order.

EXTRA/NOTES Frank's Bar next door has that roadhouse rowdiness to it, but this is all business, pizza business, and business is good.

—*Crage Kentz*

SOUTHWEST SUBURBS

Mabenka Restaurant
The best Polish food on the southwest side!
$$$
7844 S. Cicero Ave., Burbank 60459
(at 79th St.)
Phone (708) 423-7679
www.mabenka.com

CATEGORY	Polish Restaurant
HOURS	Mon-Thurs: 11 am-9 pm
	Fri/Sat: 11 am-10 pm
GETTING THERE	Free parking, but parking is limited. You can also get to Mabenka via the #79, #54B South Cicero, or Pace #379 bus, bicycle, or your own two feet.
PAYMENT	
POPULAR DISH	Take your pick, but the money dish is the Cepelinai, a Lithuanian potato dumpling stuffed with meat and authentic "white" sausage, which is not smoked. The pierogies and borscht are simply perfect. A welcome feature on the specials menu is the $18 Date—dinner for two that highlights different dishes and includes dessert.
UNIQUE DISH	The pork is particularly tender. The sauerkraut soup and kugelis are made from scratch. The Lithuanian sausage has incredible flavor and texture.
DRINKS	Coke, Diet Coke, Sprite, coffee or hot tea. Polish imported beers such as Zywiec and Okocim are a treat with any meal.
SEATING	Ample seating is available in the dining area where the decor leaves something to be desired. You can make reservations if you are planning to dine with parties of five or more or during peak periods.
AMBIENCE/CLIENTELE	While the interior design may lack any distinctions, the staff and the atmosphere is festive and homestyle. The aromas and polka music are fitting and make a suitable backdrop for an Eastern European night out.
EXTRA/NOTES	Every Wednesday night they have live entertainment in the banquet room and the dancing is infectious! The house polka band will play your favorite tunes and work in their fun mix of originals. Arrive early, as seats are first come first served.

—*Crage Kentz*

ORLAND PARK/TINLEY PARK

Cooper's Hawk Winery and Restaurant
Join the Wine Club—it's free!
$$$$
15690 S. Harlem Ave., Orland Park 60462
(at 157th St.)
Phone (708) 633-0200
www.coopershawkwinery.com

CATEGORY	American Restaurant
HOURS	Sun: 11:30 am-9 pm

SOUTHWEST SUBURBS

	Mon-Thurs: 11:30 am-9:30 pm Fri/Sat: 11:30 am-10 pm
GETTING THERE	The free parking lot is very accessible. You can also take the Pace #354 or #364 bus.
PAYMENT	
POPULAR DISH	Over the Border egg rolls are like a taco in a crispy egg roll shell. The jumbo shrimp comes in a tequila-lime butter sauce and it's delicious!
DRINKS	Cooper's Hawk has excellent wine, a fully stocked bar, and plenty of non-alcoholic refreshments.
SEATING	Seating is ample, but the bar's a little busy.
AMBIENCE/CLIENTELE	The clientele is definitely a younger party crowd, as it's loud and hard to hear, but if you're in the mood for good food and a great glass of wine you've come to the right place.
EXTRA/NOTES	The wine club is a great deal; just buy one bottle of wine per month and your membership is free. There are perks like 10 to 20% off retail pricing!
OTHER ONES	See website for more locations.

—*Susan Ball*

The Egg & I Restaurant

An upscale Mom and Pop restaurant with a laid-back atmosphere.
$$
7164 W. 183rd St., Tinley Park 60477
(at Harlem Ave.)
Phone (708) 614-0909 • Fax (708) 614-0990
www.eggni.com

CATEGORY	American Brunch
HOURS	Sat/Sun: 7 am-2:30 pm Mon-Fri: 6 am-2:30 pm
GETTING THERE	Free parking with easy access in and out of the lot. You can also take the Pace #354 bus.
PAYMENT	
POPULAR DISH	The Madison sandwich: shaved ham slices, crisp bacon and scrambled egg topped with cheddar cheese on grilled honey wheat bread. You also have to try the healthy scrambler. Turkey sausage, broccoli, mushrooms and fat-free cheddar scrambled with low cholesterol egg beaters make this healthy meal seem too good to be true. For lunch, try one of the huge Reuben sandwiches! The burgers are also a treat. Try the guacamole bacon burger with smoked bacon, melted cheddar, red onion, lettuce, and tomato. You can't go wrong with any of the large, fresh salads.
UNIQUE DISH	Strawberry, mango, and banana waffles, chocolate-covered strawberry pancakes or some other tasty twist on a classic meal. The unexpected meal to try is the potato skin breakfast—two potato skins cooked perfectly crisp on the outside and soft on the inside, topped with cheddar cheese, and served with two eggs and two pieces of meat. For a south-of-the-border treat, order the Mexican skillet. Eggs, chorizo, tomatoes, onions, and melted cheese topped with sour cream and salsa will definitely wake you up! A unique salad I love to order is the Sanibel salad.
DRINKS	Try their excellent coffee, iced coffee, cappuccinos, vanilla latte and chocolate mocha.
SEATING	There is counter seating and plenty of beautiful wooden tables and comfortable booths. There is

SOUTHWEST SUBURBS

plenty of room between tables. Free coffee is available on the weekends while you wait. However, the wait is no longer than 10 to 15 minutes because the service is fast as well as friendly.

AMBIENCE/CLIENTELE The hand-painted designs on the walls are beautiful. The restaurant is not overdone; it's a classic breakfast and lunch restaurant with a modern approach. Young friends to families and senior citizens frequent this restaurant.

EXTRA/NOTES Everything on menu is available for take-out or delivery, and a full catering menu is available online.

OTHER ONES 222 Dixie Hwy., Chicago Heights 60411, (708) 754-0909

—*Denise Goldman*

SAM'S WINES

Not Just for Beverages Anymore

With warmer weather, eating out can mean eating out of doors. When I'm looking for lunch on the run or planning a picnic at the park or harbor, I make **Sam's Wines and spirits** my one stop shop. Sam's not only has a large selection of wines, beers, and spirits, they also have a fantastic gourmet market. They offer made-to-order Sammies and party trays featuring a large assortment of domestic and imported cured meats, cheeses, condiments and pickled veggies. They also have fresh bread and pastry from Bennison's Bakery (Evanston), and assorted crackers and snackers.

Let their knowledgeable market staff create a lunch for one or many. Try the Kents Special, a vegetarian delight with creamy goat's milk cheese, roasted red peppers, and cucumbers on a crusty baguette, or a muffaletta that rivals New Orleans own Central Grocery. The Italian antipasto serves 12-15 people. Customized trays require 24-hour notice.

I round out my outing with chips—Rocky's Hummos Chip are my fave—and dips from American Spoon, Desert Pepper Trading Company, or Silver Palate to name a few. You can even satisfy your sweet tooth with Chicago's own Vosges chocolates, Sweet Margy confections, and Terry's Toffee. Or go fair trade with Divine chocolates. They are not only chocolates with a conscience but cost-conscious as well.

While you are there, don't forget the beer, wine, soda, or even premixed cocktails. Just add ice and you are golden like a margarita. Sam's even carries paper plates, plastic cups, disposable utensils and paper napkins.

With four locations in the Chicagoland area there is sure to be a store nearby. They will make your outing a breeze.

1720 N. Marcey St., Chicago 60614, (312) 664-4394

50 E. Roosevelt Rd., Chicago 60605, (312) 663-9463

1919 Skokie Valley Rd., Highland Park 60035, (847) 433-9463

2010 Butterfield Rd., Downers Grove 60515, (630) 705-9463

— *Kathy Moon*

SOUTHWEST SUBURBS

Granite City Food and Brewery

Casually elegant, this isn't your daddy's brew pub.
$$$
14035 S. La Grange Rd., Orland Park 60462
(at 147th St.)
Phone (708) 364-1212
www.gcfb.net

CATEGORY	American Restaurant
HOURS	Sun: 10 am-10 pm
	Mon-Thurs: 11 am-11 pm
	Fri/Sat: 11 am-Midnight
GETTING THERE	The free parking lot is very accessible. The entrance is sort of tricky, but parking is ample. You can also take the Pace #386 bus.
PAYMENT	
POPULAR DISH	I had the Walleye dinner, which was excellent. If you're in the mood for fish, this is a must-try. I also recommend a starter of cheddar ale soup.
UNIQUE DISH	The signature meatloaf is a very generous portion, charbroiled (who knew?) and served open-faced on grilled ciabatta. Also, try the prosciutto olive flatbread pizza—a crispy flatbread brushed with lots of roasted garlic and olives and generously topped with basil, provolone, prosciutto, mozzarella, and parmesan.
DRINKS	They have a decent beer menu, including some specialty brews as Hefeweizen, Belgian Wit, Burning Barn Irish Red, and Ostara Spring Ale. Try some of their house brews, like Brother Benedict Bock, Duke of Wellington, and Broad Axe Stout. If you aren't there for the "beer experience" they have a full service bar.
SEATING	Seating is very accommodating, and the bar area is nice and big. You don't feel like you're on top of everyone. The menu sports enough choices so if you bring the little buckaroos, mom and dad can relax knowing there's something for everyone.
AMBIENCE/CLIENTELE	The casually elegant Southwestern motif feels very chic and comfortable; nice enough to impress a first date or older family members. The waitstaff was sincere and knowledgeable.
OTHER ONES	See website for more locations!

—*Susan Ball*

Isabella Café & Catering

Intimate Italian gem of the southwest suburbs that is not to miss.
$$$$
17211 S. Oak Park Ave., Tinley Park 60477
(at 172nd St.)
Phone (708) 444-8555 • Fax (708) 444-8550
www.isabellacafe.com

CATEGORY	Italian Restaurant
HOURS	Sun-Thurs: 11 am-10 pm
	Fri/Sat: 11 am-11 pm
GETTING THERE	They have a parking lot! You can also take the Metra Rock Island District line to Tinley Park.
PAYMENT	
POPULAR DISH	My favorite is the salmon fettuccini. Save room for dessert like the strawberry mousse and cannoli cake with raspberry sauce.

SOUTHWEST SUBURBS

UNIQUE DISH The smoked chicken with rigatoni is fantastic. I have not found another restaurant in the area serving smoked chicken. I have also seen duck on the menu.
DRINKS Isabella's has a smaller, but accommodating wine list.
SEATING This restaurant was once a house. I love dining on the enclosed front porch; it has a great intimate vibe. The restaurant is not large. I have never seen anyone waiting, but they are never empty either. The best bet is probably to go either early or late, and on weekends the dining room is open until 11 pm. Isabella's can have a cozy feel, yet I have seen lively larger groups dining together as well.
AMBIENCE/CLIENTELE The decor does not fit the paint-by-number design of other restaurants. This is a great place to eat with a spouse, partner, good date or a smaller group of close friends or family. Friends of ours had their wedding rehearsal dinner at Isabella's. It is modern without being outlandish and in-your-face. Isabella's is casual, but not wear-a-baseball-hat casual. The staff is not at all overbearing, and I have never felt rushed. The waitstaff is knowledgeable about the menu and the wines.
EXTRA/NOTES Isabella's often sells art by local artists.

—*Julie Owens*

Orland Oasis

Serving delicious dishes with a neighborhood friendly smile.
$$

14306 S. Union Ave., Orland Park 60462
(between Southwest Hwy. and 143rd St.)
Phone (708) 403-5503

CATEGORY American Diner
HOURS Daily: 6 am-2 pm
GETTING THERE There is a free parking lot and plenty of free street parking available. If you are in the neighborhood, take a stroll or bike ride. The 143rd St. Metra station (SouthWest Service) is only three blocks away, or take the Pace #386 bus.
PAYMENT
POPULAR DISH One of the most popular dishes is the Biscuits and Gravy, homemade fluffy biscuits covered with sausage gravy and a side of hash brown. If you want a little bit of everything, then try one of Chef Klaus' specials that include two pancakes, two sausage links, two strips of bacon, two pieces of toast (your choice of bread) and a side of hash browns.
UNIQUE DISH The Greek omelette is one spectacular menu item to try, especially if you love feta cheese. The omelette is served with a hefty size side of hash browns and your choice of toast. The pancakes and waffles are filled with various types of fruit and topped with more fruit.
DRINKS The coffee is the best cup around, and yours will never be empty with prompt refills. They also serve orange and cranberry juice that is always fresh and perfectly chilled. Hot or iced tea is served with honey or lemon. Plain or chocolate milk is always an option, and don't forget the Pepsi products.
SEATING There are few tables in this petite restaurant, but the only day to worry about is on Sundays, when every one wants a taste of Orland's best breakfast. Also there are nearby churches that let out large amounts of

SOUTHWEST SUBURBS

	hungry patrons. If you have a party on the larger side, you may want to call ahead.
AMBIENCE/CLIENTELE	The Orland Oasis has a very homey feeling. All of the waitstaff is so friendly that they will make you feel right at home. This old little building is always decorated for the upcoming holidays or seasons. This restaurant is not fancy, but it's cozy and comfortable with speedy, smiling service. Bring the kiddies along too; the waitstaff will keep them busy with pictures to color, and when they are all done, their pictures will be hung up for the whole town to admire.

—*Megan Healy*

PALOS HEIGHTS/PALOS PARK

Capri

Huge glasses of wine plus authentic southern Italian food.
$$$$
12307 S. Harlem Ave., Palos Heights 60463
(at 123rd St.)
Phone (708) 671-1657
www.eatatcapri.com

CATEGORY	Italian Restaurant
HOURS	Sun: 3 pm-11 pm Tues-Thurs: 11 am-2 pm, 4 pm-10 pm Fri: 11 am-2 pm, 4 pm-11 pm Sat: 4 pm-11 pm
GETTING THERE	There is a free parking lot directly in front of the restaurant. You can also take the Pace #386 bus.
PAYMENT	
POPULAR DISH	There are a few veal and chicken dishes, but seafood rules the menu here. There are a number of delicious traditional dishes such as ravioli, spaghetti carbonara, and lasagna for those looking for a comforting, rich plates of pasta. The linguini with clams is served with a ton of tender clams in your choice of a rich red or white sauce and is simply delicious. The chicken Vesuvio, roasted with onions, mushrooms, and buttery potatoes, is also very popular.
UNIQUE DISH	Even appetizers are seafood-focused. Starters such as mussels, clams, calamari and octopus are a delicious start to any southern Italian meal. The grilled octopus is served in a delicious vinaigrette sauce.
DRINKS	While the wine list isn't huge, the generous pours keep bringing patrons back. It's understandable why patrons stay and linger over a long meal at Capri with a huge glass in hand.
SEATING	Seating is plentiful, but this place is so popular that you'll want to make reservations, even during the middle of the week. There are two rooms of about 40 tables altogether and a bar with stool seating.
AMBIENCE/CLIENTELE	Capri is a large restaurant, but it feels cozy due to the lighting and ambience. The restaurant is decorated with wine bottles and includes a fish tank in one room and a large HDTV next to the bar. One thing you'll notice about Capri is that people linger over

SOUTHWEST SUBURBS

their meal. Diners sit in groups, even at the bar, with lively conversation. Capri is a great place for friends or couples to go for a great meal and great conversation.

—*Jen Tatro*

Hackney's
Great Irish-American food in a south suburban Swiss ski lodge setting.
$$$
9550 W. 123rd St., Palos Park 60464
(at LaGrange Rd.)
Phone (708) 448-8300 • Fax (708) 448-8307
www.hackneys.net

CATEGORY	American Restaurant
HOURS	Sun: 10 am-10:30 pm Mon-Thurs: 11 am-10:30 pm Fri-Sat: 11 am-11:30 pm
GETTING THERE	Parking is readily available in the giant, free lot behind the restaurant.
PAYMENT	Discover, American Express, MasterCard, Visa
POPULAR DISH	The Hackney burger is oval-shaped and made with half a pound of a special blend of beef created especially for Hackney's, served on Hackney's homemade dark rye bread. Hackney's original french fried onion rings are another must-have. This is not a basket of onion rings, it's a loaf. Popular desserts include key lime pie and bread pudding (seasonal).
UNIQUE DISH	The Inside Out Burger is a Hackney burger filled with cheddar cheese and bacon, more beef, re-grilled, and served open-faced on Hackney's homemade rye. Another dish extinct from most other menus: the buffalo burger.
DRINKS	There is a full bar with a selection of eight imported and microcraft beers on tap. Try a fun specialty drink like the Dublin Apple, Hackney's version of the appletini; the Shamrock, a martini with a touch of green; Celtic lemonade, lemonade with a shot of Irish whiskey; and The Irish Trinity—Bushmills, Bailey's and Irish Mist.
SEATING	The main dining room holds a combination of 30 big and small wooden tables. There's also a large lounge with additional booths, tables, and a long, curvy wooden bar stretching the length of the room, interspersed with three large screen TVs permanently tuned to the Bears, Blackhawks, Bulls, and Cubs. During the summer, a backyard patio opens up.
AMBIENCE/CLIENTELE	You'll find lots of older couples and their children and grandchildren. Yet for all of its kid-friendliness, the restaurant maintains a peaceful and mature mentality. Hackney's inherited the Palos Park location from the Matterhorn Restaurant and decided to leave it virtually unchanged. The result: the occasional shamrock and Irish countryside painting, plus a uniquely Irish and American menu, in a setting resembling an enormous Swiss ski lodge.
EXTRA/NOTES	Every Wednesday night at 8 pm, The Brass Tracks Jazz Band headlines a performance, following a pre-show by a rotating roster high school jazz bands at 7:30 pm. You can buy T-shirts and sweats at the front counter.
OTHER ONES	See website for more locations!

—*Lori Hile*

SOUTHWEST SUBURBS

Thai Smile
The best suburban Thai food with the most entertaining host!
$$$
12241 S. Harlem Ave., Palos Heights 60463
(at 122nd St.)
Phone (708) 448-9888

CATEGORY	Thai Restaurant
HOURS	Sun: 4 pm-9 pm Tues-Sat: 11 am-9:30 pm
GETTING THERE	Don't waste time trying to park in front; there is plenty of parking behind the restaurant. Regulars use the back door. You can also take the Pace #386 bus.
PAYMENT	American Express, MasterCard, VISA
POPULAR DISH	I recommend the Thai egg rolls or Vietnamese spring rolls as a starter. For an entree, I recommend any of the many curries listed on the menu and anything with basil. Many dishes are vegetarian friendly. For those who do not want to jump out of their norms for Asian food, there are a few dishes on the menu to accommodate familiarity.
DRINKS	Thai Smile is BYOB. They provide glasses and a corkscrew with no fees. In the event you forget to bring wine or beer, there is a grocery store just a couple of blocks away.
SEATING	The dining room is small and informal but welcoming. I have never had to wait for a table, and I have seen staff pull tables out of thin air to make more room.
AMBIENCE/CLIENTELE	Thai Smile is truly a local restaurant and a hidden gem. It does not fit into any mold of an Asian-American restaurant. The dining room is not at all fancy, but definitely clean. The decor is simple. The clientele can range from dating teenagers to Indian businessmen to married couples and groups of friends.

—*Julie Owens*

SOUTH SUBURBS

SOUTH SUBURBS

EVERGREEN PARK

Chi Tung
Chi Tung—home of the $5 martini. Try the saketini, it's good!
$$$
9560 S. Kedzie Ave., Evergreen Park 60805
(at 95th St.)
Phone (708) 636-8180 • Fax (708) 636-8186
www.chitung.com

CATEGORY	Pan-Asian Restaurant
HOURS	Sun: 12:30 pm-9:30 pm
	Mon-Thurs: 11 am-9:30 pm
	Fri/Sat: 11:30 am-10:30 pm
GETTING THERE	There is a parking lot, however, it gets jammed on weekends! You will find parking, but you may make a couple of loops around the lot first or take the #95W or #52A Kedzie bus.
PAYMENT	ATM, American Express, MasterCard, Visa
POPULAR DISH	Try the weekday lunch buffet to get a good idea of the offers at Chi Tung. You get to try crab rangoon, Tso's chicken, orange chicken, Mongolian beef and huge chicken pot stickers. The sushi is great too.
UNIQUE DISH	The three separate kitchens truly make Chi Tung a unique place to eat. The menu encompasses Chinese, Thai and Japanese food.
DRINKS	Chi Tung has really great martinis for around $5. Try the green tea martini or the saketini. The menu also has Chinese beers like Tsing Tao and domestics as well.
SEATING	Chi Tung is a large restaurant that gets packed quickly on weekends and evenings. There is limited seating at the sushi bar. There are a lot of families and large groups typically dining here. There are often waits for table, especially on the weekends, so call ahead.
AMBIENCE/CLIENTELE	This is a busy place, always hopping. It is great for a group to gather over cheap drinks and massively portioned entrees. The servers are great. It is a multi-cultural establishment that feels cosmopolitan.
EXTRA/NOTES	Carry-out is available, but never as good. They take reservations, and you can call ahead to avoid a wait.

—*Julie Owens*

Roseangela's Pizzeria
No one can resist great pizza and cheap beer at Roseangela's.
$$
2807 1/2 W. 95th St., Evergreen Park 60805
(at California Ave.)
Phone (708) 422-2041

CATEGORY	Italian/Pizzeria Fast food
HOURS	Sun: 1 pm-10 pm
	Mon: 11 am-10 pm
	Weds-Thurs: 11 am-10 pm
	Fri/Sat: 11 am-11 pm
GETTING THERE	There's no parking lot, but free street parking is pretty easy. You can also take the CX49 Western Express or #52A South Kedzie bus and walk half a mile.
PAYMENT	Discover, American Express, MasterCard, Visa
POPULAR DISH	The thin crust pizza is crisp and flaky with the perfect amount of tomato sauce and mozzarella cheese. The

SOUTH SUBURBS

toppings are all fresh, and while they have standard toppings, Roseangela's also offers Italian beef, meatballs and giardiniera for an added Italian touch. The appetizer menu includes breaded mushrooms, cheese sticks, zucchini, chicken strips, and wings.

UNIQUE DISH The Italian beef is a standout, with juicy sliced beef in soft, fresh buns. All sandwiches are made with red sauce unless specified otherwise, but guests can add mozzarella cheese, have them on garlic bread, or order extra sauce on the side. Pastas include all the traditional favorites like lasagna, tortellini, and spaghetti, but the ravioli is particularly a standout.

DRINKS Ice cold, cheap beer.

SEATING There is plenty of seating at Roseangela's, but it still feels like a cozy neighborhood pizza place. There are about 20 tables and booths that are usually filled with locals during lunch and dinner.

AMBIENCE/CLIENTELE Roseangela's has a definite family feel and appeals to diners of all ages. Local families, twenty-somethings, and even elderly couples come to dine where they know the food is good and the beer is cheap.

EXTRA/NOTES Roseangela's has one TV usually tuned to sports for those who want to catch the game.

—*Jen Tatro*

Wojo's
"Where Man Bites Dog!"
$$$
9851 S. Pulaski Rd., Evergreen Park 60805
(at 99th St.)
Phone (708) 423-1121
www.wojosmenu.com

CATEGORY American Fast food
HOURS Sun: 11 am-10:30 pm
Mon-Sat: 10 am-10:30 pm
GETTING THERE Street parking is limited. Take the #53A South Pulaski bus, bicycle or your own two feet.
PAYMENT $
POPULAR DISH This is your typical hot dog/hamburger stand with a twist—it serves some unusual burgers such as a Buffalo Burger and the ever-popular ostrich burger. There is also an elk burger for those of you with a taste for the great outdoors.
UNIQUE DISH The wild game burgers are great and the gyros here are as good as any on the southwest side.
DRINKS Over 60 flavors of milkshakes hog the menu and I've yet to have a bad one. Pepsi products including Sierra Mist, Mountain Dew, Root Beer, Fruit Punch, Dr. Pepper, and Iced Tea.
SEATING Seating is limited and virtually non-existent around lunch and after-school hours. It's best to come in the summer and eat outside.
AMBIENCE/CLIENTELE From the outside, this appears to be another hole-in-the-wall hot dog stand. Inside, there are some circus clown portraits alongside Little League team photos. An assortment of students frequent this joint, along with construction workers and local hospital personnel.

—*Crage Kentz*

SOUTH SUBURBS

CHICAGO PIZZA SMACKDOWN

When it comes to Chicago deep dish pizza, almost every pizza joint worth its sauce traces its roots back to Ike Sewell, who in 1943 pulled the first true Chicago-style pizza out of the oven at Pizzeria Uno. Deep-dish pizza in Chicago is a delicious combination of cheeses, red sauce, and a topping of vegetables, sausage or pepperoni or all of the above. So why do brand loyalties pit brother against brother? While there's no accounting for taste, there are a few differences that set one "House of Pizza" apart from another, so consider three big names in Chicago Pizza: Giordano's, Edwardo's, and Lou Malnati's.

Giordano's claims their recipe for pizza heaven was based on their mother's. Pizza papers aside, Giordano's has a long list of endorsements from newspapers, magazines, and devoted fans. It is without a doubt a fine pizza that represents the traditional Chicago-style pizza well. Fresh ingredients add to the quality of the classic pizza found here so you won't go wrong when you walk into any of their locations.

www.giordanos.com

Lou Malnati's may have the most direct line to Mr. Chicago Pizza. That's because in 1971, one of Ike Sewell's pizza protégés opened his own spot in suburban Lincolnwood with his wife. Today, Lou, Jean and the Malnati also represent Chicago deep-dish pizza at its best; the addition of corn meal to the crust of Lou's pie sets it apart. They also claim a secret formula that creates a flaky, buttery crust for the entire pie, and a unique sausage blend, the recipe for which never leaves the family.

www.loumalnatis.com

Finally, there's **Edwardo's**, another award-winner and favorite local spot. Opened in 1978, it's Edwardo's that has strayed the furthest from the classic pizza line. Their "stuffed" pizza menu goes the typical Chicago pizza one better with a strong focus on vegetable oriented creations. In fact, their meatless spinach and pesto pizzas give many the impression that Edwardo's is the vegetarian pizza place to be. Maybe so, but their newer International Line of pizzas includes Tex-Mex, barbeque chicken, Hawaiian luau, and a cheeseless tomato basil pizza!

www.edwardos.com

— David Kravitz

STILL HUNGRY?

GLOSSARY

Our glossary covers many of those dishes that everyone else seems to sort of know but we occasionally need a crib sheet. As for ethnic drinks and terms—we've only covered the basics.

FOOD

Adobo (Filipino)—a stew of chicken, pork, or fish traditionally flavored with garlic, soy sauce, white vinegar, bay leaves, and black peppercorns.

Aduki beans (Chinese)—small, flattened reddish-brown bean; sometimes used as a confectionery.

Albondigas (Latin American)—meatballs. In Mexico it's popular as a soup.

Antojitos (Latin American)—appetizers (means "little whims").

Au jus (French)—meat (usually beef) served in its own juices.

Baba ganoush (Middle Eastern)—smoky eggplant dip.

Bansan (Korean)—see panchan.

Bao (Chinese)—sweet stuffed buns either baked or steamed; a very popular dim sum treat!

Basbousa (Middle Eastern)—a Semolina cake of yogurt and honey.

Bean curd (Pan-Asian)—tofu.

Bibimbap (Korean)—also bibibap, served cold or in a heated clay bowl, a mound of rice to be mixed with vegetables, beef, fish, egg, and red pepper sauce.

Bigos (Polish)—winter stew made from cabbage, sauerkraut, chopped pork, sausage, mushrooms, onions, garlic, paprika and other seasonings. Additional veggies (and sometimes red wine!) may be added.

Biryani (Indian)—meat, seafood or vegetable curry mixed with rice and flavored with spices, especially saffron.

Blintz (Jewish)—thin pancake stuffed with cheese or fruit then baked or fried.

Borscht (Eastern European)—beet soup, served chilled or hot, topped with sour cream.

Bratwurst (German)—roasted or baked pork sausage.

Bul go gi (Korean)—slices of marinated beef, grilled or barbecued.

Bun (Vietnamese)—rice vermicelli.

Callaloo (Caribbean)—a stew made with dasheen leaves, okra, tomatoes, onions, garlic, and meat or crab, all cooked in coconut milk and flavored with herbs and spices.

Calzone (Italian)—pizza dough turnover stuffed with cheesy-tomatoey pizza gooeyness (and other fillings).

Caprese (Italian)—fresh bufala mozzarella, tomatoes, and basil drizzled with olive oil and cracked pepper—a lovely salad or fixins' for a sandwich.

Carne asada (Latin American)—thinly sliced, charbroiled beef, usually marinated with cumin, salt, lemon, and for the bold, beer; a staple of the

GLOSSARY

Latin American picnic (along with the boom box).

Carnitas (Mexican)—juicy, marinated chunks of pork, usually fried or grilled. Very popular as a taco stuffer.

Carpaccio (Italian)—raw fillet of beef, sliced paper thin and served with mustard sauce or oil and lemon juice.

Ceviche (Latin American)—(also cebiche) raw fish or shellfish marinated in citrus juice (the citrus sorta "cooks" the fish).

Challah (Jewish)—plaited bread, sometimes covered in poppy seeds, enriched with egg and eaten on the Jewish sabbath.

Chicharrones (Mexican/Central American)—fried pork rinds, knuckle lickin' good.

Chicharrones de harina (Mexican/Central American)—same concept as above, only made from a flour dough. Usually in bright orange, pinwheel shapes.

Chiles rellenos (Mexican)—green poblano chiles, typically stuffed with jack cheese, battered and fried; occasionally you can find it grilled instead of fried—¡que rico!

Chimichangas (Mexican)—fried, stuffed tacos.

Chorizo (Latin American)—spicy sausage much loved for its versatility. Some folks like to grill it whole and others prefer to bust it open, fry it up, and serve it as a side dish. Another favorite incarnation finds the chorizo scrambled with eggs for breakfast.

Chow fun (Chinese)—wide, flat rice noodles.

Churrasco (Brazilian)—charcoal grilled meat or chicken, usually served on a skewer.

Cochinita pibil (Mexican)—grilled marinated pork, Yucatán style.

Cocido (Spanish)—duck confit, chorizo, sausage, and preserved pork combined.

Congee (Chinese)—(also jook) rice-based porridge, usually with beef or seafood.

Croque-madame (French)—grilled cheese sandwich, sometimes with chicken—no ham!

Croque-monsieur (French)—sandwich filled with ham and cheese then deep-fried (occasionally grilled). Cholesterol heaven!

Cuitlacoche (Mexican)—Central Mexico's answer to truffles; technically, black corn fungus, but quite a delicacy!

Dal (Indian)—lentil-bean based side dish with an almost soupy consistency, cooked with fried onions and spices.

Dim sum (Cantonese)—breakfast/brunch consisting of various small dishes. Most places feature servers pushing carts around the restaurant. You point at what you want as they come by. Literally translated means: "touching your heart."

Dolmades (Greek)—(also warak enab as a Middle Eastern dish) stuffed grape leaves (often rice and herbs or lamb and rice mixture).

Döner kebab—thin slices of raw lamb meat with fat and seasoning, spit roasted with thin slices carved as it cooks.

GLOSSARY

Dora wat (Ethiopian)—chicken seasoned with onions and garlic, sautéed in butter and finished with red wine.

Dosa (South Indian)—(also dosai) oversized traditional crispy pancake, often filled with onion and potato and folded in half; bigger than a frisbee!

Edamame (Japanese)—soy beans in the pod, popularly served salted and steamed as appetizers.

Empanada (Argentinian)—flaky turnover, usually stuffed with spiced meat; a favorite appetizer at an asado. Other Latin American countries also make their own versions of this tasty treat.

Escovietch (West Indian)—cooked small whole fish in a spiced oil and vinegar mixture, served cold.

Étouffe (Creole)—highly spiced shellfish, pot roast or chicken stew served over rice.

Falafel (Middle Eastern)—spiced ground chickpea fava bean balls and spices, deep fried and served with pita.

Feijoada (Brazilian/Portuguese)—the national dish of Brazil, which can range from a pork and bean stew to a more complex affair complete with salted beef, tongue, bacon, sausage, and more parts of the pig than you could mount on your wall.

Filo (Turkish and Mediterranean)—(also phyllo) thin pastry prepared in several layers, flaky and good.

Flautas (Mexican)—akin to the taco except this puppy is rolled tight and deep fried. They are generally stuffed with chicken, beef, or beans and may be topped with lettuce, guacamole, salsa, and cheese. They resemble a flute, hence the name.

Frites (Belgian/French)—also pommes frites, french or fried potatoes or "french fries".

Galbi (Korean)—(also kal bi) marinated barbecued short ribs.

Gefilte fish (Jewish)—white fish ground with eggs and matzo meal then jellied. No one—and we mean no one—under fifty will touch the stuff.

Gelato (Italian)—ice cream or ice.

Gnocchi (Italian)—small potato and flour dumplings served like a pasta with sauce.

Gorditas (Mexican)—fried puffy rounds of corn meal dough topped with beans, chipotle sauce, and cheese.

Goulash (Hungarian)—a rich beef stew flavored with paprika, originally based on Hungarian gulyás, a meat and vegetable soup; often served with sour cream.

Gumbo (Creole)—rich, spicy stew thickened with okra (often includes crab, sausage, chicken, and shrimp).

Gyros (Greek)—spit-roasted beef or lamb strips, thinly sliced and served on thick pita bread, garnished with onions and tomatoes.

Har gow (Chinese)—steamed shrimp dumplings.

Head cheese—(not cheese!) a sausage made from bits of calf or pig head.

Hijiki (Japanese)—a sun-dried and coarsely shredded brown seaweed.

GLOSSARY

Huevos rancheros (Mexican)—fried eggs atop a fried tortilla with salsa, ranchero cheese, and beans.

Humita (Chile/Argentina)—tamale.

Hummus (Middle Eastern)—blended garbanzo beans, tahini, sesame oil, garlic, and lemon juice; somewhere between a condiment and a lifestyle.

Iddly (South Indian)—small steamed rice flour cakes served with coconut dipping sauce.

Injera (Ethiopian)—flat, spongy, sour unleavened bread. Use it to scoop everything up when eating Ethiopian food, but be forewarned: it expands in your stomach.

Jambalaya (Creole)—spicy rice dish cooked with sausage, ham, shellfish, and chicken.

Jollof (West African)—a stew or casserole made of beef, chicken or mutton simmered with fried onion, tomatoes, rice and seasonings.

Kabob (Middle Eastern)—(also shish kabob, kebab) chunks of meat, chicken, or fish grilled on skewers, often with vegetable spacers.

Kamonan (Japanese)—noodles with slices of duck.

Katsu (Japanese)—pork.

Kielbasa (Polish)—smoked sausage.

Kimchi (Korean)—fermented, pickled cabbage with vegetables, highly chilied- and garlicked-up. Some sweet, some spicy, some unbelievably spicy. Limitless variations.

Knockwurst (German)—(also knackwurst) a small, thick, and heavily spiced sausage.

Korma (Indian)—style of braising meat or vegetables, often highly spiced and using cream or yogurt.

Kreplach (Jewish)—small pieces of noodle dough stuffed with cheese or meat, usually served in soup.

Kung pao (Chinese)—spicy-sweet Szechuan style of stir-fry, seasoned with hot peppers, ground peanuts, and soy sauce.

Kutya (Ukrainian)—traditional pudding made with wheat-berries, raisins, walnuts, poppy seeds and honey.

Lahmajune (Armenian/Turkish)—a meat (most often lamb) pizza.

Larb (Thai)—minced chicken or beef salad spiced with lemon juice, sweet onion, mint leaves, and toasted rice powder, served in a lettuce cup or with cabbage.

Lo mein (Chinese)—soft, flat noodles stir-fried with vegetables and, often, a protein item (beef, chicken, pork, shrimp, etc.).

Lychee—red-shelled southeast Asian fruit served in desserts and as a dried snack (known as lychee nuts).

Machaca (Northern Mexican)—shredded meat jerky, scrambled with eggs, tomatoes, and chiles.

Makdoos (Middle Eastern)—miniature eggplant stuffed with walnuts and garlic, marinated with olive oil.

GLOSSARY

Mandoo (Korean)—dumplings.

Marage (Yemen)—vegetable soup.

Mariscos (Pan-American)—seafood.

Masala (Indian)—blend of ground spices, usually including cinnamon, cumin, cloves, black pepper, cardamom, and coriander seed.

Matzo brie (Jewish)—eggs scrambled with matzo.

Medianoche sandwich (Cuban)—roast pork, ham, cheese and pickles pressed on a sweet roll.

Mee krob (Thai)—salad appetizer covered in fried noodles.

Menudo (Mexican)—soup made of tripe, hominy, and chile, stewed with garlic and spices. A hangover remedy, and what Mexican families eat before or after Sunday mass.

Mofongo (Dominican)—mashed green plaintains with pork skin, seasoned with garlic and salt.

Mole (Mexican)—thick poblano chile sauce from the Oaxacan region. Most popular is a velvety black, mole negro flavored with unsweetened chocolate and raisins.

Monte Cristo sandwich—sliced turkey, swiss cheese, mustard, and ham sandwich, on French toast, fried, and dusted with powdered sugar. Served with sides ranging from syrup to jam to pickles.

Moussaka (Greek)— alternating layers of lamb and fried aubergine (a.k.a. eggplant) slices, topped with Béchamel sauce, an egg and cheese mixture, and breadcrumbs, finally baked and brought to you with pita bread.

Muj chien don (Vietnamese)—crispy squid with a little salt and pepper.

Mulitas (Mexican)—literally, little mules; actually, little quesadillas piled up with meat, veggies, and other goodies.

Mung bean—small green bean, eaten as a vegetable or used as a source of sprouts. May also be candied and eaten as a snack, or used to make bean curd.

Musubi (Japanese)—rice ball, sometimes filled with bits of salmon or seaweed, or a sour plum. Hawaiian version features SPAM. Delicious grilled.

Naan (Indian)—flat bread cooked in a tandoor oven.

Niçoise salad (French)—salad served with all the accoutrements from Nice, i.e. French beans, olives, tomatoes, garlic, capers, and of course, tuna and boiled egg.

Pad Thai (Thai)—popular rice noodle stir-fry with tofu, shrimp, crushed peanuts, and cilantro.

Paella (Spanish)—a rice jubilee flavored with saffron and sprinkled with an assortment of meats, seafood, and vegetables, all served in a sizzling pan.

Panchan (Korean)—the smattering of little appetizer dishes (kimchi, etc.) that magically appear before a meal of soontofu or barbecue; vinegar lovers rejoice.

Pastitsio (Greek)—cooked pasta layered with a cooked meat sauce (usually lamb), egg-enriched and cinnamon flavored Béchamel, grated cheese, and topped with a final layer of cheese and fresh breadcrumbs.

GLOSSARY

Pescado (Spanish)—literally means fish; can be served in a variety of ways, baked in hot rock salt (a la sal), coated in egg batter and fried (a la andaluza), pickled (en escabeche) and even cooked in wine with onions and chocolate and served with mushrooms (a la asturiana).

Pho (Vietnamese)—hearty rice noodle soup staple, with choice of meat or seafood, accompanied by bean sprouts and fresh herbs.

Pico de gallo (Mexico)—(also salsa cruda) a chunky salsa of chopped tomato, onion, chile, cilantro. In Jalisco, it's a jicama and orange salad sprinkled with lemon juice and chile powder.

Pierogi (Polish)—potato dough filled with cheese and onion, boiled or fried.

Plantain (Central American)—cooked banana from tropical regions. When ripe and yellow, it's often served fried as a breakfast side dish. While it's green and unripe, it's used to make yummy chips available at neighborhood markets.

Polish sausage—Not yer average frank. Plump and juicy, with just the right balance of sweetness and spice.

Pollo a la brasa (Central/South American)—rotisserie chicken.

Porgy—various deep-bodied seawater fish with delicate, moist, sweet flesh.

Pozole (Mexican)—pork soup with corn, onions, hominy, and dried chiles. Sliced and diced cabbage and radishes are also used as garnish. Very popular come the Christmas season—so good it makes you wish it was Xmas everyday.

Pulpo enchilado (Spanish)—octopus in hot sauce.

Pupusa (Salvadorean)—round and flattened cornmeal filled with cheese, ground porkrinds, and/or refried beans, which is cooked on a flat pan known as a comal.

Quesadilla (Mexican)—soft flour tortilla filled with melted cheese (and, sometimes, fancier fare).

Raita (Indian)—yogurt condiment flavored with spices and vegetables (often cucumber) or fruits—the necessary core component to balance hot Indian food.

Ramen (Japanese)—thin, squiggly egg noodle, often served in a soup.

Reuben (Jewish)—rye bread sandwich filled with corned beef, Swiss cheese, and sauerkraut, and lightly grilled.

Roti (Indian)—round, flat bread served plain or filled with meat or vegetables.

Saganaki (Greek)—half inch thick slices of kasseri cheese fried in butter or oil, then sprinkled with lemon juice and fresh oregano. Greek restaurants often present this appetizer in style by soaking it in brandy then lighting it up tableside. Opa!

Samosa (Indian)—pyramid-shaped pastry stuffed with savory vegetables or meat.

Sashimi (Japanese)—fresh, raw seafood thinly sliced and artfully arranged.

Satay (Thai)—chicken or shrimp kabob, often served with a peanut sauce.

Sauerkraut (German)—chopped, fermented sour cabbage.

GLOSSARY

Schnitzel (English/Austrian)—thin, fried veal or pork cutlet.

Seitan (Chinese)—wheat gluten marinated in soy sauce with other flavorings.

Shabu shabu (Japanese)—hot pot. Cooked thin-sliced beef and assorted vegetables in a big hot pot at your table—served with a couple of dipping sauces and rice.

Shawarma (Middle Eastern)—pita bread sandwich filled with sliced beef, tomato, and sesame sauce.

Soba (Japanese)—thin buckwheat noodles, often served cold with sesame oil-based sauce.

Som tum (Thai)—green papaya salad.

Soontofu (Korean)—boiling hot soup with soft tofu, your choice of protein elements (mushroom or kimchi for vegetarians, seafood, and pork for non-), served with a variety of kimchis and rice.

Sopes (Mexican)—dense corn cakes topped with beef or chicken, beans, lettuce, tomato, and crumbled cheese.

Souvlaki (Greek)—kebabs of lamb, veal or pork, cooked on a griddle or over a barbecue, sprinkled with lemon juice during cooking, and served with lemon wedges, onions and sliced tomatoes.

Spanakopita (Greek)—filo triangles filled with spinach and cheese.

Spelt—ancient type of wheat, commonly used to make flour without traditional wheat flavor.

Spotted dick (British)—traditional pudding with raisins.

Sushi (Japanese)—the stuff of midnight cravings and maxxed out credit cards. Small rolls of vinegar infused sticky rice stuffed with fresh, raw seafood, sweet omelette, or pickled vegetables, and held together with sheets of seaweed (nori).

Tabouli (Middle Eastern)—light salad of cracked wheat (bulgur), tomatoes, parsley, mint, green onions, lemon juice, olive oil, and spices.

Tahini (Middle Eastern)—paste made from ground sesame seeds.

Tamale (Latin American)—cornmeal filled with meat and veggies wrapped in corn husk, then steamed. There are also sweet varieties, notably the elote, or corn, tamale.

Tandoori (Indian)—literally means baked in a tandoor (a large clay oven). Tends to be a drier form of Indian dish than, say, curries.

Tapenade (Provençale italian)—chopped olive garnish; a delightful spread for a hunk of baguette.

Taquitos (Mexican)—(also, flautas) shredded meat or cheese rolled in a tortilla, fried, and served with guacamole sauce.

Tempeh (Indian)—a substance made from soaking and boiling soy beans, inoculating with a fungus, packing into thin slabs and allowing to ferment. A great source of protein!

Thali (Southern Indian)—sampler meal comprised of several small bowls of curries and soup arranged on a large dish with rice and bread.

Tikka (Indian)—marinated morsels of meat cooked in a tandoor oven,

GLOSSARY

usually chicken.

Tom kha kai (Thai)—coconut broth soup with galangal root, lime leaves, hot chilies, onion, mushrooms, and, often, chicken.

Tom yum gung (Thai)—lemongrass hot-and-sour soup.

Tong shui (Chinese)—medicinal soups.

Torta (Mexican)—Spanish for sandwich or cake.

Tostada (Mexican)—traditionally a corn tortilla fried flat; more commonly in the U.S. vernacular, the frilly, fried flour tortilla that looks like an upside down lampshade and is filled with salad and served in wannabe Mexican restaurants.

Tzatziki (Greek)—the best condiment to come out of the Greek isles; fresh yogurt mixed with grated cucumber, garlic, and mint (or coriander, or both).

Udon (Japanese)—thick white rice noodles served in soup, usually bonito broth.

Warak enab (Middle Eastern)—see dolmades.

Welsh rarebit (British)—(also Welsh rabbit) toast topped with melted cheese cream, and ale, usually served with Worcestershire sauce (very hot and spicy).

Yakitori (Japanese)—marinated, grilled chicken skewers.

WAYS OF EATING AND LIVING

Fair Trade—a movement that aims to help producers in developing countries by exporting to developed countries for a reasonable price, as well as promote social, economic, and environmental sustainability. These exported goods include coffee, cocoa, sugar, tea, and chocolate.

Halal—food permissible by Islamic law. Things that are not halal include pork, alcohol, and other carnivorous animals.

Kosher—food that is permissible by Jewish dietary law. Things that are not kosher are pork, shellfish, and the mixing of meat and cheese.

Macrobiotic—diet and lifestyle of organically grown and natural products.

Organic—food grown and produced without pesticides, insecticides or herbicides, and not genetically modified, as well as livestock reared without antibiotics or hormones, and fed a healthy diet.

Pescatarian—Someone who only eats fish (or seafood) and vegetables, but no other meat.

Vegan—Someone who does not eat any meat or dairy products.

Vegetarian—Someone who does not eat any meat.

STRAIGHT FROM CHICAGO

Butter Crust—a buttery, crisp pizza crust found exclusively in Chicago deep-dish pizza.

Chicago-Style Deep Dish Pizza—pizza made by stretching dough up the sides of a deep pan, which is then parbaked, oiled, and lined with cheese, meat, veggies, sauce, and a final layer of cheese.

GLOSSARY

Chicago-Style Hot Dog—a true Chicago-Style dog consists of a steamed Vienna Beef dog topped with yellow mustard, neon green relish, raw onions, tomato slices, a pickle spear, sport peppers and a dash of celery salt served in a poppyseed bun with absolutely, positively no ketchup.

Chicken Vesuvio—bone-in chicken pieces baked or roasted with wedges of potato, garlic, oregano, white wine and olive oil until the skin is crispy.

Combo—a variation of the Italian Beef that nestles an Italian sausage within the layers of meat. This can also be ordered wet or dry.

Dry—a variation of the Italian Beef. Ordering the sandwich "dry" means without any au jus at all.

Flaming Saganaki—a Greek-American appetizer of fried cheese that is lightly doused with brandy or other alcohol then lit ablaze tableside. Often accompanied by shouts of "Opaa!"

Foie Gras—fattened liver of duck or goose that produces a buttery, meaty pâté-like substance. Due to controversy regarding the force-feeding methods used to obtain this fatty liver, the product was banned in Chicago for a short time.

Italian Beef (see also Wet and Dry)—Beef that has been slow-cooked with herbs and spices until tender, then sliced thinly and served on Italian bread with giardiniera. These sandwiches can also be served wet or dry.

Jibarito—an original jibarito uses pressed, fried green plantain slices in place of bread and is stuffed with steak, cheese, lettuce, tomato, and garlic mayo.

Ketchup—a delicious, tomato-based sauce to top fries and burgers. A complete no-no for Chicago-Style Hot Dogs for any self-respecting Chicagoan.

Localvore—people committed to eating foods grown or raised in their hometown.

Maxwell Street Polish—a Maxwell Street Polish is a grilled or fried Polish sausage topped with copious grilled onions and yellow mustard served on a bun. It originated at the site of the famous Maxwell Street Market.

Mother-in-Law—a sandwich comprised of a tamale served in a hot dog bun and topped with chili.

Pan Pizza—pizza with an extra thick crust, also baked in a pan as with Chicago-Deep Dish, but with sauce under the ingredients instead of on top.

Red Sauce—another term for marinara sauce.

Shrimp de Jonghe—a casserole of whole shrimp topped with garlic breadcrumbs and laced with sherry.

Sport Peppers—naturally small, medium-hot peppers that are a necessary ingredient in a Chicago-Style Hot Dog.

Stuffed Pizza—a Chicago Deep-Dish pizza topped with an extra layer of crust, sauce, and cheese on top; sometimes taller than a deep-dish.

Thin Crust Pizza—pizza with crust that is nearly cracker-thin.

Vienna Beef Hot Dog—a necessary ingredient in the Chicago-Style Hot Dog, these dogs have no fillers, artificial flavorings or binders and are 100% beef.

Wet—a variation of the Italian Beef. Ordering "wet" means dipping (or double-dipping) the sandwich into au jus before serving.

ALPHAPETICAL INDEX

3rd Coast Café, 2

A

A Taste of Heaven, 92
A Tavola, 60
Al's Deli, 163
Al's Italian Beef, 57
Alice & Friends' Vegetarian Café, 92
Ann Sather, 85
Avec, 18

B

Ba Le Sandwiches & Deli, 93
Baba Palace, 2
Bagel Art, 163
Barba Yianni, 128
Bella Via, 174
Ben's Noodle and Rice, 94
Bijan's Bistro, 3
Birch River Grill, 182
Bistrot Zinc, 4
Blackbird, 19
Bongo Room, 26
Bonsoirée, 139
Booby's Charcoal Rib, 190
The Book Cellar, 129
Boris Café, 171
The Bourgeois Pig, 44
Bricks Chicago, 45
Buona Terra, 139
Burt's Pizza, 190
Butterfly Sushi Bar and Thai Cuisine, 61
Byron's Hot Dogs, 98

C

C-House Restaurant, 5
Café Bernard, 46
Caffe De Luca, 31
Calypso Café, 154
Capri, 213
Carlos & Carlos, 182
Carnitas Urupan, 80
Carnivale, 5
Cedars Mediterranean Kitchen, 155
The Celtic Knot Public House, 164
Cemitas Puebla, 136
Chaise Lounge, 31
Charlie Beinlich's Food and Tap, 172

Chen's, 99
Chi Tung, 217
Chicago Brauhaus, 130
Chicago Diner, 100
Chickpea, 62
Chiyo, 120
Chowpatti, 183
Chuck's Southern Comfort Café, 205
CJ's Eatery, 136
Club Lago, 6
Coalfire Pizza, 62
Coast Sushi, 32
Coco, 137
Coobah, 101
Cooper's Hawk Winery and Restaurant, 208
The Counter, 102
Cozy Noodles & Rice, 102
Cross-Rhodes, 165
Cucina Paradiso, 197
Curry Hut Restaurant, 175

D

D4 Irish Pub & Café, 7
De Pasada, 63
Dinotto Ristorante, 53
Dixie Kitchen & Bait Shop, 167
Dragon Inn North, 185
Drew's Eatery, 131
Duck Walk, 103
Duke of Perth, 104
Duke's Drive-In, 206

E

Ed's Potsticker House, 75
The Egg & I Restaurant, 209
El Barco Mariscos, 64
El Burrito Mexicano, 105
El Llano, 115
Eleven City Diner, 27
Enoteca Roma, 33
Ethiopian Diamond, 85

F

Five Guys Burgers and Fries, 198
Flo, 64
Flourish, 86
Francesco's Hole in the Wall, 173
fRedhots and Fries, 186
Friendship Chinese, 140
Fuego Mexican Grill & Margarita Bar, 184

231

ALPHAPETICAL INDEX

G

Gale Street Inn, 124
Garcia's, 132
Gaylord India, 8
Ginza Japanese Restaurant, 8
Golden Bean @ the Hotel Indigo, 9
Granite City Food and Brewery, 211
Grant's Wonderburger Grill, 146
The Grill on the Alley, 10
Groucho's Bar & Grill, 146
The Grove Restaurant, 46

H

Habana Libre, 65
Hackney's, 214
The Handlebar Bar & Grill, 34
Harold's Chicken Shack #36, 35
Heaven on Seven, 19
Honey 1 BBQ, 35
Hops & Barley, 125
Hot Chocolate, 36
Hot Doug's, 115
House of Sushi & Noodles, 37

I

Icosium Kafe, 87
India House, 11
Indie Café, 87
Irazú, 39
Isabella Café & Catering, 211

J

Johnnie's Beef, 199

K

Kevin's Place, 174
Koda: A Unique Bistro and Wine Bar, 151
Kuma's Corner, 141

L

La Cebollita, 81
La Lucé, 66
La Pasadita, 67
La Petite Folie, 155
La Scarola, 20
La Unica, 88
La Villa, 120
Lalo's, 187
Lamplighter Inn Tavern & Grille, 193
Lao Szechuan, 75
Late Night Thai, 116
Letizia's Natural Bakery, 39
Linz and Vail, 168
Lito's Empanadas, 47
Little Frank's Pizzeria, 207
Lula Café, 142

M

M. Henry, 89
Mabenka Restaurant, 208
Manny's Cafeteria & Delicatessen, 28
Maria's Bakery, 176
Marion Street Cheese Market, 199
Marion Street Grille, 200
Mariscos El Veneno, 68
Max's Deli & Restaurant, 177
May Street Market, 69
Maya del Sol, 201
McNamara's, 121
Medici on 57th, 156
Mexican Inn, 161
Milk and Honey Café, 40
Mini Hut Chicken, 148
Miramar Bistro, 178
Molly's Cupcakes, 48
Monk's Pub, 21
Moody's Pub, 89
Mykonos, 191

N

Natalino's, 70
The New Rebozo, 202
Nite 'N Gale, 178
NoMI @ the Park Hyatt Chicago, 12
The Noodle, 76
North Coast Café, 105
Nuevo Léon, 82

O

Old Jerusalem, 54
Old Oak Tap, 70
Orange, 106
Original Rainbow Cone, 147
Orland Oasis, 212
Over Easy, 117

P

Parisi's, 148
Pasta Palazzo, 49
Pasticceria Natalina, 90

ALPHAPETICAL INDEX

Pequod's Pizza, 49
Perry's Deli, 12
Petterino's, 22
Pho 777, 95
Phoenix Restaurant, 78
Pick Me Up Café, 107
Pita Inn, 188
Pizano's Pizza & Pasta, 189
Pizza Rustica, 107
Pompei, 58
Province, 22

R

Rajun Cajun, 158
Ras Dashen, 91
Ribs 'N' Bibs, 158
Riverside Family Restaurant, 196
Roseangela's Pizzeria, 217
Roy's Hawaiian Fusion, 13
Russell's Barbecue, 202
Russian Tea Time, 23

S

Salt and Pepper Diner, 50
Sami Swoi, 126
San Soo Gab San, 133
Semiramis, 122
Seven Treasures Cantonese Cuisine, 79
Sher-A-Punjab, 110
Shokolad Pastry & Café, 71
Sicilia Bakery, 126
Silver Cloud Bar and Grill, 41
Silver Palm, 42
Skylark, 82
Smoque, 123
Soul Vegetarian East Restaurant, 152
Soupbox, 14
South Gate Café, 179
Spacca Napoli, 118
Spiaggia and Café Spiaggia, 15
Stanley's Kitchen and Tap, 51
Streetside Bar & Grill, 138
Sultan's Market, 42
Sun Wah BBQ, 95
Superdawg Drive-In, 127
Sushi Station, 193
SushiSamba Rio, 15

T

TAC Quick Thai Kitchen, 108
Tank Noodle (Pho Xe Tang), 96
Tapas Barcelona, 169
Taqueria Moran, 144
Tarascas International, 52
Taza, 16
Tecalitlan, 72
Tempo Café, 17
Thai Bowl, 59
Thai on Clark, 97
Thai Smile, 215
That Little Mexican Café, 98
Toast, 53
Top-Notch Beefburgers, 152

U

UBAA & Old Crawford Inn, 169
Udupi Palace, 111
UFood Grill, 25
Uncle Julio's Hacienda, 55
Uncommon Ground, 109
Uru-Swati, 112

V

Va Pensiero, 170
Valois, 159
Viceroy of India, 113
Villa Rosa Pizza, 149
Village Pizza, 73
Vittorio De Roma, 194

W

Waba, 134
Wakamono, 110
Walker Brothers Pancake House, 180
Wheaton's Soul Food Café, 205
White Chocolate Grill, 203
White Palace Grill, 29
Wholly Frijoles Mexican Grill, 192
Wojo's, 218

X

Xni-Pec, 197

Z

Z&H MarketCafe, 160
Zen Noodles, 43

CATEGORY INDEX

American Bagelry
Bagel Art, 163

American Bakery
A Taste of Heaven, 92
Flourish, 86
Letizia's Natural Bakery, 39
Molly's Cupcakes, 48
Sicilia Bakery, 126

American Bar & Grill
Groucho's Bar & Grill, 156
Hops & Barley, 125
Lamplighter Inn Tavern & Grille, 193
Silver Cloud Bar and Grill, 41
Silver Palm, 42
Streetside Bar & Grill, 138
UBAA & Old Crawford Inn, 169

American Bistro
Bijan's Bistro, 3
Marion Street Grille, 200
May Street Market, 69

American Brunch
The Egg & I Restaurant, 209
Toast, 53

American Café
The Book Cellar, 129
Milk and Honey Café, 40

American Cafeteria
Drew's Eatery, 131
Valois, 159

American Coffee Shop
Golden Bean @ the Hotel Indigo, 9
Linz and Vail, 168

American Deli
Al's Deli, 163
Max's Deli & Restaurant, 177
Perry's Deli, 12

American Diner
Bongo Room, 26
Boris Café, 171
Kevin's Place, 174
North Coast Café, 105
Orland Oasis, 212
Over Easy, 117
Pick Me Up Café, 107
Salt and Pepper Diner, 50
South Gate Café, 179
Tempo Café, 17
Top-Notch Beefburgers, 152
White Palace Grill, 29

American Fast Food
The Counter, 102
Five Guys Burgers and Fries, 198
fRedhots and Fries, 186
Harold's Chicken Shack #36, 35
Parisi's, 148
Superdawg Drive-In, 127
Wojo's, 218

American Lounge
Hot Chocolate, 36

American Market Grocery
Z&H MarketCafe, 160

American Pub
Monk's Pub, 21
Moody's Pub, 89

American Restaurant
3rd Coast Café, 2
Birch River Grill, 182
Blackbird, 19
Byron's Hot Dogs, 98
C-House Restaurant, 5
Charlie Beinlich's Food and Tap, 172
CJ's Eatery, 136
Cooper's Hawk Winery and Restaurant, 208
Duke's Drive-In, 206
Gale Street Inn, 124
Grant's Wonderburger Grill, 146
Granite City Food and Brewery, 211
The Grove Restaurant, 46
Hackney's, 212
Hot Doug's, 115
Kuma's Corner, 141
Lula Café, 142
M. Henry, 89
Manny's Cafeteria & Delicatessen, 28
Marion Street Cheese Market, 199
Mini Hut Chicken, 148
Nite 'N Gale, 178
Old Oak Tap, 70
Orange, 106
Petterino's, 22

CATEGORY INDEX

Skylark, 82
Soupbox, 14
Uncommon Ground, 109
Walker Brothers Pancake House, 180
White Chocolate Grill, 203

American Sandwich Shop
The Bourgeois Pig, 44
Johnnie's Beef, 199

American Steak House
The Grill on the Alley, 10

Barbeque Cafeteria
Smoque, 123

Barbeque Dive
Ribs 'N' Bibs, 158

Barbeque Fast Food
Booby's Charcoal Rib, 190

Barbeque Restaurant
Honey 1 BBQ, 35
Russell's Barbecue, 202

Caribbean Restaurant
Calypso Café, 154

Chinese Hole-in-the-Wall
Seven Treasures Cantonese Cuisine, 79

Chinese Restaurant
Chen's, 99
Dragon Inn North, 185
Ed's Potsticker House, 75
Friendship Chinese, 140
Lao Szechuan, 75
Phoenix Restaurant, 78
Sun Wah BBQ, 95

Colombian Restaurant
El Llano, 115
Lito's Empanadas, 47

Cuban Restaurant
Habana Libre, 65

Ethiopian Restaurant
Ethiopian Diamond, 85
Ras Dashen, 91

French Bistro
Avec, 18
Bistrot Zinc, 4
Miramar Bistro, 178

French Restaurant
Bonsoirée, 139
Café Bernard, 46
Koda: A Unique Bistro and Wine Bar, 151
La Petite Folie, 155
NoMI @ the Park Hyatt Chicago, 12

Fusion Lounge
SushiSamba Rio, 15
Fusion Restaurant
Tarascas International, 52

German Restaurant
Chicago Brauhaus, 130
Mykonos, 191

Greek Restaurant
Barba Yianni, 128
Cedars Mediterranean Kitchen, 155
Cross-Rhodes, 165
Icosium Kafe, 87

Hawaiian Restaurant
Roy's Hawaiian Fusion, 13

Ice Cream/Gelato/Frozen Yogurt Fast Food
Original Rainbow Cone, 147

Indian Restaurant
Curry Hut Restaurant, 175
Gaylord India, 8
India House, 11
Sher-A-Punjab, 110
Udupi Palace, 111
Uru-Swati, 112
Viceroy of India, 113

Irish Pub
D4 Irish Pub & Café, 7
The Celtic Knot Public House, 164

Irish Restaurant
McNamara's, 121

Italian Bakery
Maria's Bakery, 176
Pasticceria Natalina, 90

235

CATEGORY INDEX

Italian Cafeteria
Pompei, 58

Italian Fast Food
Al's Italian Beef, 57

Italian Pizzeria/Restaurant
Bricks Chicago, 45
Burt's Pizza, 190
Coalfire Pizza, 62
Little Frank's Pizzeria, 207
Pequod's Pizza, 49
Pizano's Pizza & Pasta, 189
Pizza Rustica, 107
Spacca Napoli, 118
Village Pizza, 73

Italian Pizzeria/Restaurant Fast Food
Roseangela's Pizzeria, 217
Villa Rosa Pizza, 149

Italian Restaurant
A Tavola, 60
Bella Via, 174
Buona Terra, 139
Caffe De Luca, 31
Capri, 213
Carlos & Carlos, 182
Club Lago, 6
Cucina Paradiso, 197
Dinotto Ristorante, 53
Enoteca Roma, 33
Francesco's Hole in the Wall, 173
Isabella Café & Catering, 211
La Lucé, 66
La Scarola, 20
La Villa, 120
Medici on 57th, 156
Natalino's, 70
Pasta Palazzo, 49
Spiaggia and Café Spiaggia, 15
Va Pensiero, 170
Vittorio De Roma, 194

Japanese Restaurant
Chiyo, 120
Ginza Japanese Restaurant, 8
Sushi Station, 193

Japanese Sushi Restaurant
Coast Sushi, 32
House of Sushi & Noodles, 37
Indie Café, 87
Wakamono, 110

Jewish Deli
Eleven City Diner, 27

Korean Lounge
Waba, 134

Korean Restaurant
San Soo Gab San, 133

Latin American Cafeteria
La Unica, 88

Latin American Restaurant
Carnivale, 5
Coobah, 101
Irazú, 39
Maya del Sol, 201
Province, 22

Lebanese Restaurant
Semiramis, 122

Mexican Dive
Cemitas Puebla, 136
La Pasadita, 67

Mexican Hole-in-the-Wall
De Pasada, 63
El Burrito Mexicano, 105

Mexican Restaurant
Carnitas Urupan, 80
El Barco Mariscos, 64
Fuego Mexican Grill & Margarita Bar, 184
Flo, 64
Garcia's, 132
La Cebollita, 81
Lalo's, 187
Mariscos El Veneno, 68
The New Rebozo, 202
Nuevo Léon, 82
Taqueria Moran, 144
Tecalitlan, 72
That Little Mexican Café, 98
Uncle Julio's Hacienda, 55
Wholly Frijoles Mexican Grill, 192
Xni-Pec, 197

Middle Eastern Diner
Chickpea, 62
Taza, 16

CATEGORY INDEX

Middle Eastern Dive
Baba Palace, 2
Old Jerusalem, 54

Middle Eastern Fast Food
Sultan's Market, 42

Middle Eastern Restaurant
Pita Inn, 188

Organic Fast Food
UFood Grill, 25

Pan-Asian Restaurant
Chi Tung, 217
Cozy Noodles & Rice, 102
Zen Noodles, 43

Polish Restaurant
Mabenka Restaurant, 208
Sami Swoi, 126

Puerto Rican Restaurant
Coco, 137

Russian Restaurant
Russian Tea Time, 23

Spanish Restaurant
Tapas Barcelona, 169

Soul Food Restaurant
Wheaton's Soul Food Café, 205

Southern Restaurant
Chuck's Southern Comfort Café, 205
Dixie Kitchen & Bait Shop, 167
Stanley's Kitchen and Tap, 51

Swedish Restaurant
Ann Sather, 85

Tex-Mex Restaurant
Mexican Inn, 161

Thai Bistro
TAC Quick Thai Kitchen, 108

Thai Restaurant
Ben's Noodles and Rice, 94
Butterfly Sushi Bar and Thai Cuisine, 61
Duck Walk, 103
Late Night Thai, 116
Thai Bowl, 59
Thai on Clark, 97
Thai Smile, 215

Vegan Restaurant
Soul Vegetarian East Restaurant, 152

Vegetarian Café
Alice & Friends' Vegetarian Café, 92

Vegetarian Diner
Chicago Diner, 100

Vegetarian Restaurant
The Handlebar Bar & Grill, 34

Vietnamese Diner
The Noodle, 76

Vietnamese Noodle House
Tank Noodle (Pho Xe Tang), 96

Vietnamese Restaurant
Pho 777, 95

Vietnamese Sandwich Shop
Ba Le Sandwiches & Deli, 93

World/International Bakery
Shokolad Pastry & Café, 71

World/International Pub
Duke of Perth, 104

World/International Restaurant
Chowpatti, 183
Rajun Cajun, 158
Riverside Family Restaurant, 196

CONTRIBUTORS

Ian R. Alexander was raised in north suburban Chicago and attended the University of Illinois at Urbana-Champaign and Tulane University in New Orleans. Ian is a partner in the Chicago law firm of Goldberg & Goldberg and resides with his family on Chicago's North Shore.

Joshua A. Arons was raised in the Metro-Detroit area. He started in food service at the age of 14, and has worked in every facet of the restaurant business . He is a graduate of the International Culinary Academy at the Illinois Institute of Art, and currently works in wine retail.

Susan Ball's infinite love affair with food includes a fondness for farmers' markets and the small haunt "markets" that quite often are the little hidden "mom and pop" gems. She currently lives in Frankfort where she is an avid gardener and an aspiring food writer.

Paul Barile has written about nearly every facet of art and culture in the great city of Chicago for over two decades. Whether he is talking music or theater, restaurants or nightclubs, Paul brings a fiery passion to his work that reflects his love for the city. Mangia!

Steve Bellinger is a webmaster, software trainer, writer and one of the world's oldest Trekkies. He lives with his wife Donna, a marketing and sales coach in the Gold Coast area, and he loves good food a lot more than he should.

Katelyn Bogucki moved from Kansas to Chicago to attend DePaul University where she majored in Journalism and Digital Cinema. Katelyn keeps herself busy writing for various publications and making videos. To see more of Katelyn's work, visit her website at http://doit4vangogh.com.

Dana Bottenfield has spent four years in Chicago frequenting the plethora of fabulous local restaurants her city has to offer. As a small-town gal, she appreciates the atmosphere of a small neighborhood restaurant where everyone is treated like family and there's always dessert.

Annalee Bronkema's background in the food and beverage industry extends far beyond her career. With experiences in both the front and back of the house, catering, and management, her appreciation for superb service and amazing food has been a magnetic force in all of her endeavors.

Patrick Brown is a college student from Lincoln Park. He has a love for great food and great restaurants. He is studying Digital Cinema with a minor in Catholic Studies.

Heather Calomese lives in Oak Park. She currently works for the Illinois State Board of Education, daydreaming of cooking to her heart's content. A writer of poetry and flash fiction, she has works slated for publication in the online journal *G22*. Please loan cookbooks to her with caution.

Kristen Campagna was born and raised in Chicago's Midway neighborhood. The two things she is most passionate about are writing and food. She is pursuing a career in Writing with the support of her fiancée, Mark.

Rachael Diane Carter is a self-proclaimed foodie and has been residing in Chicago for the last seven years is currently studying for a degree in Journalism while working on a collection of personal essays. Her favorite food? "Pie. Lots of pie...with ice cream."

Luca Cimarusti currently resides in Humboldt Park. His hobbies include sleeping, eating, and spending money. His favorite beer is Coors Light, his favorite record of all time is "Tarkus" by Emerson, Lake & Palmer, and his

CONTRIBUTORS

favorite superhero is Wolverine.

Laura Cococcia is the author of the writing and reading motivation blog Laura Reviews. She's a member of PEN American Center, the National Book Critics Circle, and volunteers as a book reviewer for Armchair Interviews. Laura graduated from Southern Connecticut State University with a graduate certificate in women's studies and a degree in English..

Benjamin Coy is a classically trained trombonist, maintaining a portfolio of free sheet music on his website, www.tenorposaune.com. Always inspired by Chicago's culinary abundance, he and his wife have lived in The Loop, South Loop, Edgewater, Andersonville, Oak Park, and Hyde Park.

Susan "Devin" Droste's favorite foods include Mexican and Italian, but her passion lies with Middle Eastern, Indian and Mediterranean fare. In her spare time she likes writing short stories and poetry, listening to rock and rap, watching wrestling, hanging out with friends and reading books.

Andrea Eisenberg lives in the Lincoln Park/DePaul area of Chicago with her wry and witty husband Josh and writes about her foodie adventures at www.themaidenmetallurgist.com. Andrea and her husband travel often, especially to her hometown, Denver, CO.

Cliff Etters has traveled across the face of America while living and working in Atlanta, Seattle, Baltimore, and most recently Chicago. He lives with The Sadie (writer, monologist, and vengeful comedic goddess). They have an unnatural love of bacon and English Bulldogs.

Donny Farrell is a Commercial Real Estate Agent in Chicago. He enjoys coaching lacrosse at his alma mater Loyola Academy in his free time. Donny, along with his girlfriend Allie, is always seeking new restaurants to sample and also enjoys cooking.

Denise Goldman's favorite pastime is reading cookbooks, hanging out with her daughters, and bike riding with her husband. The Goldmans love to go out for breakfast, sometimes with their grandchildren, who request their favorite French toast at The Egg & I.

Katy Graf lives and eats in Chicago.

Whitney Greer is a Chicago-born journalist and writer. Though she's covered many topics, the cuisine-related ones have been some of the closest to her heart. She's also very proud to have a hometown that offers some of the tastiest vittles on the planet to write about!

Romania-born **May C. Gruia** has lived in the Chicagoland area for almost 20 years and has come to appreciate its diverse culture. One of the most important lessons that May has learned from visiting so many different people is that the golden rule applies anywhere: "Do unto others as you would have them do unto you."

Julie Harber moved to Chicago from St. Louis after graduating from Lake Forest College with a BA in English. She recently graduated from the Cooking and Hospitality Institute of Chicago nd is now a freelance food writer. She loves going out to eat at both well-known and hidden restaurants and cooking with her friends.

Megan Healy is a restaurant manager from the south side of Chicago that loves to tour the tastes of Chicago. She is majoring in Journalism and is a staff writer for *The Glacier*. She enjoys all types of food and is never afraid of a dish that has ingredients she can't pronounce or articulate.

CONTRIBUTORS

Dylan Heath is a Journalism student at Roosevelt University and a barista for an Evanston café. He loves making and eating good food. His favorite meals include great food and even better friends. He is also the Editor-in-Chief of the literary magazine *New Stone Circle*.

Lisa Hede can be found reading vintage cookbooks, dining out, designing specialty cakes, and building edible bouquets. While her graphic design skills have helped her develop a career that briefly touched the food industry, it was her grandma that first introduced her to her love of food.

Dorothy Hernandez is a native Chicagoan who would rather starve than eat anything from a place that rhymes with Sick Donalds. She's always on the lookout for a vegetarian place that serves booze and has a patio. She is a firm believer in that everything could use Sriracha. Well, maybe except for ice cream.

Lori Hile, a Thai food aficionado, has spent her 10 years in Chicago writing reviews for *Lake Magazine* and *Time Out Chicago* while completing a graduate certificate in Creative Nonfiction Writing at the University of Chicago. To find out more about Lori, visit www.lori-hile.com.

Gina Holechko graduated from Columbia College Chicago's illustrious Fiction Writing department. She has survived Pizza Hut and is still seeking to experience the perfect dish of lasagna. She adores her two gerbils House and Chase, despite recognizing they may indeed be considered a tasty dish in a far-off land.

Charlie S. Jensen is an actor, traveler, writer and practiced eater. He has a Masters in English from Northwestern University, has traveled around the world, and currently writes and acts around Chicago. You can always read more about what he's up to at www.charliejensen.com.

Erika Jones is a career development professional by day, unabashed foodie by night. The other great loves of her life include music, travel, coffee, doodling in her planner with big, fat, colorful markers, and meandering.

Molly Kealy graduated from Notre Dame, and after a brief stint in Dallas, decided that the Windy City was a much better fit. Who doesn't love the long, harsh winters in January? She now works in operations at a financial advisory firm, loves the Cubs, and loves to eat. All three are full-time jobs.

Crage Kentz is a 48-year-old engineer/DJ born and raised on the southwest side of Chicago. He likes to cook and watch Guy Fieri's Diners, Drive-ins and Dives. He's a huge White Sox and Blackhawks fan. Tampa Bay, with its fantastic people, is his second home.

Devin Kidner is a citisen of both the United Kingdom and the United States. She moved to Chicago to pursue a Masters in Broadcast Journalism at Medill at Northwestern University. In her spare time she loves to travel, eat, and of course, eat some more!

Carrie Kirsch lives and eats near Chicago.

David Kravitz is a freelance writer, playwright, actor, and long-suffering Cubs fan living in the Oak Park area. He has written for a long list of Fortune 500 companies, several national publications, and had his short plays produced across the U.S. You can reach him at dkrav@xsite.net.

Christine Lambino is as consultant for a software company in Chicago. When she's not writing reviews, she enjoys checking out restaurants and

CONTRIBUTORS

other fun places in the Chicago area. Check out her HR blog at http://clambino.wordpress.com.

Helen Lee is a freelance entertainment and lifestyle writer with 14 years of professional experience. Her work has appeared on numerous online sites, and her print and magazine credits include *Complete Woman*, *Electronic Gaming Monthly*, *Cinescape* and a syndicated column through the Tribune Company.

Jessica Lewis lives and eats in Chicago.

Mark and **Julia Lobo** are happily married in the greatest culinary city in the world. Julia edits children's books and loves to cook. Mark is a graphic designer and artist. They were both raised in Chicagoland. Together they share a passion for great food and will stop at nothing to find it.

Rhea Manalo is a Filipino freelance writer in Chicago whose love for food matches her love for writing. Her delusions of supermodel grandeur were recently shattered upon trying on a pair of skinny jeans, so she is now training for her first triathlon, but her love for food remains intact.

Debra Monkman lives and eats in Chicago.

Nick Montelone is an award-winning composer, musician, and writer. Since graduating from Columbia College Chicago, Nick has scored several independent films and is currently working on his first opera. Nick is an avid Chicago foodie that enjoys finding those unique, under-the-radar establishments.

Kathy Moon lives and eats in Chicago.

Alex Moore grew up in Yokohama, Japan and moved to the United States at the age of 14. After undergoing a Jesuit high school education, he proceeded to earn a Bachelor's degree in Economics from the University of Chicago. Alex currently lives in Chicago and reads numbers for a living.

Norine Mulry attended the University of Illinois Urbana-Champaign, obtaining a Bachelor's degree in English Literature and an Associate's degree in Culinary Arts. Currently, she works as a cheesemonger and the cheese buyer for Marion Street Cheese Market. Norine loves to frequent the many small ethnic markets around Chicago.

Kim Nawara is a Chicago native and graduate of the Le Cordon Bleu Program at CHIC. She has a passion for food and for spending time with family and friends around the dinner table. Kim is a member of Slow Food and the James Beard Foundation.

Craig Nemetz moved out to Chicago from Connecticut and has been in the food industry for five years. What got him into cooking is the love of food and the way it is able to bring family and friends together.

Santrise Nicole writes and edits documents professionally, mainly grants and articles for fashion, government, and media publications. From time to time, she writes on a freelance basis and acts as a web contributor to various sites based in Chicagoland and abroad.

Jenna Noble resides in Rogers Park and works for a large law firm downtown. She travels most of the month, but finds that the best eats are located right in the heart of Chicago. She loves writing restaurant reviews to help others find a delightful place to enjoy life's best food experiences!

Renee Ochs lives and eats in Chicago.

CONTRIBUTORS

Emily Olson is a Southern girl from Memphis who decided to change careers and move to Chicago to go to culinary school. She spends her weekends going to farmer's markets, testing recipes in her small kitchen, and checking out the newest cafes & restaurants.

Julie Owens is a DePaul graduate and Chicago native. She eats out at least once a week, most often with her husband who has worked in the food industry for over 18 years! Her favorite places are usually local haunts and those that emphasize fresh products and cultural cuisine.

Denise Peñacerrada's palate comprises her penchant for pretentious fine dining and her affinity for ghetto gourmet—after all, she is a southern-fried Waffle House girl at heart. Word of warning: don't get in her way around feeding time. She bites.

Hillary Proctor is graduating from Northwestern with a Journalism degree, but loves eating and writing about fine cuisine so much that she's heading straight to culinary school. At restaurants, she's known to take more pictures of the food itself than her dining companions. She is determined to try all the best sushi and tapas the city has to offer.

Nora "Noe" Quick, a longtime resident of Chicago, is a writer, model, award-winning poet, and true epicurean foodie. With a taste for spicy, exotic foods, she's always on the hunt for good, cheap eats. Track her on-going Chicago and fiction writing adventures at www.planetpigasus.com.

Lori Rotenberk is a local journalist with work appearing in *The New York Times*, *The Boston Globe*, *Newsweek*, *Chicago Wilderness Magazine*, *The Chicago Sun-Times*, *The Chicago Tribune* and many national magazines. She was a waitress at Wonder Burger a number of years ago and was known to make a mean malt.

Robert Sabetto has spent over a decade living in Chicago. He has written for *The Downtown Tab* and *US Rocker* magazines, as well as Indie Express and Pride City Guide websites. He published a law journal article on a lawsuit alleging emotional distress against Howard Stern. When not writing (or eating), Rob practices employment law.

April Schneider has three addictions: running, traveling, and eating. When she's not traveling around the world, she is devouring her way through Chicago's neighborhoods. She adores both hole-in-the-wall spots and haute cuisine, and has a weakness for cheap but delicious wine.

David Shapiro is a bookstore employee by day and a writer/musician by night. He spends his free time wandering the streets looking for two things: 1) things to take pictures of, and 2) great places to eat. Examples of his music can be found at www.myspace.com/hazelrahmusic.

Andrew Skweres lives and eats in Chicago.

Rachael Smith lives and eats in Chicago.

Matthew Sove dedicates the majority of his time to teaching English at Truman College. When he is not grading student papers, he is eating.

Jim St. Marie has lived in Chicago for 20 years working in commercial real estate. He also plays in a blues band here in Chicago, and has a degree in Music and an MBA. While in college, he worked in a variety of restaurants and bars and he loves music, wine and cooking.

Jennifer Stone is a Chicago native who makes the transition from media

GLOSSARY CATEGORY INDEX CONTRIBUTORS

planner by day to restaurant explorer by night. She resides in Bucktown but will venture to any neighborhood to try something new. When she's not dining out she enjoys cooking at home and reading magazines.

Jen Tatro is always looking for undiscovered dining gems. She works as a public relations writer and is interested in all things food, wine, travel, and Bears football. If she's not going out to dinner, she's trying out new recipes in her own kitchen. Born in Chicago, Jen currently lives in Oak Park with her husband.

Isa Traverso-Burger is a bilingual script- and copywriter. She holds a BA from Loyola New Orleans and is originally from Caracas, Venezuela. She has collaborated with several magazines such as *Art Voices*, *Distrikt*, *Loft*, and *Chicken Soup for the Recovering Soul*. Isa scripted a documentary that won a regional Emmy, and she appeared in HBO's *Habla y Habla* and in the film *Trust 22*. Her blog and website is www.isatraverso.com.

Marquis Tucker is a financial services professional that thrives in the commercial real estate industry. Marquis also provides makeovers for underprivileged women entering the workforce, emphasizing "inside out" beauty where health and wellness are foremost.

Araceli Valenciano lives and eats near Chicago.

Lindsay Valentin holds a BFA in writing from the renowned Pratt Institute in Brooklyn and received a work-study award from The Center for Book Arts NYC for her studies of letterpress printmaking and bookbinding. Lindsay resides in Chicago and you can view her writing and presswork at www.imprintedink.com.

Veronica Wagner lives and eats in Chicago.

Liz Walker is a lifelong Chicago area foodie. After graduating from DePaul College of Law in Chicago, she practiced as an attorney for five years and taught Criminal Justice at Westwood University. She now works as a Mass Litigation Claim Specialist for Zurich North America in Schaumburg. She is the lead vocalist for local blues/rock band EversoJake.

Travis Lee Wiggins is a musician, artist, writer, and graphic designer residing in Chicago. He has been a part of 13 full-length music albums, written 2 novels, and has shown his artwork extensively all over the world. For more on Travis please visit www.travisleewiggins.com.

Jessica Word writes fiction and volunteers at 826 CHI, a non-profit that supports students with creative writing skills. She enjoys cooking with her husband, baking cupcakes, watching the Cubs, and is proud that she (finally!) eats hot dogs like a real Chicagoan: without ketchup.

Evan Wormser lives and eats in Chicago.

Jennifer Worrell realized after editing this guide that she hasn't eaten nearly enough tacos and plans to remedy that. Now it's back to working as an assistant cookbook editor, playing chew toy to her ever-feisty cat-beast, stumbling through her latest bellydance lesson, and blathering unchecked about her latest gorgings at www.hungrycityblog.com/Chicago.

Brandon Wuske lives in the west Chicago suburbs while studying Library Science at Dominican University. When he is not tucked away in the stacks, he enjoys discovering all of Chicago's food and cultural offerings. He is having a great time sampling all of the wonderful ethnic restaurants here, having moved from Ohio a year ago.

HUNGRY? CITY GUIDES

Get the Inside Scoop on Where to Eat and Drink!

HUNGRY?
Hungry? Boston
Hungry? Chicago
Hungry? Los Angeles
Hungry? New York City
Hungry? San Francisco
Hungry? Washington DC
Hungry? Thirsty? Las Vegas
Hungry? Thirsty? Miami
Hungry? Thirsty? New Orleans

THIRSTY?
Thirsty? Boston
Thirsty? Chicago
Thirsty? Los Angeles
Thirsty? New York City
Thirsty? San Francisco

$14.95 ISBN prefix 978-1-893329-

Check out our newly revised website at:

www.ThirstyCityGuides.com